Resort Fashion

STYLE IN SUN-DRENCHED CLIMATES

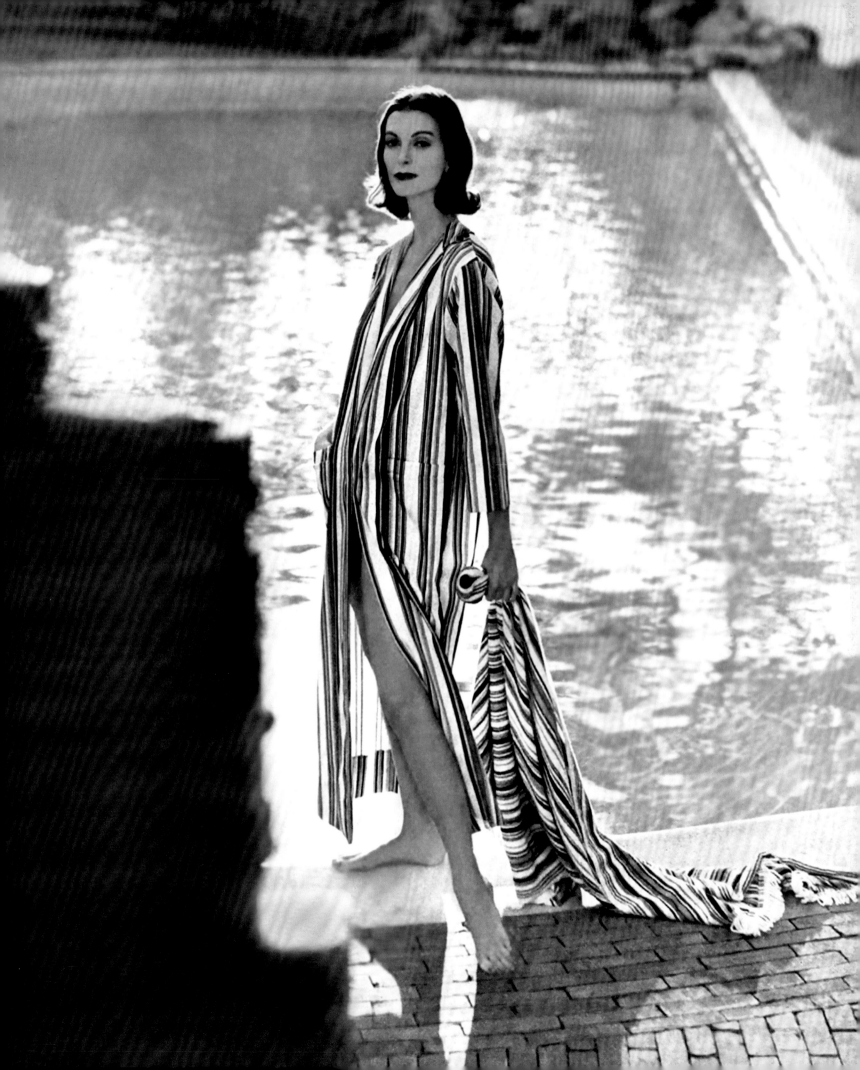

Resort Fashion

STYLE IN SUN-DRENCHED CLIMATES

CAROLINE RENNOLDS MILBANK
FOREWORD BY AMY FINE COLLINS

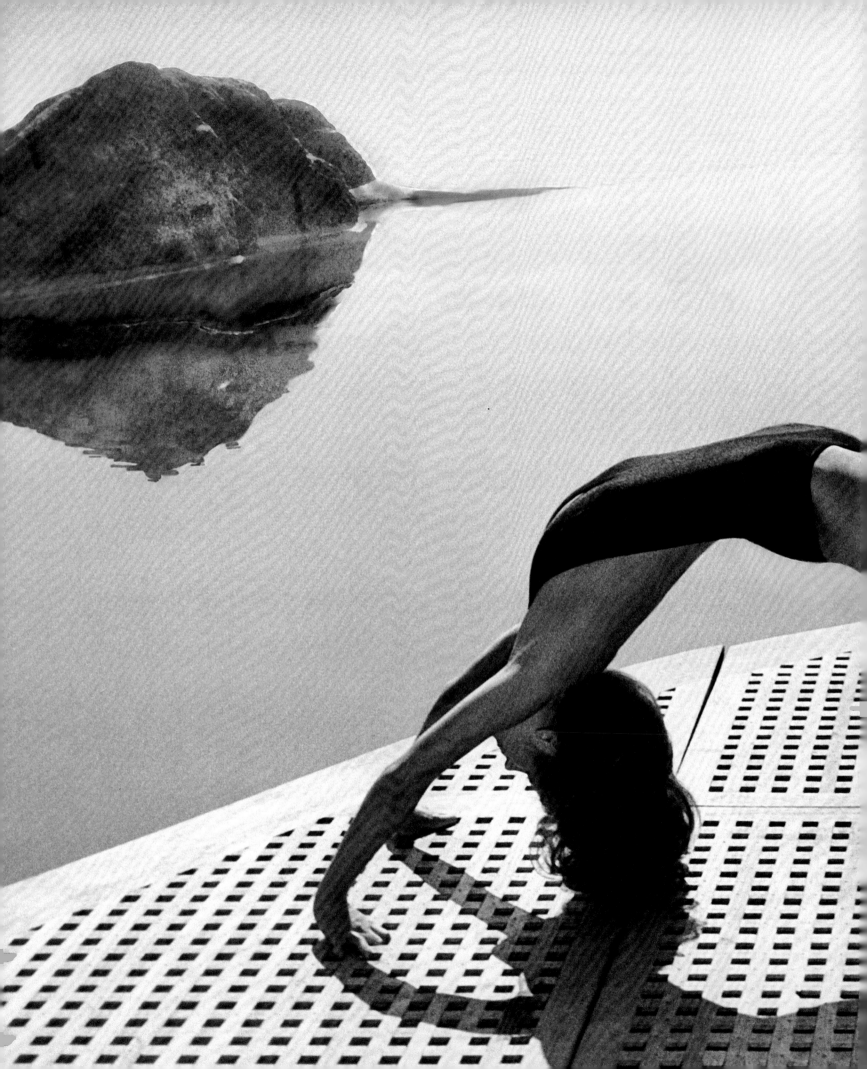

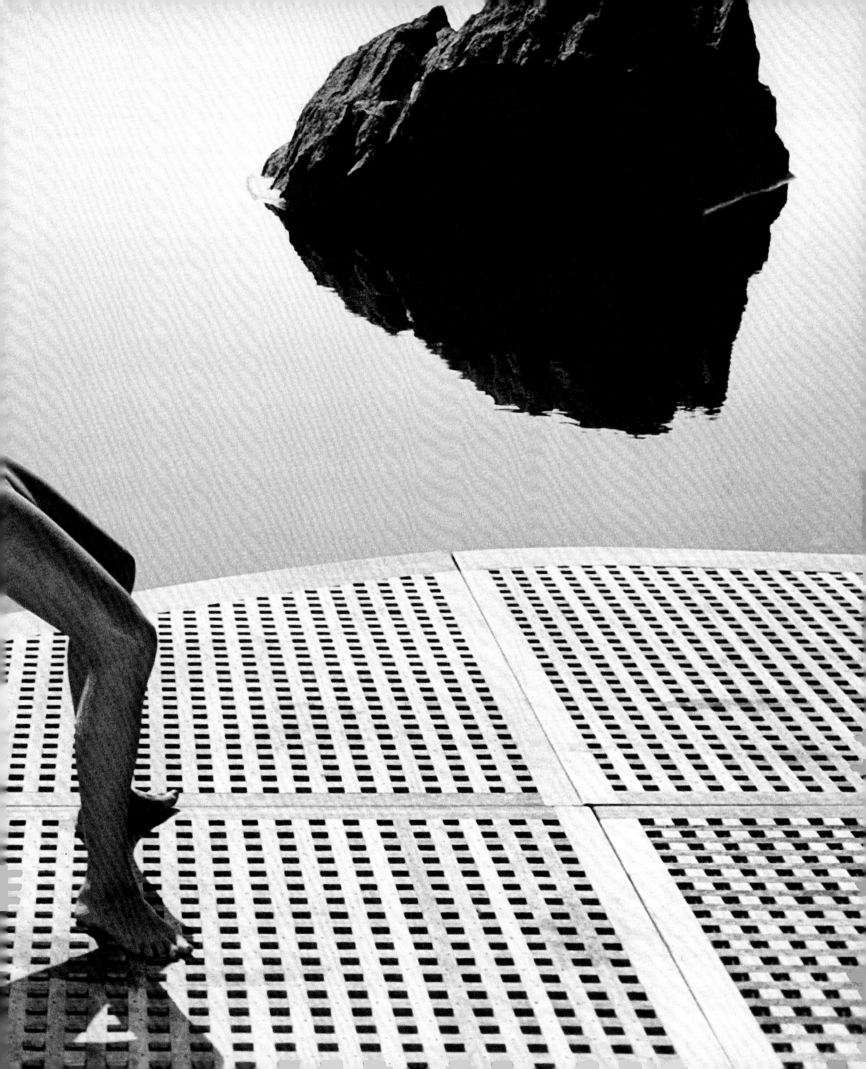

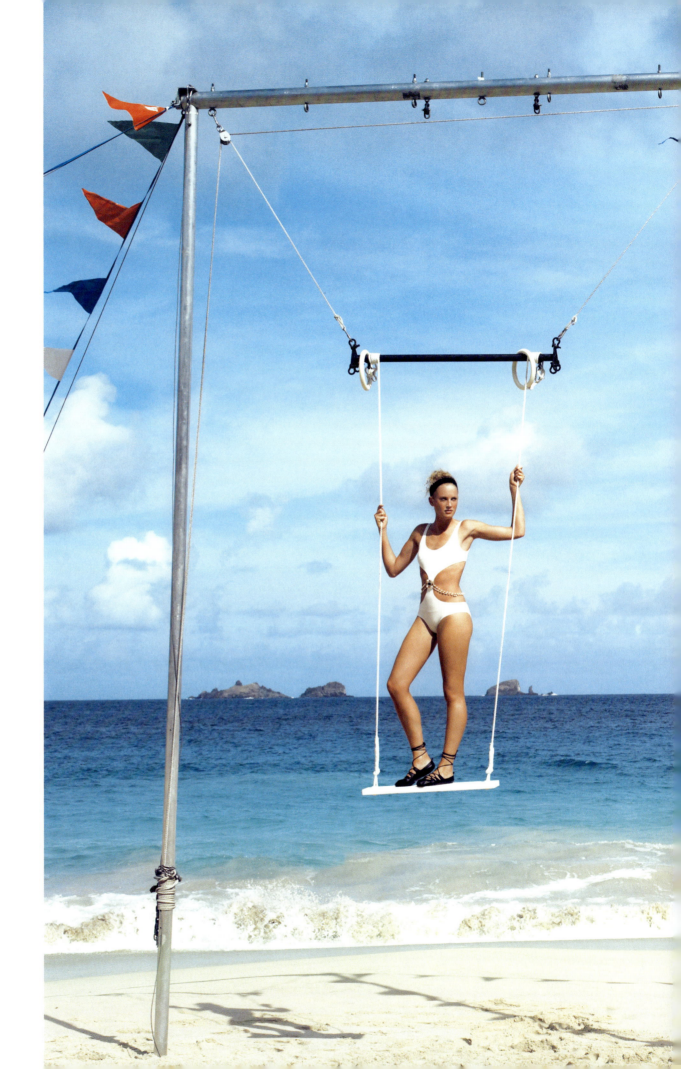

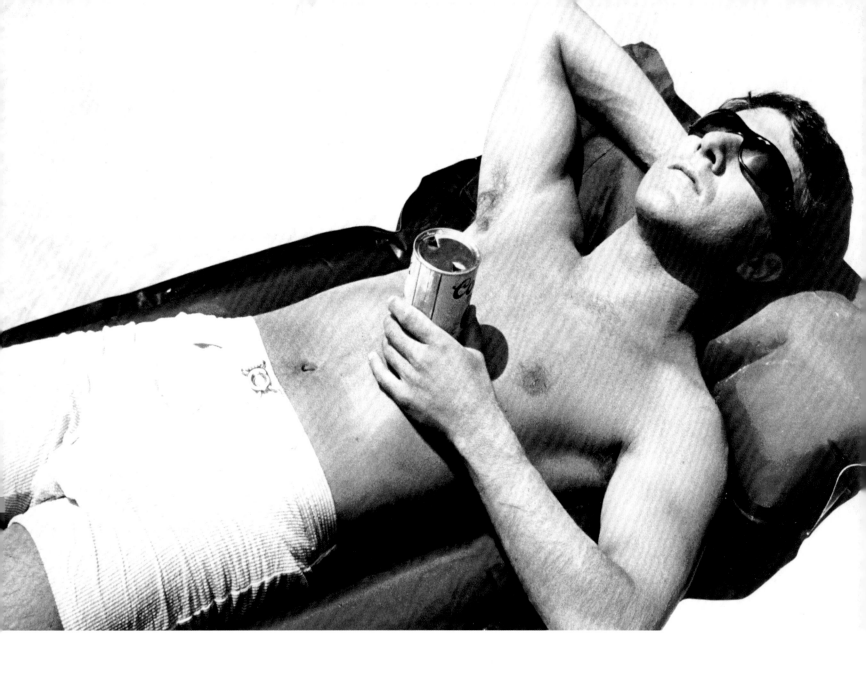

Dustin Hoffman as Benjamin Braddock in The Graduate: *"Well, I would say that I'm just drifting. Here in the pool."* RIGHT: *Two swimsuits photographed by Toni Frissell in 1949 for* Harper's Bazaar: *a reversible bikini by Cabana in navy cotton poplin on one side and red-checked gingham on the other, and a tubular maillot by Margaret Newman in pink puckered satin woven with Lastex.*

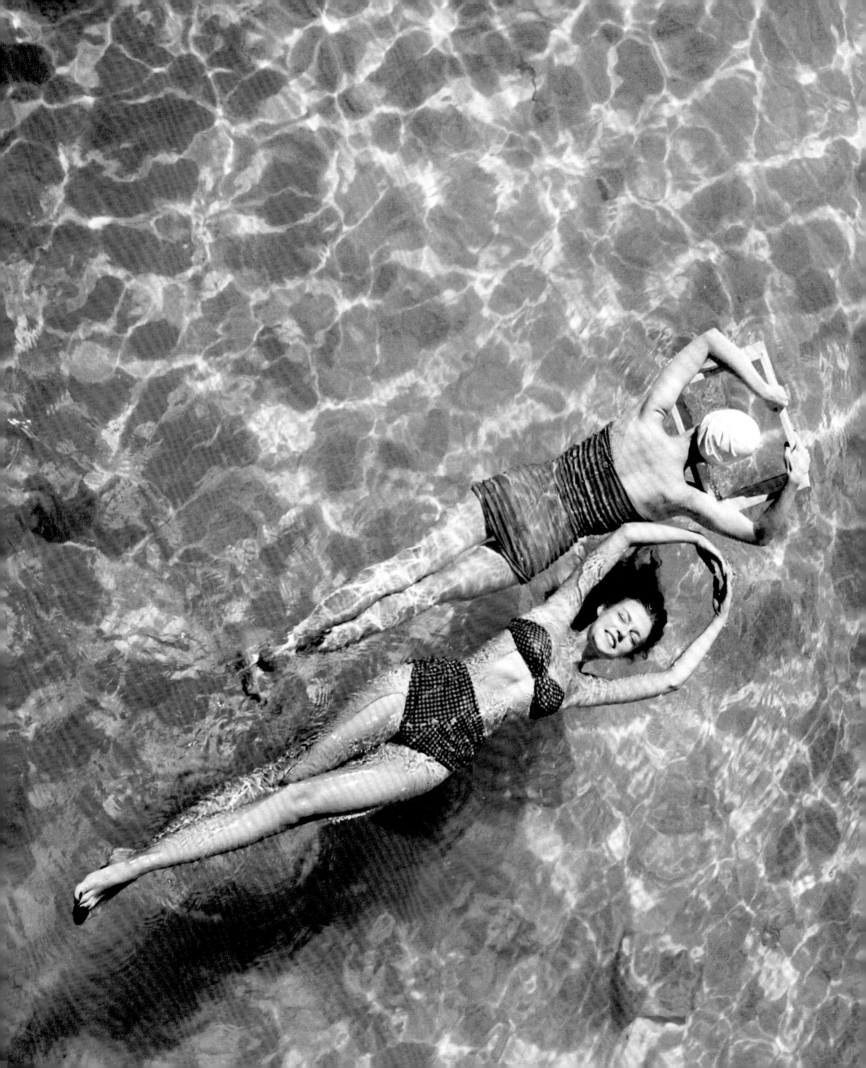

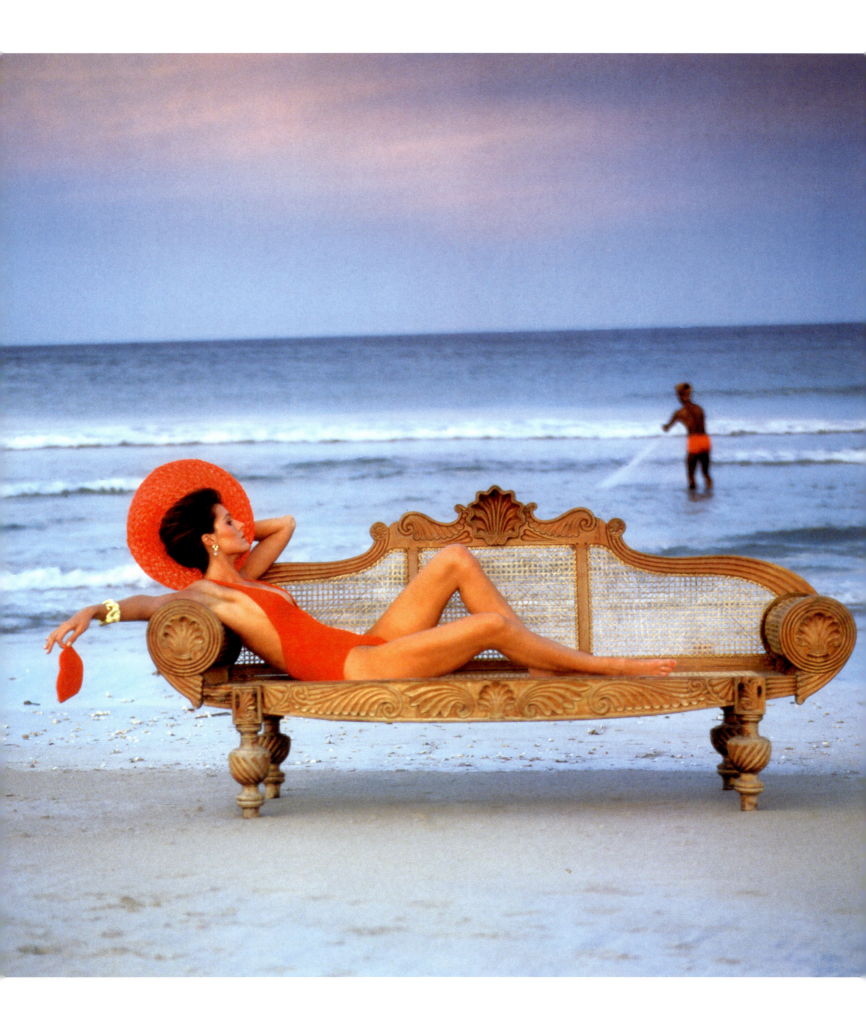

FOREWORD by AMY FINE COLLINS, 15

Introduction, 19

ONE
At Sea, 49

TWO
Stripes, 77

THREE
Prints, 107

FOUR
White, 133

FIVE
Playclothes, 163

SIX
The Summer Dress, 189

SEVEN
The Bathing Suit, 221

IMAGE CREDITS, 280
NOTES & BIBLIOGRAPHY, 282
ACKNOWLEDGMENTS, 284

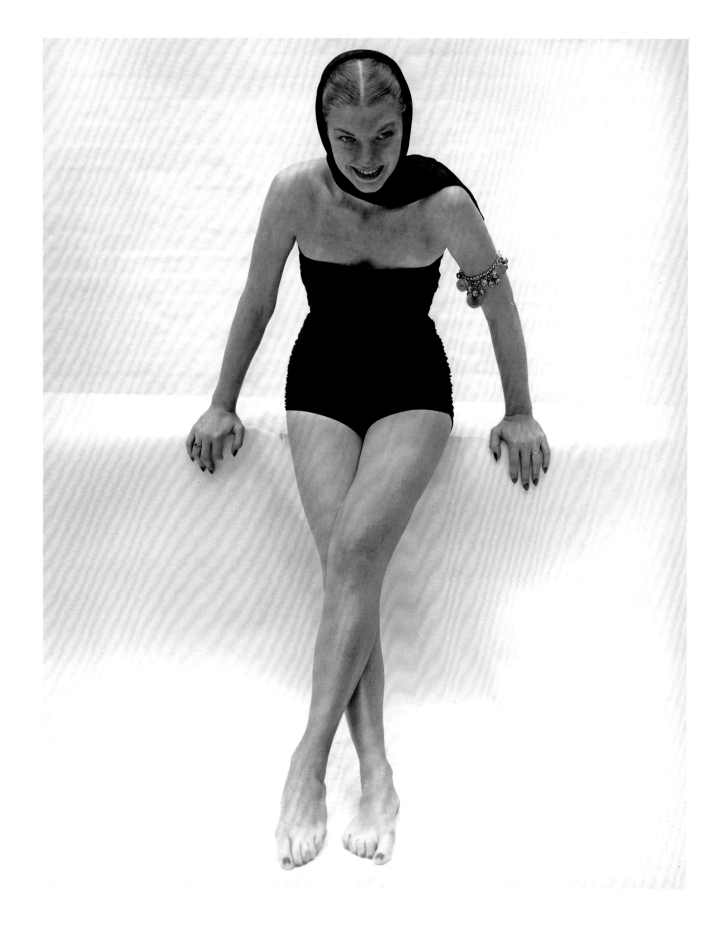

PREVIOUS PAGE: *Pilar Crespi wearing a Krizia maillot, David Webb jewelry, and Don Kline hat. Photographed at Trincomalee, Sri Lanka, by Norman Parkinson for* Town & Country, *1980.* ABOVE: *Tina Leser designed this strapless black wool jersey suit with matching headscarf, as well as the bracelets. Photographed by John Rawlings for* Vogue, *1945.* RIGHT: *Gabrielle Reece, the volleyball star turned golfer, wearing a beringed bikini by Melissa Odabash and holding daughter Reece. Photographed by Pamela Hanson for* Self, *2005.*

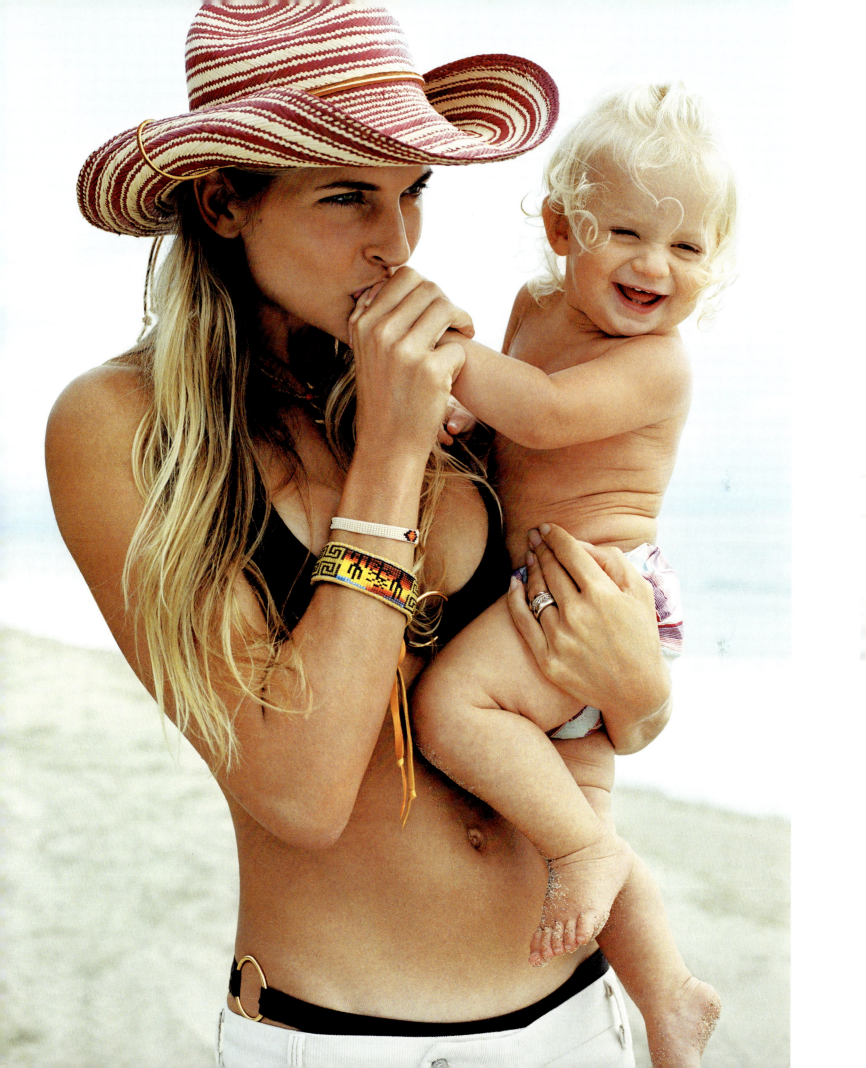

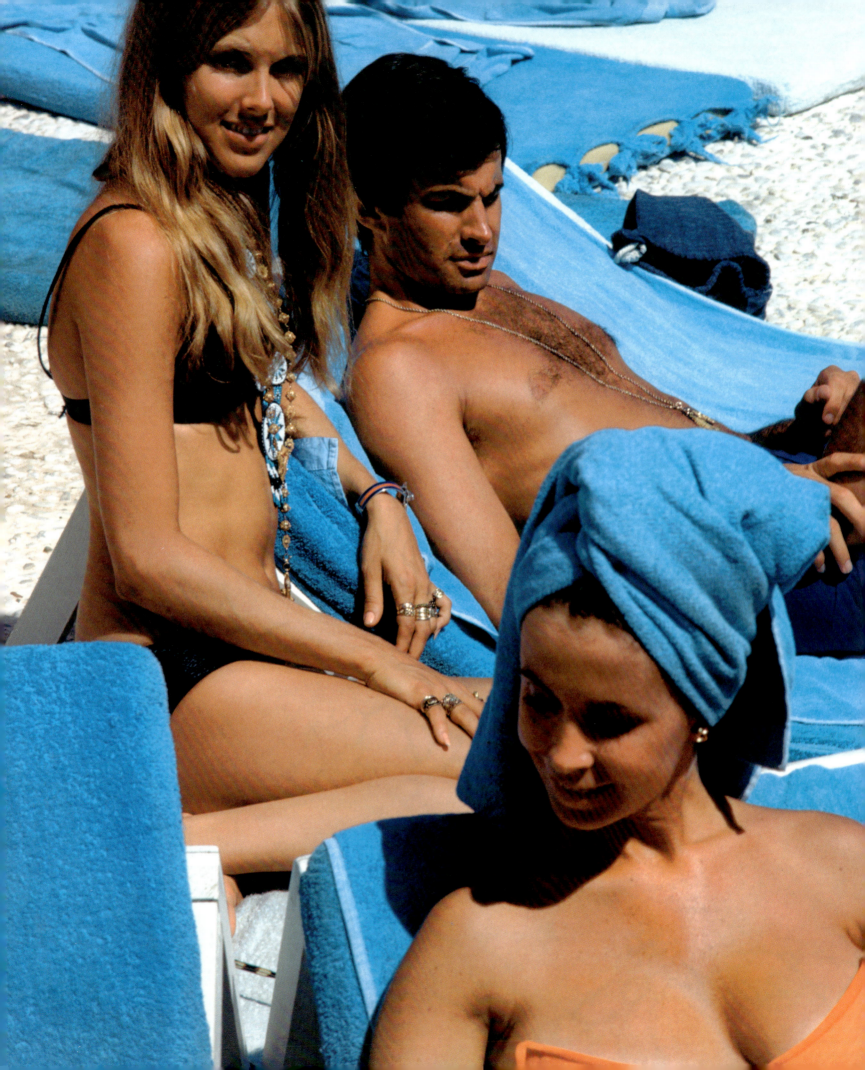

FOREWORD
AMY FINE COLLINS

On terraces in Saint-Jean-Cap-Ferrat and dance floors in Palm Beach, at cafés on St. Croix and hotels in Positano, you can depend upon hearing a band play that bossa nova standard "The Girl from Ipanema." I've come to think of this retro tune as the universal anthem of the warm-weather resort. What this seductive song promises with music—an unfettered, fleeting good time—resort fashion concentrates into clothing. Not coincidentally, the staples of present-day resort wear—sweaters in barrier-reef brights, pants in sailcloth whites, dresses in vertiginous heatstroke patterns, blazers in nautical navy blues, Nereid-bare bikinis—were codified about the same moment, 1965, that "Ipanema" won its Grammy. That year was also the high point of the jet set, or at least the very instant when the Beautiful People first flew around in candy-colored Braniff planes staffed by Pucci-clad stewardesses.

While so much of fashion today percolates up from the street, resort fashion typically trickles down from high society and its swanky enclaves. Lilly Pulitzer sprang from the sands of Palm Beach, and Emilio Pucci arose from the cliffs of Capri. A Florentine aristocrat, Pucci invented not only his signature kaleidoscopic prints but also the eponymous ankle-baring Capri pant. Similarly, holidaying Boston Brahmins popularized the preppie "Nantucket" handbag. Beachy curiosities from more exotic shores—the sarong from Malaysia, the pareo from Tahiti, the djellabah from Morocco, the muumuu from Hawaii—were domesticated and absorbed into the mainstream vacation repertoire. Golf, tennis, and yachting references, dating as far back as the Gilded Age, were also incorporated into this mongrel mix, permitting skirts to get briefer, colors to grow gaudier, and dresses to become breezier. Like most upper-crust wardrobe perennials—girls' smock dresses, hunters' riding pinks, men's dinner jackets—resort

During the 1960s and 1970s, lying on a chaise meant that you were hard at "work" on your tan, and sun products were designed to increase rather than block the sun's effects. A particularly diligent example of this work ethic is actor George Hamilton, photographed by Slim Aarons in Capri with Alana Hamilton, circa 1970.

attire is a little archaizing. The clothes conjure up the good old days of Slim Aarons's *A Wonderful Time* and nostalgically evoke a vanished era of empire and privilege. And resort garb is also deep-dyed aspirational; even if you can't afford the house, maintain the boat, or score a membership in the club, you can still acquire the uniform.

Resort dressing allows men in particular, whose license to self-express sartorially is otherwise more limited, to go a little goofy. Literary critic Northrop Frye famously wrote about Shakespeare's dramatic device of "the green world," an Arcadian parallel universe (such as the Forest of Arden in *As You Like It*), representing the "dream world that we create out of our own desires." If the resort is our real-life Shakespearean "dream world," then resort wear allows us to go native there. For men, that often means dressing the jaunty, motley part of the jester. How else to explain the garishly festive attire of the WASPy golfer out on the cocktail circuit, with his patchwork madras blazer, clashing tie, and loud lime pants? This peacock eccentricity, in Palm Beach at least, goes back to founding father Paris Singer, who in 1917 was already strutting about in purple espadrilles and showily striped shirts. I confess that my favorite get-up every summer on Fishers Island is a vintage Acapulco caftan, from whose pleated bodice flutter dozens of pink and white party-streamer ribbons. Confronted with all this off-kilter zaniness, some old-guard resort clubs periodically issue dress codes banning objectionable fads (bare midriffs, low-rise pants) whose popularity, inevitably, has passed.

"Resort," in the fashion professional's parlance, is not a place but a supplemental selling season, wedged into the calendar between Fall/Winter and Spring/Summer. With global warming, the resort season could soon expand to fill the entire year. But resort, ultimately, is neither a season nor a place, but a state of mind—sometimes anarchic, usually wistful, and on the best occasions euphoric.

This zinnia-patterned playsuit with cowled back, worn by Tan Arnold at San Simeon, California, is by Jeanne Campbell for Sportwhirl. Hat by Mr. John. Photographed by Louise Dahl-Wolfe for Harper's Bazaar, *1958.*

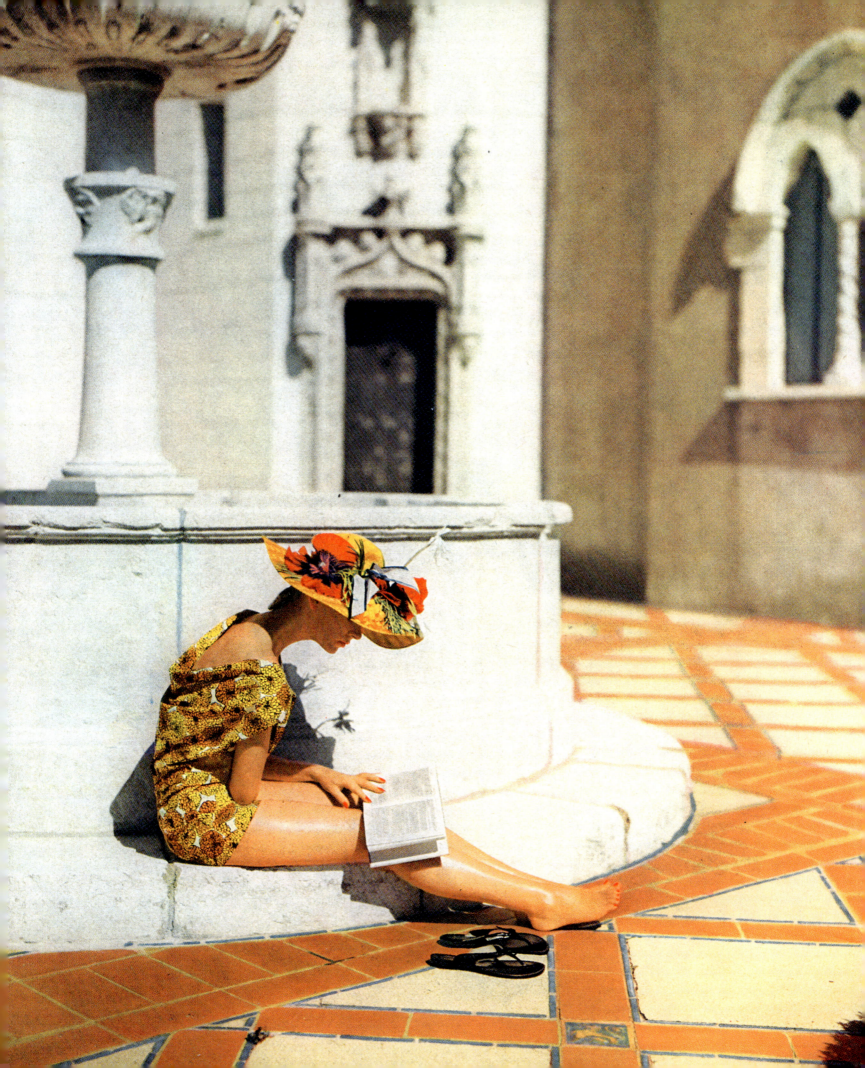

Introduction

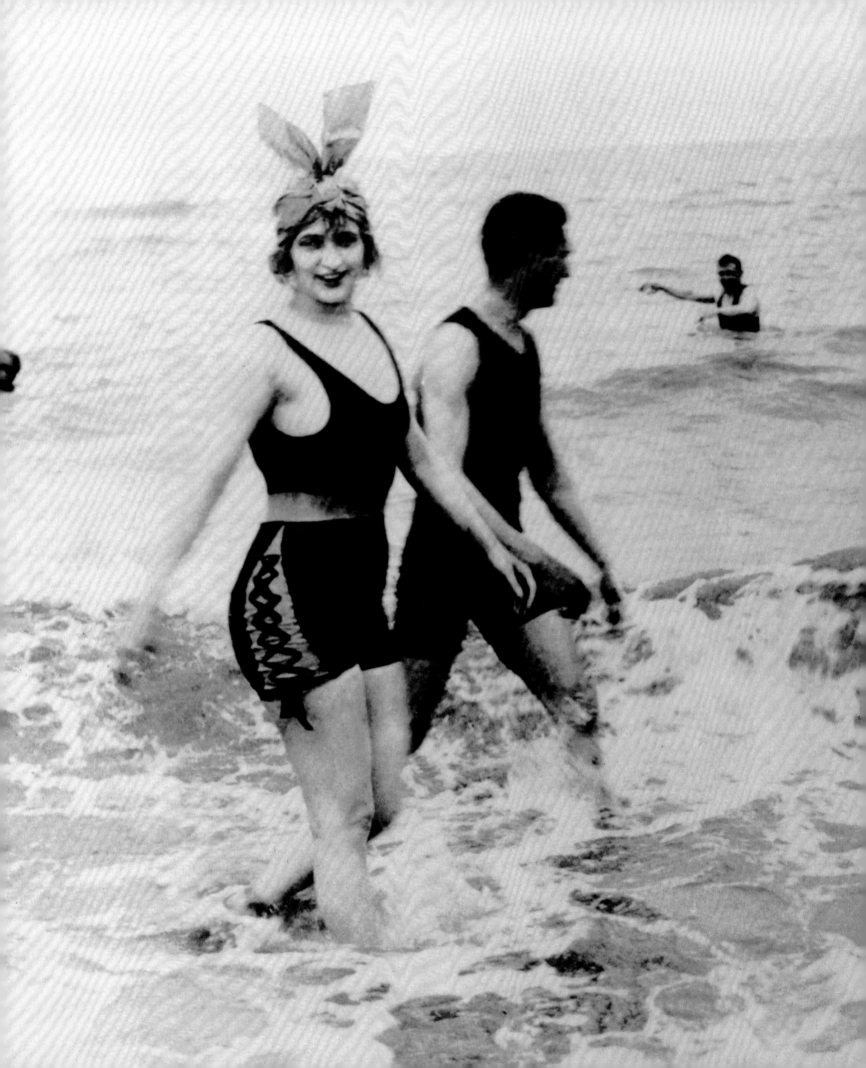

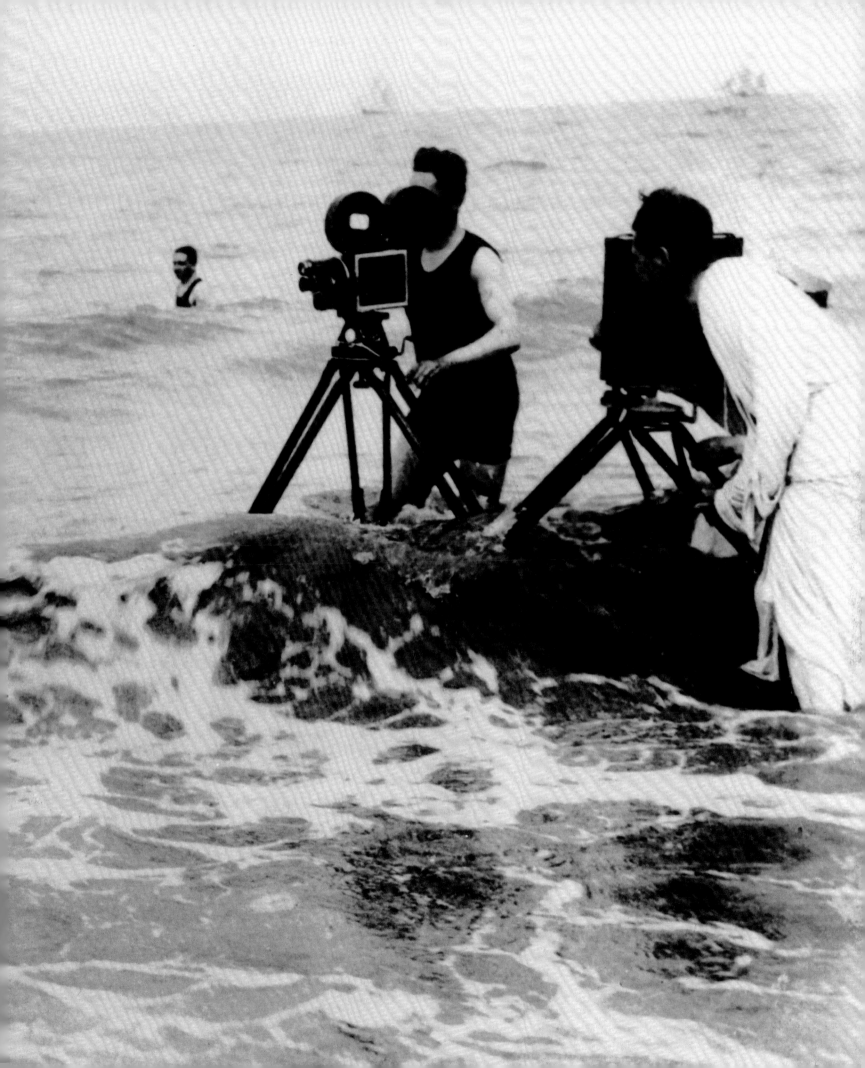

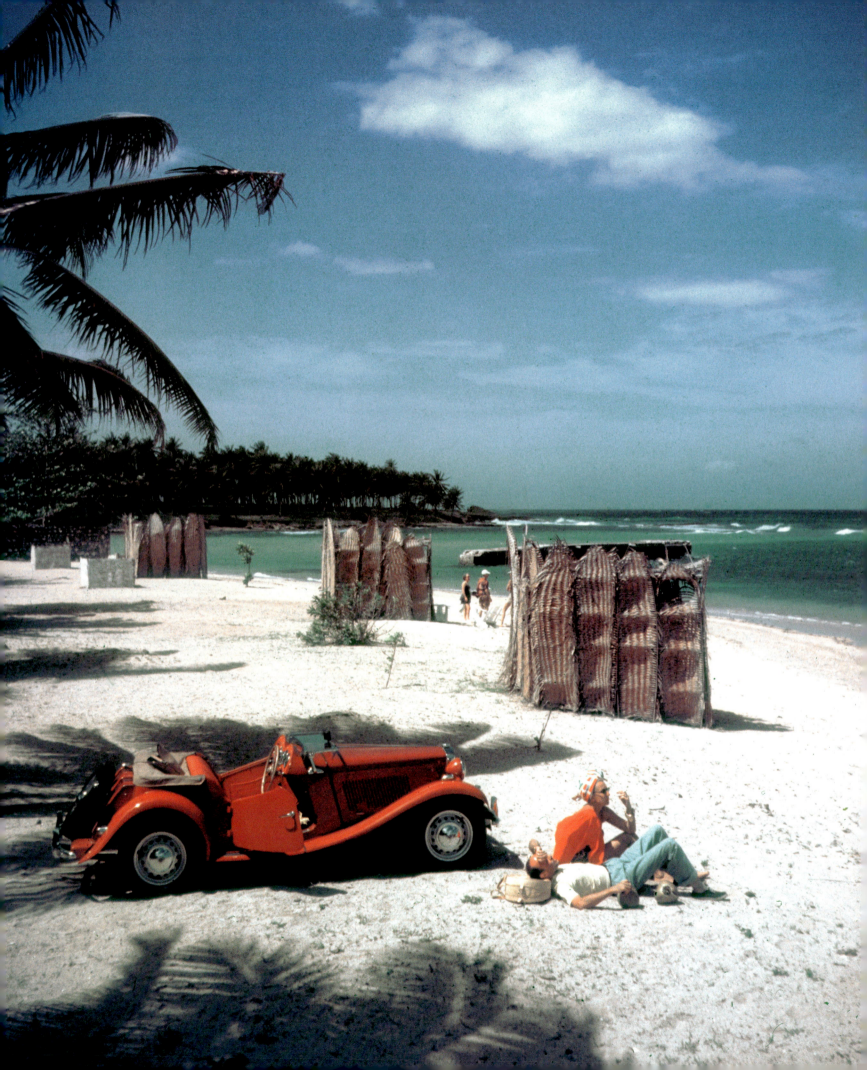

INTRODUCTION

Chasing summer, an urge deeply embedded in the twenty-first-century psyche, has not always been a top vacation goal. Recreational travel—usually to escape the heat—became common only with the onset of the railway age, circa 1830. Grand hotels were built in the mountains, by lakes, or by the sea, and city dwellers flocked to them not to bask in the sun but rather to reap the benefits of the fresh air. These great hotels and the railroads often enjoyed a symbiotic relationship: Palm Beach got off to a luxurious start when railroad tycoon Henry Flagler built palatial hotels there in the hopes of inspiring passengers to use his railroad.

The most fashionable resorts of the nineteenth century were organized around natural thermal springs in areas such as Baden-Baden, Germany; Saratoga Springs, New York; White Sulphur Springs, West Virginia; and Hot Springs, Virginia. The idea of a spa then was, if not more medicinal than it is now, at least more closely associated with the established medical wisdom of the time. Bathing in hot or warm springs was thought to be effective in treating rheumatism, gout, neuralgia, paralysis, dyspepsia, and nervous disorders, along with what were described as "female troubles." For some conditions, science offered no other treatment.

A description of this type of holiday can be found in Cornelius Vanderbilt Jr.'s biography of his mother. For sixty years Vanderbilt's parents made an annual trip to the Homestead, a spa resort in Virginia. Once ensconced at the hotel, they would take a daily carriage ride to the nearby springs, where there were two "wooden bathhouses

PREVIOUS SPREAD: *Actress, singer, and dancer Gaby Deslys was one of the most popular and provocative entertainers in the world when she was photographed in the surf while making a movie at Villerville in Normandy, circa 1912. Her bathing suit features corsetlike lacing—as if any further emphasis of her hourglass figure were needed. Photographed by Jacques-Henri Lartigue.* LEFT: *Proving that relaxed elegance need not be an oxymoron, Slim Aarons captured his fellow photographer John Rawlings and Rawlings's wife picnicking at Montego Bay, Jamaica, 1950.*

built at the time of Thomas Jefferson." In keeping with Victorian notions of decorum, the sexes were segregated. Vanderbilt writes:

"After donning a shapeless Mother Hubbard coverall, Mother slipped into the five-foot-deep pool; the water was warm and as clear and bubbling as champagne. Over in the men's establishment, Father was bathing in the nude, while a[n]. . . . attendant awaited the command to float out to him a tall frosted mint julep balanced on a cork tray."

The rest of their day might be spent in rocking chairs "watching the restless surge of beautifully gowned women cross and re-cross the shade-dappled lawns"; at dusk they would retreat to their cottage, where they dined in full evening dress. Even at this level of formality, spa life was a break from the rigidity of everyday life for the affluent.

By the end of the nineteenth century the great hotels, with spas or without, had become self-contained universes of leisure. Guests enjoyed billiards, bowling, dancing to orchestras, horseback riding, and, starting in the 1890s, the newly popular sports of golf and tennis. Vacationers in these elaborately constructed environments observed the niceties of wearing attire appropriate to each specific activity, distinguishable from their town clothes only in type of fabric used.

As transportation options continued to flourish through the twentieth century, the act of travel itself grew grander and grander. Train travel could be enhanced by the use of private train cars, and ocean liners became ever larger and more elaborate, culminating in the 1930s when the elegant behemoths *Normandie* and *Queen Mary* made their first voyages. Each mode of travel carried with it its own requirements for behavior. Taking the train called for dark tailored clothes (it could get dusty) and manners appropriate to a city street; a 1926 etiquette book reminded gentlemen that they should "lift their hats on entering a railway carriage in greeting to the other occupants." The first ocean liners, on the other hand, were seen as places where rigid social codes could be relaxed, with one etiquette expert in the teens noting that "formal introductions are really not necessary at sea."

"Romance sans paroles," Sorrente. Pochoir illustration by George Barbier.
Falbalas & Fanfreluches: Almanach des Modes, *Autumn, 1922.*

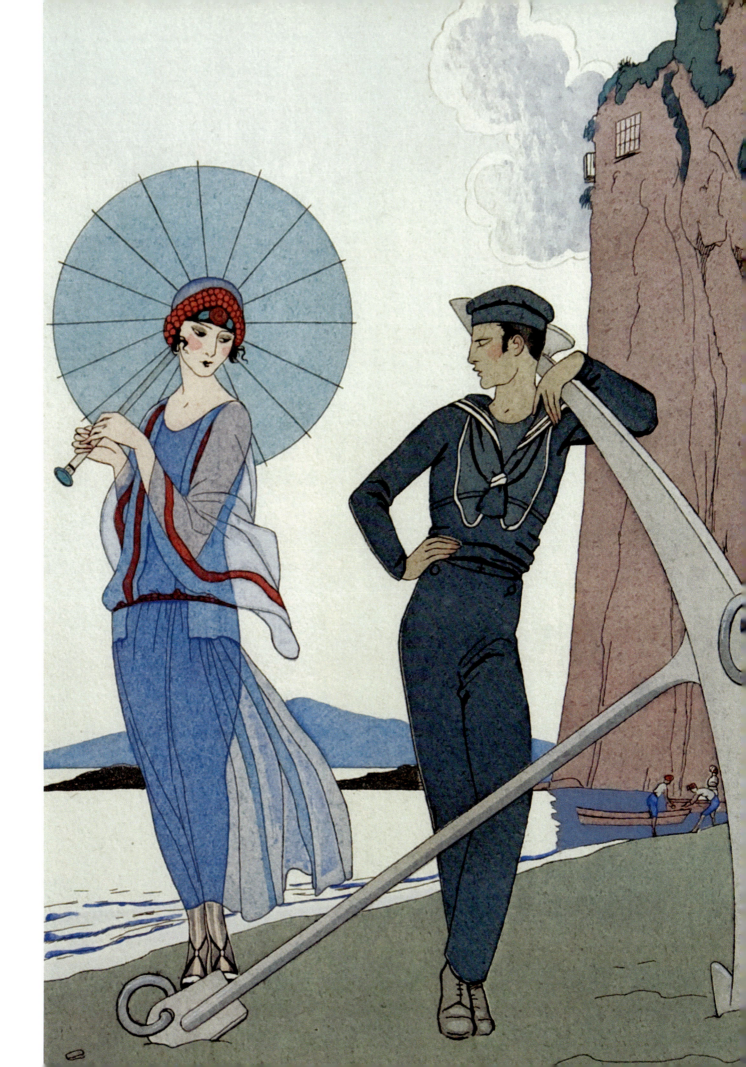

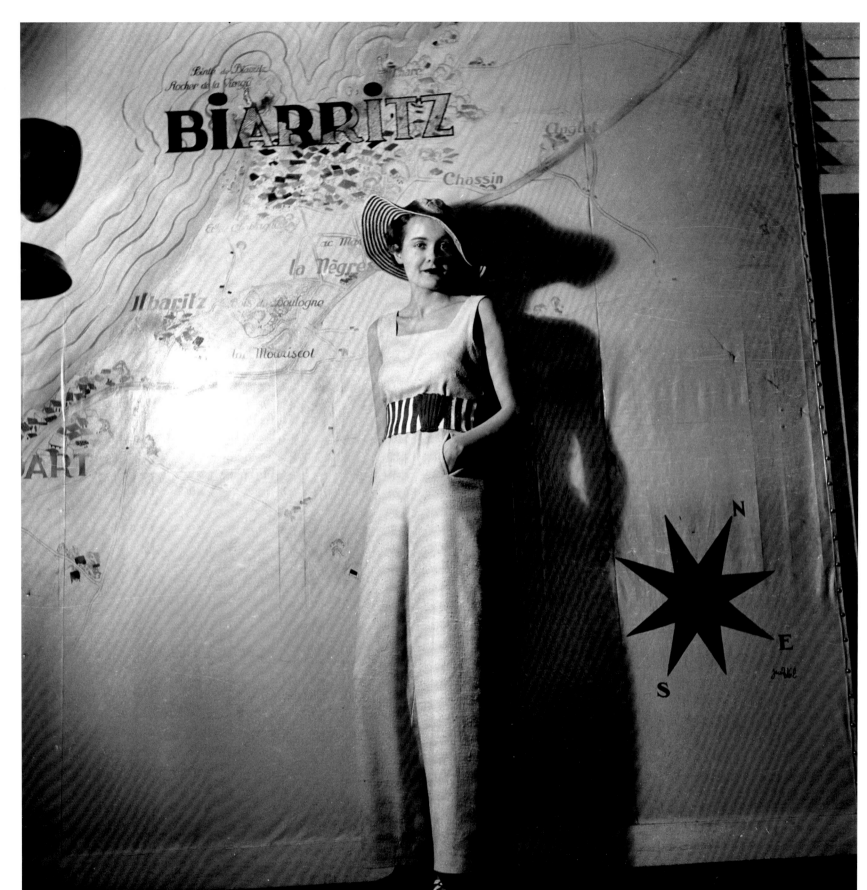

An ocean crossing also meant numerous opportunities for mixing with the other passengers, at dinners, dances, and costume parties. But as ships grew more and more enormous, travelers were cautioned against expecting to hobnob with the nabobs. "The days when a trip to Europe invariably meant the acquisition of a new group of interesting and congenial friends have passed. . . . the woman who dresses elaborately at sea . . . at once dubs herself a novice or a climber. So marked is the lack of showy dressing on shipboard that it is smart not to dress too smartly. . . . any display of jewels is at once vulgar and dangerous."

Early jet travel carried its own set of expectations for a luxurious experience. In the mid-1950s, Pan American World Airways advertised private staterooms on its overnight flights to Europe. It was expected that the stewardess—who was also a registered nurse—could provide not only a meal but cigarettes, writing paper and stamps, a blank form for sending wires, infant care while a mother napped, and baby formula at designated feeding times. Jet travel opened up many parts of the world that were out of the reach of trains and ocean liners, and as each previous advance in travel had done, it substantially increased the numbers of people on the move.

Travel could be broadening, but not all early globetrotting was educational. In the twentieth century, chic seaside resorts superseded the Victorian spa hotels, providing a revolving supply of new fashionable locales as the seasons progressed. Artists and social luminaries would sniff out a place first; then followed the journalists, who reported on all the glamorous doings; and then along came the hoi polloi—at which point the avant-garde would have already moved on to the next place to be. Ever since Biarritz became the new Deauville, fashions in resorts have been ephemeral, with travelers ever on a quest to find the next tropical contact high.

Along with the focus on seaside resorts came interest in who was wearing what. In 1928 the *New York Times* announced that there was now a fifth season on the fashion calendar: Palm Beach Season. The Paris couture houses had traditionally

Elsa Schiaparelli was an inventive couturiere whose earliest collections concentrated not on evening or formal day looks but on designs for leisure: sweaters, beach pajamas, bathing suits, and novelties. This 1934 beach suit appears in front of a map of where it was likely to be worn.

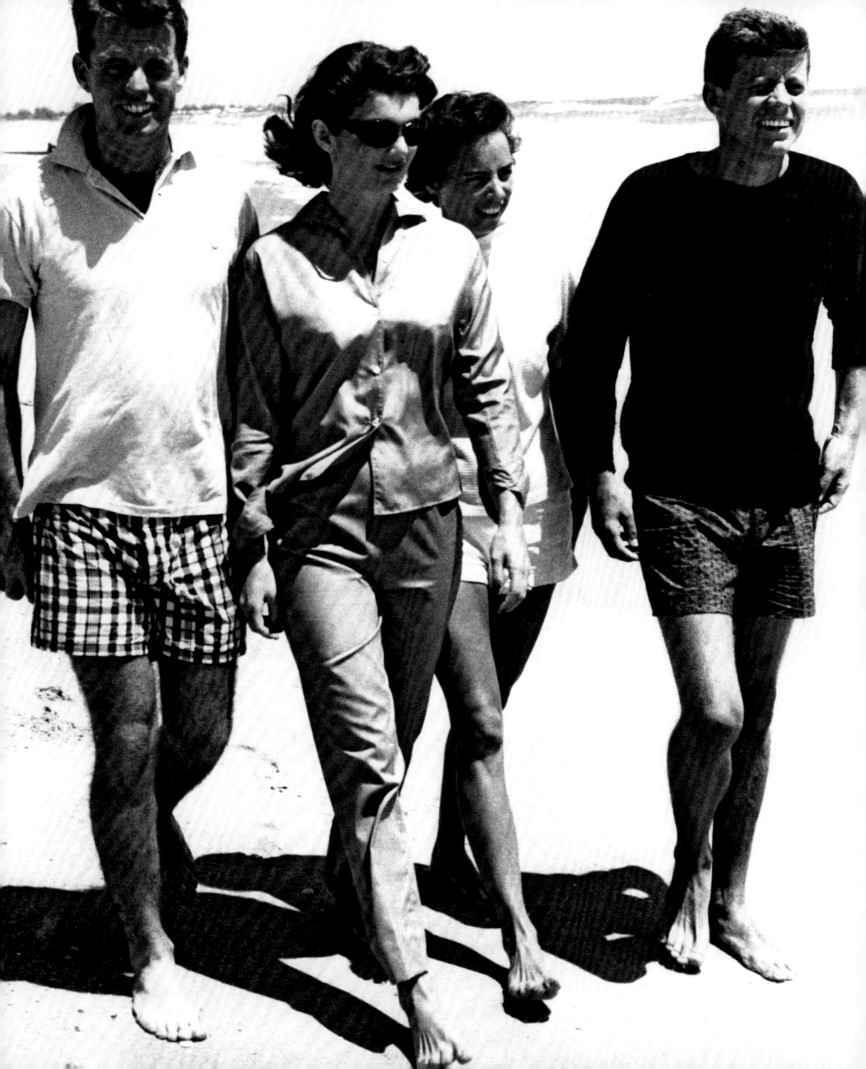

showed new collections twice a year, spring-summer and fall-winter; to accommodate clients heading off on chic holidays they added midseason showings to their schedules. Reporting on what was being designed for or worn at resorts filled pages when other fashion news was not available. Since consumers had typically shopped for clothes just twice a year, these new collections inspired purchases in between. Thus "resort" became part of the fashion cycle, sometimes touted as fashion's best-kept secret, the realm of finds that hadn't been overexposed, or of clothes that were more wearable than full-fledged runway. The first decade of the twenty-first century has seen resort clothes take yet another turn, becoming fashions for all seasons. Pucci prints provide bright color year-round; white is worn winter, summer, spring, and fall; sleeveless dresses, ankle-length pants, 1960s/1970s jet-set references, little cardigans, tunics with jeweled necklines, long shorts, versions of caftans, and even thong sandals can show up anytime, anywhere.

The first fashion to originate in a resort was designed by Gabrielle "Coco" Chanel. In 1913 this as-yet-little-known Deauville boutique owner began selling belted jersey cardigans that went like hotcakes. The antithesis of everything else available, these relaxed, warm cardigan jackets had been not so much designed as devised by a woman who herself had abandoned corsets because one couldn't laugh while wearing them. Chanel didn't just design well for women because she was a woman; she invented how modern women should dress, because she herself epitomized the independent rule-breaking new woman. When she wasn't building her enormous couture business around such original designs as easy jersey suits and little black dresses, she was combining work and pleasure in Deauville and Biarritz, where she had boutiques, or entertaining houseguests at her Villa La Pausa overlooking the Mediterranean, going to the Lido, or accompanying her beau, the Duke of Westminster, on one of his two yachts. Her off-duty style of beach pajamas (she was photographed wearing these as early as the late teens), her bronzed skin, and her windblown hair would be as influential as the designs she created in her atelier.

A gaggle of Kennedys in Palm Beach, 1957.

In 1923 everything clicked and it suddenly became fashionable to seek out the sun in summer, as opposed to escaping the heat. The epicenter of this sea change was the French Riviera, where villages such as St. Tropez, Juan les Pins, and Cap Ferrat had been discovered by artists seeking charming but inexpensive places to live and paint during the off-season. At the epicenter of the epicenter were Gerald and Sara Murphy, who were able to persuade the Hôtel du Cap at Antibes, which normally closed for the season in May, to remain open through that summer while they continued renovating what would become their Villa America. The Murphys had one foot in the arts—Gerald had taken up painting and would shock the Salon des Indépendents the following year with his 18-by-12-foot modern painting of a ship's deck—and one foot in wealthy expatriate society, and their particular style of "living well" influenced their varied social circles, and beyond. Faced with a poor excuse for a beach at the nearby seaweed-covered la Garoupe, they imposed their vision of what a beach should be, based on fond memories of summers at East Hampton. The way they spent their Riviera days—playing with their children (rather than delegating the task), performing calisthenics, raking the pebbles and seaweed, canoeing, dressing up for costume parties, enjoying picnics so relaxed that the blanket lay right on the sand, spread with wine bottles and stemmed glasses, fruits and cheeses—was immortalized by such artists as Picasso, Fernand Léger, F. Scott Fitzgerald, Archibald MacLeish, and Man Ray and, decades later, became the subject of scholarly books and museum exhibitions.

The Murphys were by no means the only or even the first people to exhibit such resort style; however, they were so interconnected with everybody-who-was-anybody that their look spread. Gerald had created a natty form of anti-establishment dress, and his signature sailor top was worn by all his friends, most notably Picasso. His

OPPOSITE, LEFT: *Actress Catherine Deneuve in the briefest of underwire bikinis with her fiancé, director Roger Vadim, in St. Tropez, France, 1962.* OPPOSITE, TOP RIGHT: *Coco Chanel and the Duke of Laurino on the Lido in Venice, circa 1936. Chanel, who singlehandedly relaxed women's clothing beginning with her very first design, the Deauville cardigan, was photographed as early as the late teens wearing a slightly crumpled white pajama suit on the beach. By the 1930s her resort style, while still decidedly informal, had taken on a much more luxurious feel, thanks to the ropes of pearls and the ultimate beach jewel: the designed-for-her Verdura cuff.* OPPOSITE, BOTTOM RIGHT: *The Deauville look as worn in Newport, circa 1913.*

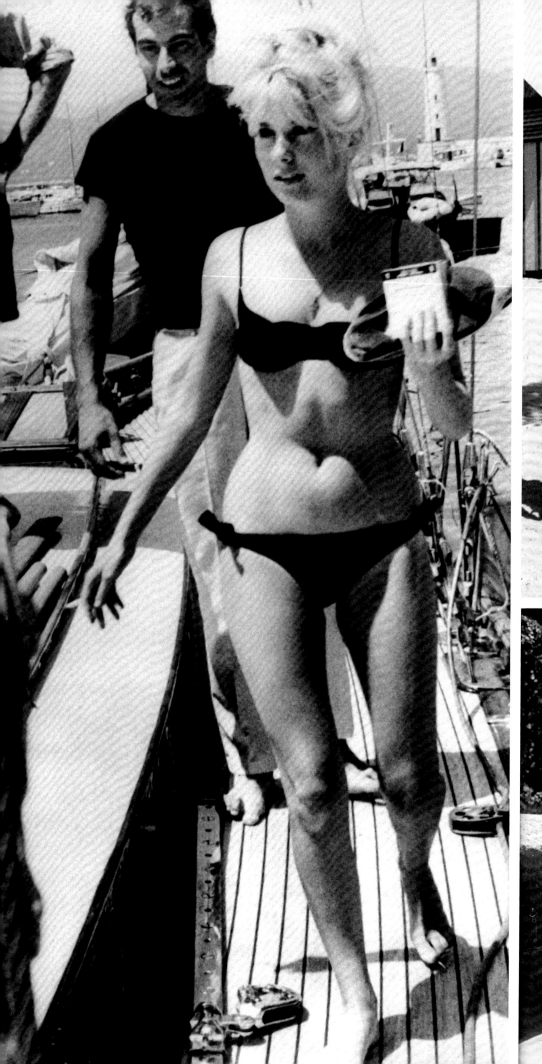
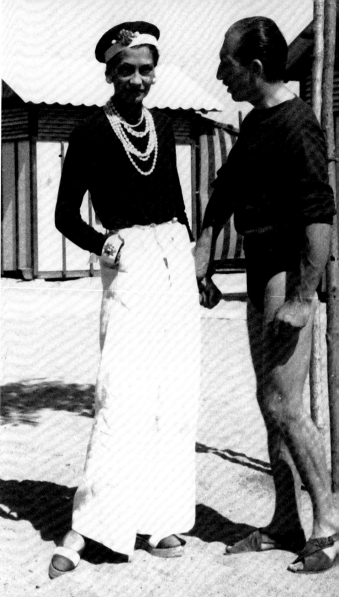

scanty bathing suits, knee-length shorts (worn when others might be wearing pants), webbing belts, and espadrilles proved prophetic as well. After Sara pulled down her maillot top to ensure a better tan, the haute couture designed sunburn suits, bare enough to prevent unsightly strap marks. Pearls were still the most costly and coveted of jewels—it had been less than a decade since Cartier acquired its Fifth Avenue building in exchange for a mere two strands—but Sara wore hers on the beach and threw them down her back. She had the insouciance that comes from having been quite a beauty, and she was utterly natural, a social attribute that was blindingly new.

His finger ever on the pulse, Edward, Prince of Wales, the future king and Duke of Windsor, also visited the Riviera in 1923, wearing a knit polo shirt. Such a choice might seem innocuous to modern eyes, but this single episode brought about a major change in how men dressed. Prior to this, the man's long-sleeved, button-front shirt made of woven cotton or linen, with a starched collar, was worn for all purposes except some sports. It was considered impolite to remove one's coat and appear in just shirtsleeves, particularly in the heat. There was no relaxed alternative until the Prince of Wales gave wearing a soft shirt in public his considerable imprimatur. At a time when there were no designers or fashion shows of men's clothing, people paid close attention to the sartorial moves of a few key figures like the Prince of Wales; other innovations of his that resulted in almost immediate international popularity include town suits in bold chalk stripes or tattersall plaids worn with brown suede shoes, the spread collar with a chunkily knotted tie, midnight blue dinner jackets and backless evening vests, Fair Isle sweaters, and plus fours. Like Chanel, his choices had much to do with his desire to live a modern life, an element of which was rebelling against the old order.

Women's beach pajamas and other forms of pants were worn first by the sea, by Chanel and others, and then gradually entered "real life" dressing. Elsa Schiaparelli created a stir with culottes in 1931, wearing them herself on the streets of London and designing a culotte ensemble for tennis player Lili de Alvarez to wear for tournaments at Highbury and at Wimbledon. In 1936, *Vogue* addressed readers' burning need to know when and where it was proper to wear culottes: "Everywhere

A Dries Van Noten shorts outfit in a typically artisanal hand-painted-looking print. Necklaces by Dries Van Noten, hat by Bernstock Speirs. Photographed by Patrick Demarchelier for Glamour, *2008.*

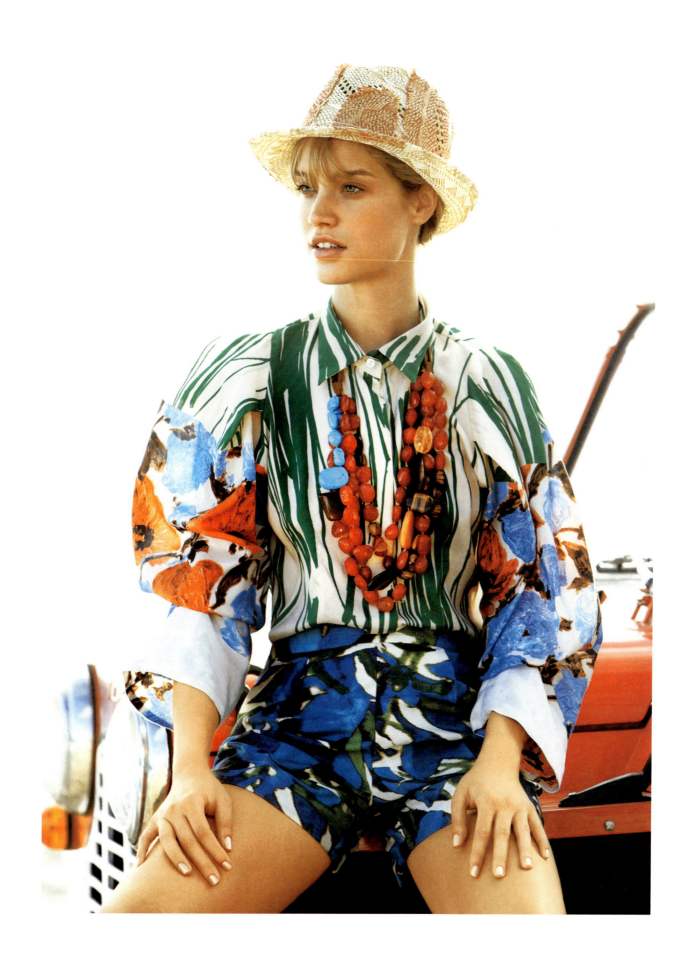

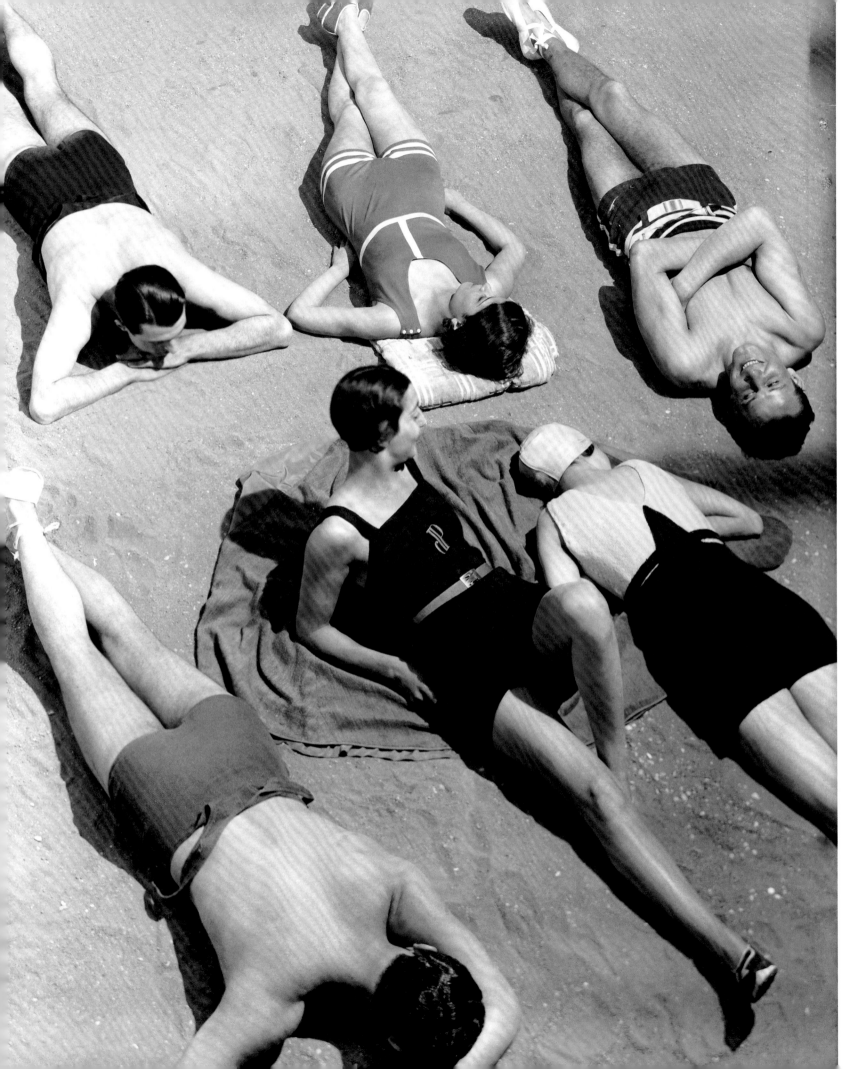

in the country and for almost every sport: golf, tennis, fishing, bicycling, boating, et al. But can one wear them in town?—people ask. A few smart women do (providing the culotte is so cleverly cut that you can't tell it from a skirt)." Ultimately, knee- or below-the-knee-length culottes remained no more than an occasional novelty because of the absorption of pants into women's everyday dress, accomplished fully in the 1970s. Another threshold in the modernization of women's wardrobes was wearing pants for evening. In the late 1950s the question was: could pants be worn to dinner or nightclubs? But by 1963 Charlotte Curtis reported for the *New York Times* that Diana Vreeland, editor of *Vogue*, had worn a pair of bright tapered pants out to dinner in Southampton and "nary an eyebrow was raised."

Travel restrictions had put a damper on leisure pursuits during the Second World War, but during the period of postwar abundance that followed, a new wave of resort style began. No couple personified this shift more than the hugely influential young American president John F. Kennedy and his wife, Jackie. By the time Kennedy was elected president, the couple had already been photographed water skiing, on a sailboat, barefoot, in slacks, shorts, and even bathing suits. Once President Kennedy was seen golfing in yellow slacks at Seminole any notion that men should shy away from bright colors was done away with. In *Tales of Palm Beach*, Beatrice de Holguin described the role the Kennedys played in how style evolved in that Florida town: "In the 1950s there was a shift towards the casual look, headed by Jackie Kennedy, who could be seen in the resort wearing a dirndl skirt, peasant blouse, and Mexican huarache sandals." Although the young senator's wife dressed for leisure in much the same way as other young married women in her affluent set, her choices conveyed the seal of approval to a much wider audience. Among the styles Jackie put over were the daring new waistless, knee-baring Lilly shifts, Pucci-style tapered-leg pants worn with untucked shirts, and flat Jack Rogers Navajo sandals.

Jackie Kennedy shared her fashion pedestal with another supernova across the Atlantic. As Phyllis Lee Levin wrote for the *New York Times* in 1959, "The most

This photograph offers a stylized vision of what had become, by the 1920s, a rather common seaside sight: men and women, wearing next to nothing, comfortable in their proximity to one another. The women wear swimsuits by Parisian couturiers Jean Patou, Molyneux, and Yrande. Photographed by George Hoyningen-Huene for Vogue, *1930.*

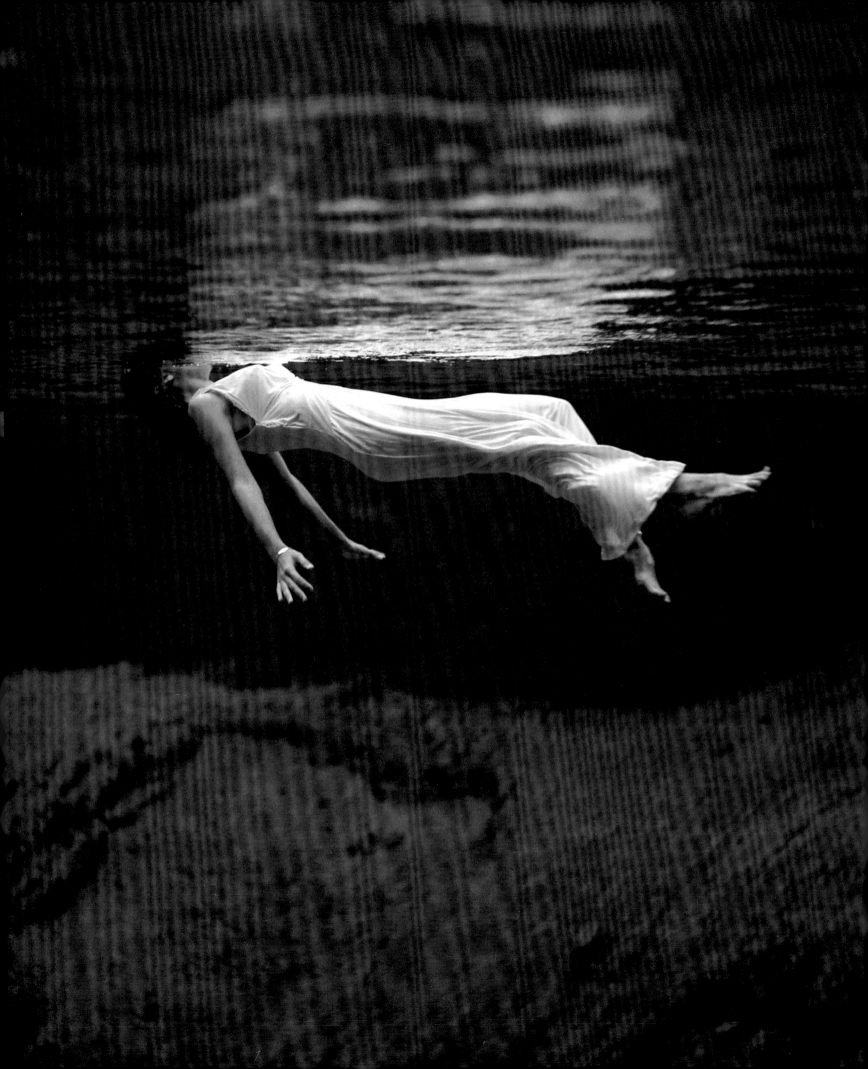

influential fashion leader in Europe did not show at the recent Paris collections for fall and winter. This was not surprising, for she is a film star, not a dress designer. Her name is Brigitte Bardot." Having become a worldwide sensation when her bikini-clad form jiggled its way through Roger Vadim's 1956 film *And God Created Woman*, Bardot was the inspiration behind girls everywhere growing their hair long and arranging it in a just-got-out-of-bed pouf, smudging their eyes with black eyeliner, and wearing pale or no lipstick. Bardot's faithful followers poured themselves into skin-tight pants paired with loose frilly tops or body-hugging knits, short shorts, very full skirts cinched by wide belts ("a centimeter short of suffocation," as Levin put it) above bare tanned legs, and, of course, bikinis. So popular became the large colorful silk headscarf she wore babushka-style that Halston, at the time a custom milliner at Bergdorf Goodman, began making little velvet-edged wire mesh shapes (similar to the "rats" worn to puff out the hair in Edwardian times) for his ladies to wear under their scarves so that they would have that *comme il faut* swollen shape. These elements of Bardot's St. Tropez look were embraced by twenty-year-olds from Europe to Greenwich Village.

Jackie Kennedy's marriage to Aristotle Onassis in 1968 officially signaled the zenith of the jet-set era. Jet-set style ran the gamut from casual to extravagant. The more relaxed end of the spectrum came courtesy of the Europeans' carefree attitude toward nudity, with auto magnates diving naked off yachts and even minor royals sunbathing topless, captured for posterity by telephoto lenses. For day, the studied, relaxed look was best personified by Jackie with her perfectly fitting white jeans, black T-shirt, and gigantic sunglasses—just the thing for *la passegiata*, the afternoon walk, exquisitely dressed (albeit casually) to see and be seen. For evening, full-blown exoticism best expressed the escapist nature of resort fashion. The pages of Diana Vreeland's *Vogue* brimmed with photographs of models posing in far-flung regions of the globe, sporting architectural coiffures and elaborate *maquillage*, wearing opulent palazzo pajamas, mini-dresses, ballgowns in vivid colors and patterns, with daring details like bare midriffs and massive, vibrantly colored jewels. At the same time,

Toni Frissell photographed this model floating at Weeki Wachee Springs, a tourist attraction in Florida that featured a theater with a glass wall through which visitors could watch "mermaids" swimming. Harper's Bazaar, 1947.

hippie style was starting to emerge. During her brief time in the limelight, Talitha Getty, the actress married to scion John Paul Getty Jr., made an indelible impression in her Moroccan caftans, ballooning pants, little chiffon ponchos, short Japanese kimonos, and knee-high lace-up sandals.

It used to be a status symbol of the highest order to sport a tan out of season. Or to have scored a special souvenir on holiday, like a pair of the exquisitely flattering stretch silk pants from that amusing little shop called Emilio's on the Piccola Marina. All this changed in 1970, when the first commercial 747 flew from New York's JFK airport to Heathrow. Within six months, a million people had flown in a 747. The age of the jumbo jet had begun, and an era had ended: traveling in style became a thing of the past. The nostalgia for jet-set travel in all its aspects is one of the most enduring strains in fashion today.

Resort fashions beguile because they were originally designed with no ulterior motive; they were truly made for fun. Resort clothes have always had an air of insouciance, *sprezzatura*, ease. Clothes first worn on holiday changed how men and women dressed, even back at home, and they relaxed dress codes forever. The classic items in the resort vocabulary instantly convey casual chic. Now, in a time of fashion overload, when every week offers up another awards ceremony and there is always a new haute couture or ready-to-wear collection from somewhere in the world, classic resort style provides a refreshing antidote. Resort is no longer a type of clothing designed to be worn at a specific place or for a specific purpose; it's an aesthetic, or even a mood. The two great heydays of resort style—the 1920s and 1930s and the 1950s, 1960s, and 1970s—consistently inspire fashion offerings, both high and low. Designers regularly invoke the muses of Jackie, Brigitte, Talitha. Perfumes are named after favorite island destinations. Wearing a little bit of resort can give even an armchair traveler an instant lift. Resort fashion's escapist allure is indomitable.

PREVIOUS SPREAD: *Two-piece suit circa 1970. Photographed by John Rawlings.* RIGHT: *Emilio Pucci in black tie with two models wearing a creation of his that can be seen as a bikini turned into an evening gown; the bra top has an attached panel that folds through the legs forming a "harem" hem. This style was included in Pucci's collections from the late 1960s through the early 1970s.*

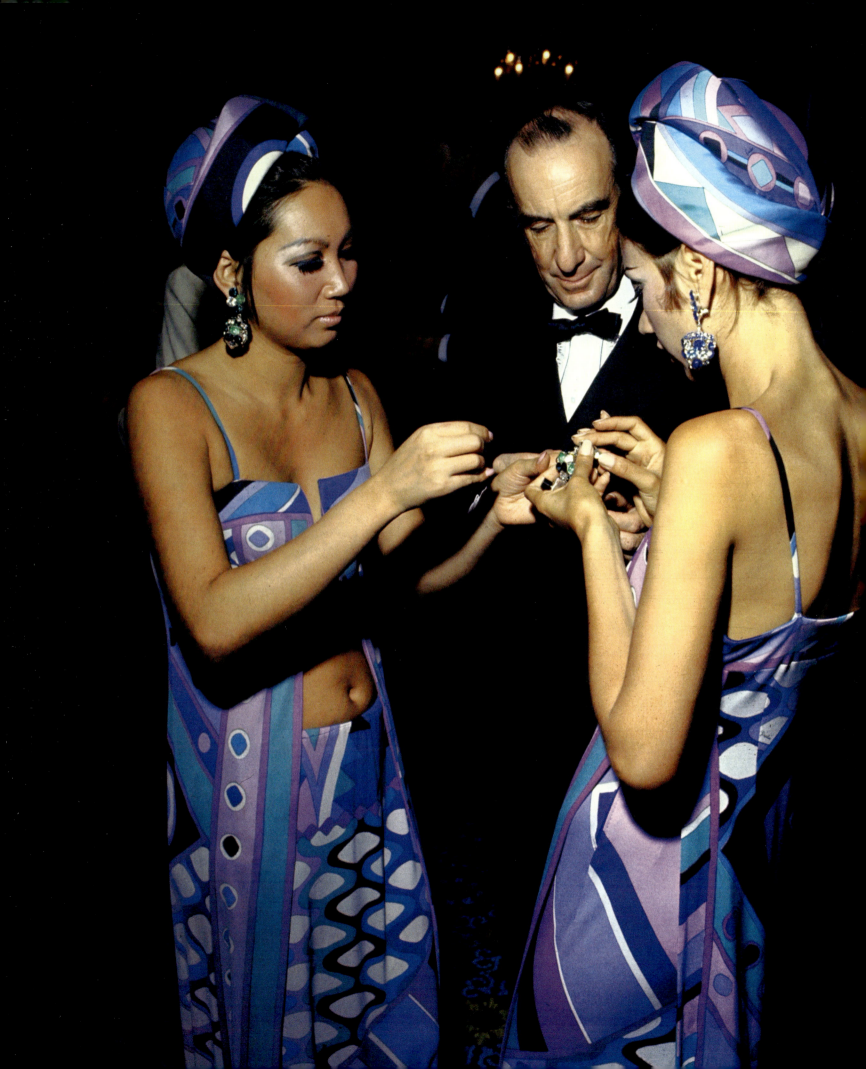

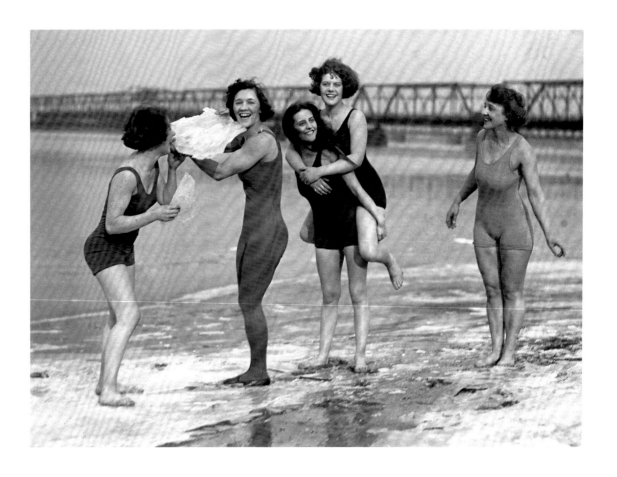

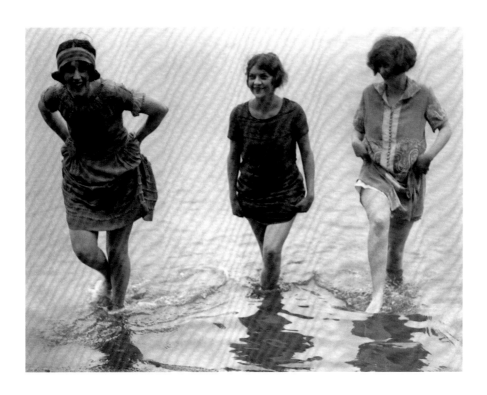

LEFT: *Talitha Getty wearing a tasseled chiffon caftan on board the yacht* Antinoo, *which belonged to Baron and Baroness Arndt Krupp von Bohlen. Photographed by Patrick Lichfield for* Vogue, *1970.* THIS PAGE, TOP: *By 1924, when these five women were photographed, bathing suits had relaxed to the point of (almost) seeming like second skins. The body stocking swimsuit had been introduced by renowned swimmer and gymnast Annette Kellerman in 1907.* THIS PAGE, BOTTOM: *Three women wading, holding up their chemise dresses, 1924.*

Designer Valentina's elegant minimalism was a characteristic of everything she designed for herself and for her clients, from formal evening gowns to relatively casual beachwear. In this photograph from the 1930s, she wears a ballroom-worthy beach robe and wide-brimmed hat crinkled just so. RIGHT: *Whereas Valentina's clothes were sold at the highest prices to an exacting private clientele, Claire McCardell's designs were for everywoman and, as such, had enormous impact. This casual yet smart linen shorts suit, paired with a navy elasticized tube top, was photographed in Tunisia by Louise Dahl-Wolfe for* Harper's Bazaar, *1950.* FOLLOWING SPREAD: *Cameron Diaz on a surfboard on the set of* Charlie's Angels: Full Throttle, *2003.*

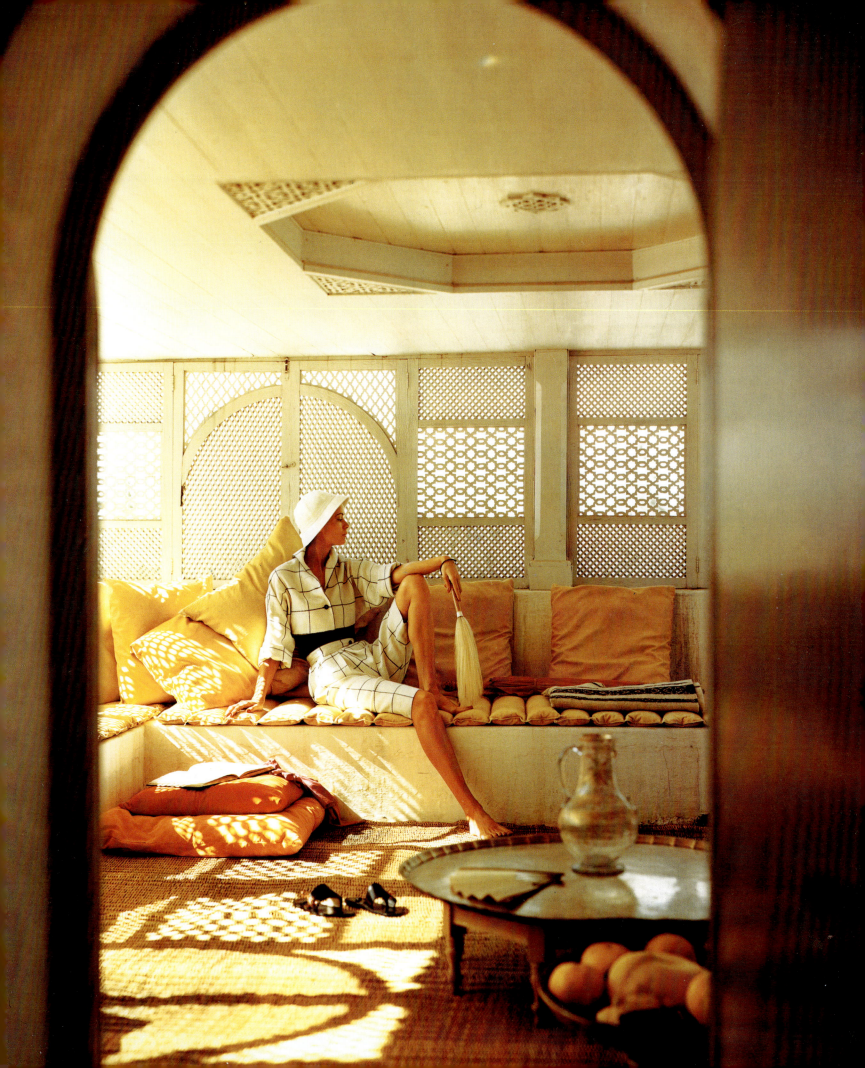

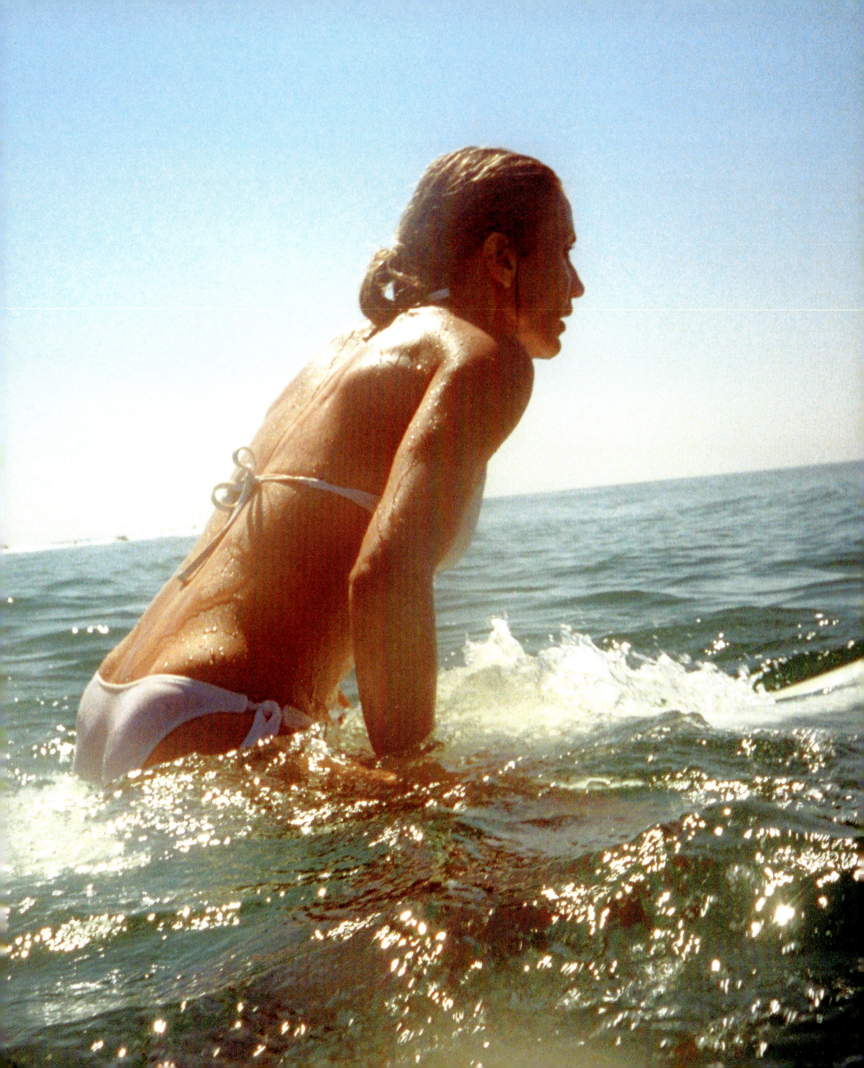

ONE

At Sea

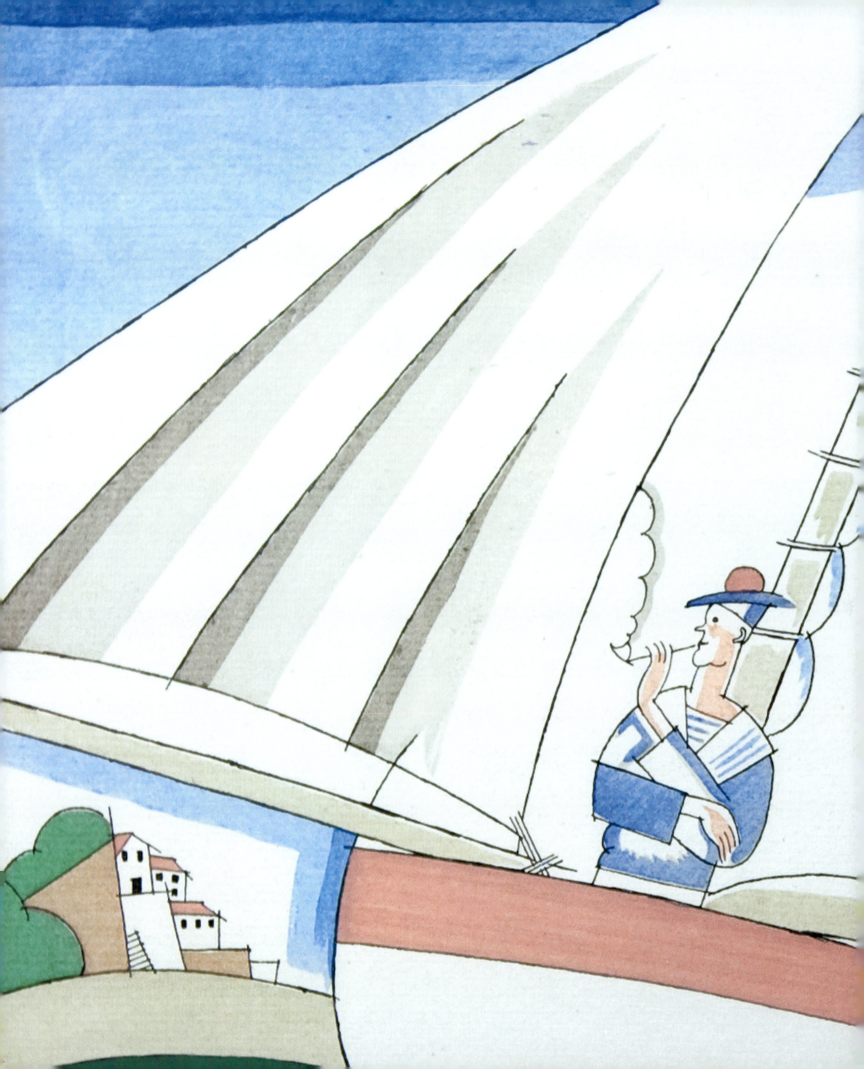

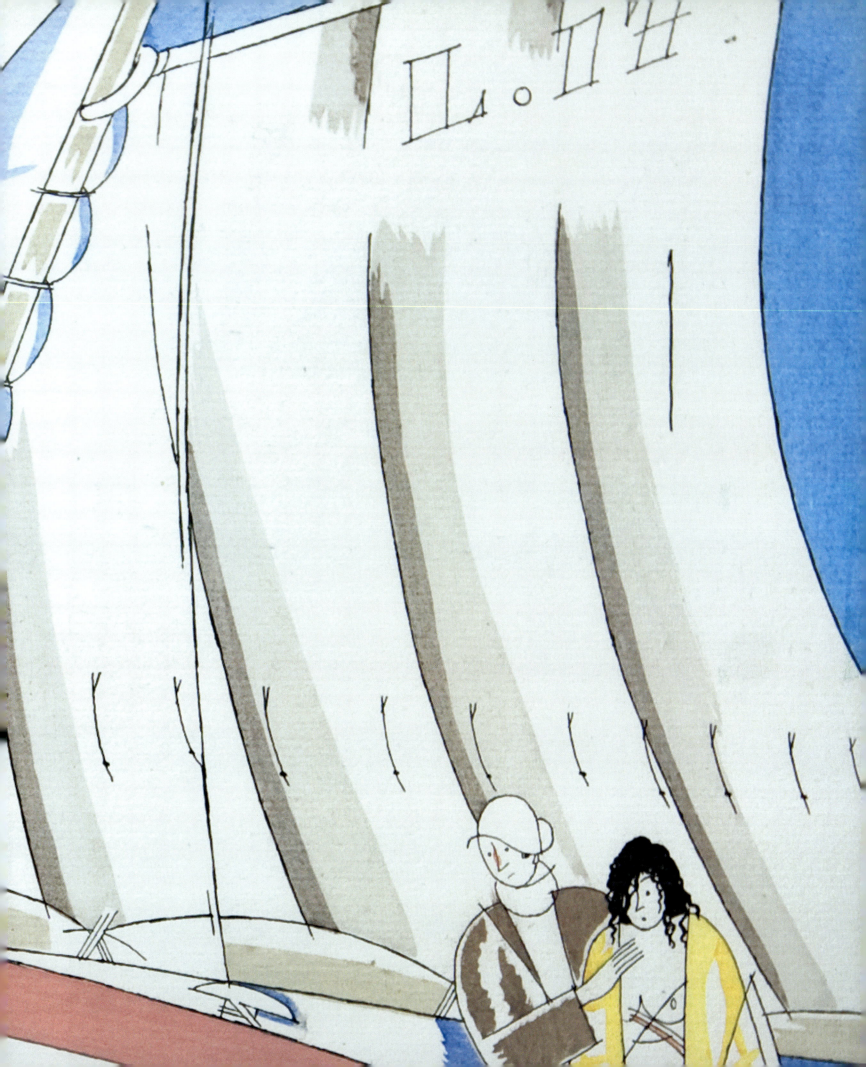

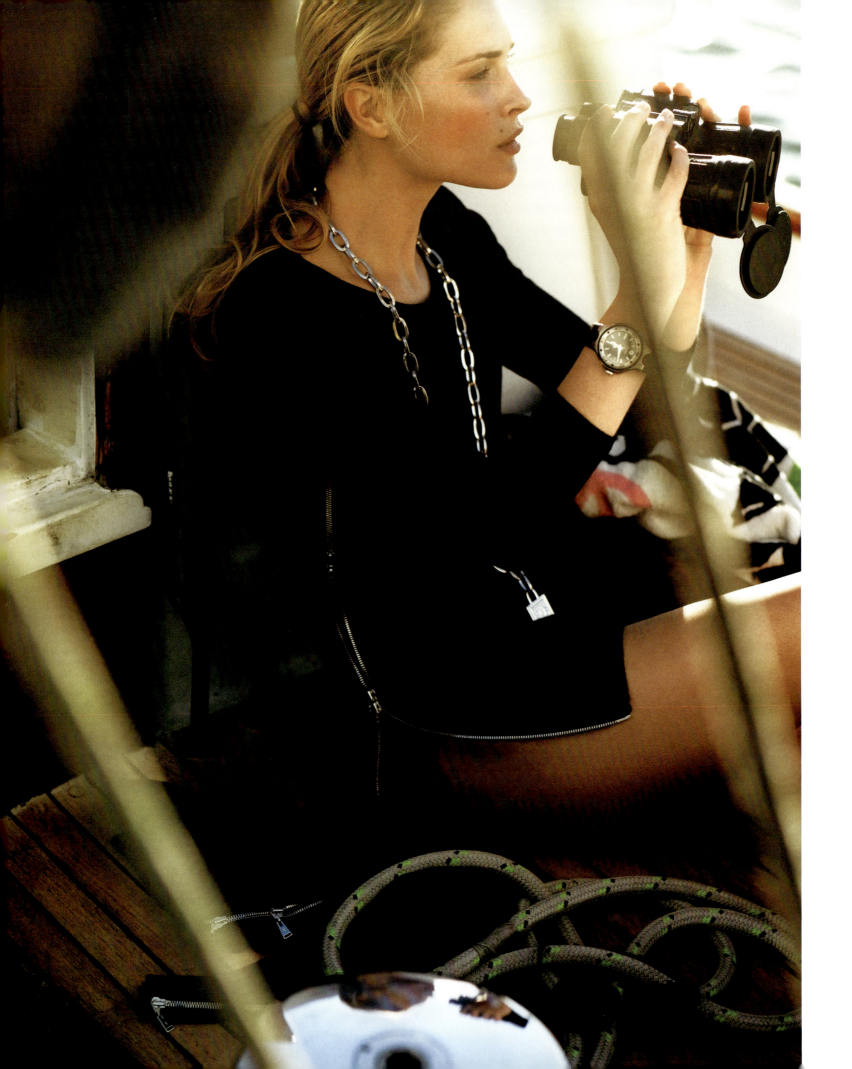

AT SEA

It is said that the word "posh" derives from the phrase "port out, starboard home," a reference to the most desirable placement for a berth on the passage from England to India and back. Whether this is true or not, the term gives off a definite whiff of ocean liner crossings and island hopping by sail-powered yacht. Evocative of this is nautical style, which rises to the forefront of fashion every so often, usually providing an antidote to excessive . . . excess. Paradoxically for a look with such elite associations (privately commissioned yachts being so much rarer than, say, fractions of jets), it involves the simplest of elements. Navy on top and white on the bottom are all it takes to suggest a breath of fresh (salt) air.

 Dark blue and white have been part of the dress code of official navies of several countries—including Great Britain, Canada, and the United States—going back at least to the eighteenth century. The U.S. Navy uniform was developed in concert with the new country's naval force itself: in fits and starts. Beginning with the War of 1812, dark blue was used for jackets, vests, and trousers. Bell bottoms and middy blouses appeared during the Civil War. A white duck uniform was called for when the gunners and the machinists working in the filthy engine rooms of the new steamships needed clothing that could be laundered on board. Since fabric dyes were still unreliably fugitive and could fade or bleed, white was chosen because it was the easiest color to keep clean.

PREVIOUS SPREAD: *"Le Yachting," Aquarelle by Charles Martin, included in a portfolio titled* Sports et Divertissements, *each sport or diversion accompanied by an original composition by Erik Satie, 1925.* LEFT: *Cashmere zipper sweater/tunic by Louis Vuitton over a Chanel stretch jersey bikini, with a Chanel metal belt worn as a necklace. Photographed by Regan Cameron for* Allure, *2007.*

As the official naval uniform evolved, nautical looks became prevalent in civilian fashion. Sailor suits were worn by children of all ages, sometimes as school uniforms, from the mid-nineteenth century well into the twentieth century. And nautical touches like middy collars and lines of braid sewn in twos or threes often decorated women's tailored clothes, like walking or traveling suits. A dark jacket (with shirt and tie) and white pants was a common look for men to wear by the sea from the late nineteenth century on.

Sailor suits (with pants) began being worn by women in the late 1920s. Beach pajamas had been all the rage for several years when a nautical version in navy broadcloth with a sailor collar and tie was introduced in Paris in 1929. From then on, various couturiers offered yachting suits as alternatives to the increasingly fussy pajama styles being shown for resort wear. Marlene Dietrich was photographed at the seaside in France in 1932 wearing such an ensemble, with white pants, mess jacket, and a captain's hat. In 1936 Jean Patou showed a yachting suit for women consisting of navy cashmere trousers and double-breasted blazer jacket with gold buttons. In lieu of a pocket, there was an embroidered "coat of arms" that could be customized with the purchaser's initials. Other designers in this period who perennially referenced sailor attire include the sports couturiers Mary Nowitsky and Jane Regny and the American ready-to-wear designer Norman Norell, who included sailor collars and other touches in his collections, beginning with his work for Hattie Carnegie in the 1930s.

Yves Saint Laurent set off a new wave of nautical chic in 1966. Having visited an army-navy store on Manhattan's Forty-second Street the previous year, he based his entire collection for the following spring on the pea jackets and bell bottoms he purchased there. The looks were accessorized with oversized yachting caps and brooches in the shape of anchors and fish. Within the year, Saint Laurent launched both his tuxedo suit and his ready-to-wear line, thus bringing his perfectly proportioned double-breasted jackets, pea jackets, blazers, and high-waisted wide-legged pants to a broader audience. The success of these styles led to women wearing pants not just for sports or holiday but day in, day out. It would be many years before the allure of

On a junk in Hong Kong harbor, a dressed-down evening look of cowl-necked shirt and long pleated skirt in white acetate crepe by Peter Hedges. Shot by Gleb Derujinsky for Harper's Bazaar, *1958.*

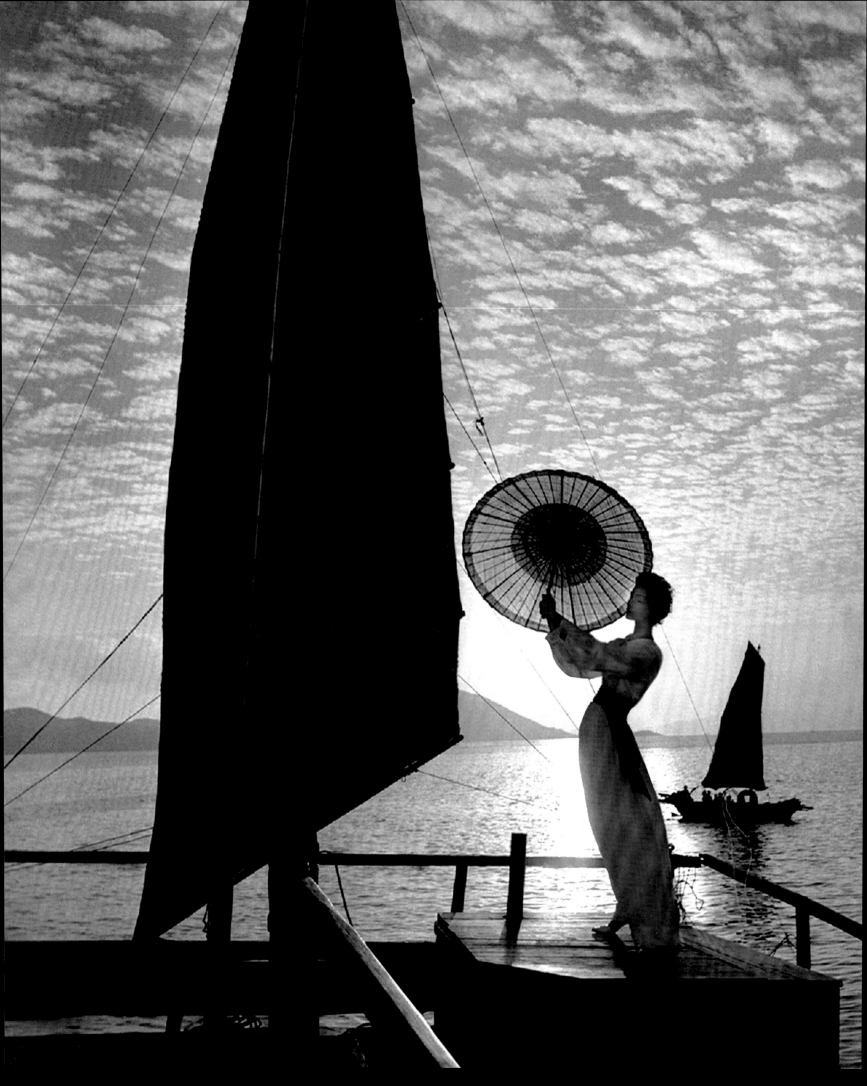

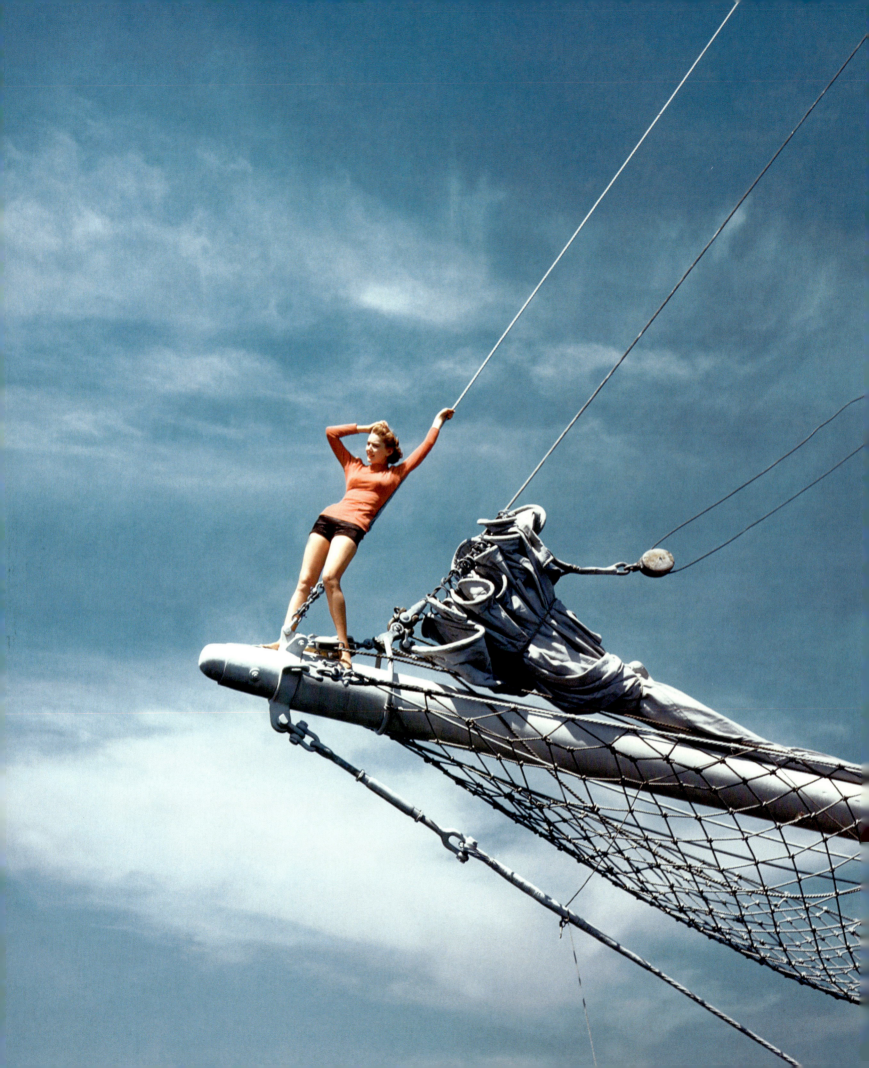

nautical looks started to wane. In 1969 Bernadine Morris wrote in the *New York Times*, that though "For the first time in years Norman Norell hasn't made any sailor dresses," virtually every other Seventh Avenue ready-to-wear designer had.

In popular culture, the yachting look's pretentiousness was hilariously satirized in the mid-1960s by Jim Backus's Thurston Howell III in the television sitcom *Gilligan's Island*—a skewering that, if anything, has added to its charm. Fresh-off-a-boat style endures, inspiring designers from Tommy Hilfiger to Dolce & Gabbana. Navy and white stripes, crisply tailored whites, and deck-soled canvas shoes are just a few of the elements of Ralph Lauren's constantly seaworthy repertoire.

The nautical look has unusual crossover appeal: it seems patriotic without alluding to a specific country, and it celebrates the sharp tailoring of a uniform without looking military. It is unabashedly cheerful and clean-cut, a balm for trying times. Whenever fashion is in need of a sea change, back come pure navy and white for spring, blouses billowing like spinnakers, blazers cut like diamonds, middy collars and ties, and the color-block graphics and hues of signal flags.

Model posing on jib boom for a 1940 cover of Vogue *in a long cover-up of lisle over a scanty bathing suit of satin with Lastex from Peck & Peck. Photographed by Toni Frissell.*

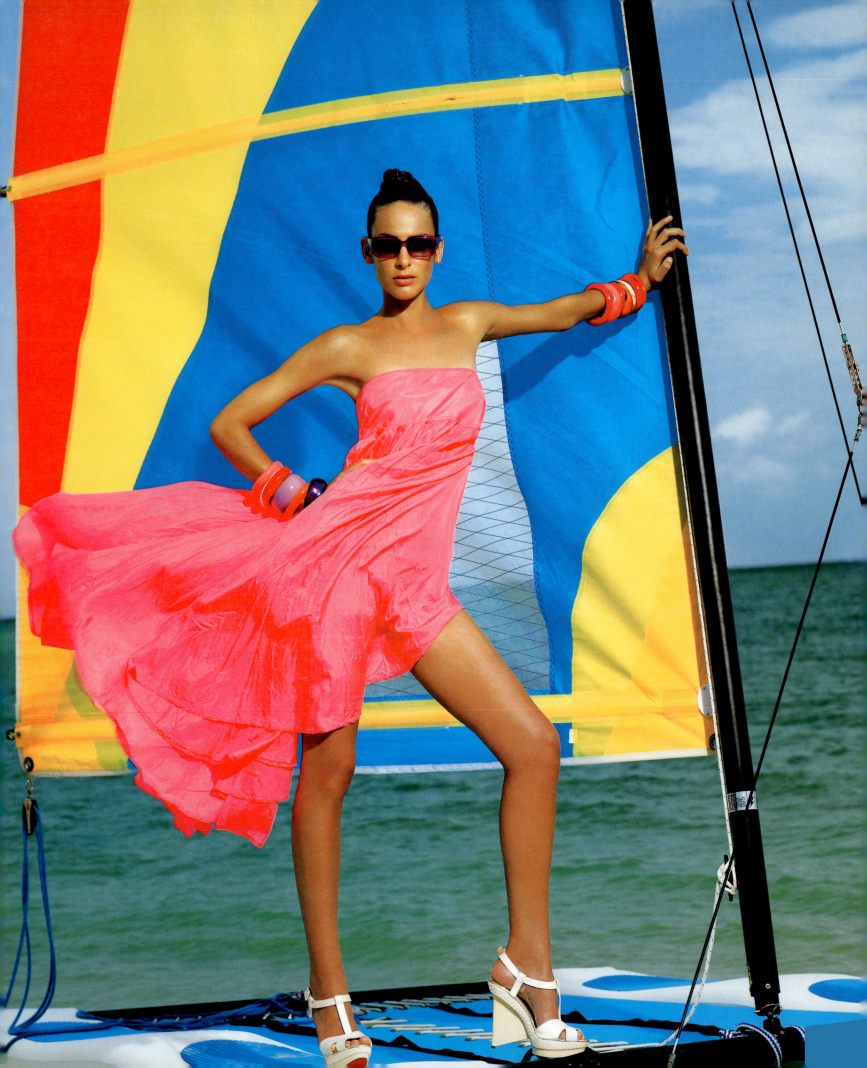

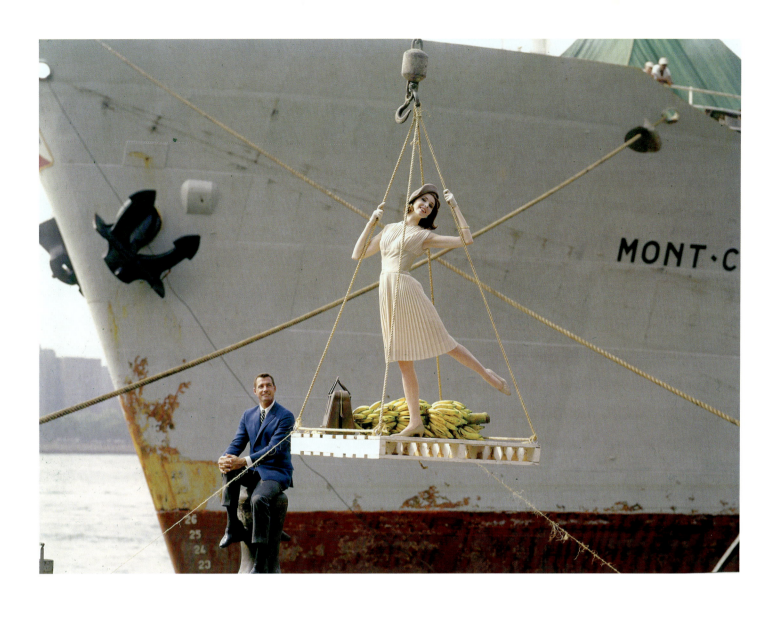

LEFT: *Parrot Cay, 2007. A Gregory Parkinson skirt worn as a dress, with Christian Louboutin wedge sandals and Alain Mikli sunglasses. Photographed by Gavin Bond for* Condé Nast Traveler, *2007.* ABOVE: *Travelers in the 1960s were hungry for laundry-friendly fashions made of drip-dry or permanent-pleated fabrics. This 1962 dress, designed by Harold Weinberg and made of permanently pleated wool, was called the* Andrea A. *Photographed by John Rawlings.*

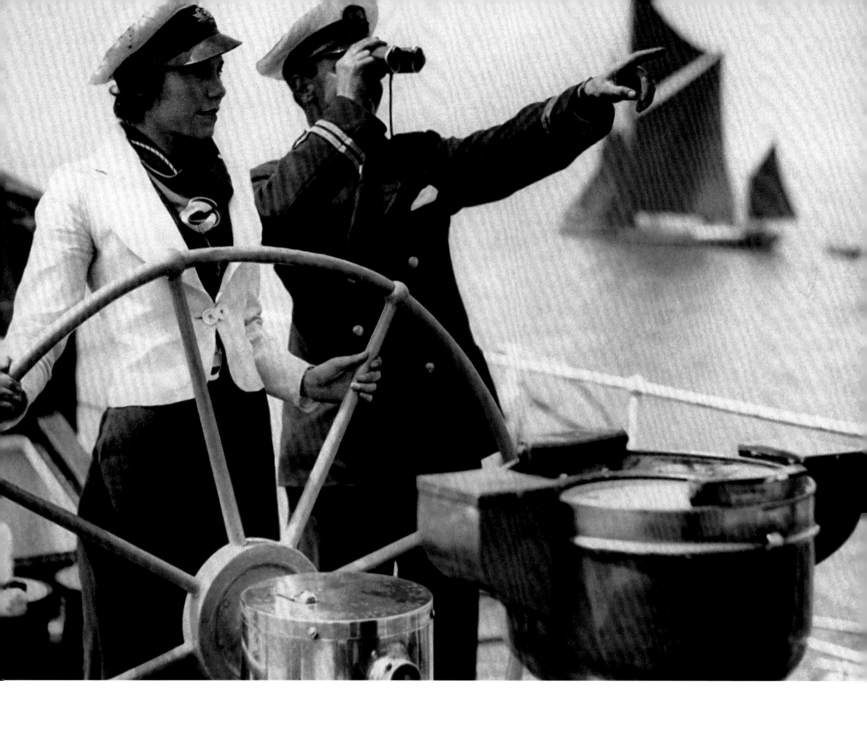

ABOVE: *This steamer passenger takes a turn steering while wearing a shorter 1930s jacket in properly nautical white.* RIGHT: *On her, a polka dot dress by Moschino Cheap & Chic, an Eric Javits hat, and Ralph Lauren sandals; on him, a Dries Van Noten suit and white bucks by Polo Ralph Lauren. Photographed by Pamela Hanson for Glamour, 2005.*

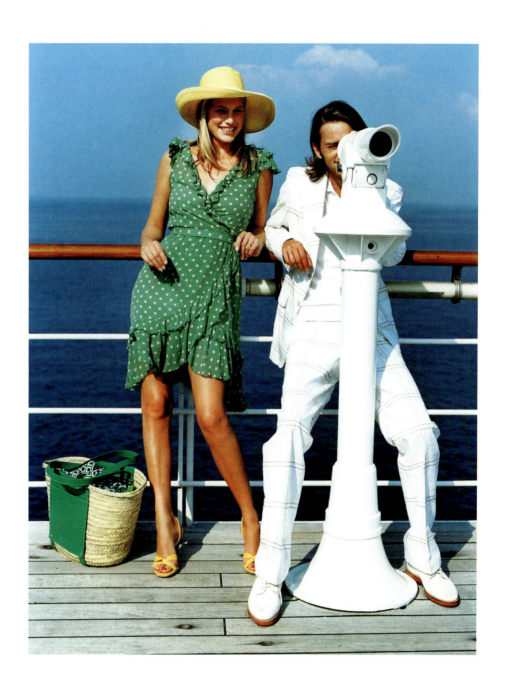

ABOVE: *Scene from* High Society, *1956. Grace Kelly, in white dressmaker bathing suit by costumer Helen Rose, contemplates a model of the* True Love. RIGHT: *At sail in Halong Bay, Vietnam. Actress Bao Hoa in Thomas Maier bikini, actor Charlie Hunnam in Perry Ellis tank and Dries Van Noten cotton pants. Photographed by Frederike Helwig for GQ, 2003.*

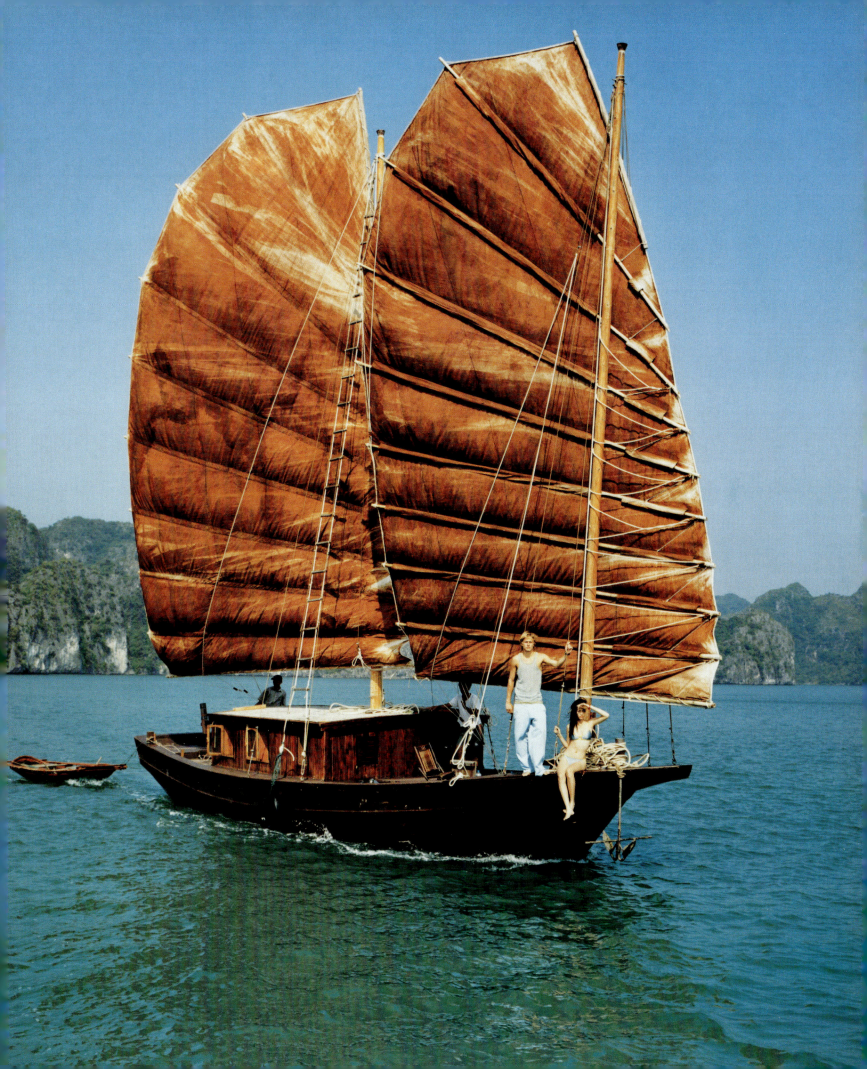

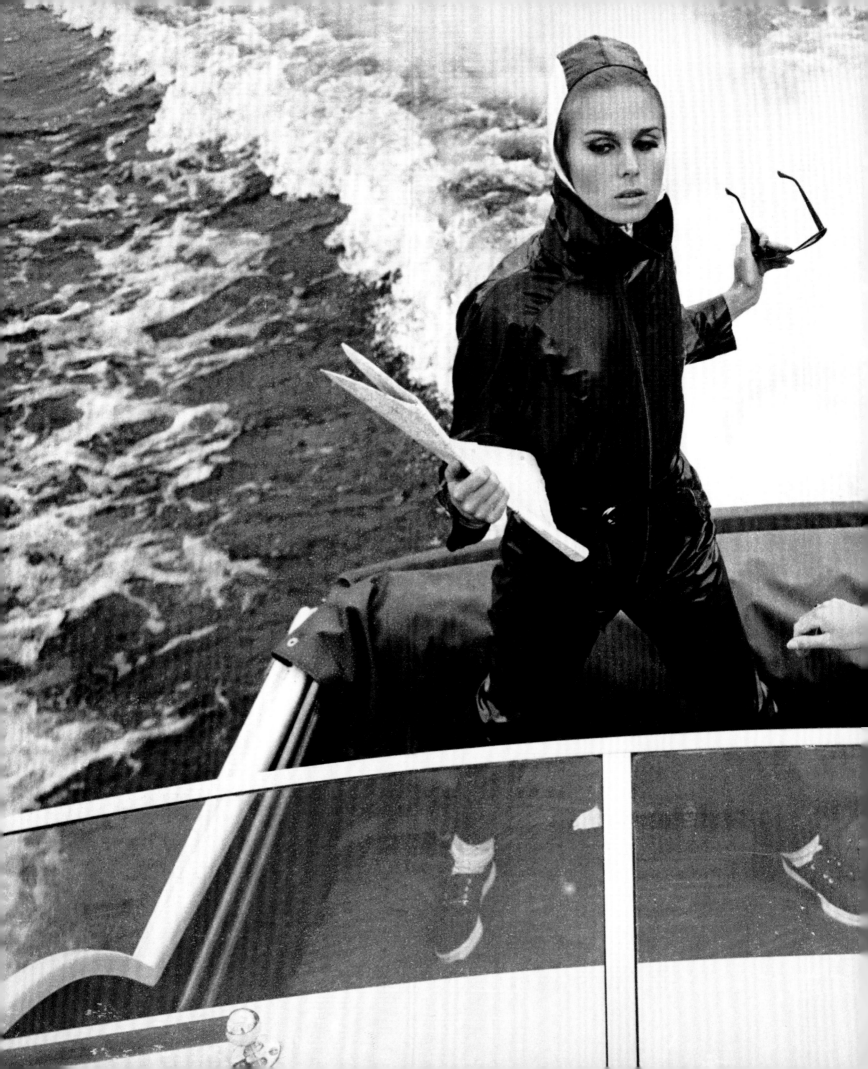

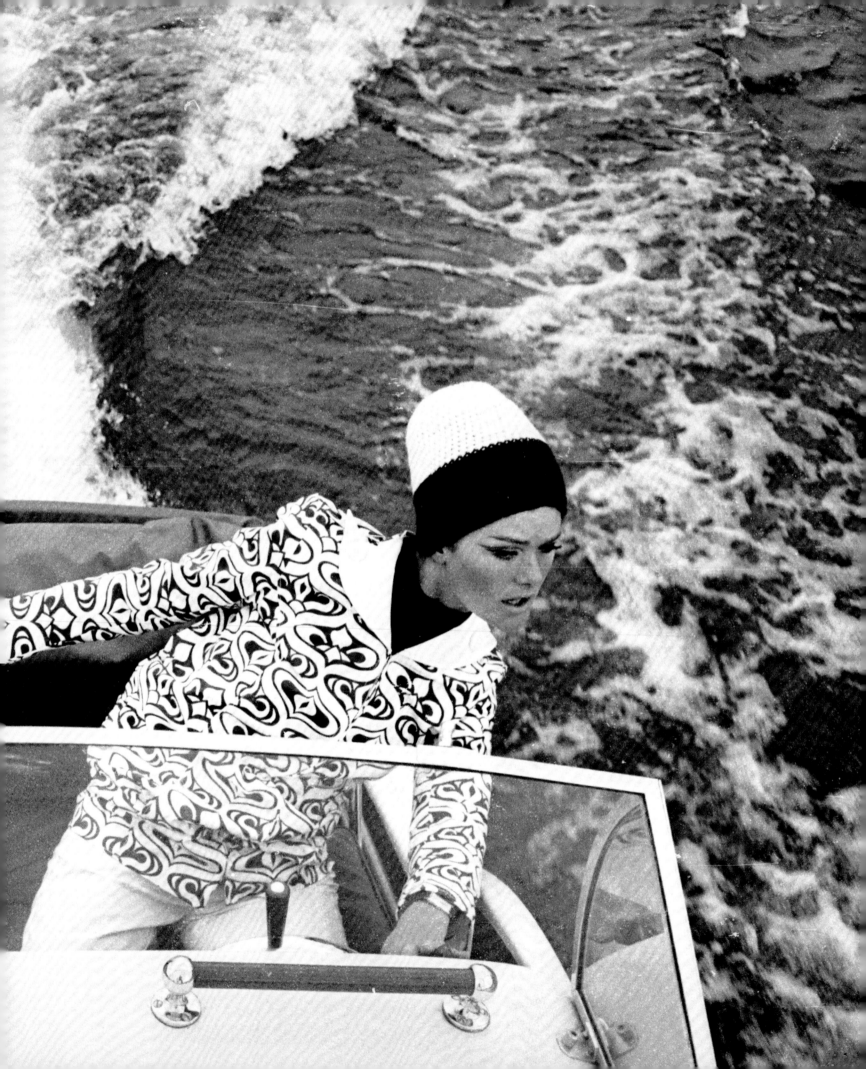

PREVIOUS SPREAD: *Joanna Lumley and fellow model sporting groovy foul weather gear on a motorboat on the Thames, 1965.* LEFT: *Cole of California cotton maillot printed with tropical fish in blues and violet. Photographed in Pound Ridge, New York, by Gleb Derujinsky for* Harper's Bazaar, *1957.*

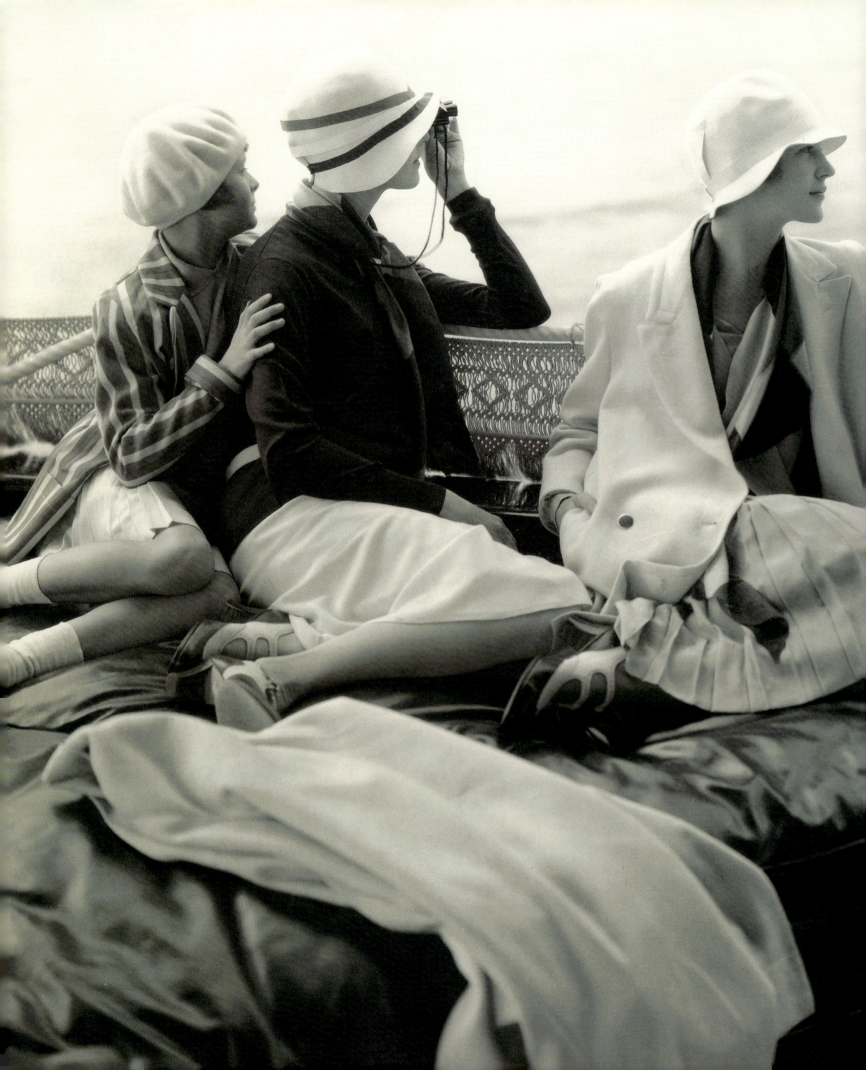

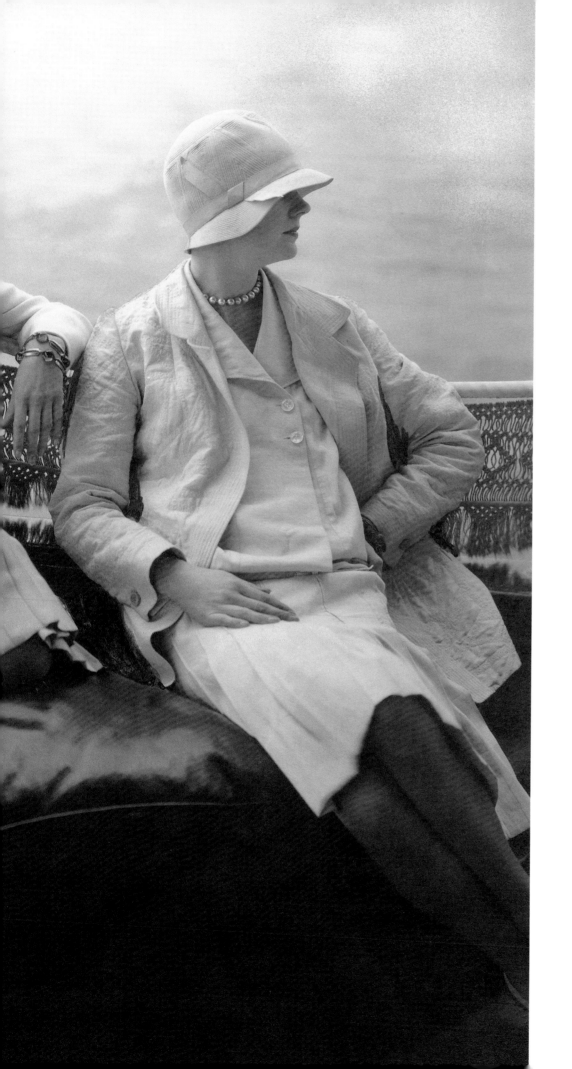

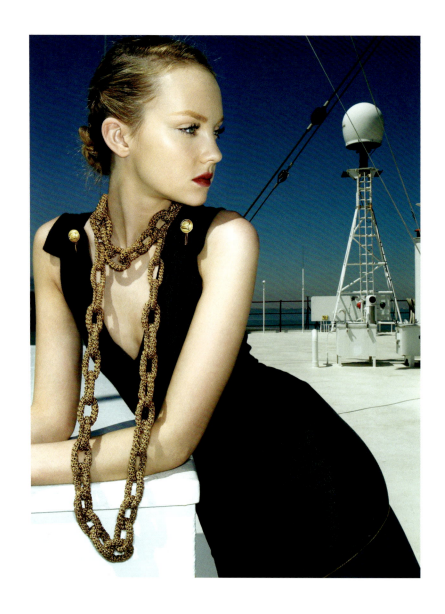

PREVIOUS SPREAD: *Lee Miller (third from left) and fellow models embody yachting chic; Miller wears a white flannel coat over a two-piece crepe de chine dress with dark top and white pleated skirt by Mae and Hattie Green, with the Chanel scarf that was all the rage that year. Photographed by Edward Steichen for* Vogue *aboard George Baker's yacht, 1928.* ABOVE: *Navy V-neck dress by Nicolas Ghesquière for Balenciaga, worn with Marc Jacobs gold knit anchor chain-link necklace. Photographed at the Nantucket Yacht Club by Raymond Meier for* Vogue, *2005.* RIGHT: *During the 1920s, clothes worn for sporting activities and fashionable sporty clothes often merged. Model and photographer Lee Miller (left) and June Cox (right) on board George Baker's yacht, wearing navy flannel blazers and white flannel skirts. Photographed by Edward Steichen for* Vogue, *1928.*

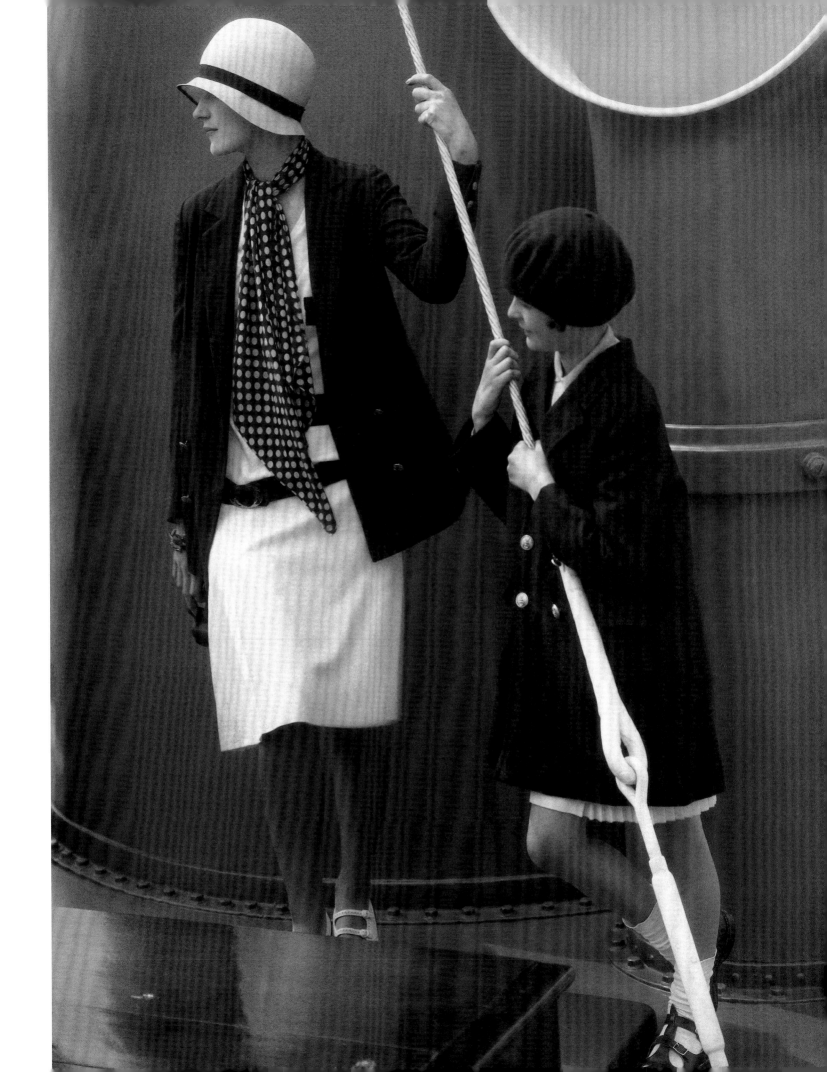

RIGHT: *"Midi sur l'eau."* Pochoir illustration by George Barbier, Modes et Manières d'Aujourd'hui, *1914.* FOLLOWING SPREAD, TOP LEFT: *The Henley Regatta, July 1914. On the eve of World War I, the last traces of what had been a dominant summer look for women for decades: the lingerie dress, so called because it was made from the same materials that were used for the underwear of the time, such as white linen, cotton decorated with embroidery, or Valenciennes lace.* FOLLOWING SPREAD, BOTTOM LEFT: *New York Yacht Club race, Maine, circa 2000. East Coast sailing style personified, down to the long, baggy shorts. Photographed by Joe Standart.* FOLLOWING SPREAD, RIGHT: *Maggie Rizer in a Ralph Lauren turtleneck sweater and white leather shorts. Photographed by Arthur Elgort for* Vogue, *2000.*

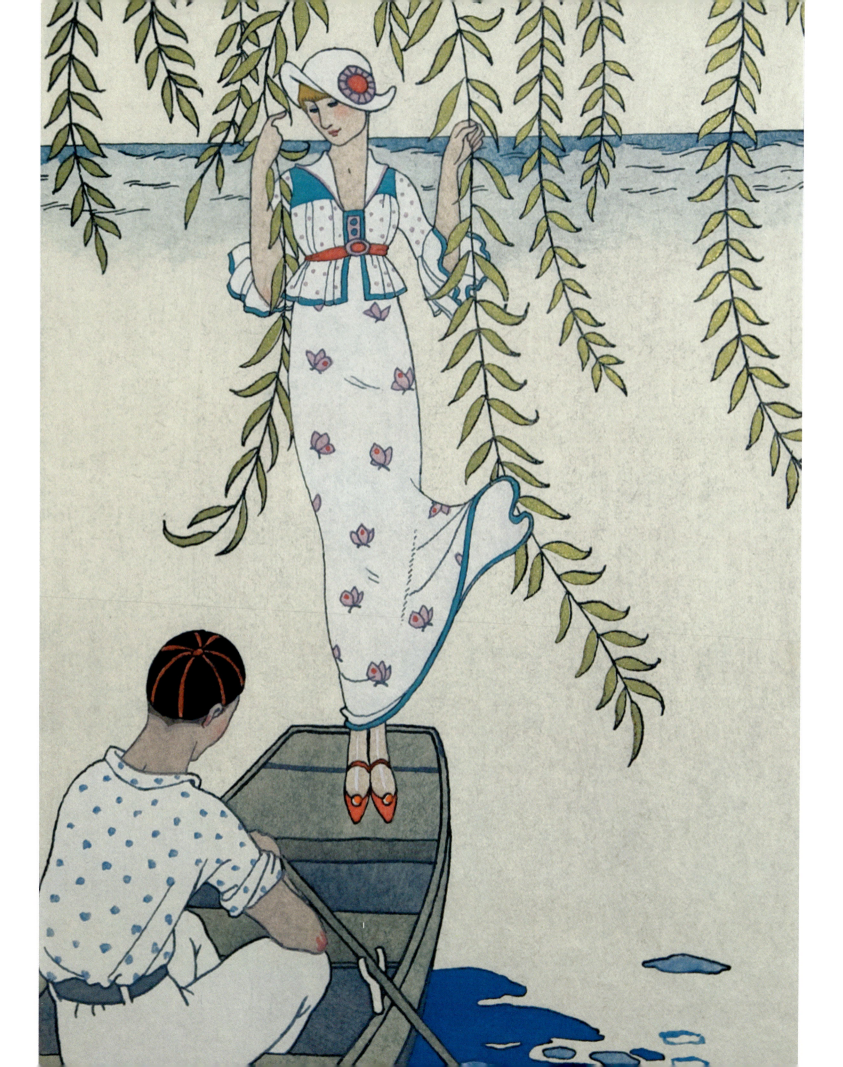

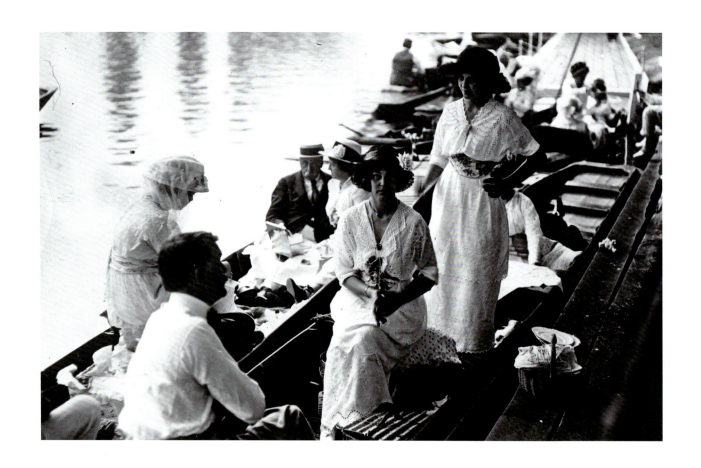

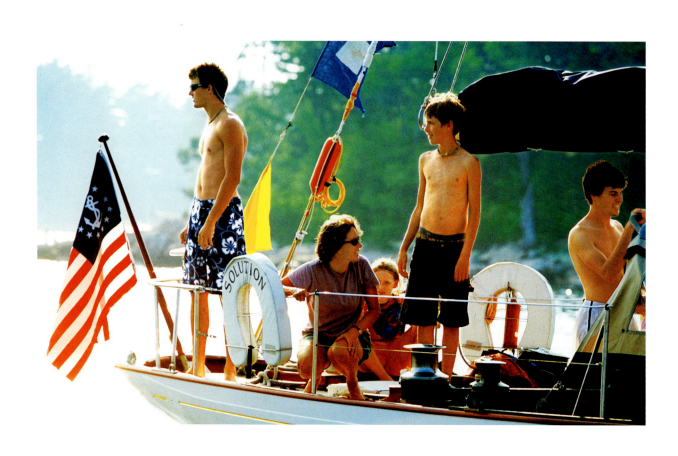

TWO

Stripes

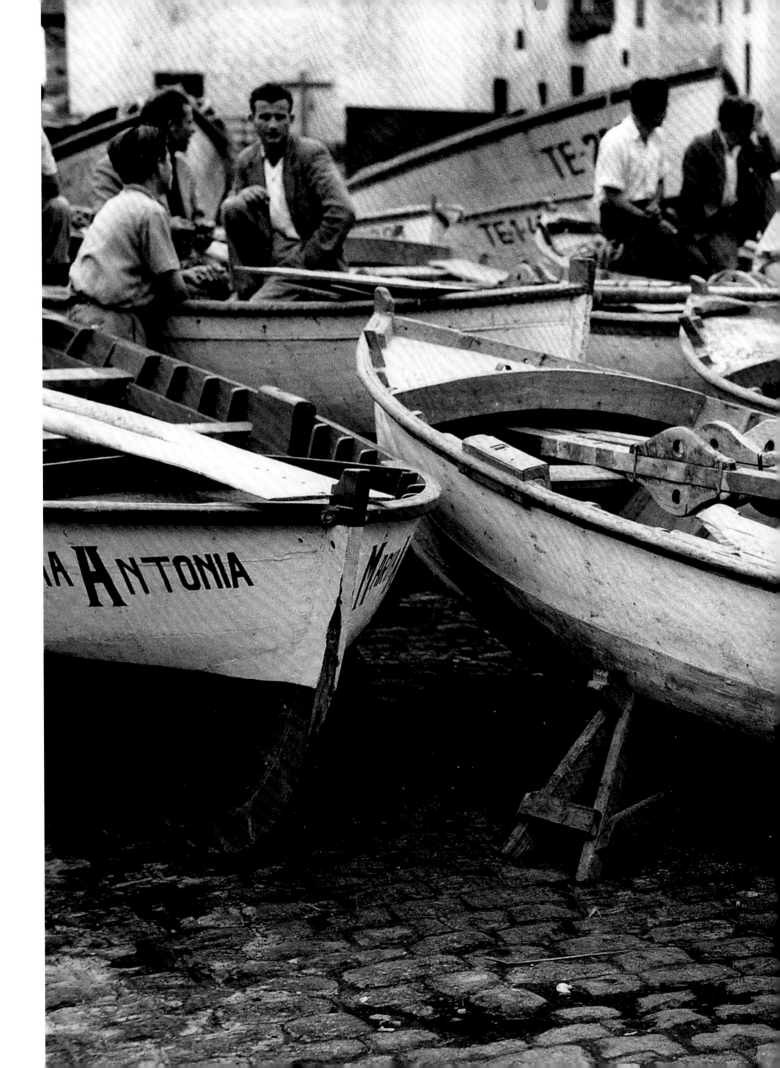

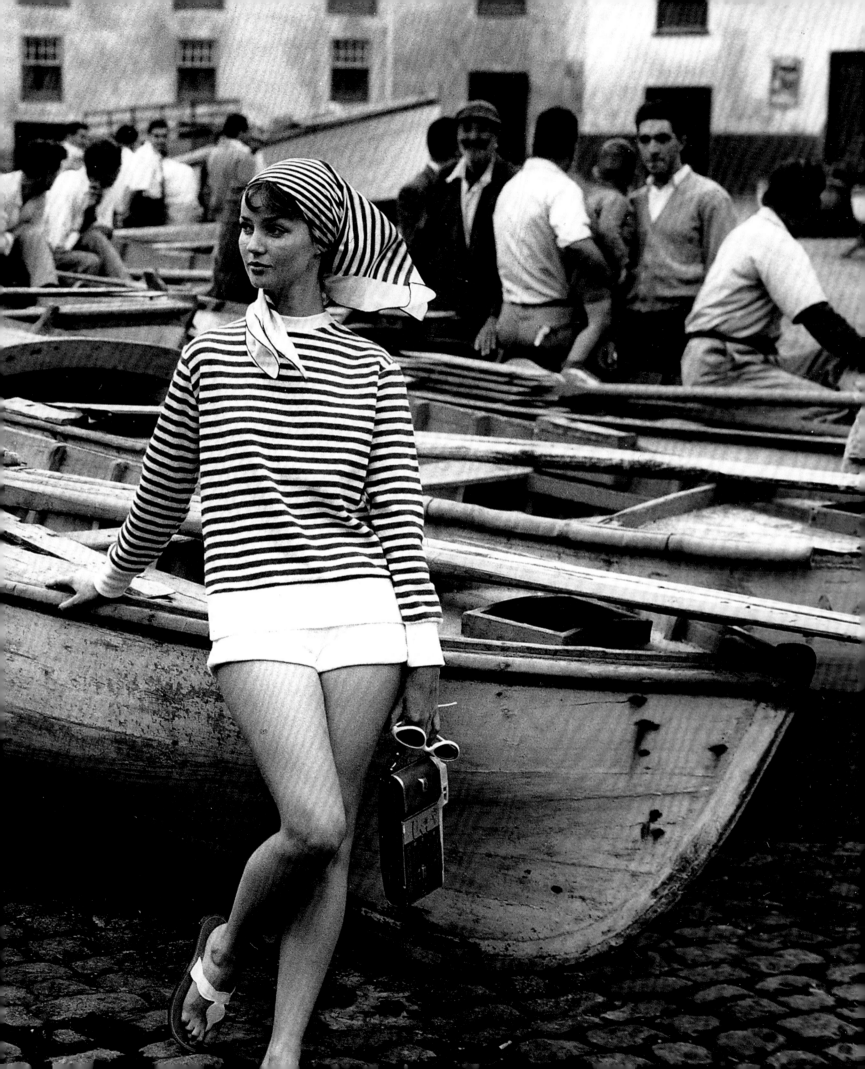

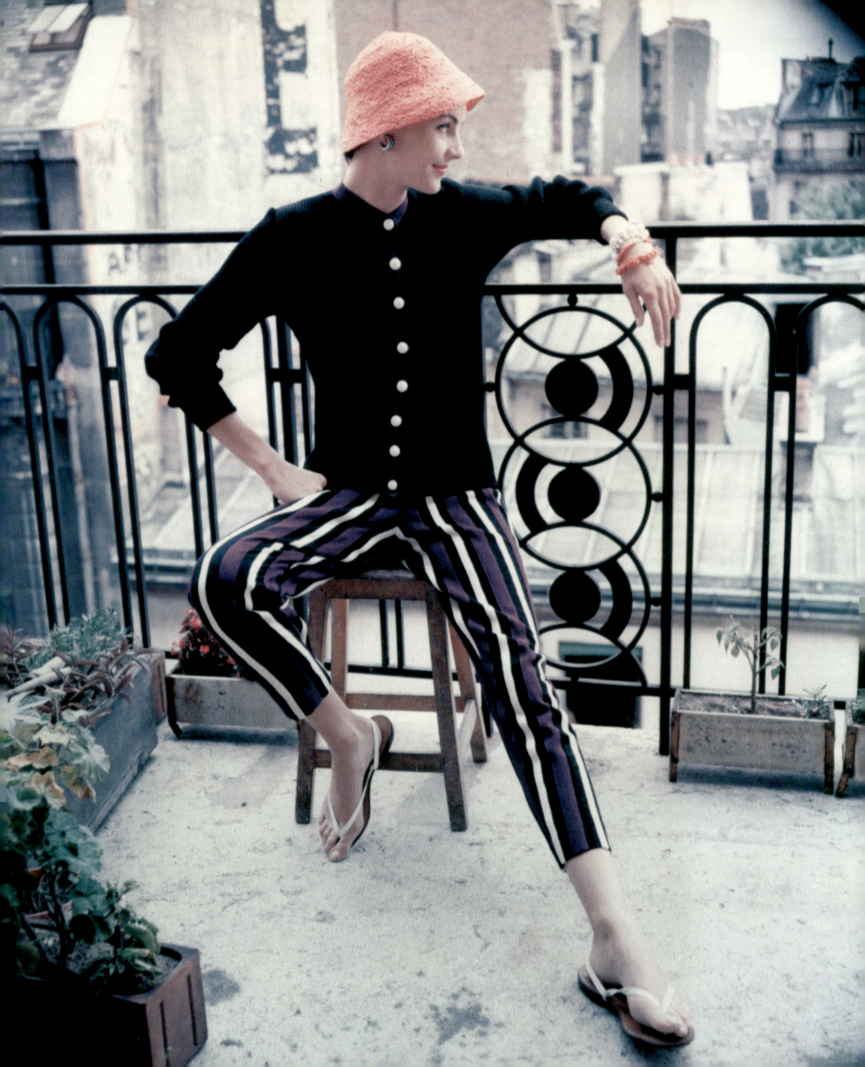

STRIPES

The stripes of awnings and wind-blown clothes are evocative seaside elements, seen in the mid-nineteenth-century paintings of such artists as Eugène Boudin, Édouard Manet, Gustave Caillebotte, and Winslow Homer. Working *en plein air*, these artists captured the appeal of what was, at the time, the modern activity of enjoying the seashore. In the earliest of these images, men and women are pictured in formal dress and standing in clusters along wide, vacant beaches. Sprinkled about are wooden ladder-back chairs, echoing the somewhat stiff demeanor of the figures, who seem to be doing nothing but gazing at the horizon. In the decades leading up to the twentieth century, paintings depicting resort life show evidence of increasingly casual attitudes: men in shirtsleeves rowing, women reclining on the ground. Stripes animated the composition as the Impressionists attempted to portray the effects of light on various surfaces, such as ladies' crinoline and, later, bustle-back dresses; the shirts of men rowing boats; bathing machines, dressing pavilions, and flags fluttering from poles. The first photographs of resort life, taken in the early twentieth century, feature some of the same sorts of scenes. The figures, whether formally dressed or *en déshabille*, pose among striped beach chairs and in front of cabanas and awnings. Crisp, graphic stripes—used for a punter's blazer, the hatband of a boater, or a cushion on a wicker chair—have come to symbolize summer, and for this reason designers turn to them for inspiration again and again.

Perhaps the most iconic are the navy-on-cream stripes of the Breton fisherman's sweater, as significant a part of the French clothing vocabulary as the beret. In 1911 Pierre Bonnard painted fellow artist Paul Signac, at the tiller of a boat, wearing

PREVIOUS SPREAD: *Photographed in the Canary Islands, model Sondra Peterson sports cotton-knit velour separates along with Bernardo sandals. Photographed by Herman Landshoff for* Mademoiselle, *1958.* LEFT: *Relaxing on a balcony in Paris. Photograph by Genevieve Naylor, 1958.*

the narrow horizontal stripes that suggest (although faintly) such a top. A sailor, Signac had discovered St. Tropez in 1892 when a storm came up and he had to bring his boat into the nearest harbor. He stayed, his friends flocked to visit, and the area, especially in the cheaper summer off-season, came to be seen as an antiurban refuge for artists of all ilks, from visual and literary to *manqué*. Society soon discovered the charms of seaside summers, and by the mid-1920s the south of France was home to a heady mix of art and fashion.

The striped top became a badge of casual beach style for this set, thanks to American expatriate Gerald Murphy, who returned from a shopping expedition in Marseilles in 1923 with an armload of matelot tops for him and his fellow Cap d'Antibes beachcombers, including Pablo Picasso. Coco Chanel appreciated the matelot's appeal as well, and it was one of many articles of men's clothing she chose for her own wardrobe. A photograph in a 1931 issue of *Vogue* shows Diana Vreeland and her equally fashionable husband Reed in Tunisia, in day ensembles that included a narrow beach pajama for her and a Breton sweater, dark pants, and espadrilles for him. And the Duke of Windsor, on his somewhat infamous cruise aboard the yacht *Nahlin* in 1936 while he was briefly king of England (and accompanied by his married girlfriend Mrs. Simpson), was photographed in a decidedly un-royal way, in a Breton striped boat-neck sweater, relaxing on a dinghy.

The sailor top resurfaced during the 1960s as an outside-the-fashion-system look, notably worn by Jean Seberg in *Breathless*, by Joan Baez at the Newport Jazz Festival, by Norman Mailer at a radical chic party, and by Andy Warhol at a Turkish bath happening with the Velvet Underground. Its allure waned during the 1970s, as it came to be seen as merely another element in a lexicon of sturdy unisex wear, along with blue jeans, work shirts, bandannas, jean jackets, work boots, and fatigues. More recently, the Breton stripe has been resuscitated and parsed by Jean-Paul Gaultier, who emphasizes its erotic sailor-on-leave aspect. He has used the stripes in men's and women's designs and on the male-torso-shaped bottle for his perfume Le Mâle, as well as in haute couture evening gowns. He himself is often photographed wearing a matelot, dressing it up for black tie with a tuxedo-striped skirt.

Sailor-inspired beach dresses by the French couture house Beer, 1920. Pochoir illustration, Gazette du Bon Ton.

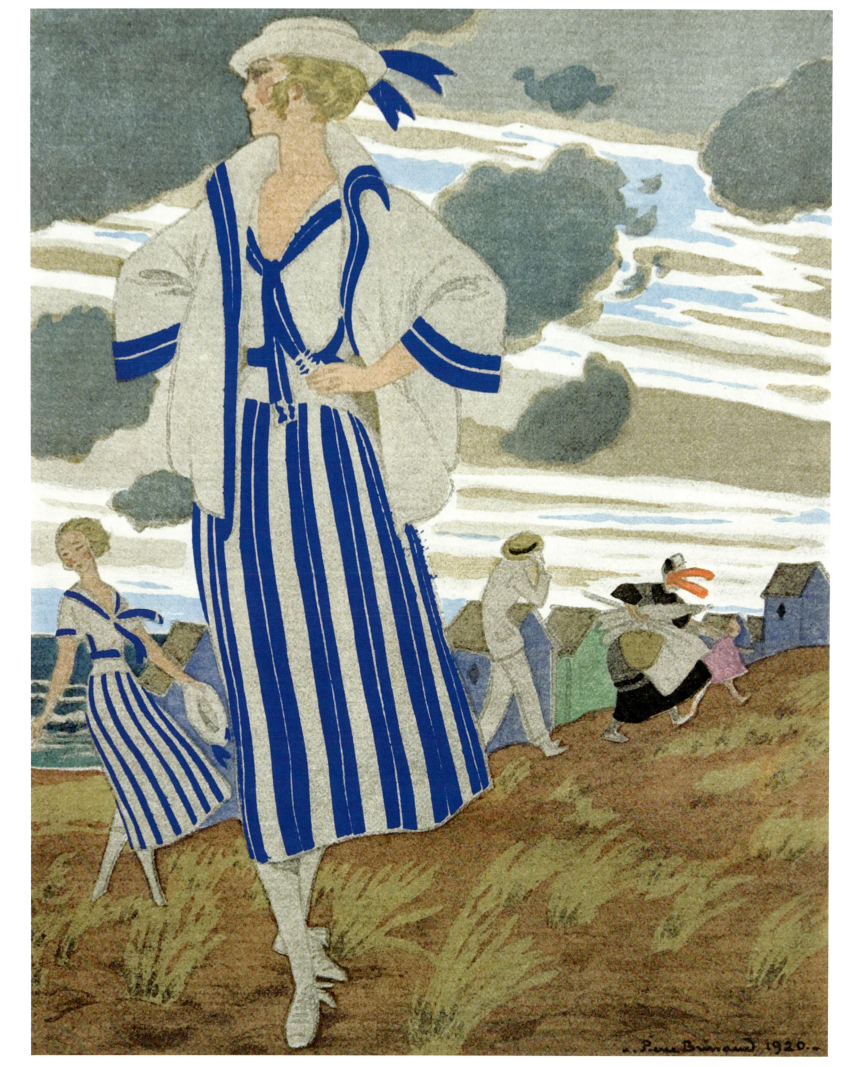

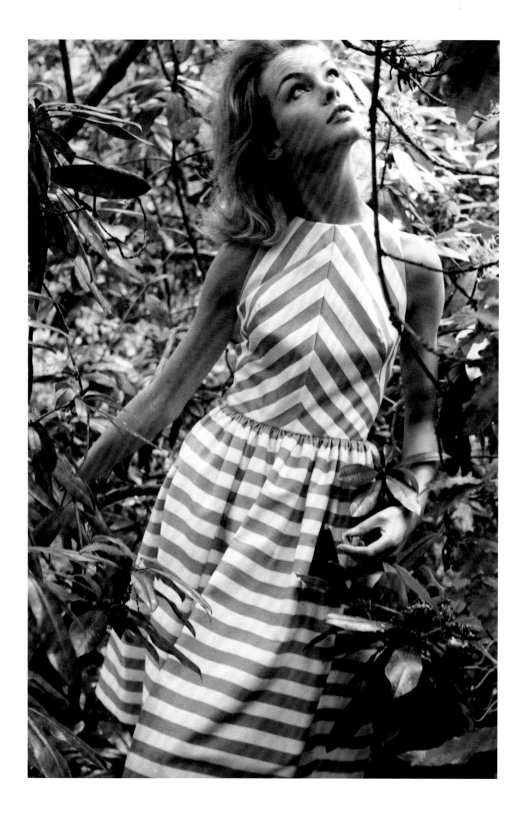

English fashion model Jean Shrimpton wearing a halter-neck sundress in 1962. RIGHT: *Mildred Orrick designed this rayon jersey dress with a wrapped, slightly empire bodice. Photographed by Serge Balkin for* Vogue, *1946.*

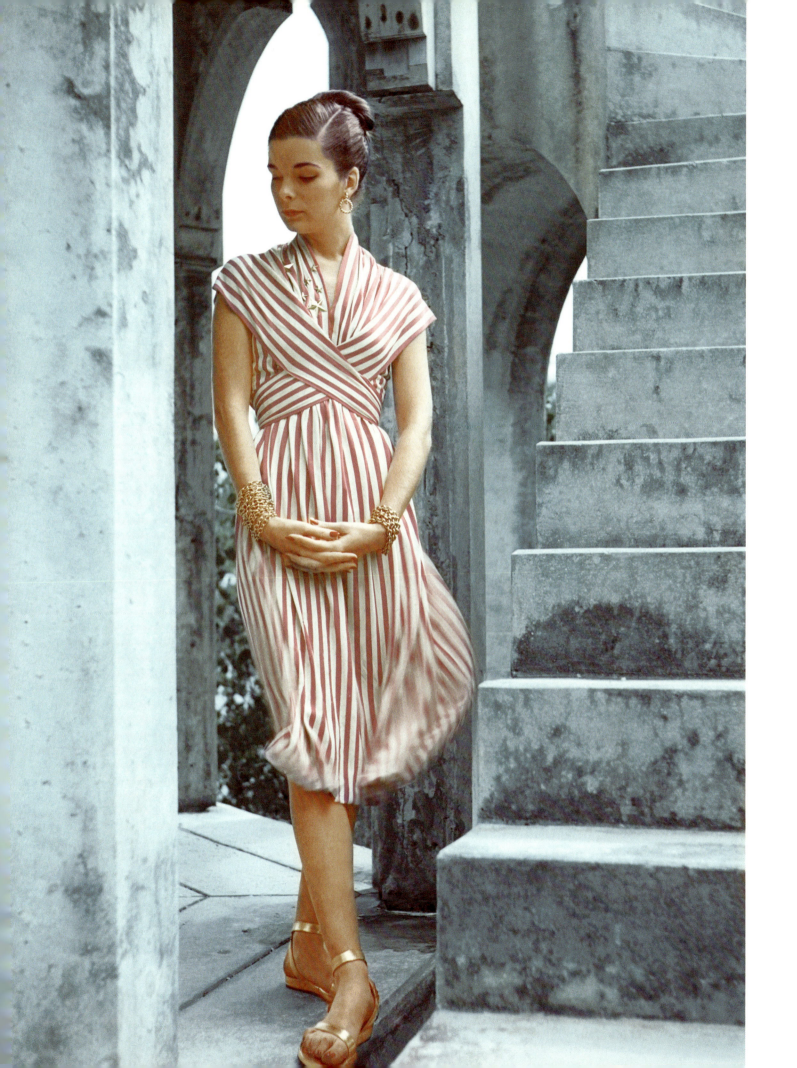

Audrey Hepburn in a scene from Two for the Road *(1967) wearing a two-piece suit with abbreviated T-shirt top and boy-leg bottoms in yellow, red, blue, and white. In the movie, Hepburn wears off-the-rack clothing from a number of designers, including Mary Quant, Ken Scott, and Paco Rabanne.*

Dolores Hawkins and Nan Rjis strolling in Jamaica. On Dolores is an elasticized wool maillot with high halter neckline and boy-legs; Nan wears a two-piece suit in elasticized cotton by Saxony. Photographed by Herman Landshoff for Mademoiselle, *1956.*

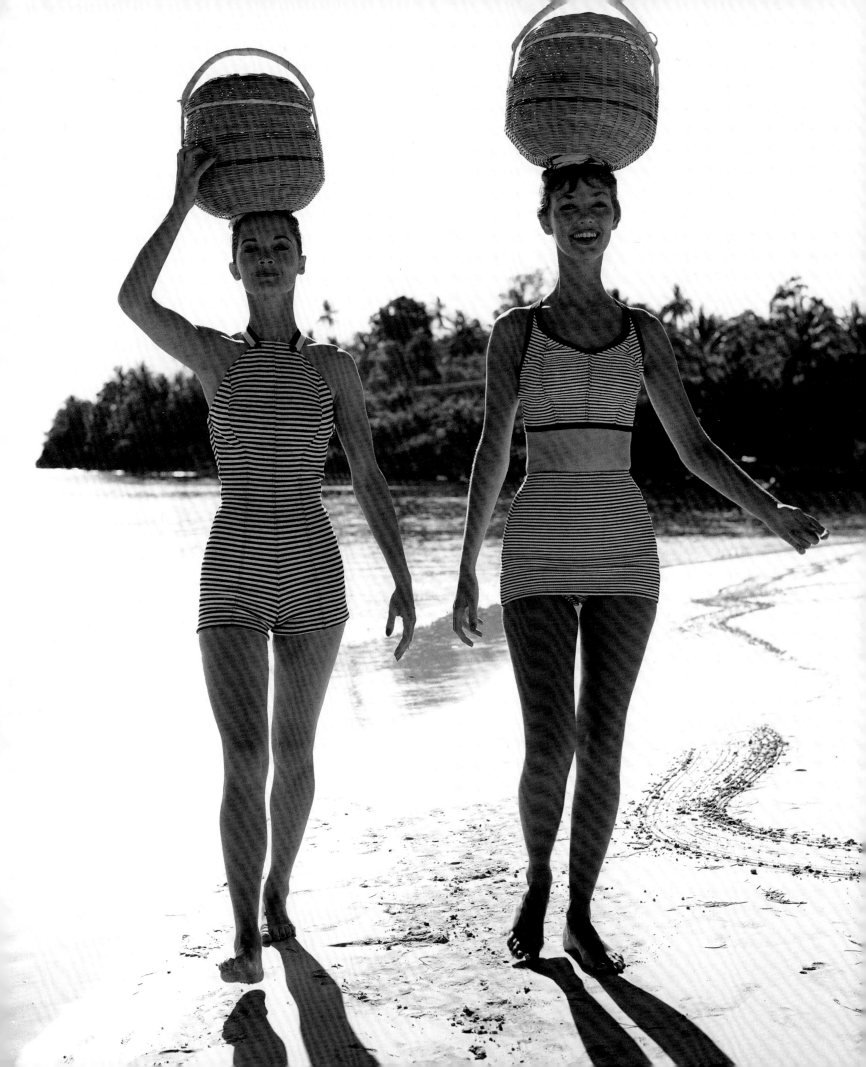

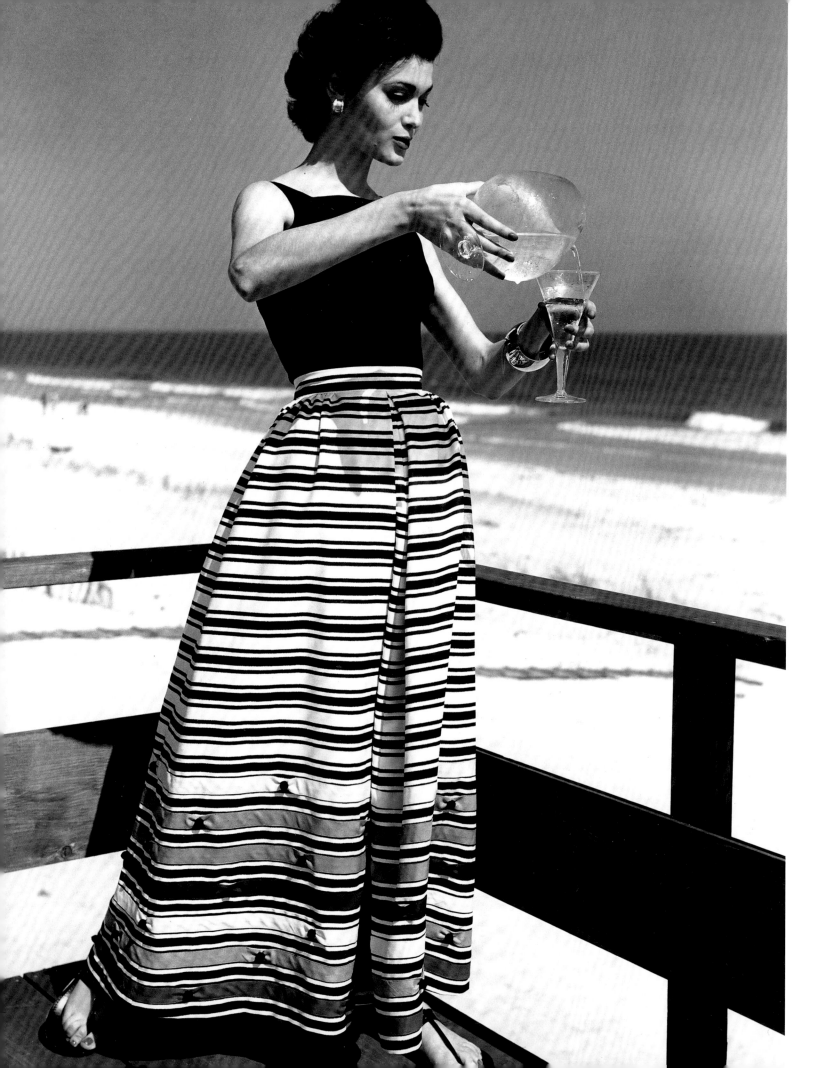

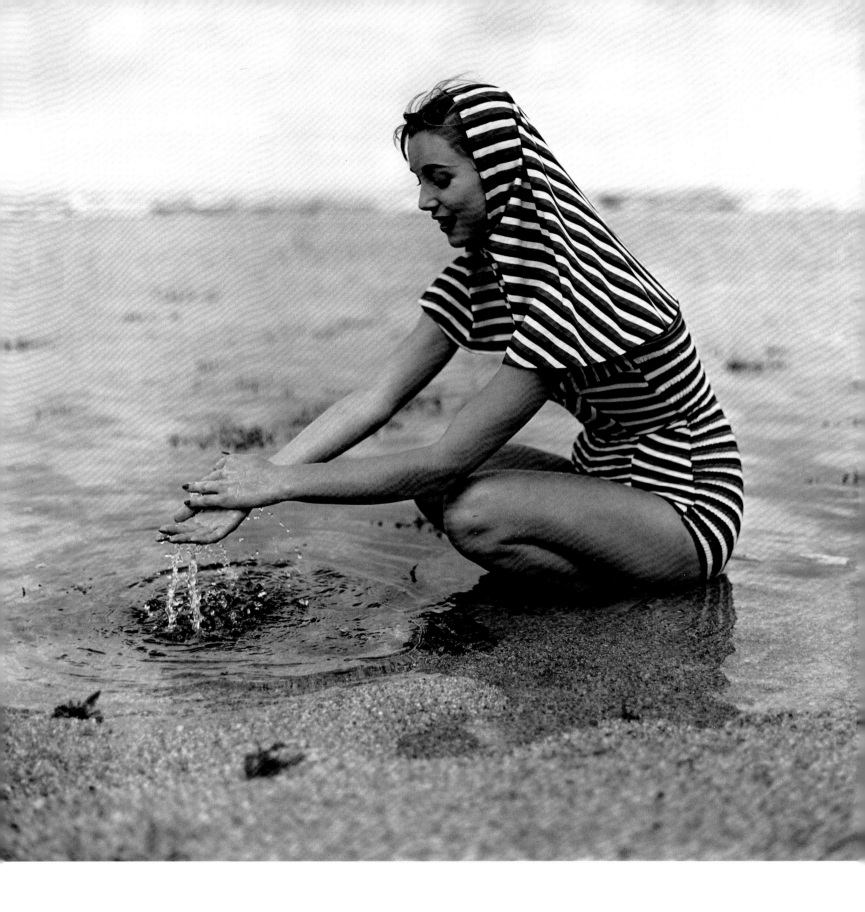

LEFT: *Once the sun is over the yardarm, this black herringbone cotton duck playsuit could be dressed up with an overskirt of striped cotton duck, both by Sportsmasters. Cuff bracelet by Accessocraft. Photographed by Herman Landshoff for* Mademoiselle *(out-take), 1957.* ABOVE: *Modeled in Hawaii in 1955, this Cole of California suit in red, white, and blue striped acetate and nylon jersey featured a separate hood that could also be worn as a shoulder cape. Photographed by Herman Landshoff for* Mademoiselle, *1955.*

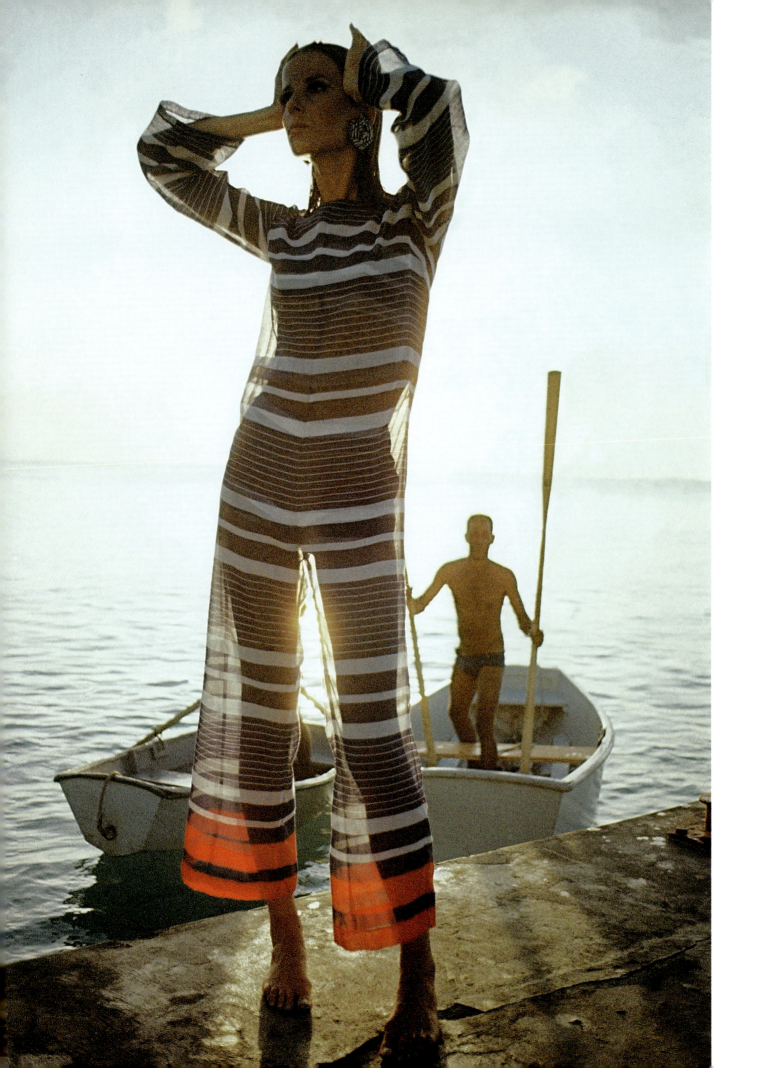

This jumpsuit cover-up was made out of tricolor cotton voile, and is here worn over a blue and white striped bikini by Robert Sloan. Earrings by Atelier Nina. Photographed in Barbados by Louis Faurer for Mademoiselle, *1965.*

Claire McCardell included versions of her Monastic tent dress in every collection. This summery version, modeled by Helen Beatty, was made of a Hope Stillman satin-striped cotton and fastened with signature hooks at the neck. Photographed at Oak Beach, New York, by Herman Landshoff for Mademoiselle, *1951.*

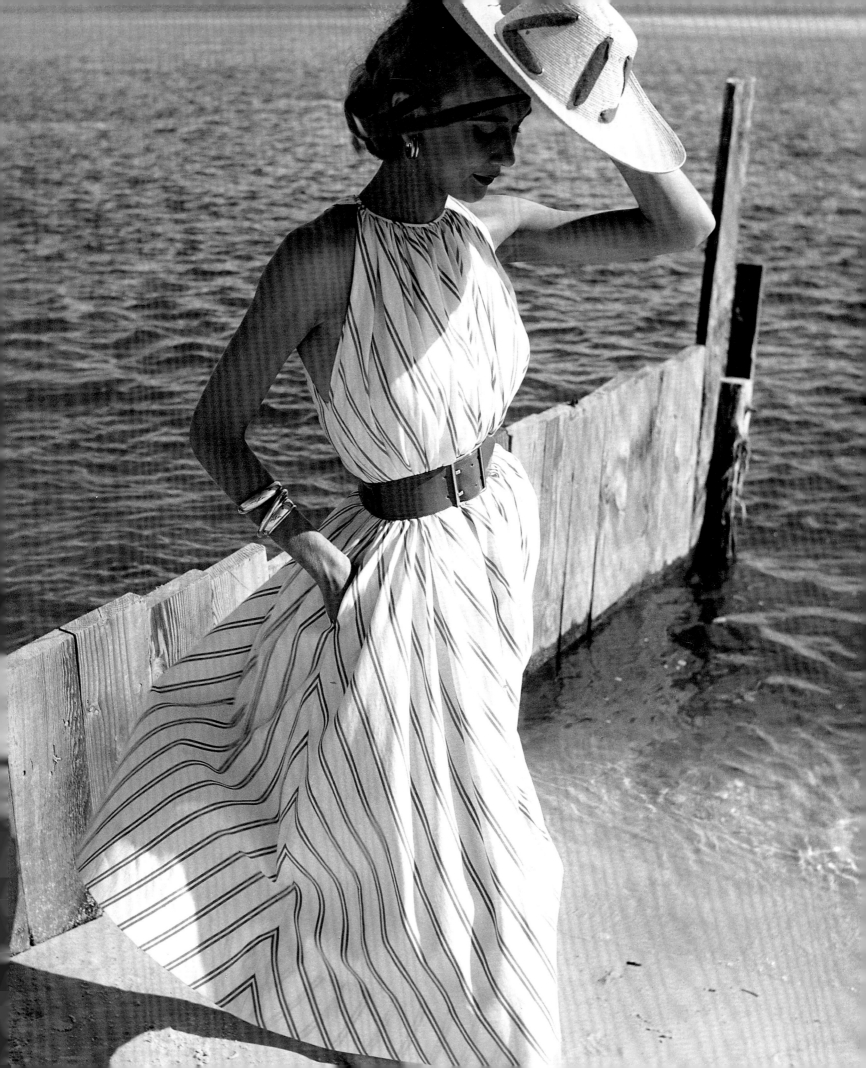

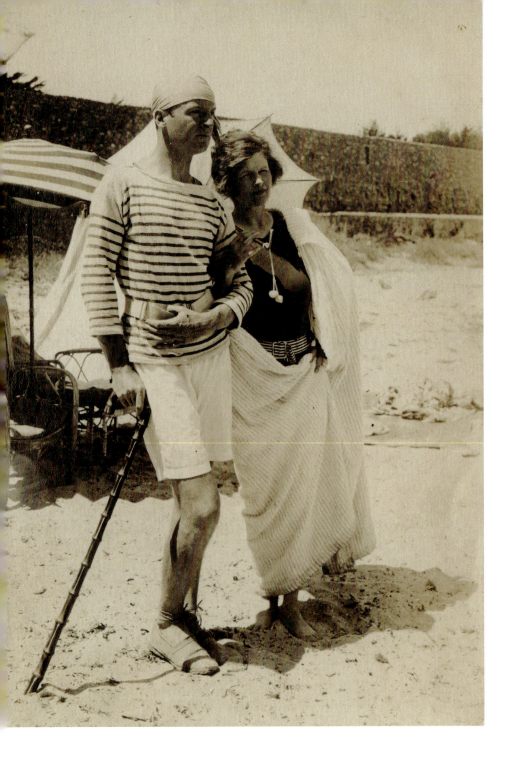
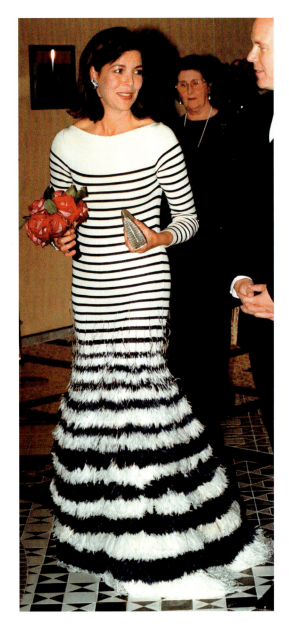

ABOVE, LEFT: *Sara and Gerald Murphy at La Garoupe beach, Cap d'Antibes, summer 1926. The Murphys brought their relaxed East Hampton ways to the south of France, where they moved after visiting Linda and Cole Porter in 1922.* ABOVE, RIGHT: *The most elegant riff on the French sailor top ever, Jean Paul Gaultier's extenuated haute couture version, its skirt flared out with feathers. Worn by Princess Caroline of Monaco to the Bal de la Rose, Monte Carlo, 2000.* RIGHT: *Two of the three famous Cushing sisters, Betsey Whitney and Babe Paley, on the green at Lyford Cay, the Bahamas. Photographed by Patrick Lichfield for* Vogue, *1968.*

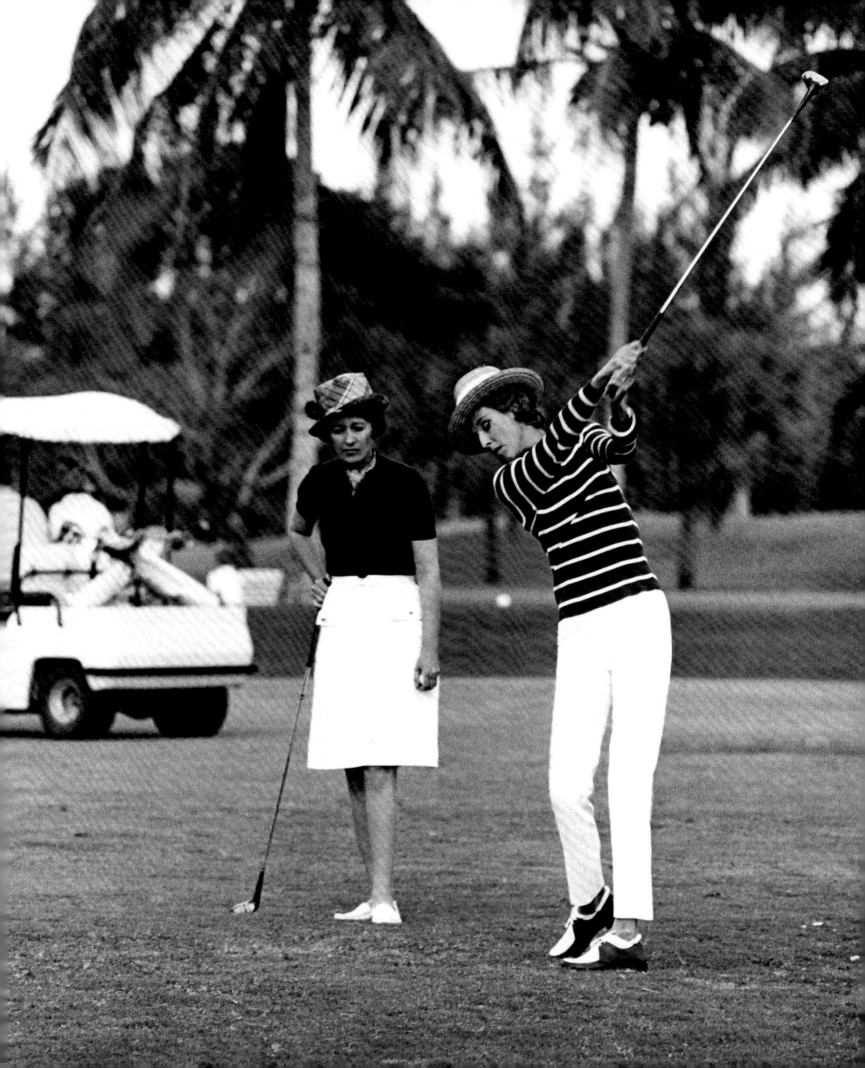

Viewed through the screen door of a beach cottage, model wearing Ralph Lauren Blue Label boatneck sailor jersey and cutoff shorts, and Bulgari wristwatch. Photographed by Arthur Elgort for Vogue, *2006.*

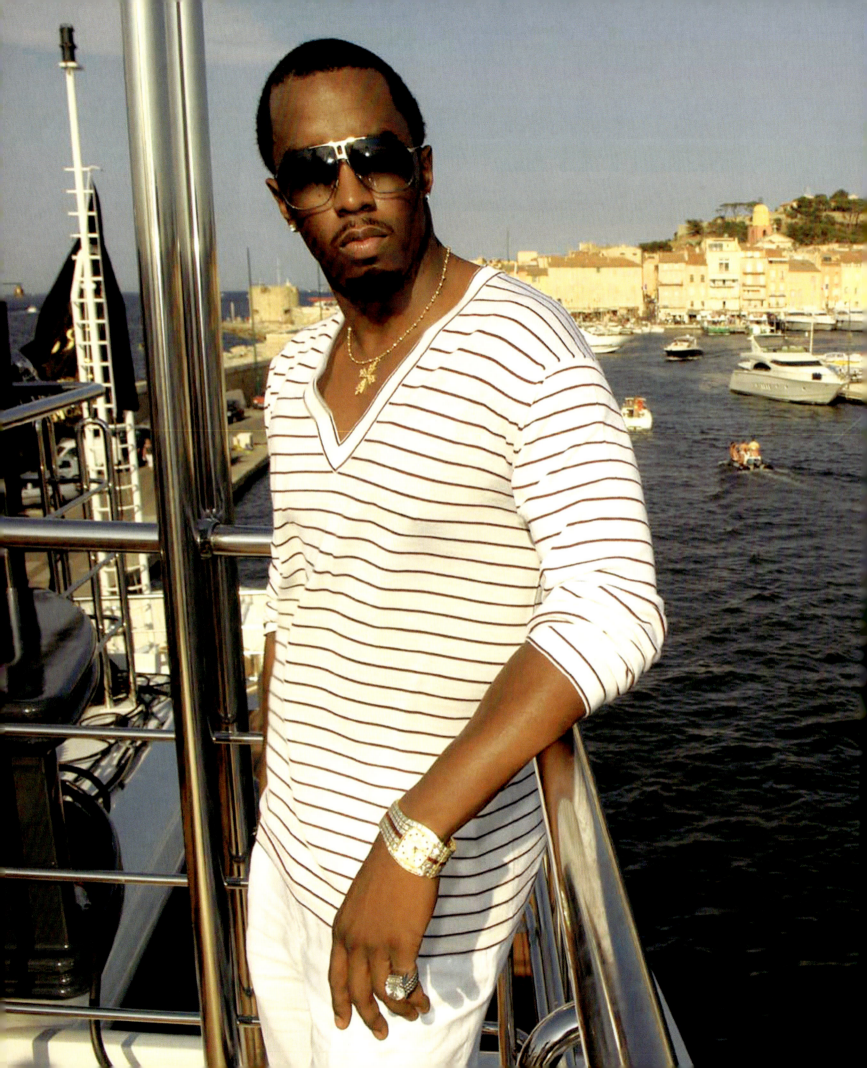

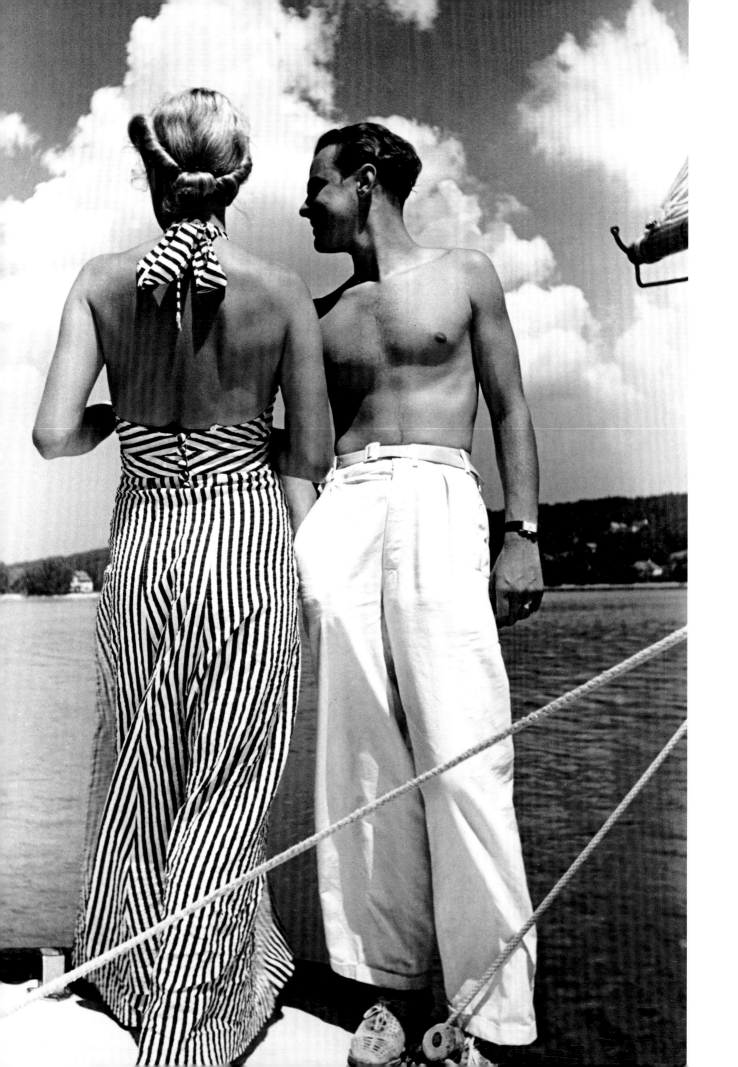

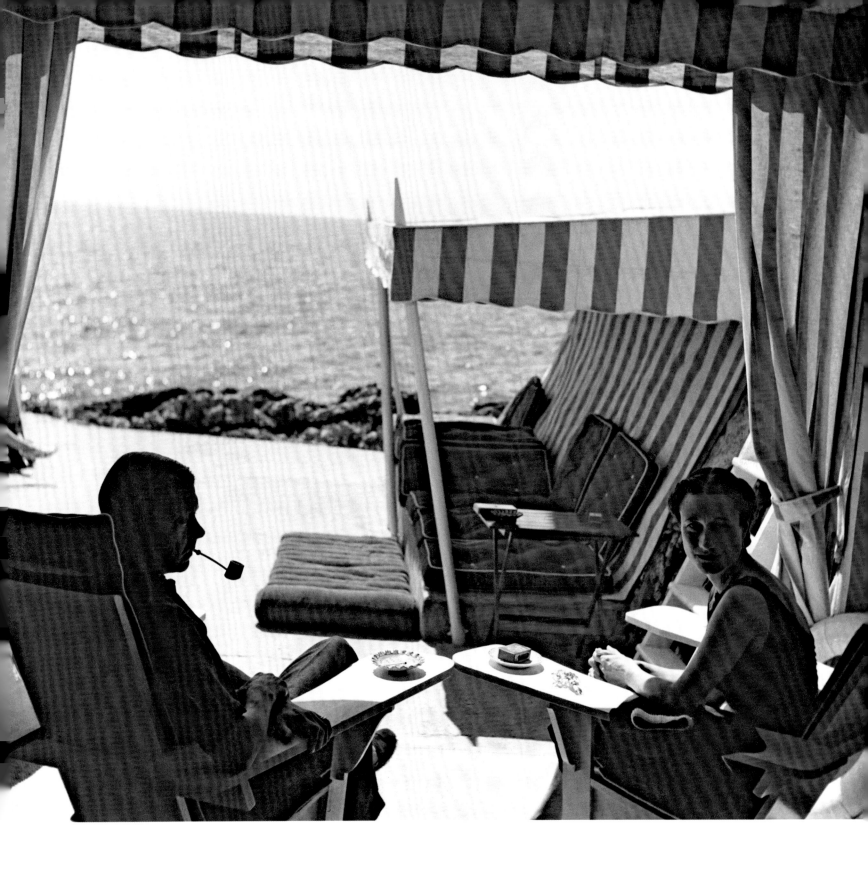

PREVIOUS SPREAD: *Sean "Diddy" Combs in St. Tropez, 2006.* LEFT : *Couple standing on a sailboat, she in a striped halter-neck beach pajama, he in white trousers, 1930s.* ABOVE: *The Duke and Duchess of Windsor sitting in the shade of their oceanside cabana, at their recently acquired Riviera Château de la Croë, 1938.* FOLLOWING SPREAD: *A bevy of bikini-clad beauties. Photograph by Walter Chin.*

THREE

Prints

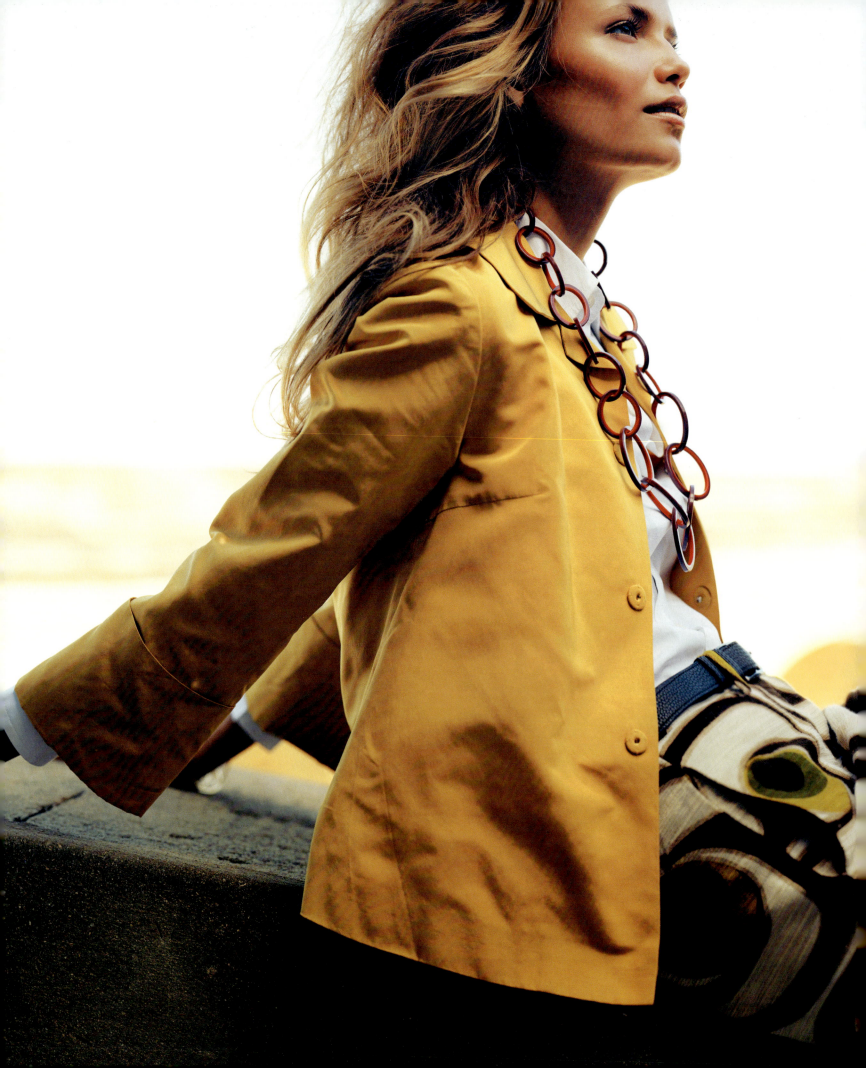

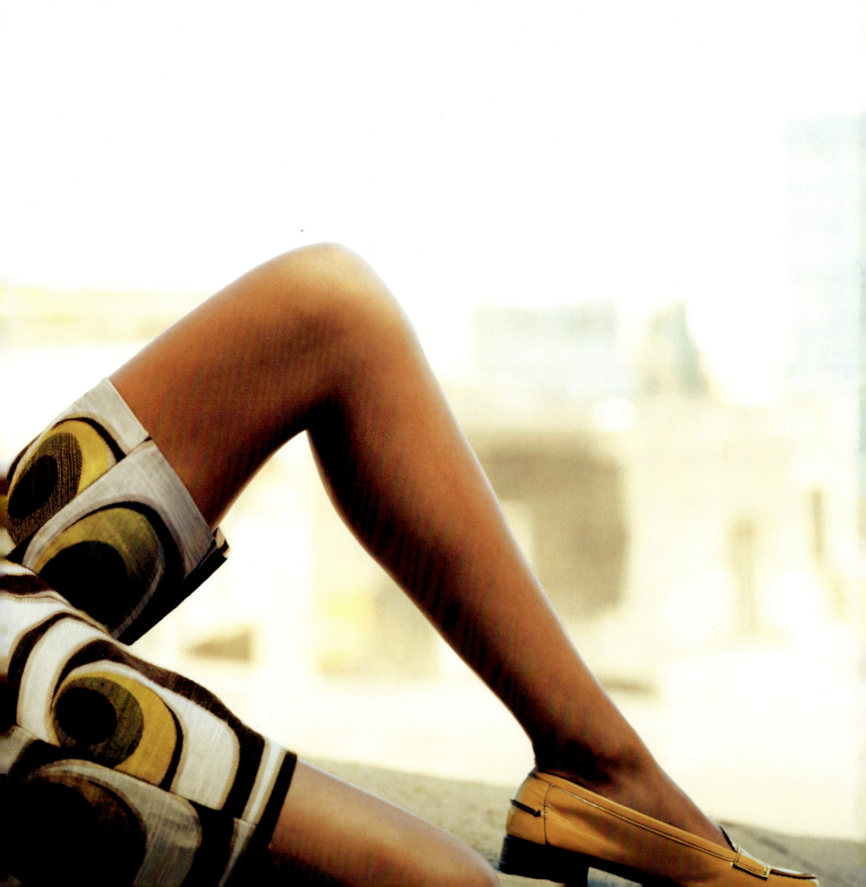

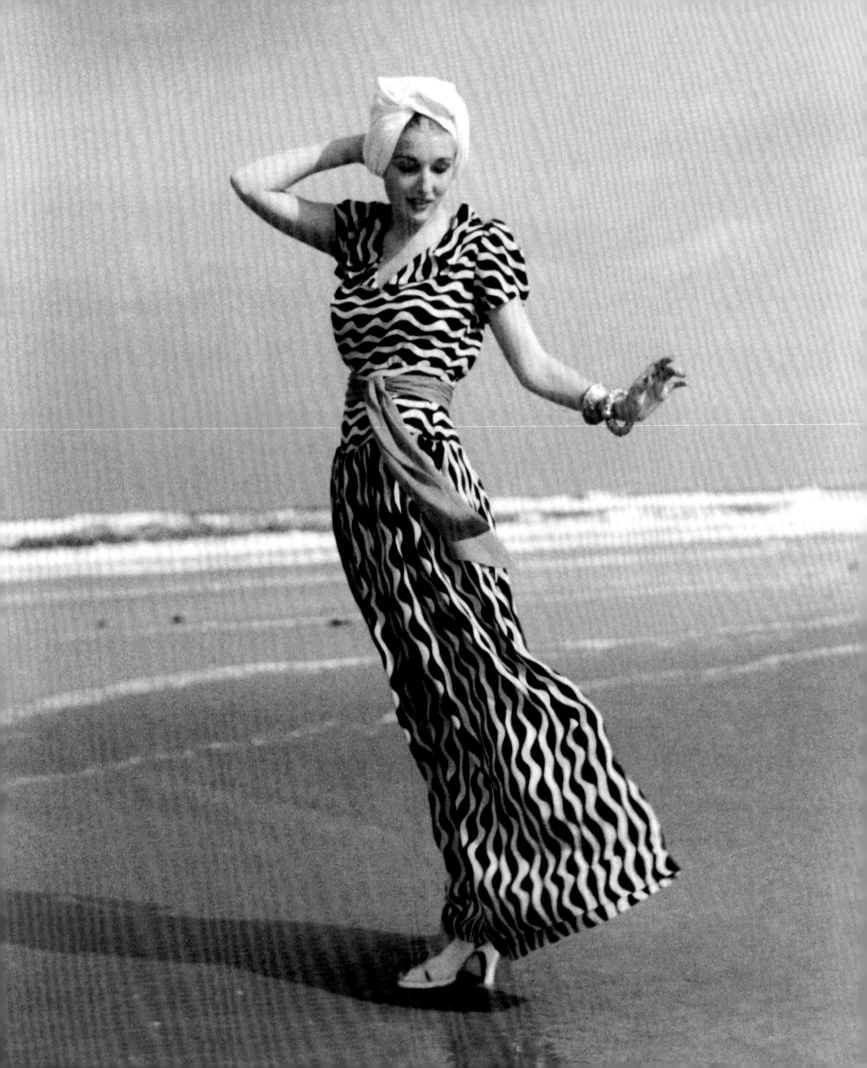

PRINTS

In the 1930s, fashion embraced the tropics. Designing clothing meant specifically for relaxing by the sea was still a relatively novel concept in 1931 when an exposition of colonial life and culture took Paris by storm. Up to 300,000 people a day streamed in to see exhibits featuring representatives of French Colonial outposts in simulated environments demonstrating native crafts, dance, music. None of the participants were allowed to wear European clothing. While European fashion had long been entranced by the costume, decorative, and fine arts of China, Japan, India, and the Near East—typically resulting in Asian shapes and motifs being grafted onto standard Western forms of dress—these exhibits introduced to the Paris fashion world the distinctive clothing styles of the South Seas. Among the first couturiers to be inspired was Jacques Heim, who showed bathing suits with pareo cover-ups beginning in 1932. Tropical prints gained momentum on both sides of the Atlantic with the popularity of the American movie actress Dorothy Lamour, who first wore a sarong in *The Jungle Princess* in 1936. Hawaii, which had its own variety of island-themed prints, became a stop on an increasing number of cruise ship circuits, bringing the Aloha shirt to an even wider audience. Since the 1930s, island patterns have been a part of the international warm-weather fashion vocabulary.

The first print born in a resort was, of course, the Pucci. At his Emilio of Capri shop, opened in 1949, Marchese Emilio Pucci di Barsento started with brightly colored separates and then quickly developed such patterned wares as silk scarves and blouses. In the beginning, the prints had subject matter: the isle of Capri, a sprinkling of gemstones, heraldic motifs from the banners of the *contrades* who compete in Siena's annual Palio races. But by 1956 Pucci was offering patterns unlike any ever

PREVIOUS SPREAD: *About the mod-peacock pattern of these Miu Miu shorts—here paired with a Miu Miu jacket, plastic necklace, and Prada loafers—*Vogue *cautioned that "the season's high-energy prints are sometimes best in small doses." Photographed by Craig McDean for* Vogue, *2005.* LEFT: *A fluid dinner dress from Henri Bendel in green silk printed with white wavy lines and worn with a red chiffon belt, a white jersey turban, and gold bracelets. Photographed by Toni Frissell for* Vogue, *1939.*

seen before: kaleidoscopic, increasingly abstract, the colors carefully delineated from each other by hair-thin black lines. There were up to sixteen colors in one design. "I tried bougainvillea pinks, and turquoises as intense as the Mediterranean. I brought out shades that weren't on the International Color Chart," he told the *New York Times* in 1956. Pucci had to convince the mills in Como to keep increasing the intensity of the colors. "In Italy, or any warm climate, bold color belongs because it's all around you in the sky, the sea and the foliage." The Pucci print struck a chord. More than ten years later, it was not just going strong, but 1966 saw an explosion of Pucci copies by manufacturers of everything from umbrellas to underwear. The fakes were as popular as the originals.

Meanwhile, on the other side of the Atlantic, there was the Lilly Pulitzer print. Married to a socially prominent Palm Beacher, Lilly Pulitzer opened a stand where she sold orange juice from her husband's family's groves in 1961. Needing to wear something that wouldn't show the juice splatters, she began making little brightly colored shift dresses for herself, and quickly her orange juice customers were clamoring for those as well. Whereas the Pucci print was linear with hair-thin touches of black, Pulitzer designs were painterly, often leavened with opaque white. She branched into children's and men's clothing, and by 1968 the *New York Times* reported that socially established men like George Plimpton were wearing "P.J.s" (Pulitzer Jeans) in wildly flowered patterns in Southampton.

It was at resorts that men began to regain their long lost plumage, starting in the 1950s with madras pants worn on golf courses. The observation, in the early 1960s, that the young president John F. Kennedy wore bright yellow pants for golf and red pants while sailing helped disseminate the bright vacation colors of Cape Cod and Palm Beach to the rest of his countrymen. While bold colors and vibrant prints come and go in men's runway fashion, they remain the nucleus of East Coast unisex preppie tribal attire from Maine all the way down to Florida. For large-scale patterns, there's madras and Lilly and Pucci; there's Vineyard Vines for smaller designs; and then there

Tory Burch has built a career on expanding our resort frame of reference. Deftly merging modernity and nostalgia, her designs have become ever more versatile: appropriate for the office, casual enough for the school run, or decorative enough for a weekend party. Here, a version of her signature tunic. Photographed by Catherine Wessel for Self, *2008.*

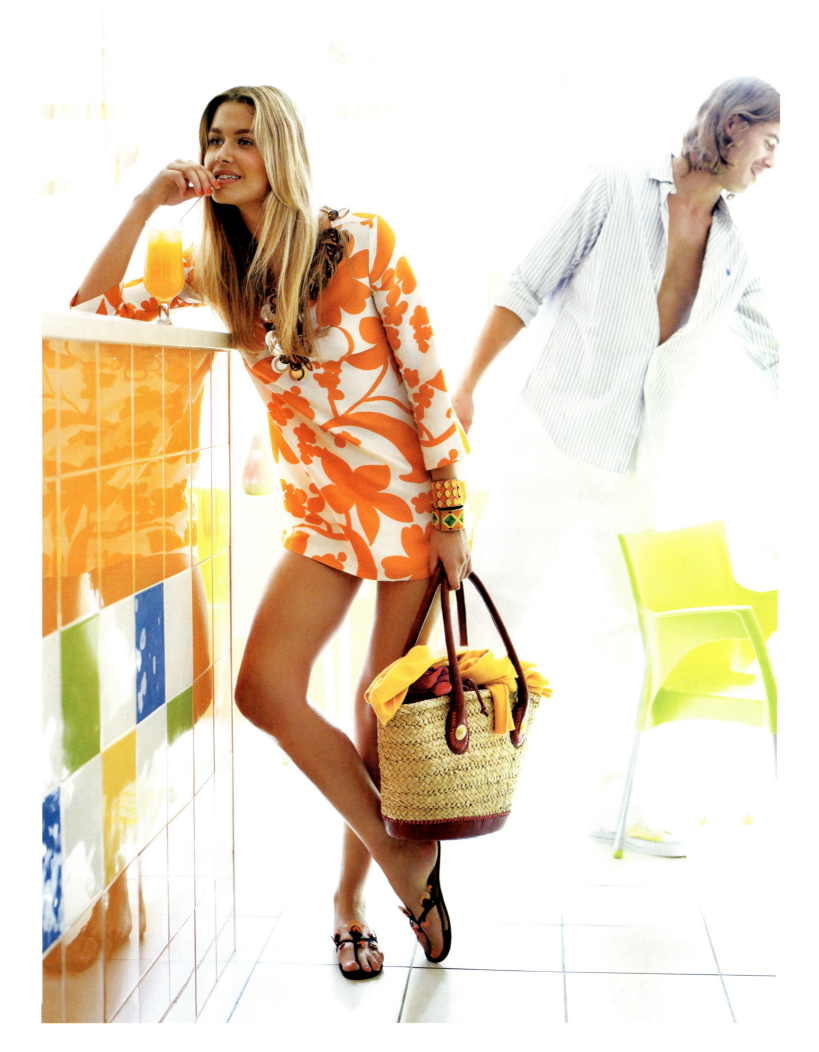

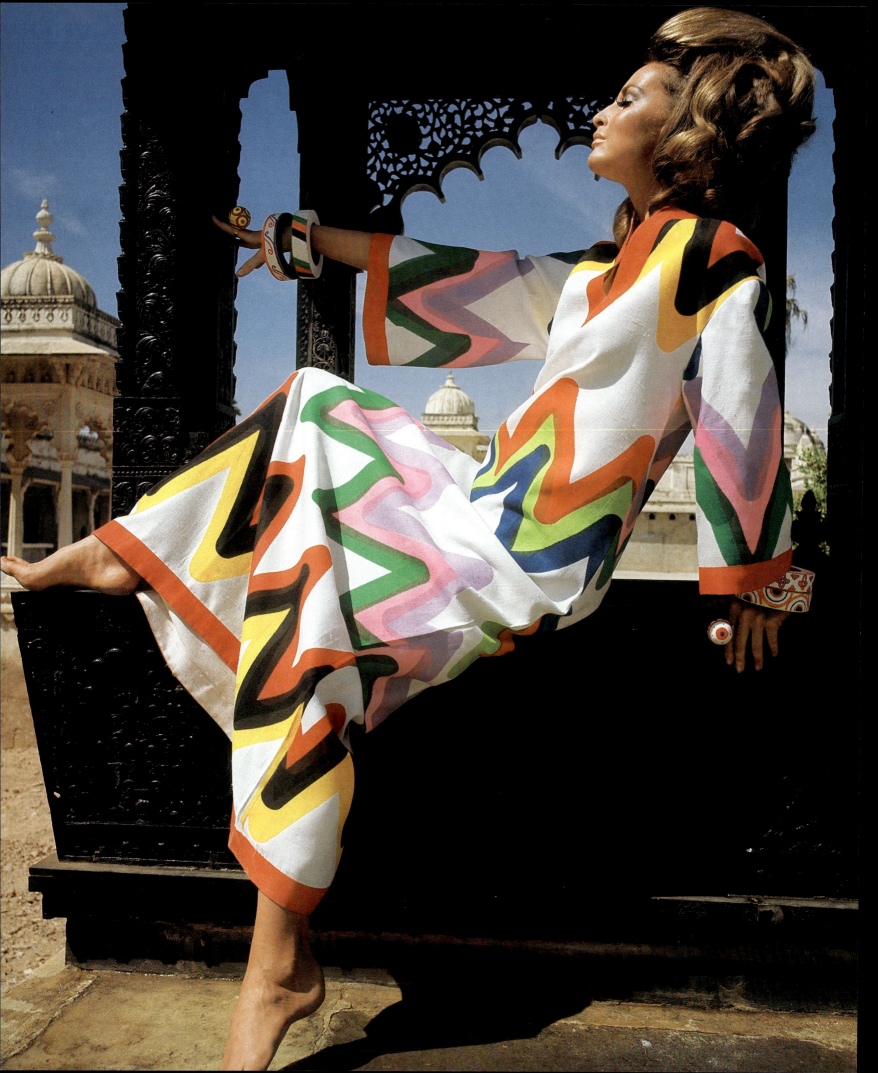

are embroidered insignia, old school stripes, and graphic monograms. All are patterns that are never out of style, at least at country clubs, and no color consulting firm can improve upon such stalwart favorites as Nantucket red, Kelly and lime green, and hot pink, sometimes paired with a dose of navy.

The affinity of the usually buttoned-up male for the *outré* print is evident in an anecdote about second-generation New York tailor Paul Winston of Chipp 2. (Winston's father, a favorite with the Dilatory Domicile set, was the first to make a madras patchwork material. He was known for his trousers made in four panels of different colors and corduroys embroidered with animal motifs like pheasants, fish, and frogs.) On his blog, the younger Winston tells of a client bringing in a length of material printed with a *Kama Sutra* design and commissioning a jacket to wear to his sister's wedding on Fishers Island. Winston hesitated at first, thinking that his client wouldn't get much use out it, but eventually he complied; the jacket was a big hit, leading Winston to have the fabric, originally made as a shower curtain for bachelor pads, copied to use as a (popular) lining material.

Bright prints and colors are so firmly embedded in the clubby resort psyche that they make plausible the possibly apocryphal story of the Hobe Sound black sweater. Many decades ago, the Jupiter Island Club at Hobe Sound was run by its president and founding member, Mrs. Joseph Verner Reed, who was known for her extraordinary attention to detail; she chose who would stay in which guest room and dictated the seating for dinner every night in the club dining room. During the 1960s there was a dormitory called the "brig" where boarding school and college students could stay during spring break. A certain level of decorum was expected, and if a golf cart went astray, or the midnight curfew was not strictly observed, or someone didn't hold their liquor, they'd be banished to Palm Beach. The signal that they were not being asked back was the delivery of a present from Mrs. Reed of a black sweater. Black would stand out from the swirl of typical resort prints like a scarlet letter.

LEFT: *Model Samantha Jones in Udaipur, India, wearing a caftan-inspired evening dress in colossal hand-printed zigzag by Livio de Simone, and Tiziani rings and bracelet. Photographed by Henry Clarke for* Vogue, *1967*
FOLLOWING SPREAD: *Michael Kors forties-style swimsuit in orange and white Lycra, and cork platform sandals by Christian Louboutin. Photographed by Regan Cameron for* Allure, *2006.*

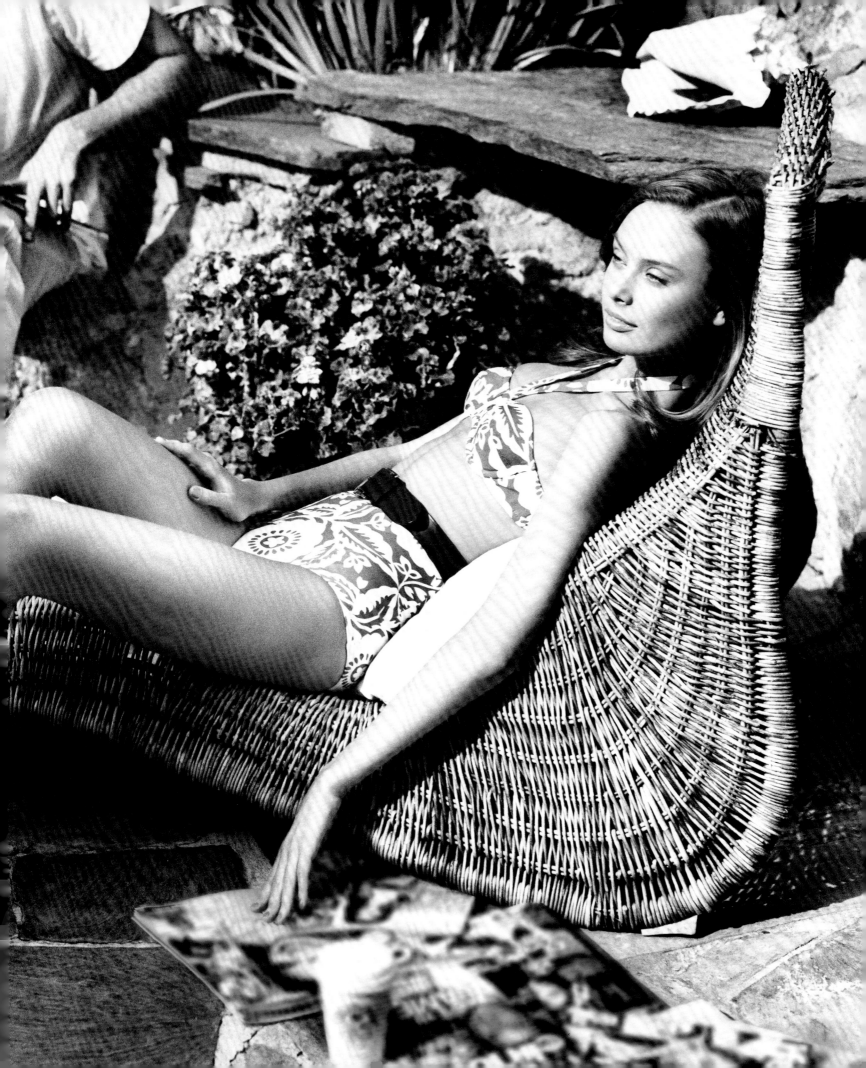

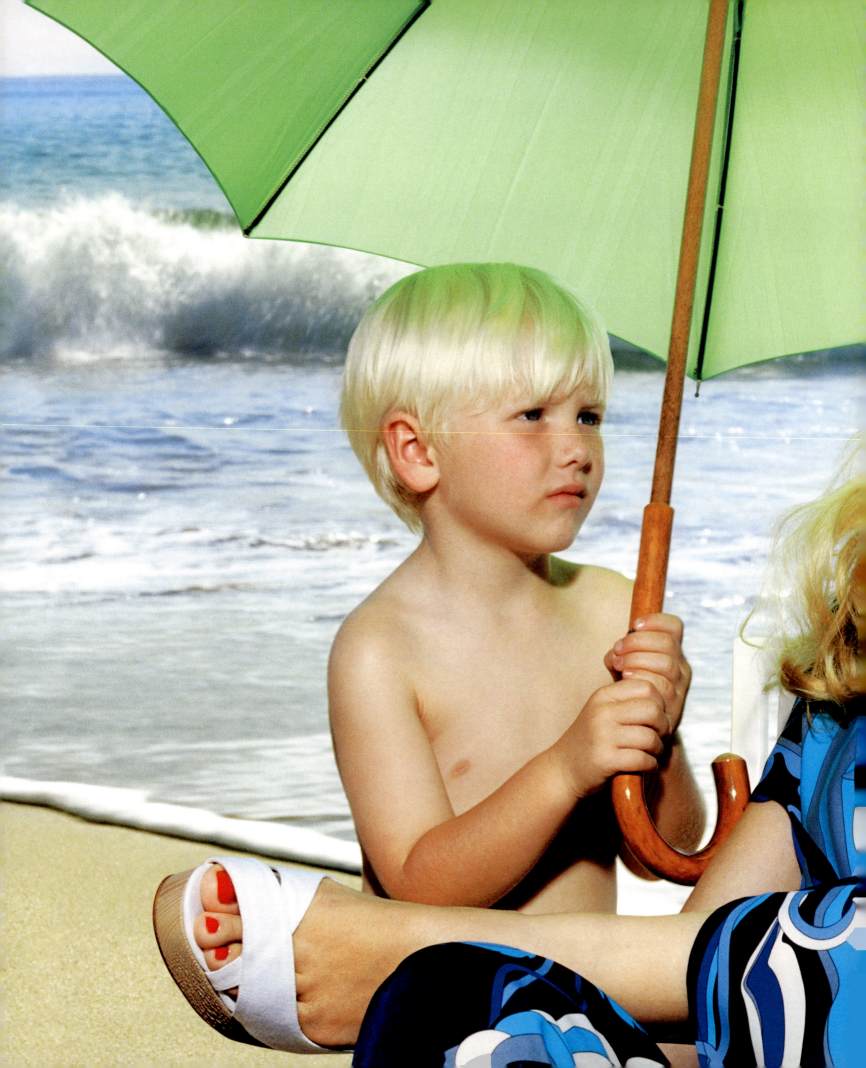

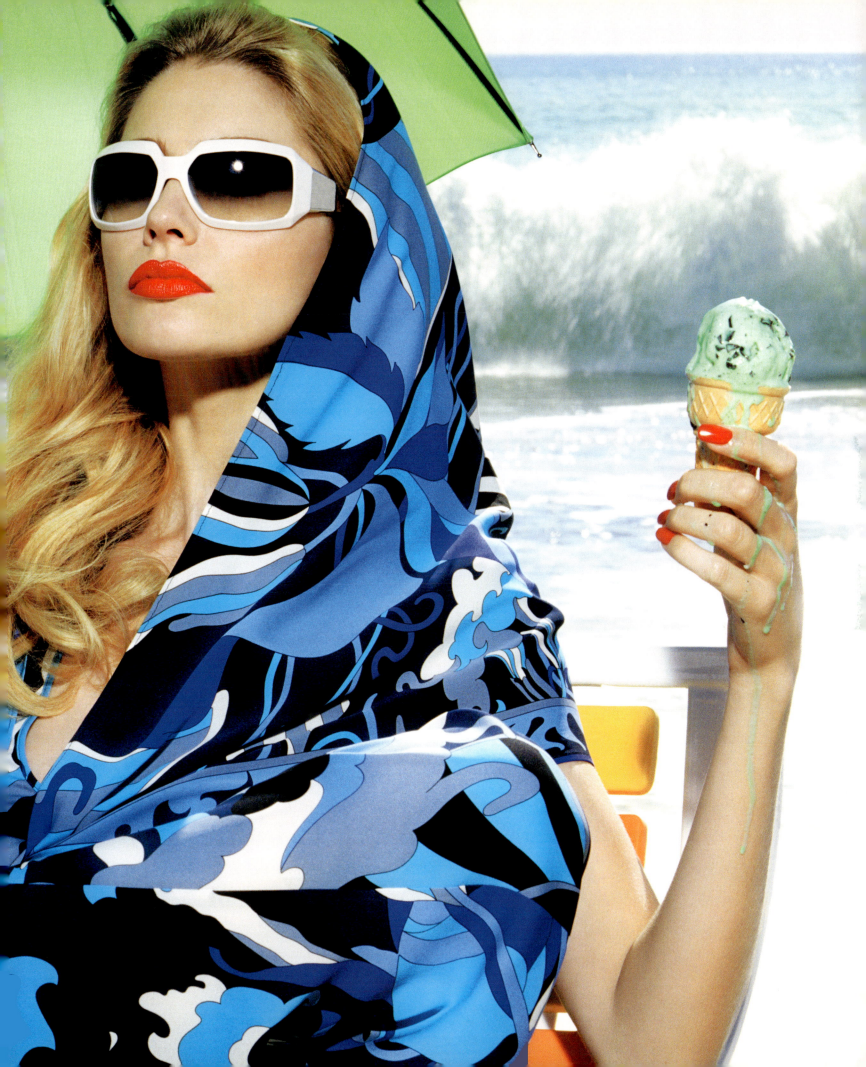

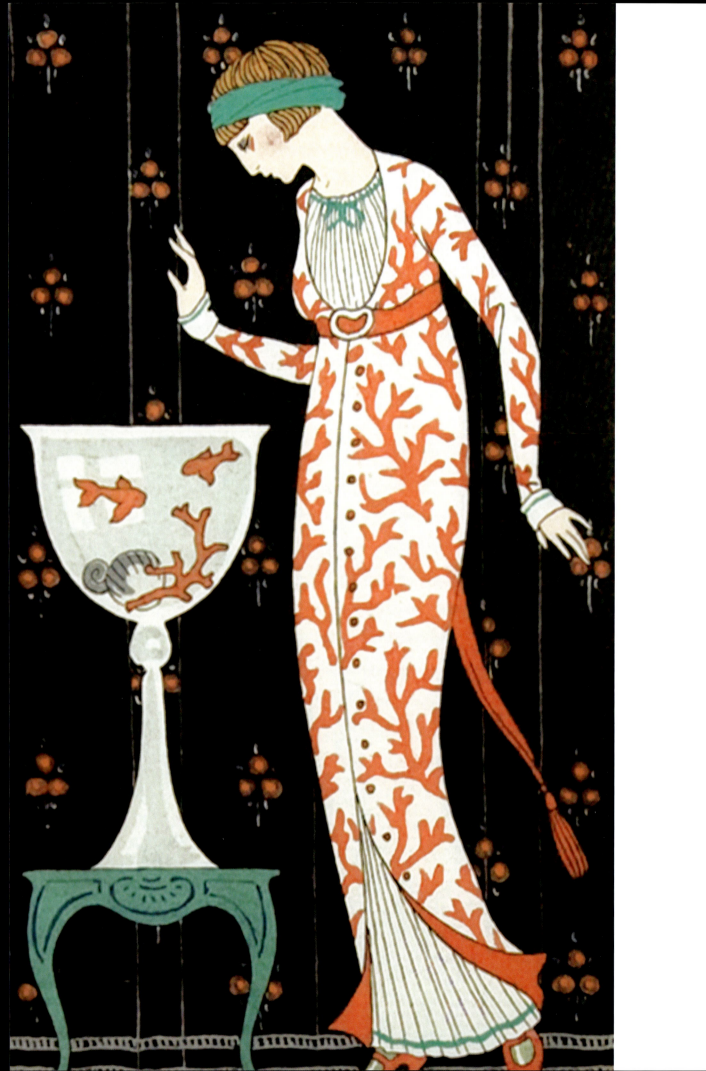

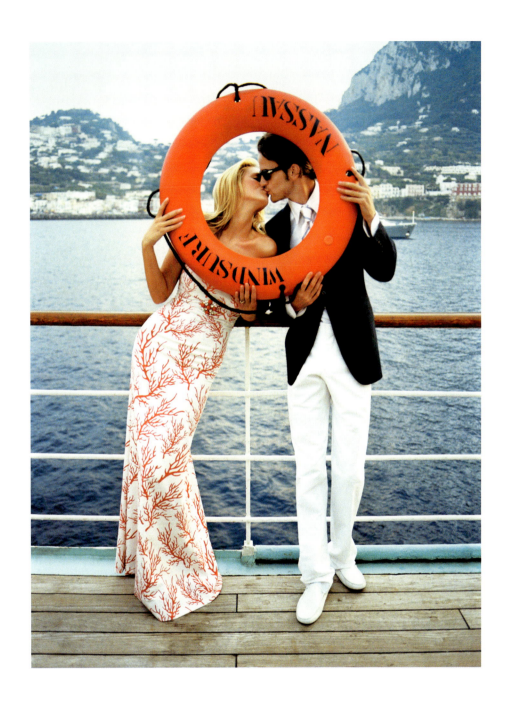

PREVIOUS SPREAD: *Pucciesque swirls, as integral a part of a vacation as ice cream. Photographed by Miles Aldridge for the* New York Times Magazine, *2006.* LEFT: *Coral, a sea motif that often pops up in resort design, here embroidered on a linen tea gown, 1913. Pochoir illustration,* Costumes Parisiens. ABOVE: *Michael Kors coral-patterned evening dress, with faux coral and rhinestone travel jewel. On him, a look often worn by destination wedding grooms: the navy blazer (this one by Etro) and white pants (Burberry London). Photographed by Pamela Hanson for* Glamour, *2005.*

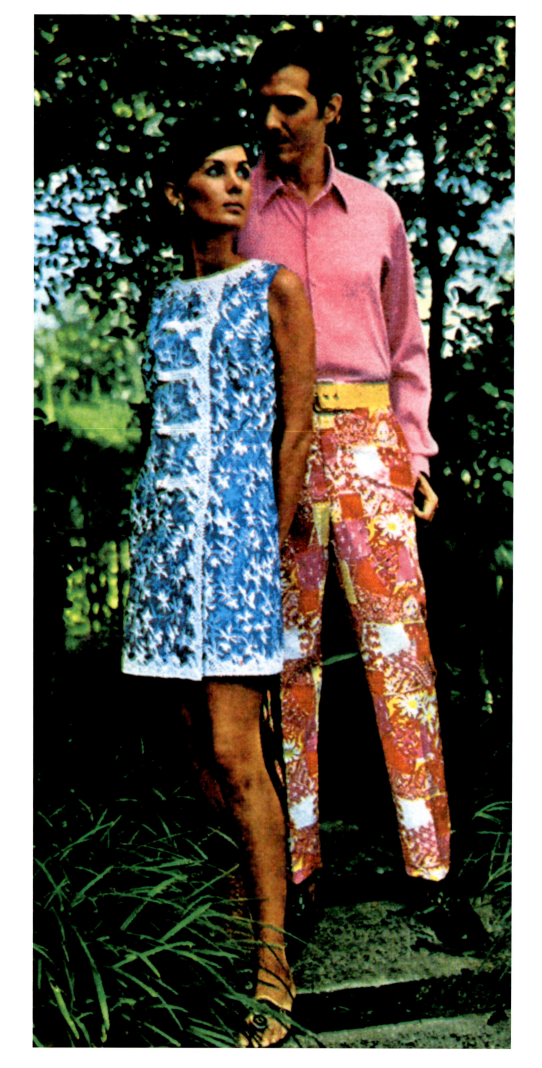

Lilly Pulitzer unisex plumage, 1970.

A Talitha Getty-inspired caftan in a swirling print by Roberto Cavalli. Photographed by Jonathan Becker for Vogue, *2005.*

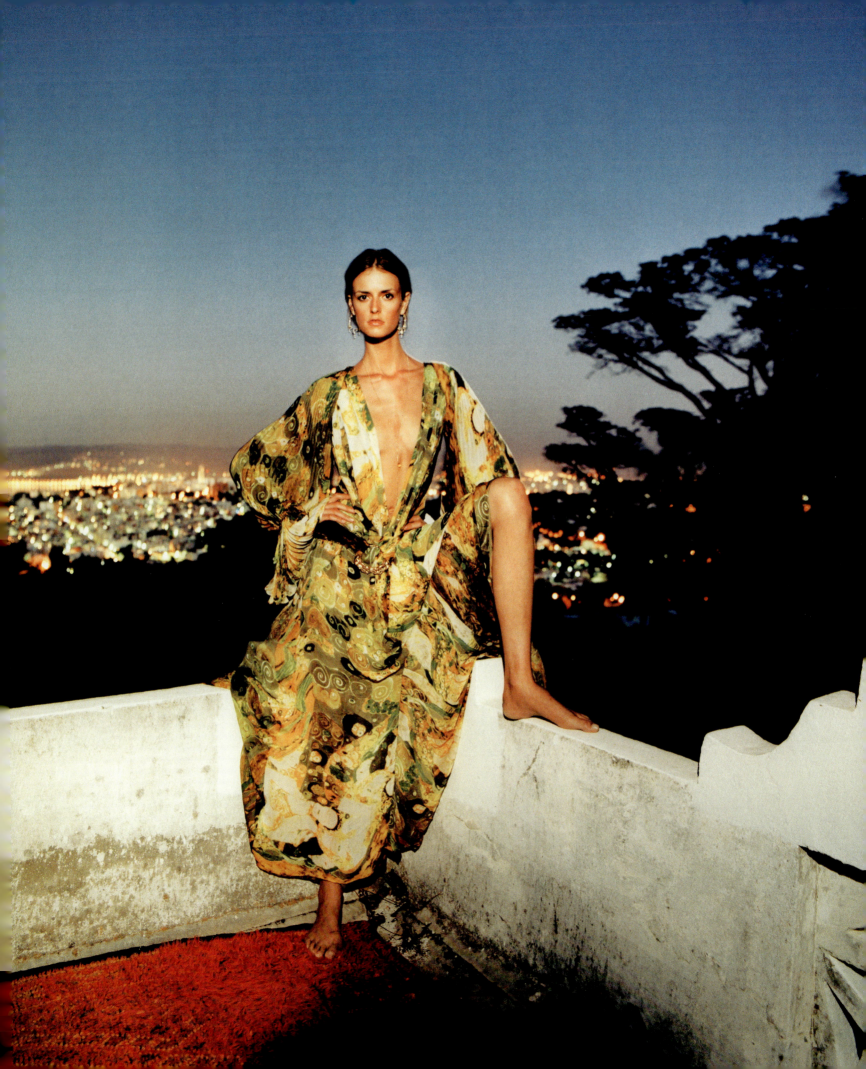

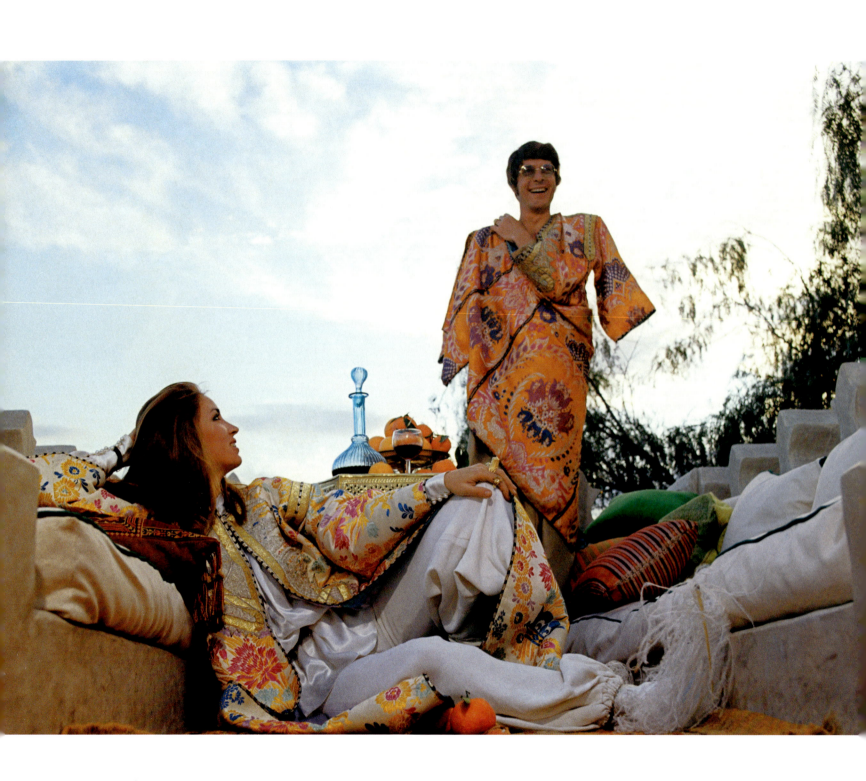

Style setters Mr. and Mrs. John Paul Getty Jr. at their house in Marrekech wearing Moroccan luxe. Photographed by Patrick Lichfield for Vogue, *1970.* RIGHT: *A Pucci print designed by Matthew Williamson with the geometric volume amped up, Spring/Summer 2008.*

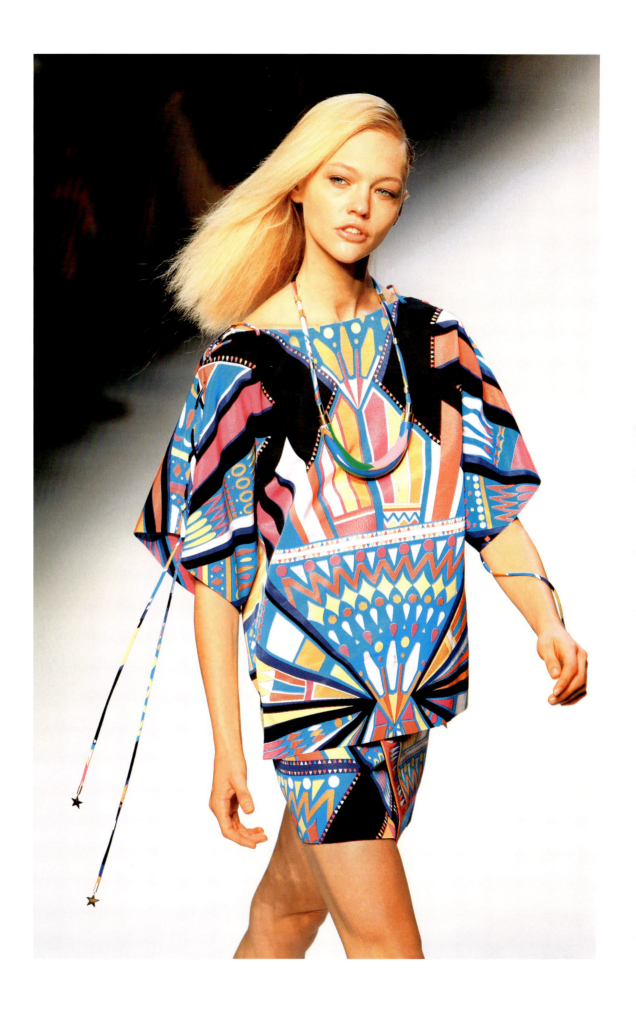

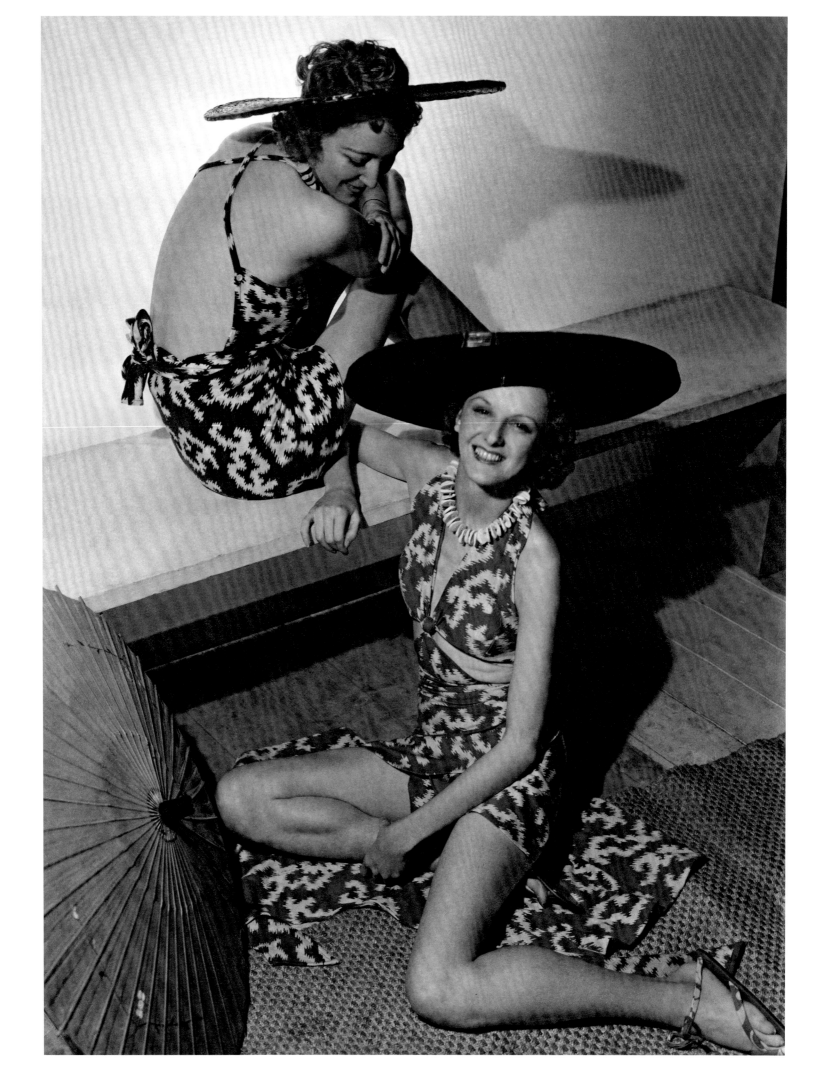

LEFT: *When these bathing costumes appeared in* Vogue *in 1935, they were considered examples of Jacques Heim's practical bent. The bathing suits were made of printed wool jersey; one featured a skirt that could be worn as a cape. Jacques Heim also designed the shade hats, one without a crown. Photograph by Horst P. Horst.*
FOLLOWING SPREAD, LEFT: *The original caption for this image read: "For Palm Beach, a matte silk jersey dress printed in a riot of tropical flowers, Bonwit Teller. Marcus jewels." Photographed by Louise Dahl-Wolfe for* Harper's Bazaar, *1938.* FOLLOWING SPREAD, RIGHT: *Country club couture: American custom designer Mainbocher often included cashmere cardigans as part of his more casual evening looks. Photographed by Karen Radkai for* Vogue, *1956.*

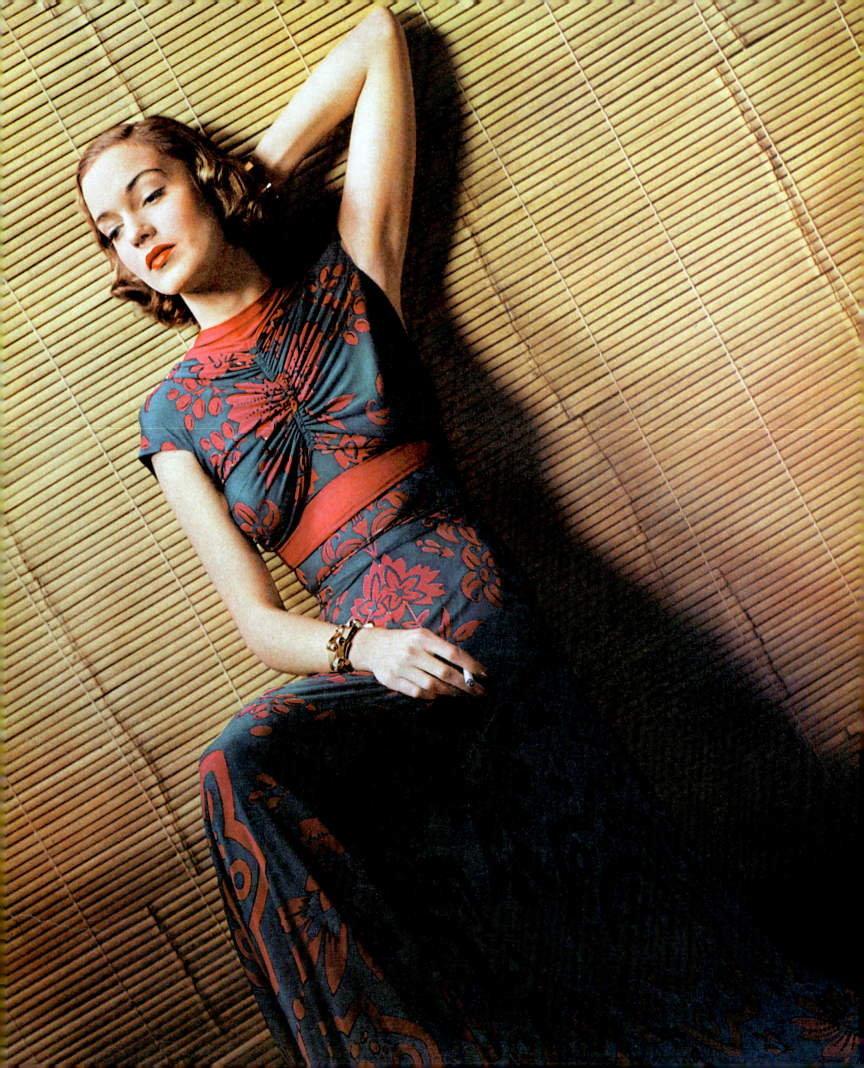

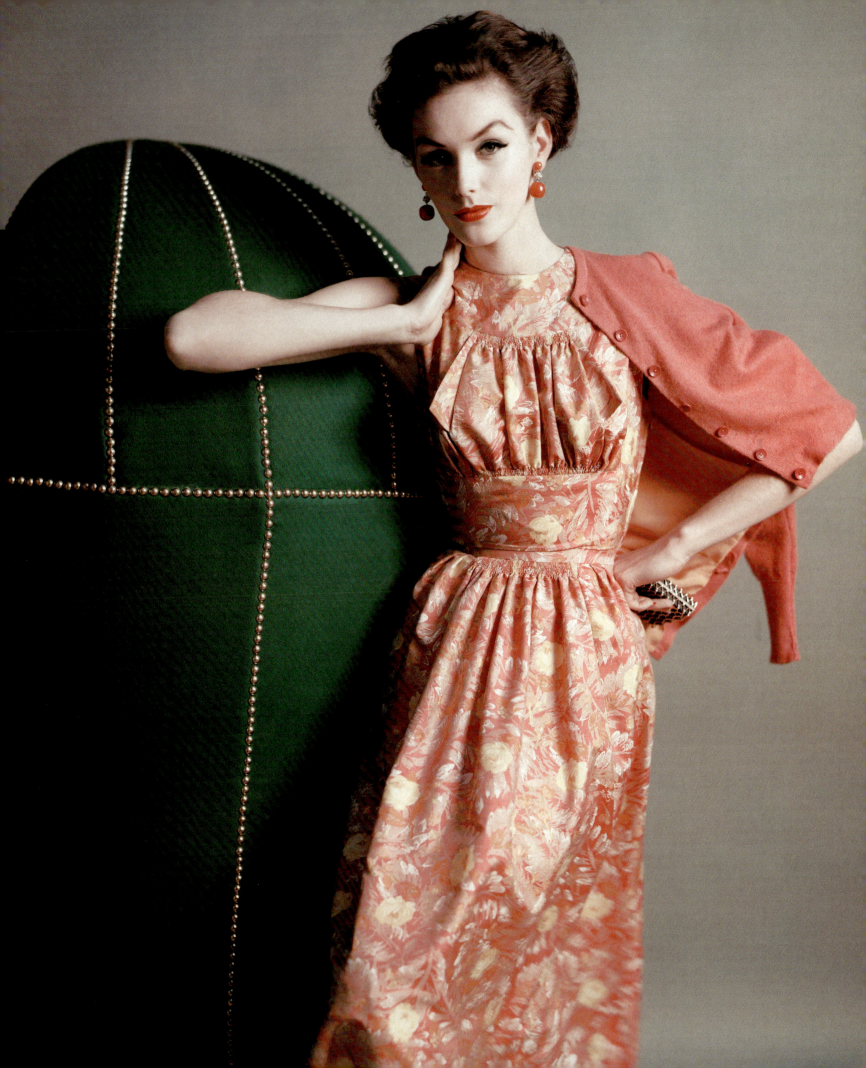

FOUR

White

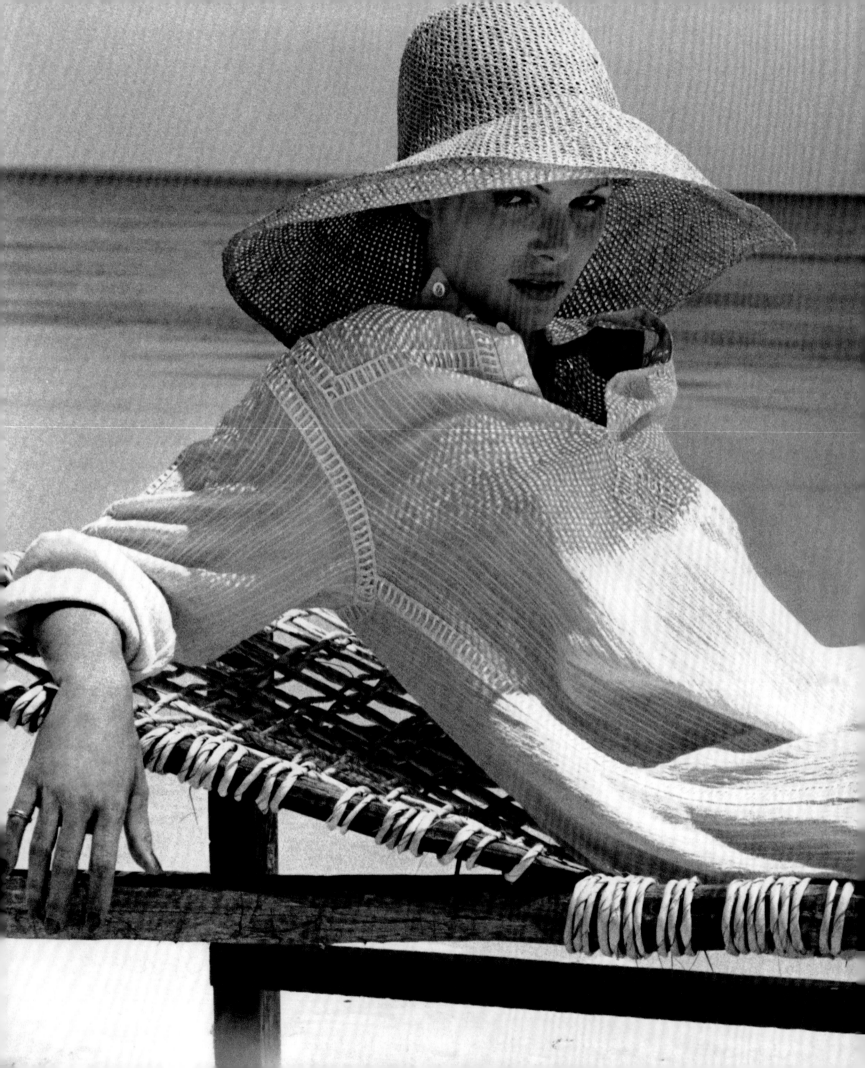

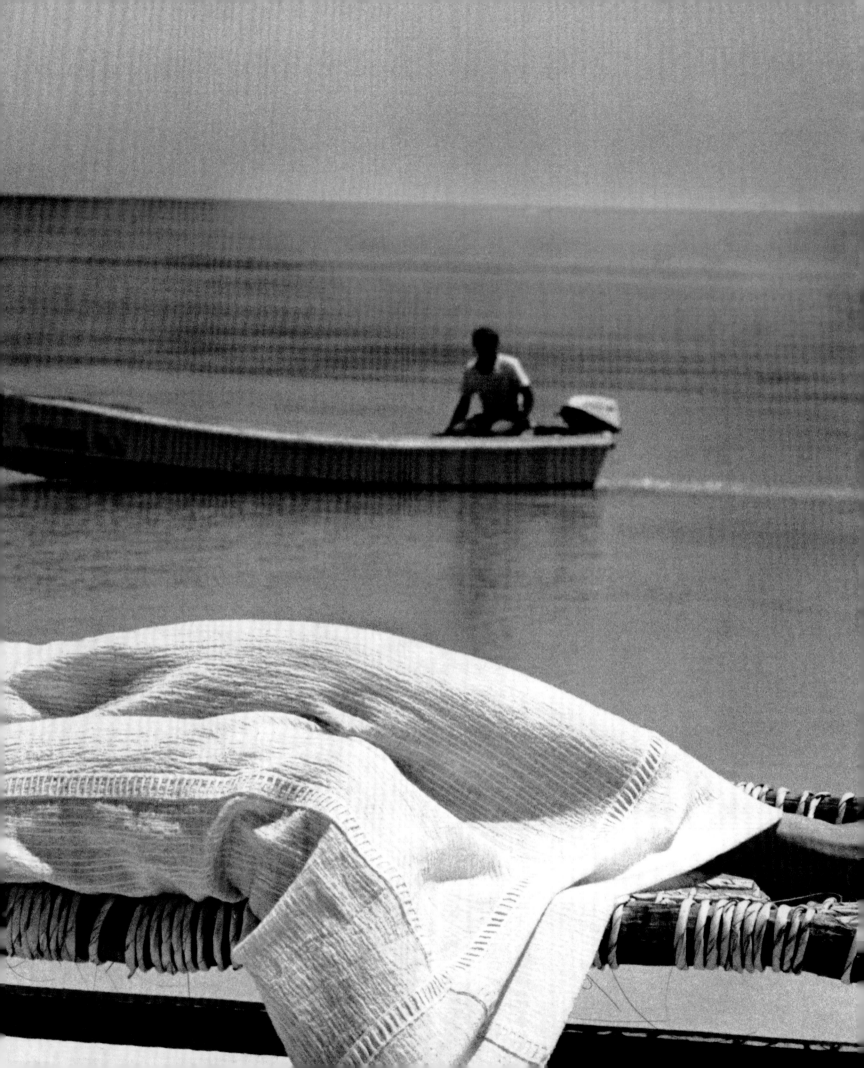

WHITE

Before the invention of washing machines, reliable dyes, and synthetic fabrics, white clothing was relatively easy to launder, and thus it was the default choice for such sports as tennis, croquet, cricket, and polo. The early greats of tennis in the first quarter of the twentieth century were appreciated for their grace as much as for their ability to win, and the white clothes the players wore made it easier for them to be seen. The men's billowing flannel trousers and long-sleeved collared shirts, and the women's pleated silk skirts that fanned out as they ran for the ball, appeared almost balletic. Since it deflects rather than absorbs heat, white has long been an obvious color to wear in the tropics. In the nineteenth century it was believed that heat caused tropical diseases, and thus the white top for a sea captain's hat was supposed to be medically prophylactic. As travelers from the Western world began seeking out tropical destinations, white became a favorite color for resort wear, never losing its ability to look calm, cool, and collected, especially in contrast to the deeply saturated colors of an azure sea and sky and brilliantly colored flowers.

 The craze for suntans that started in the 1920s further enhanced the chic of white. Reminiscing in his 1954 book *The Glass of Fashion*, Cecil Beaton extolled the Duchess of Peñaranda, as "one of a whole coterie of women who, in Paris during the twenties, invented their own style, and the dressmakers kept an eye on them, rather than the reverse." The duchess was a "Spanish beauty who appeared wearing a short white tunic with a deep scooped neckline and a skirt that stretched barely to the knees

PREVIOUS SPREAD: *Actress and model Lois Chiles at La Romana, the Dominican Republic, wearing a caftan of natural cotton gauze by Donna Karan and Louis dell'Olio for Anne Klein. Photographed by Chris von Wangenheim for Vogue, 1973.* LEFT: *C. Z. Guest wearing a boy-leg swimsuit in Palm Beach, photographed by Slim Aarons in 1955.*

. . . hair, brilliantined to a satin brilliance. . . . her complexion . . . was burned by the sun to a deep shade of iodine. The uncompromising simplicity of this sunburned body and white dress, coupled with the straightness of her back and neck, was quite dazzling." As Suzy Menkes has observed, the 1920s fascination with the suntan "now seems class-ridden, patronizing, even uncomfortably racist." However, not even the now well-known risk of a deadly form of cancer has yet to dim the vacation-defining appeal of baking in the sun.

In 1837, when Queen Victoria married Prince Albert, she wore a white dress with tiers of lace. In the images of the wedding party, all eyes are drawn to the bride, whose white dress guaranteed that she be the focal point. Previously, white had been a sometime choice of brides; that it photographed so well (the camera was a new invention) helped it become the dominant look for weddings as well as many other ceremonies. Filmmakers realized early on that it cast a flattering light on the face, and white became an eye-catching design element of pre-Technicolor films. A platinum blonde clad in white bias-cut charmeuse glittering with diamonds became the quintessential thirties Hollywood image.

As fashion grew simpler in the twentieth century, cut became the most pivotal element of a dress. The brilliant designs of such couturiers as Madeleine Vionnet and Mme Grès were thrown into high relief when shown in white. Chanel, who claimed to have invented the idea of white satin—shortly after she invented beige—designed white evening dresses that ranged from demure and lacy to siren-worthy. She wore her own white designs well. In a 1938 photograph at a dinner after the ballet in Monte Carlo, she is pictured with her elbow on the table, leaning away from Salvador Dalí and gossiping with Georges Auric. Her simple, covered-up white evening dress makes the other women look extraneous.

Designers who have since made entire collections all in white include Hubert de Givenchy, Valentino, and Alber Elbaz for Lanvin. Jason Wu, given mysterious directions to design a dress he suspected might be used for an important occasion, chose white for what did indeed turn out to be Michelle Obama's inaugural ball gown. Explaining his choice of hue, he said: "It's a bold color—nothing's cleaner than white."

Mocking the arch femininity of 1950s sportswear, this Toni Frissell photograph shows a model waterskiing in a white evening dress and diamond drop earrings.

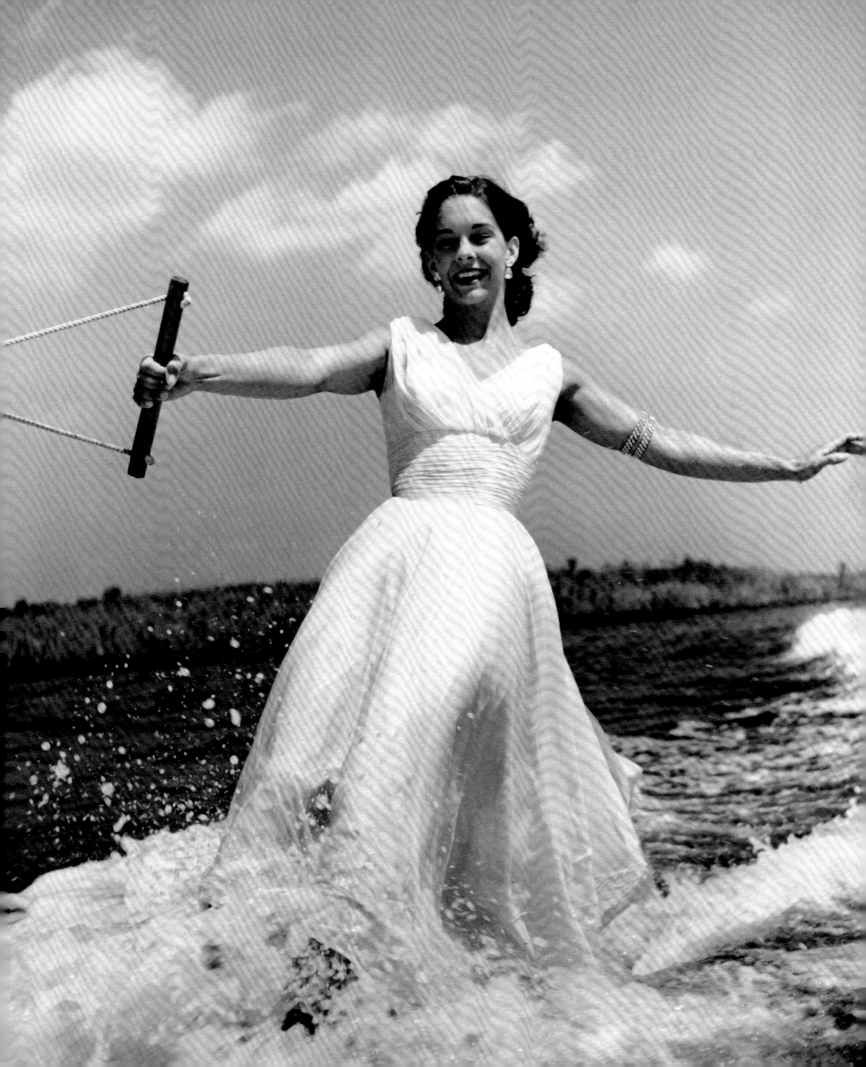

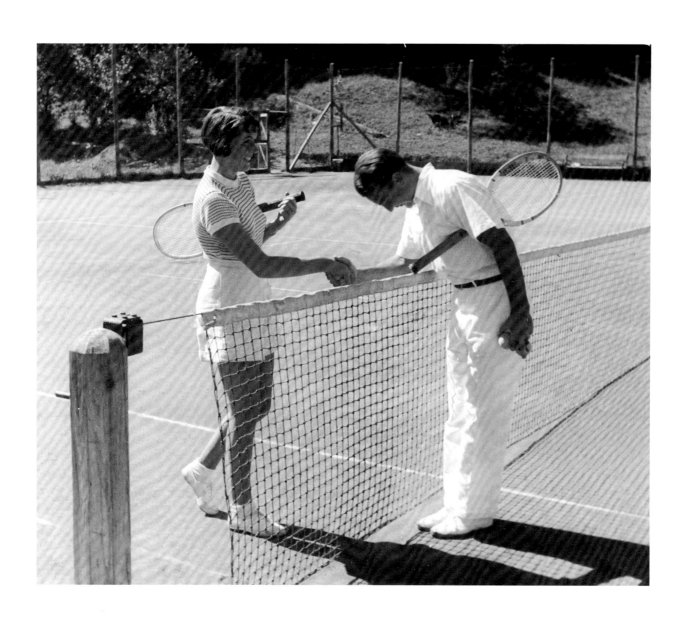

Courtly manners, circa 1940. RIGHT: *What to wear for a casual dinner at a beach "cottage": Michael Kors floral appliqué bikini top and wide-legged linen pants. Photographed by Arthur Elgort for* Vogue, *2006*

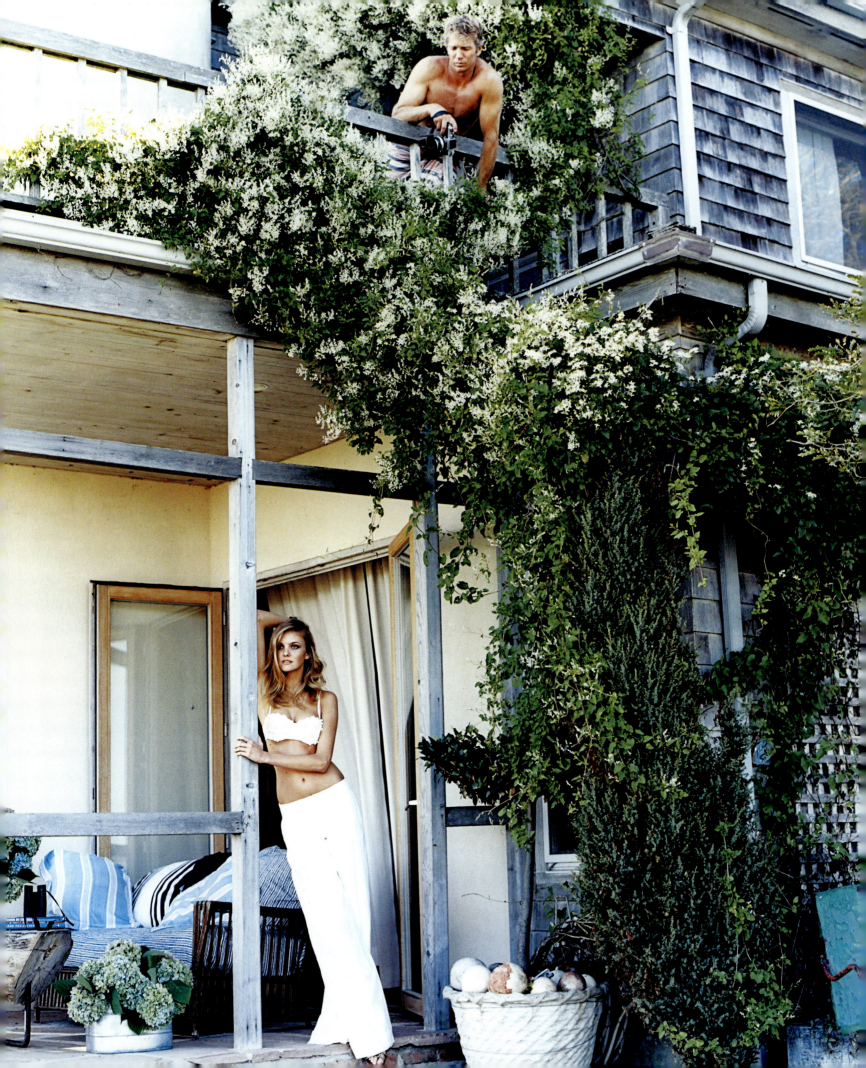

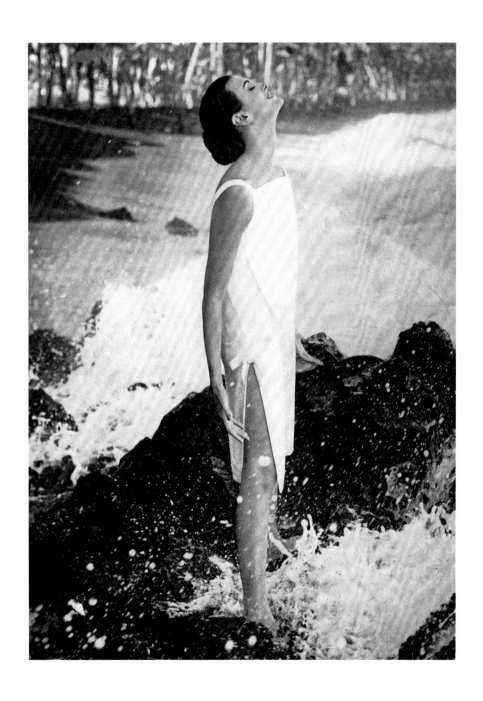

ABOVE: *Jeanne Campbell of Sportwhirl designed this cotton tunic, which* Harper's Bazaar *extolled for its slit sides that made it possible to bend down and collect shells. Photographed by Gleb Derujinsky in Hawaii, 1959.*
RIGHT: *Quilted white trapeze jacket over Capri-style pants, photographed in Mykonos by Herman Landshoff in 1955.*

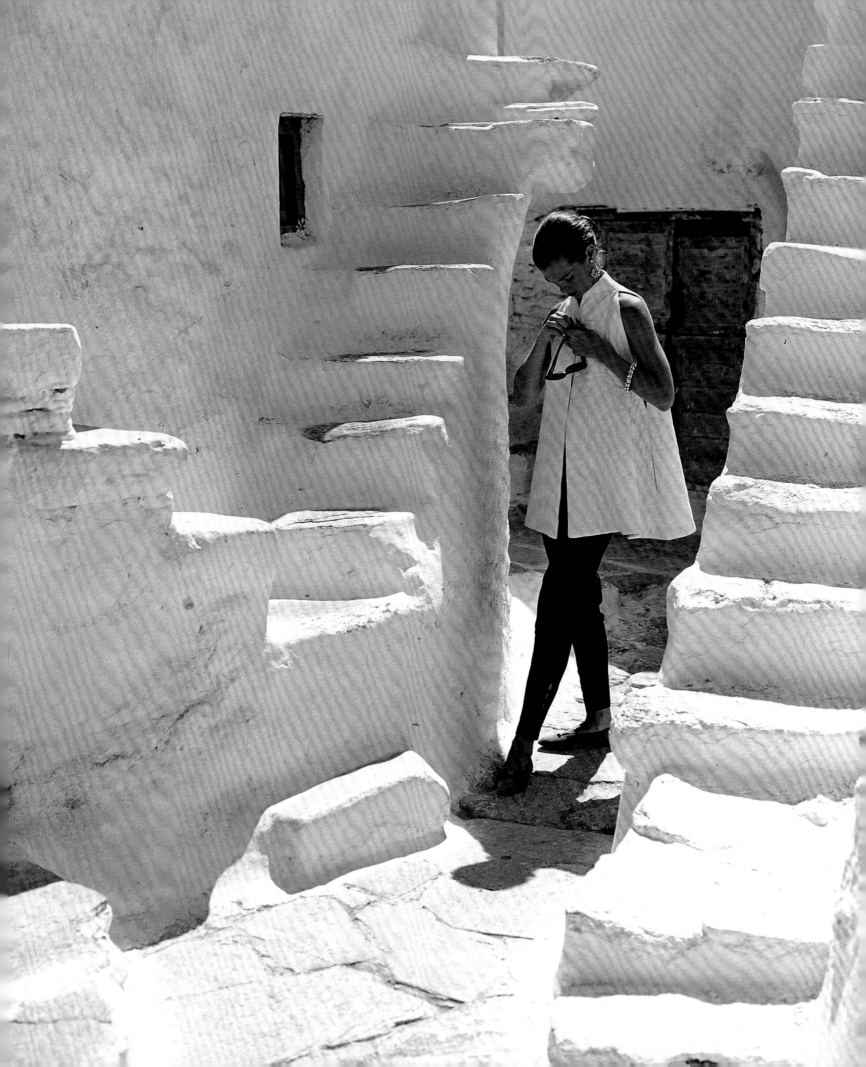

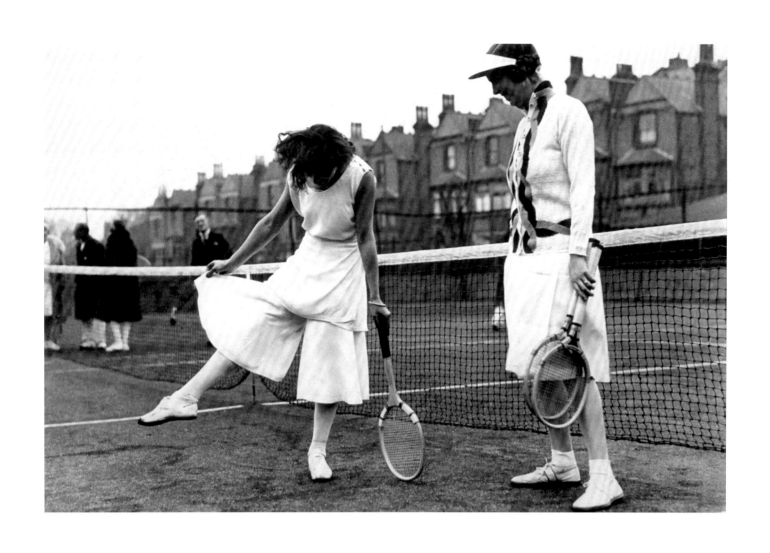

ABOVE: *Lili de Alvarez, Spanish tennis star, was the first to wear a culotte ensemble on a tennis court, 1931. Designed by Schiaparelli, the divided skirt was wildly controversial, even with its decorous apron panel.* RIGHT: *When this photograph was taken, around 1905, women competing at Wimbledon still had to play in gigot sleeves, corsets, layers of petticoats, and leather boots.*

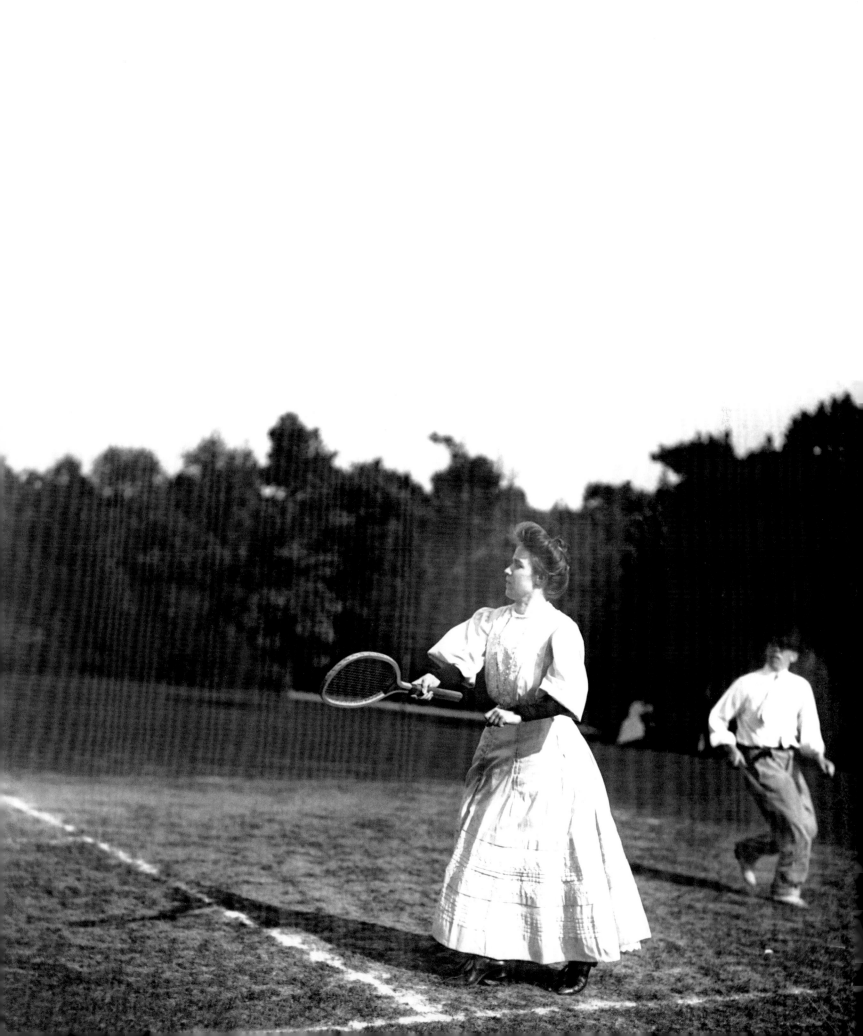

A tennis suit (or "one-piece rig" as the fashion editors described it) with pleated overskirt, made of rayon shantung and designed by Carolyn Schnurer. Keds sneakers and Bonnie Doon socks. Photographed at the Citadel Hotel, Haiti, by Toni Frissell for Harper's Bazaar, *1947.*

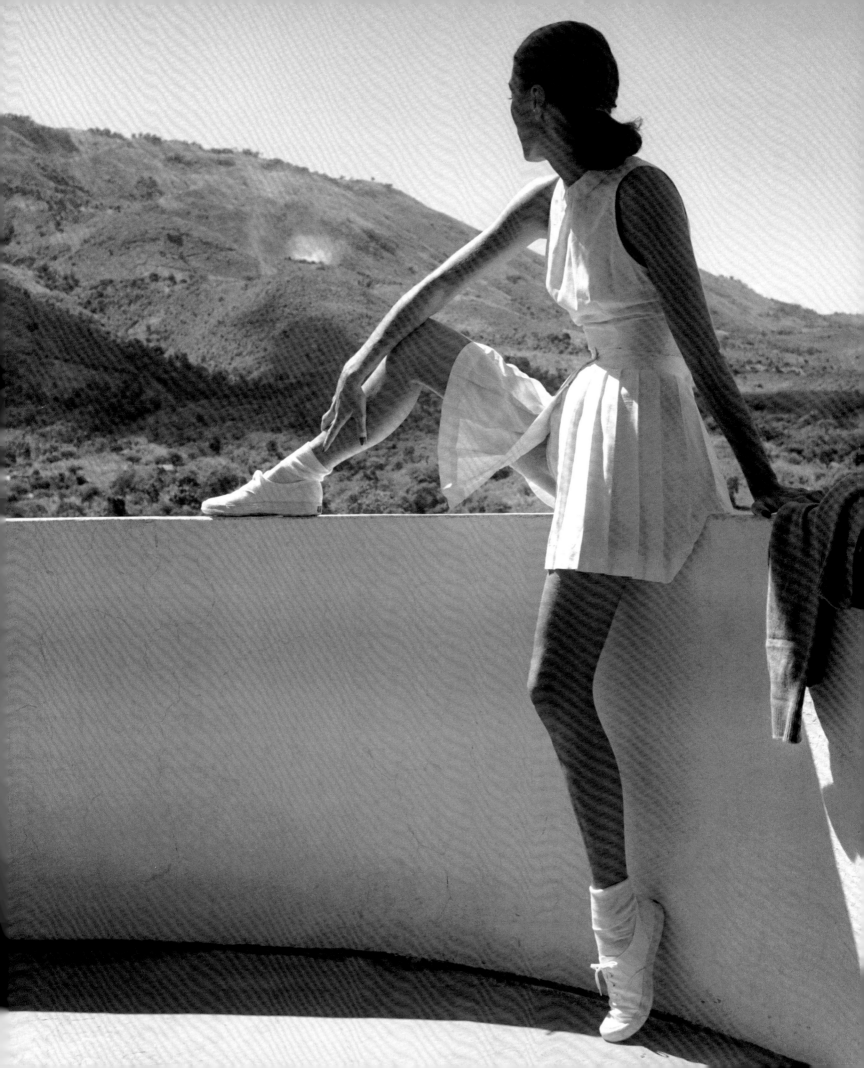

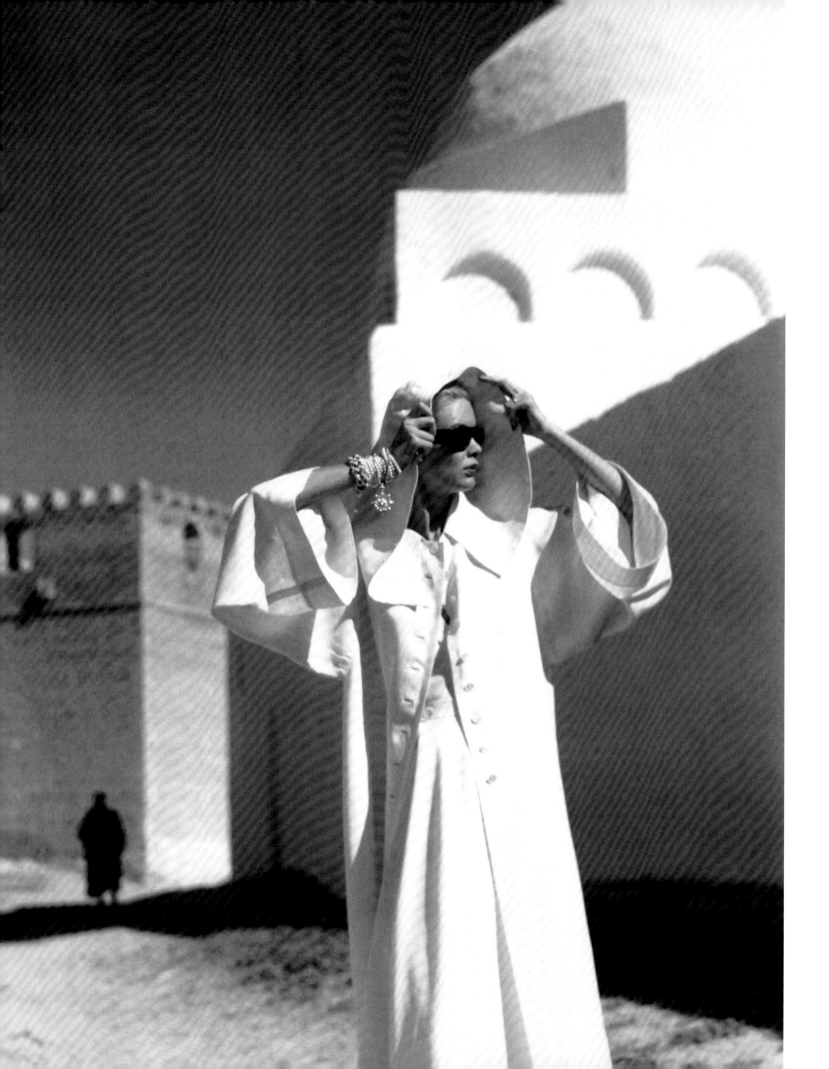

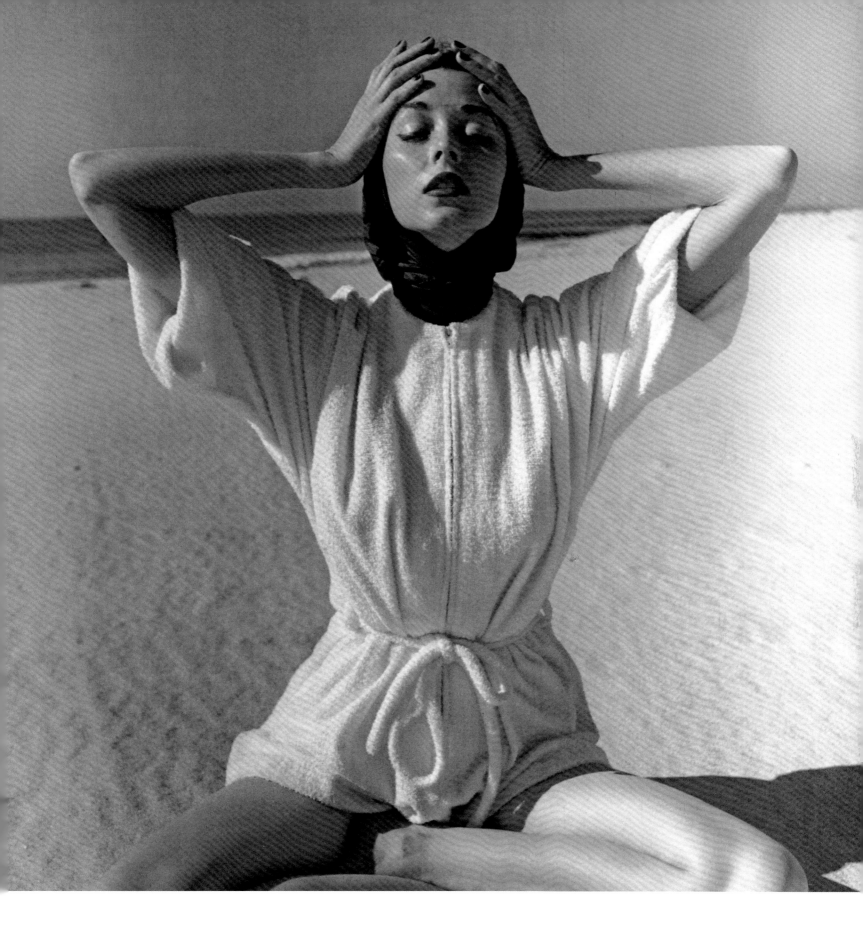

LEFT: Harper's Bazaar *described this Grès coat from 1950 as* "massively, blindingly white" *and* "pure heaven in the hot sun." *Photographed in Tunisia by Louise Dahl-Wolfe for* Harper's Bazaar, *1950.* ABOVE: *Short belted cover-up of terry cloth. Photographed by Toni Frissell for* Harper's Bazaar, *1948.*

Apollonia van Ravenstein atop a column at the Crane Beach Hotel wearing an ivory Ban-Lon dress by Jane Cattlin. Photographed by Norman Parkinson for British Vogue, *1973.*

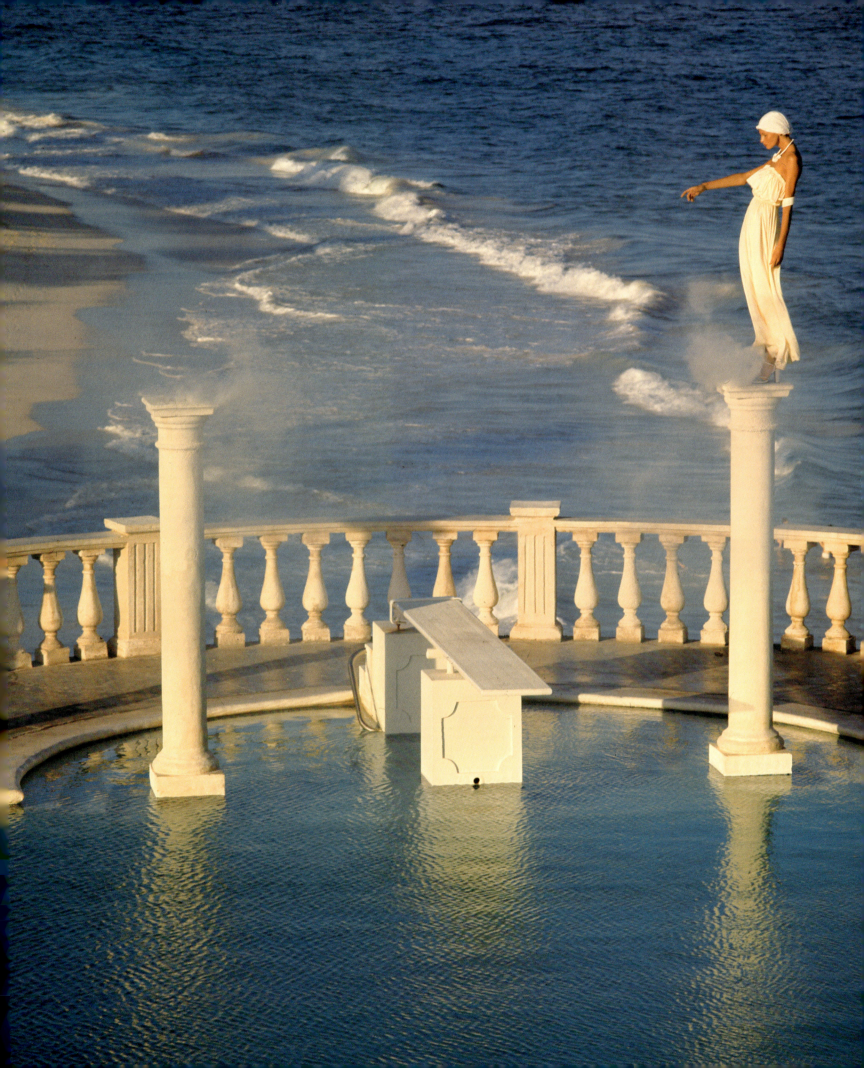

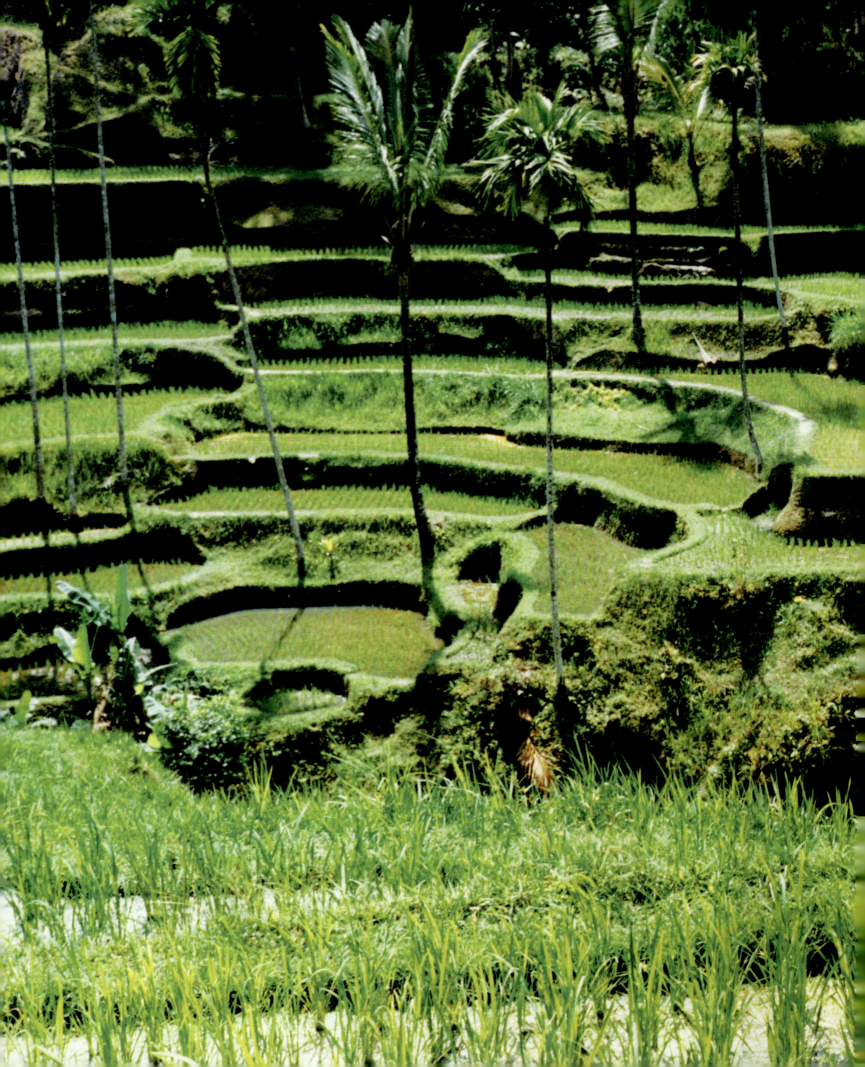

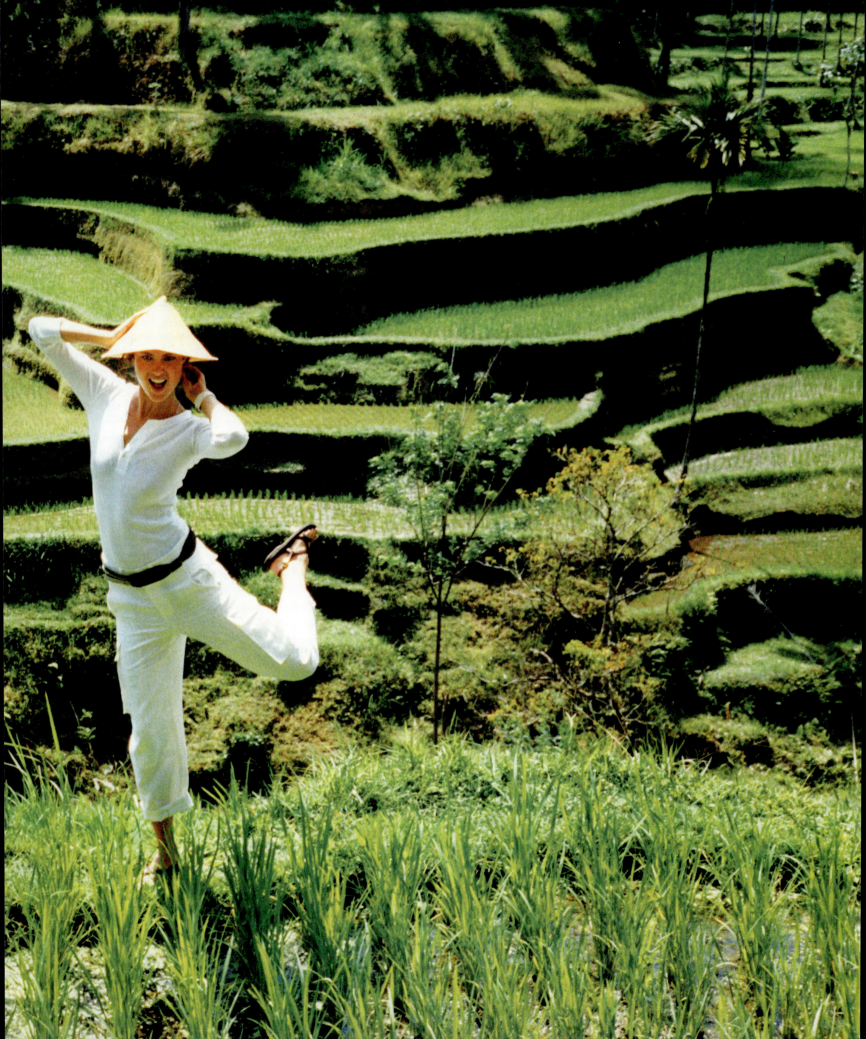

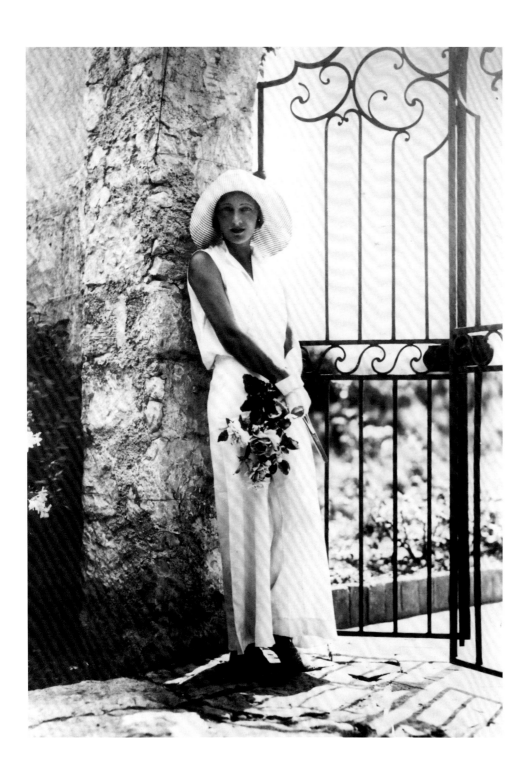

PREVIOUS SPREAD: *Shalom Harlow posing in a Ralph Lauren Collection henley top and cargo pants on the rice terraces of the Begawan Giri Estate in Bali. Photographed by Arthur Elgort for* Vogue, *2003.* ABOVE: *Stage actress Gertrude Lawrence at her villa on the Côte d'Azur wearing beach pajamas, 1930.* RIGHT: *1926 Cheruit chemise dress with folkloric embroidery. Photographed by Seeberger Frères.*

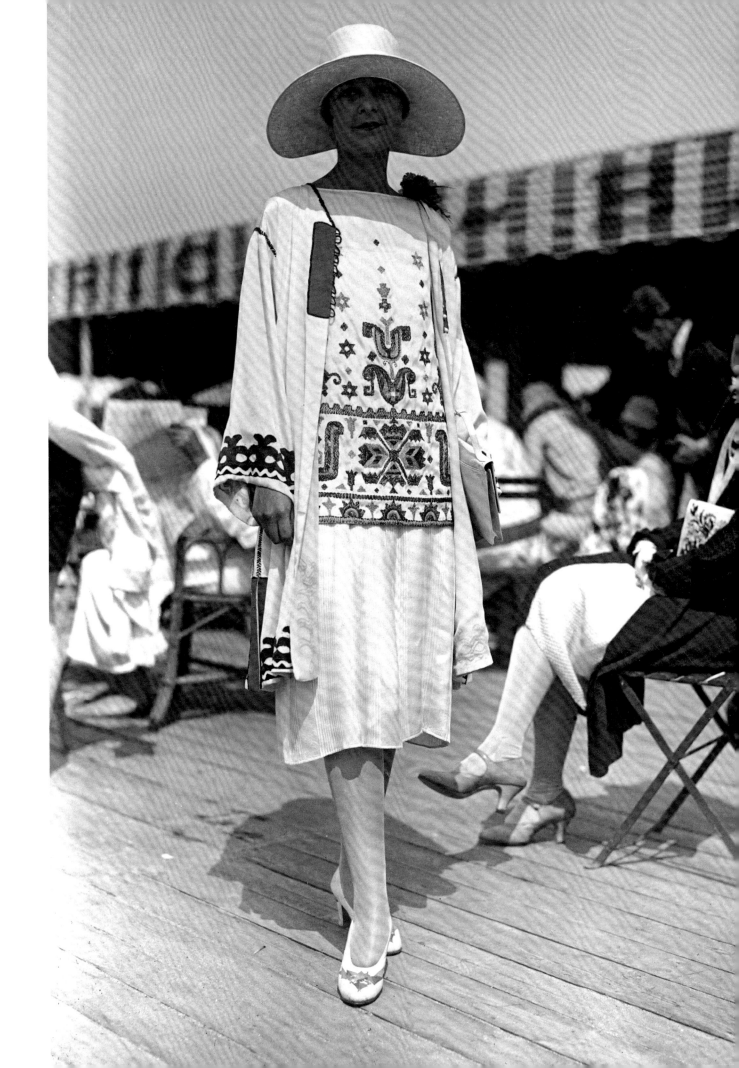

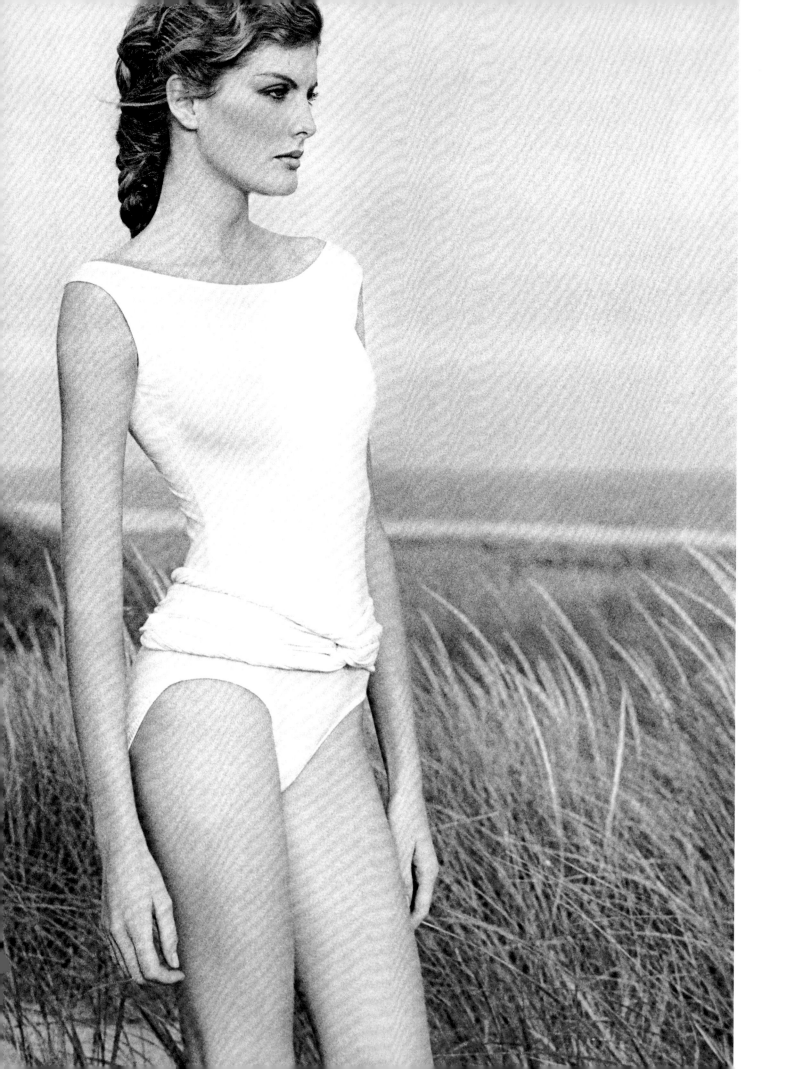

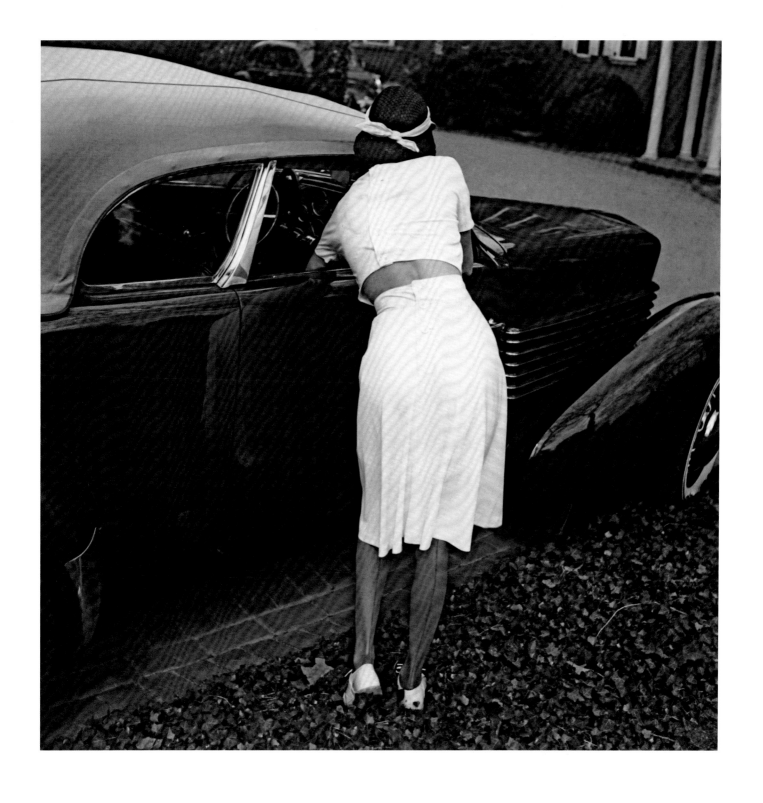

LEFT: *Rene Russo in a maillot with twisted detail. Photographed in Southampton, New York, by Francesco Scavullo for* Vogue, *1977.* ABOVE: *Tennis dress of white rayon, slit only across the back — all the better, as* Vogue *put it, "to take up the tension of a good, healthy swing at the ball." Photographed by Toni Frissell for* Vogue, *1939.*

Gucci shirt and Calvin Klein pants. Photographed by Arthur Elgort for Vogue, *1976.*

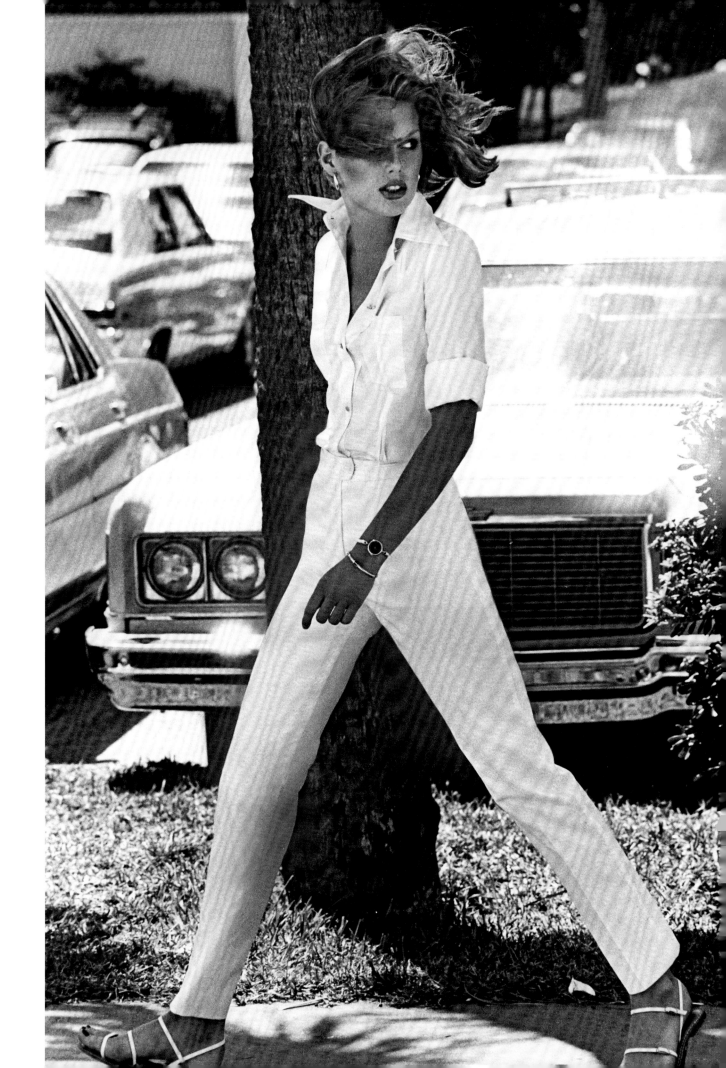

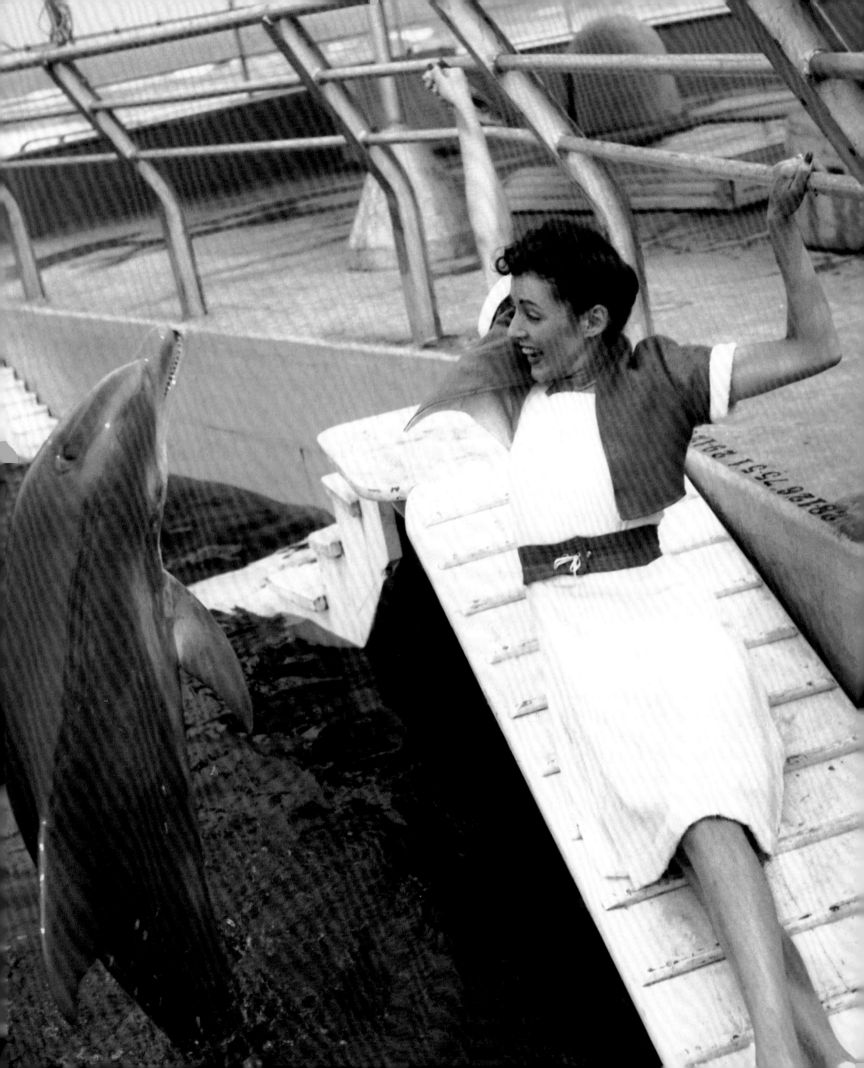

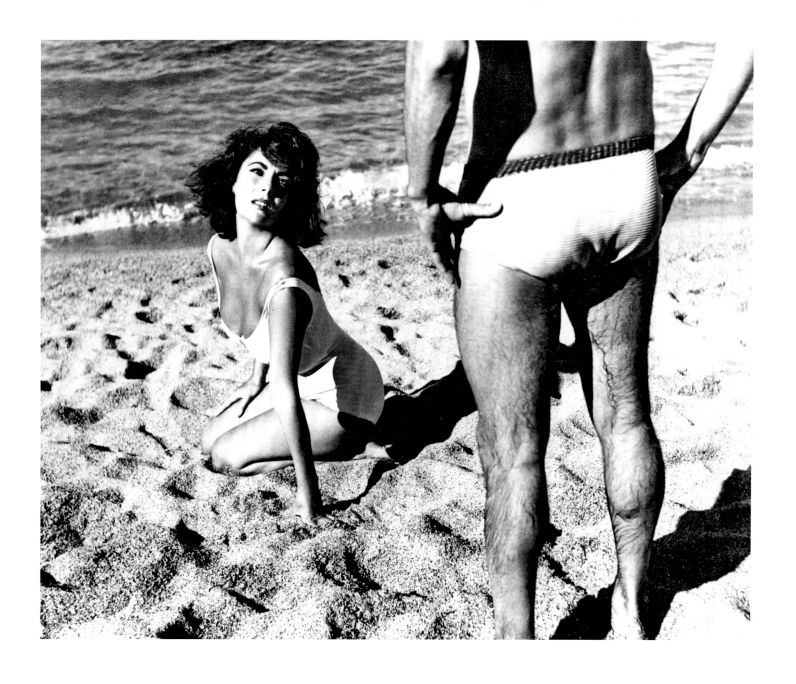

LEFT: *Lord & Taylor tennis dress made of terry cloth and paired with a blue burlap bolero. Photographed at Marineland, Florida, by Toni Frissell for* Vogue, *1939.* ABOVE: *In this scene from* Suddenly Last Summer *(1959), Elizabeth Taylor's white maillot is perhaps too attractive; the men who flock to her end up killing her cousin, played by Montgomery Clift, and she ends up in a mental institution.*

FIVE

Playclothes

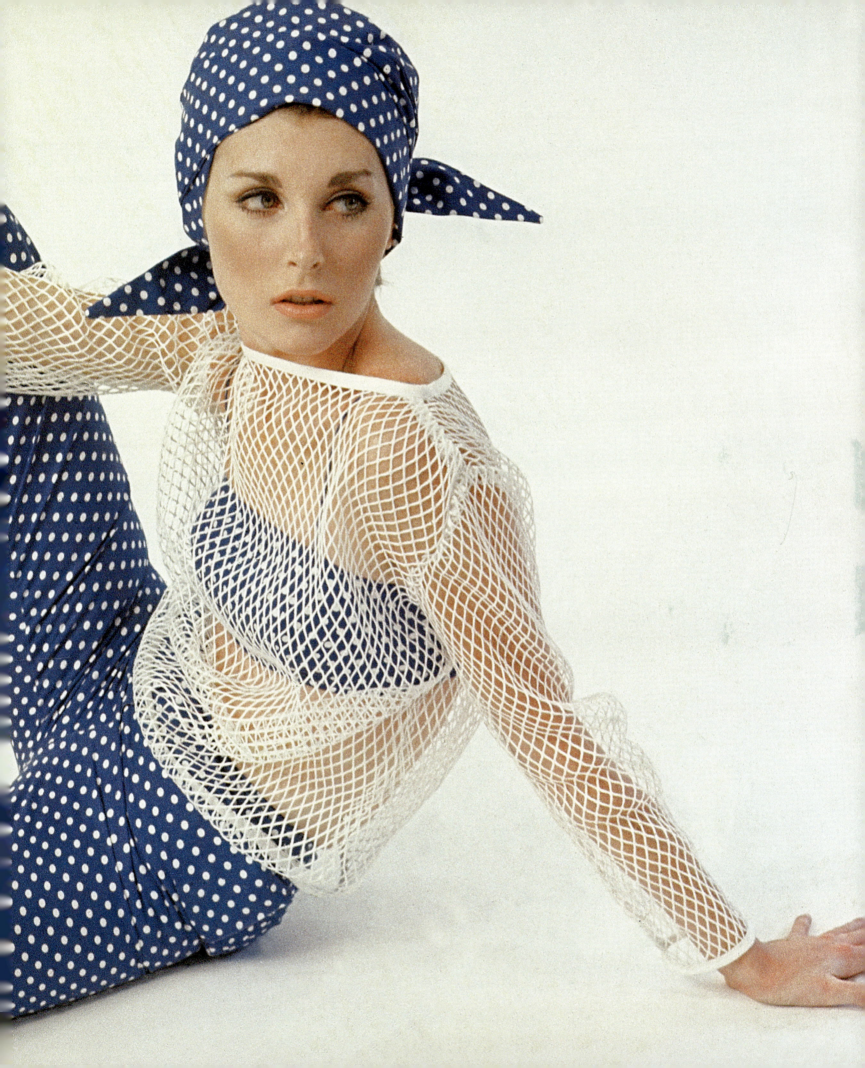

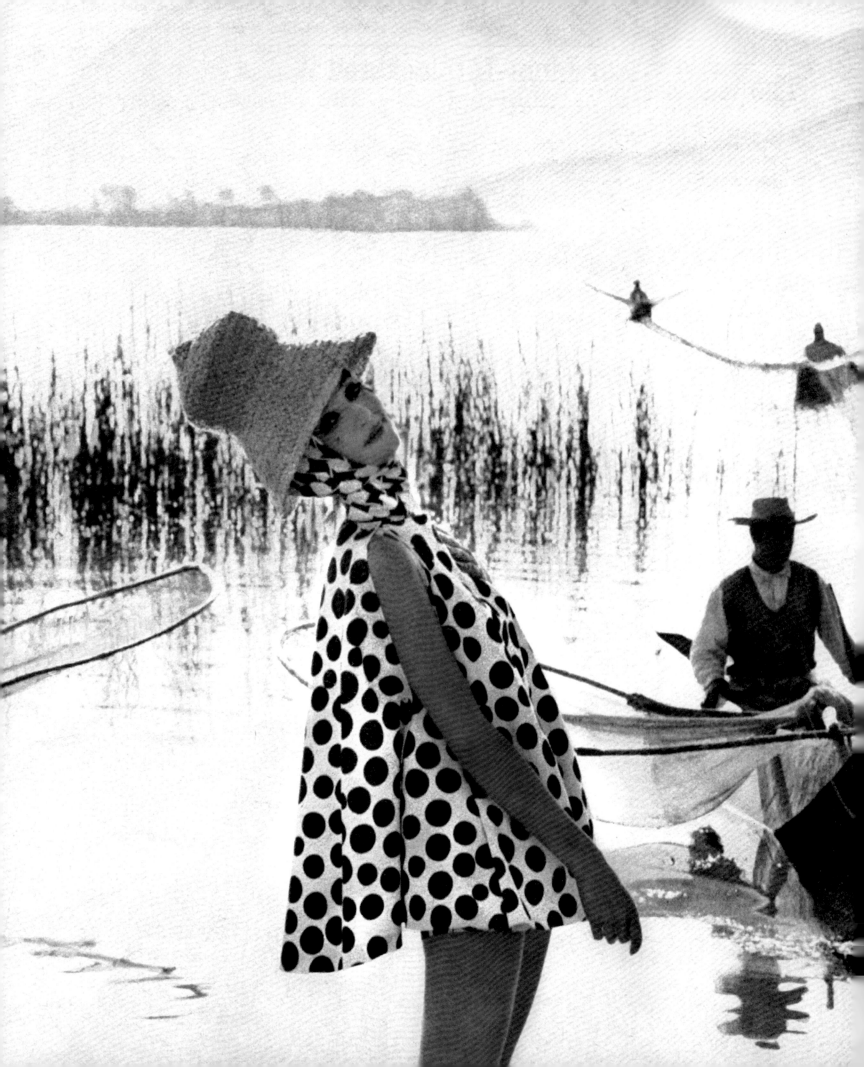

PLAYCLOTHES

As people began to take their leisure activities more seriously, it became less feasible to participate in them wearing restrictive everyday clothes. Old clothes, worn enough to be comfortable, might be suitable for gardening, but as the rage for sports and outdoor living grew, so did the appetite for attire that was both appropriate and fashionable. Whereas a lot of sports clothing was adapted from standard dress and looked sturdy and functional, the clothes designed for play were as breezy and whimsical as the day is long.

The original beach pajama, worn by Coco Chanel as early as 1918, looked exactly like a pair of men's white pajamas. However, the pajamas shown by designers like Mary Nowitsky, Jane Regny, and Elsa Schiaparelli beginning in the late 1920s resembled jumpsuits with longer, slightly flared legs. This type of garment had not existed before, and can be considered the first article of clothing designed purely for play. Paris couturiers followed the huge success of the pajama with a wide range of looks, most offered as something to wear on the beach all day and even into the (casual) evening. Somehow it was easier to accept a woman in pants if the pants in question were called pajamas and didn't ape men's trousers.

While it might seem that playclothes would be considered wholly unnecessary frivolities during a depression, they proved increasingly popular as the 1930s wore on, possibly as a diversion from the sober, make-do, dark-colored clothes that were dominant, and also because they were a relatively cheap thrill, costing less

PREVIOUS SPREAD: *Robert Sloan designed this 1965 nautical outfit with bandeau top, clamdigger pants, and fishnet overblouse. Matching kerchief by Madcaps and suede mules by Capezio. Photographed by Gosta Peterson for* Mademoiselle, *1965.* LEFT: *In this picture, shot by Gleb Derujinsky at Lake Pátzcuaro, Mexico, for the May 1959 issue of* Harper's Bazaar, *a model wears a poncho in black and white sharkskin by Cabana with a hat by Adolfo for Emme.*

than ball gowns or tailored suits. By 1936 the fashion consultants at *The Tobe Report* were advising American department stores to stock up not just on basics—which had come to mean slacks, shorts, and culottes—but also on what were called dressmaker items: more decorative or feminine versions of romper suits, pareos, skirt and shorts outfits, and beach ensembles. Claire McCardell designed simplified wardrobes consisting of multipurpose separates like a two-piece halter-top bathing suit, shorts, a short skirt, a long skirt, and a second top that could take the wearer from a day at the beach to an informal dance.

The mood at the end of the Second World War is thought to be epitomized by Christian Dior's "New Look." But the first Paris collections after the end of World War II also included novelties of resort wear like "pedal pushers," inspired by the role bicycling played during the occupation of France. By 1952 the *New York Times* made note of the proliferation of tapered, shorter pants for women, pondering if that newfangled television was to blame or just the "increasing trend toward practical but pretty attire for casual living." (These were also known as Capri pants, after Emilio of Capri, who popularized them.)

The great heyday of playclothes was the 1950s and 1960s. The new prevalence of private pools, or at least patios, brought casual, resortlike entertaining to backyards everywhere, and the increasing ease and affordability of air travel gave more and more people the opportunity to get away from it all—and the need for a separate travel wardrobe. While life had become more informal in many ways, there was a lingering sense of propriety that prescribed a specific kind of outfit for every different activity. Perhaps the most innovative of the American fashion designers were those with the savviest sense of these requirements. They included Claire McCardell, Tom Brigance, Clare Potter, Tina Leser, Carolyn Schnurer, Sydney Wragge for B. H. Wragge, and Jeanne Campbell for Sportwhirl. It is often assumed that the most imaginative design goes into the most formal clothes—say, for elaborate cuts or embroideries or decorative treatments—but these designers understood the contemporary lifestyle

Two models peering into the stable at the Tijuca, Brazil, plantation of Raimundo Castro, one in a Carolyn Schnurer playdress of rayon with matching shorts underneath, the other in kilt and bra-top outfit in rayon by Duchess Royal. Photographed by Louise Dahl-Wolfe for Harper's Bazaar, *May 1946.*

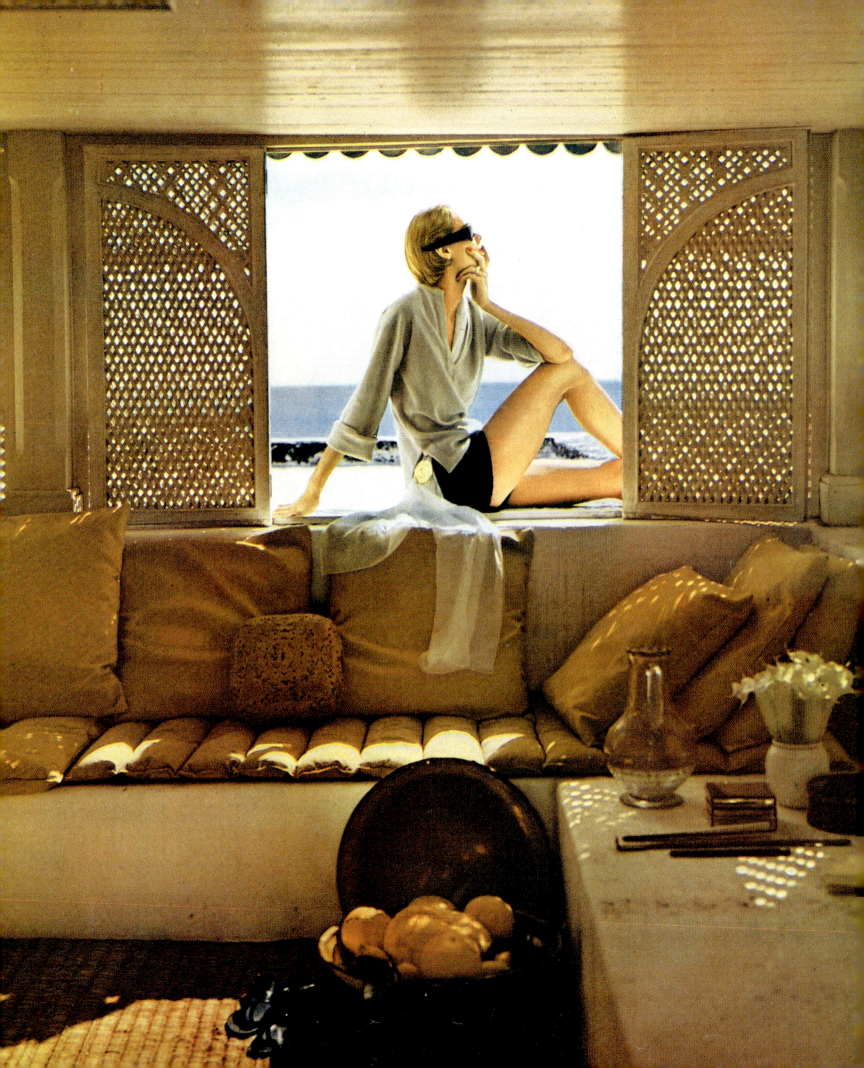

and excelled at making pieces for activities as diverse as playing ping-pong, sunning on a rock, tossing a salad tableside, and joining in a game of pin-the-tail-on-the-donkey. They made clever use of inexpensive fabrics, as well as details like McCardell's double rows of top-stitching (borrowed from jeans). Since they were not hampered by any precedents, these designers sought inspiration from all over, adapting elements seen on their travels as well as from an almost-too-obvious source, children's fashion. It was only a couple of decades since children had ceased being dressed as miniature adults; grown-up playclothes options from the 1940s through the 1960s included what were thus fairly new items from the nursery wardrobe, such as short shorts, little bloomers, loose jackets, bubble shapes, flyaway overskirts, apron wrap skirts, skorts, and tops with puffed sleeves.

While the 1970s started out with a brief revival of the designs of the 1930s, including styles that were inspired by the original beach pajama, the death knell had sounded for playclothes. Women were demanding to be taken seriously, and for this they turned to power suits or designer jeans. Since then, playclothes have been absorbed into general fashion as separates. For active sports, performance-enhancing materials have come to trump decorative looks. When contemporary designers do reference the charming shapes and details of midcentury playclothes, it is by injecting a vintage spirit into clothes aimed for general multifunctional use. A cropped trapeze beach cover-up interpreted in wool results in a jacket that, depending on how it is layered, goes from work to a night on the town—or anywhere in between.

In Tunisia, a Clare Potter top of ribbed wool jersey and short shorts in heavy linen.
Photographed by Louise Dahl-Wolfe for Harper's Bazaar, *1950.*

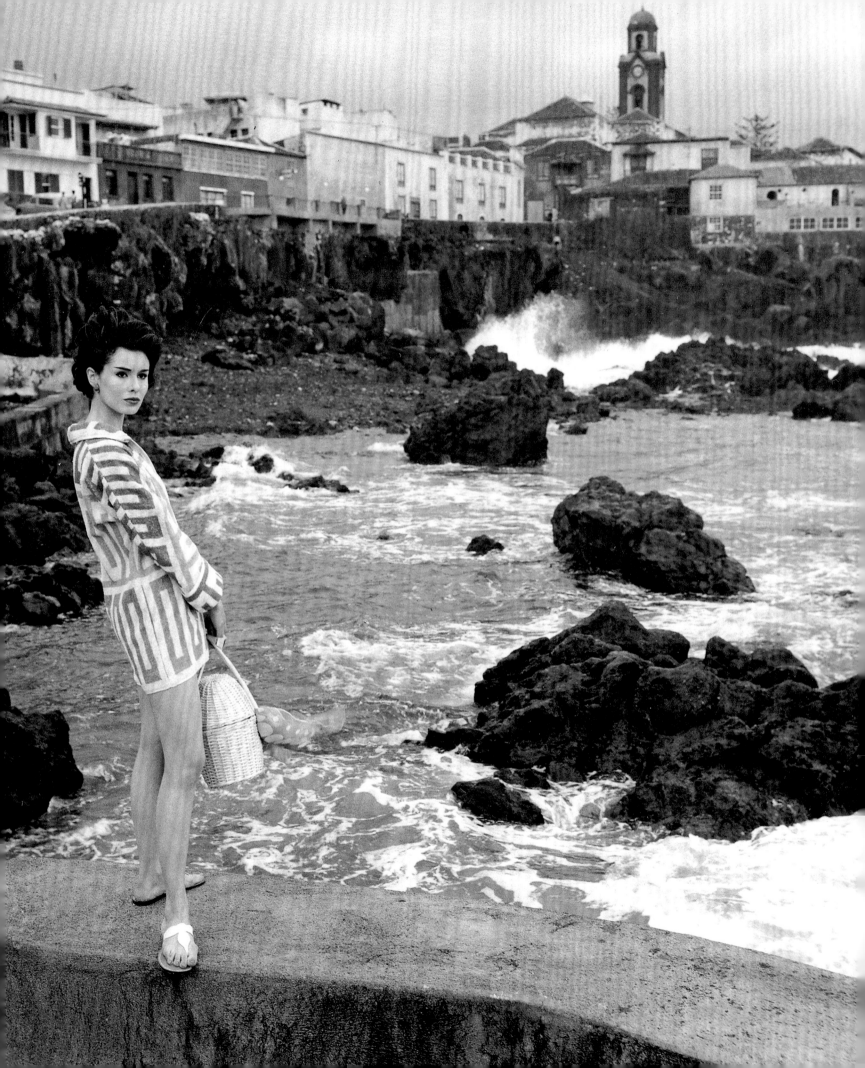

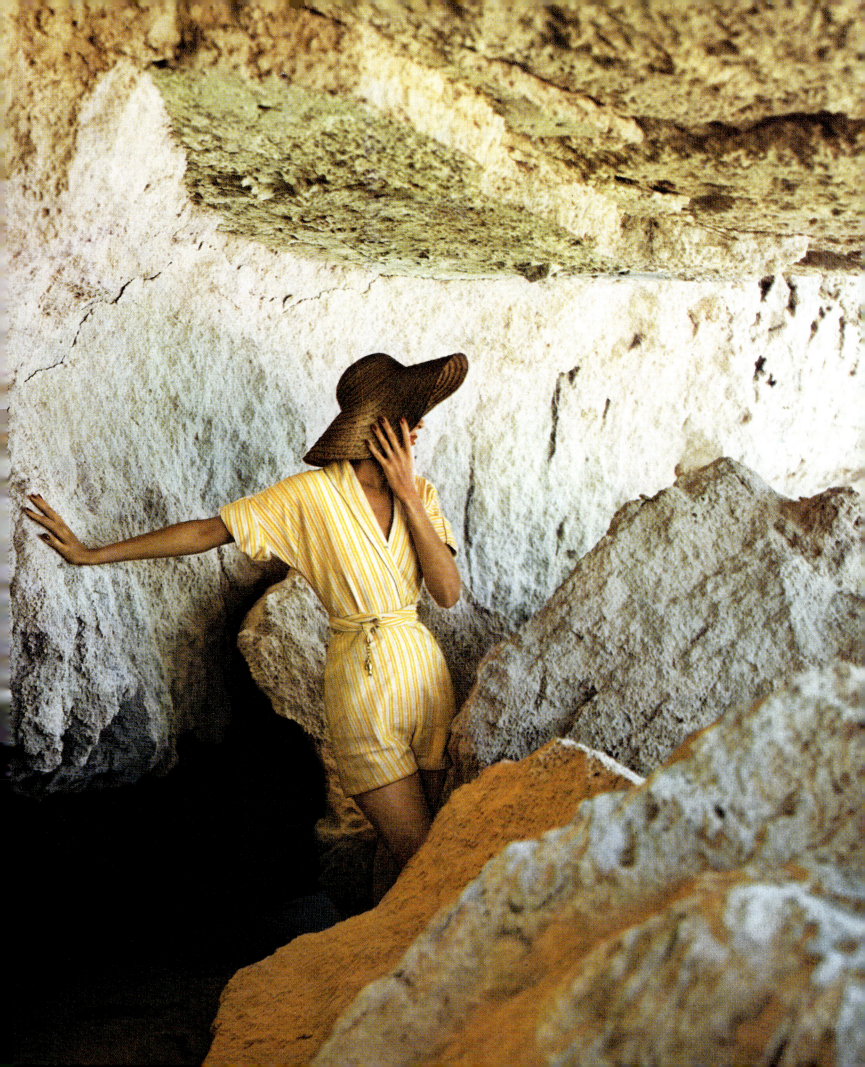

PREVIOUS SPREAD, LEFT: *Tenerife, Canary Islands: geometric terry cover-up by Toni Owens with Bernardo sandals. Photographed by Herman Landshoff for* Mademoiselle, *1958.* PREVIOUS SPREAD, RIGHT: *Made out of handwoven madras cotton, this Tina Leser kimono wrap playsuit was the perfect piece "to change into after a swim," as* Harper's Bazaar *put it. Photographed in a cave on the western end of Nassau, the Bahamas, by Louise Dahl-Wolfe for* Harper's Bazaar, *1949.* RIGHT: *Lauren Bacall wearing a Carolyn Schnurer turnout of a navy off-the-shoulder, bare-midriff top and brown shorts. Photographed by Louise Dahl-Wolfe for* Harper's Bazaar, *1945.*

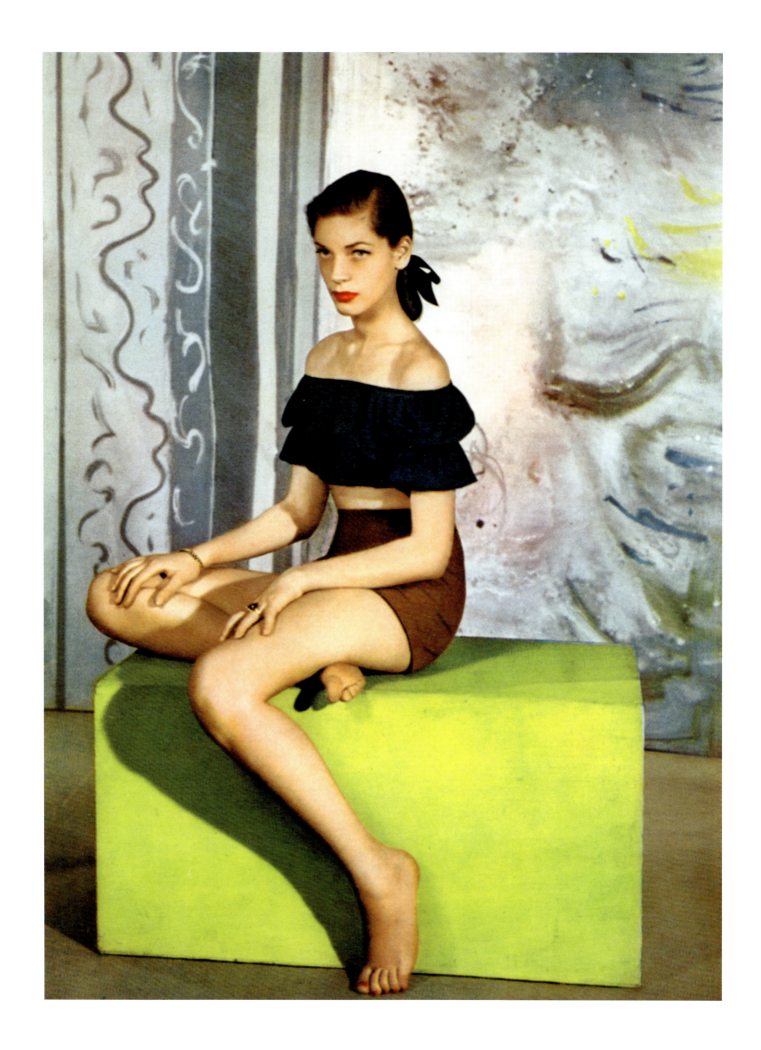

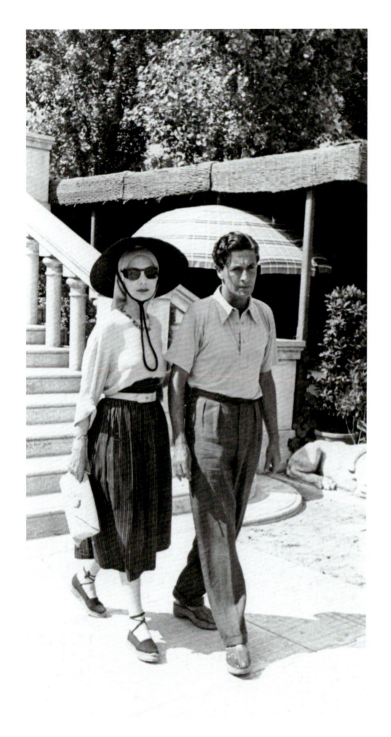
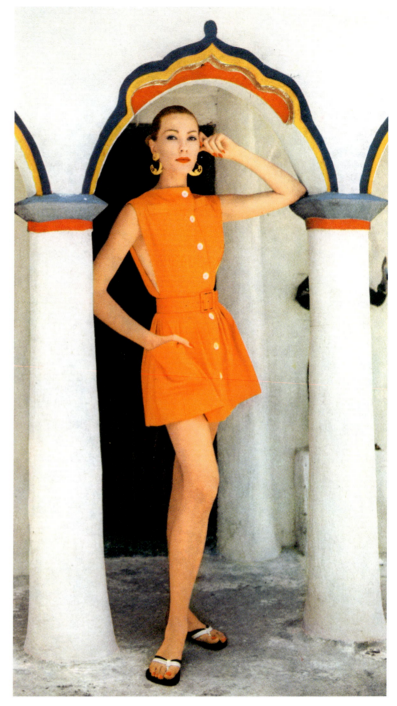

ABOVE, LEFT: *Designer Valentina and companion, photographed in Italy in the late 1930s. Valentina is wearing her signature cord-tied "coolie" hat over a headscarf, linen pullover blouse, and high-waisted dirndl skirt.* ABOVE, RIGHT: *Model Jessica Ford in a beach coat of tangerine cotton twill by Tom Brigance for Sportmaker. Earrings by Mosell, sandals by Bernardo. Photographed at a Hindu temple in Trinidad by Louise Dahl-Wolfe for Harper's Bazaar, 1957.* RIGHT: *Portofino, Italy: Honeymooners Elizabeth Taylor and Eddie Fisher strolling in the marketplace, 1959.*

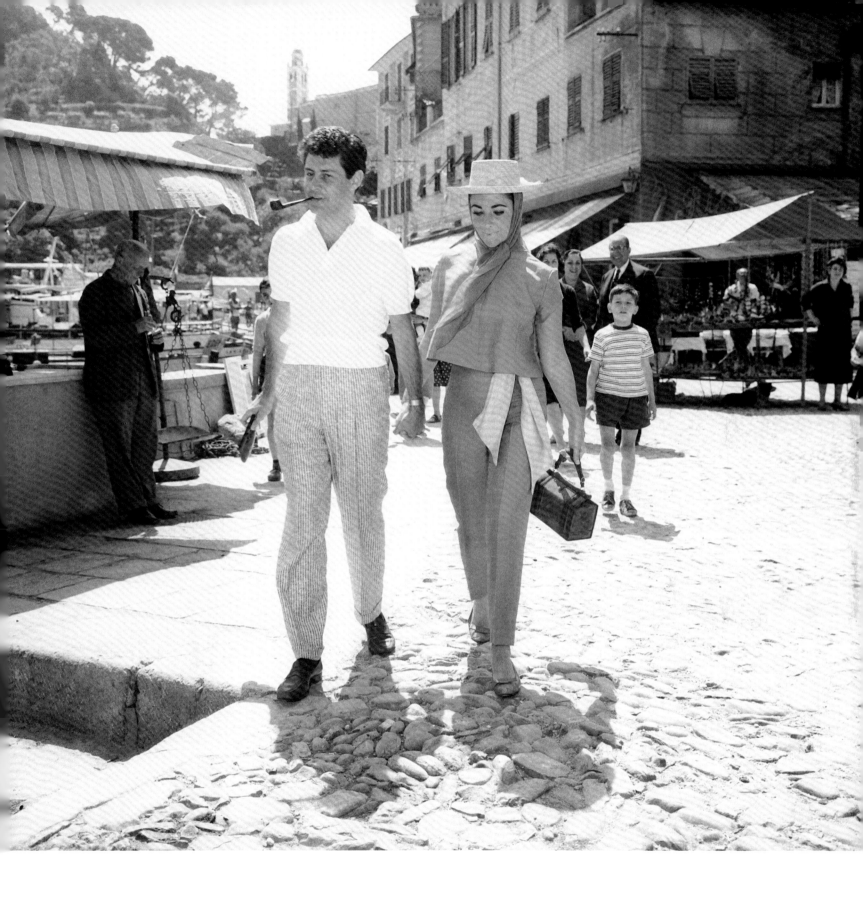

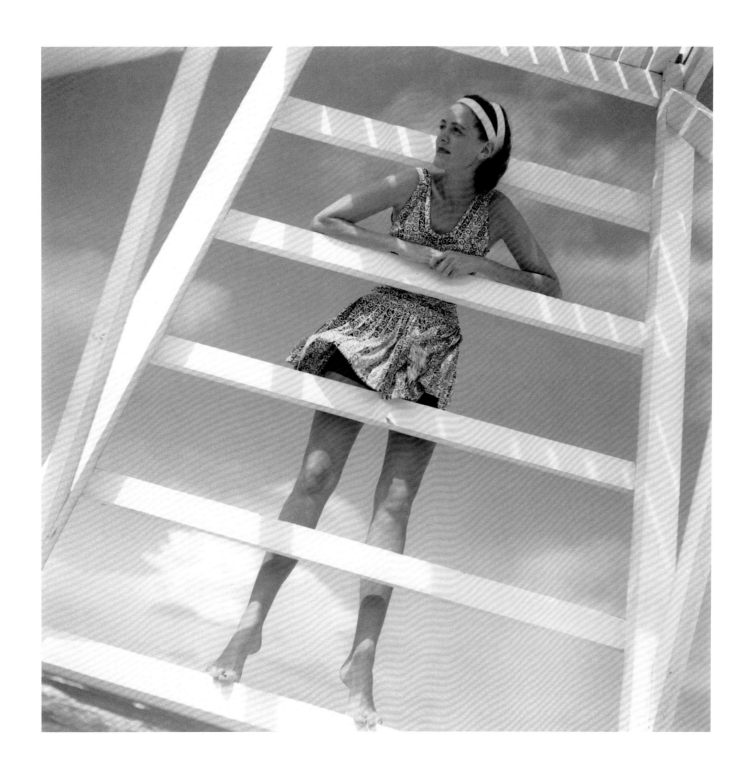

ABOVE: *This 1939 bathing suit from Jay-Thorpe was considered very novel because of its ballerina skirt; it was made in an acetate jersey and available in a print of white, black, and rust. Photographed at Marineland, Florida, by Toni Frissell for Vogue, 1939.* RIGHT: *Described as "an excellent catch," this ensemble of white linen culottes with backless top from Lord & Taylor featured a blue flannel bolero for warmth. Photographed by Toni Frissell for Vogue, 1936.*

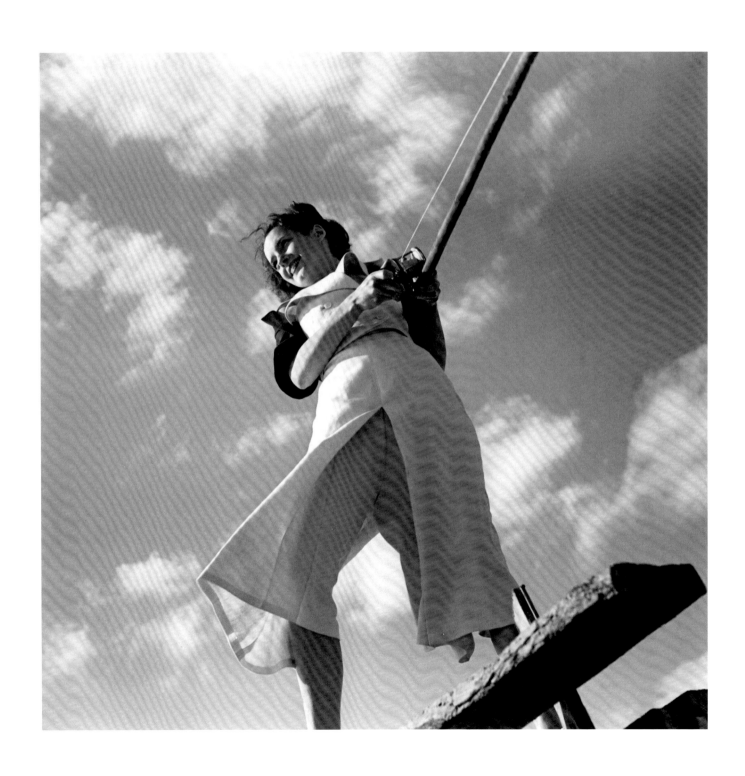

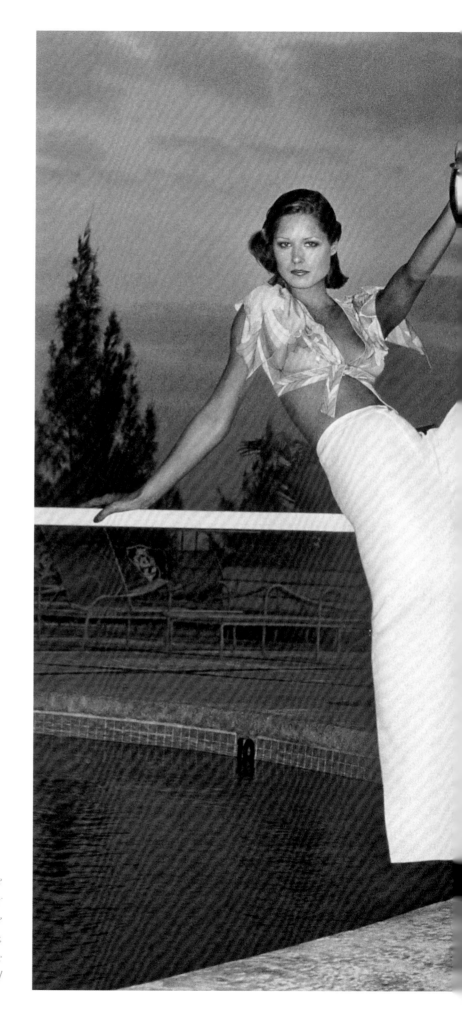

The 1970s fondness for the 1930s reveals itself in the bare top and wide-legged beach-pajama-like pants by Leonard. Revivals of such looks could go from poolside to disco. The center ensemble was designed by Gil Aimbez for Genre and the turnout with peasant blouse tunic was by Clovis Ruffin for Ruffin Sport. Photographed by Kourken Pakchanian for Vogue, 1975.

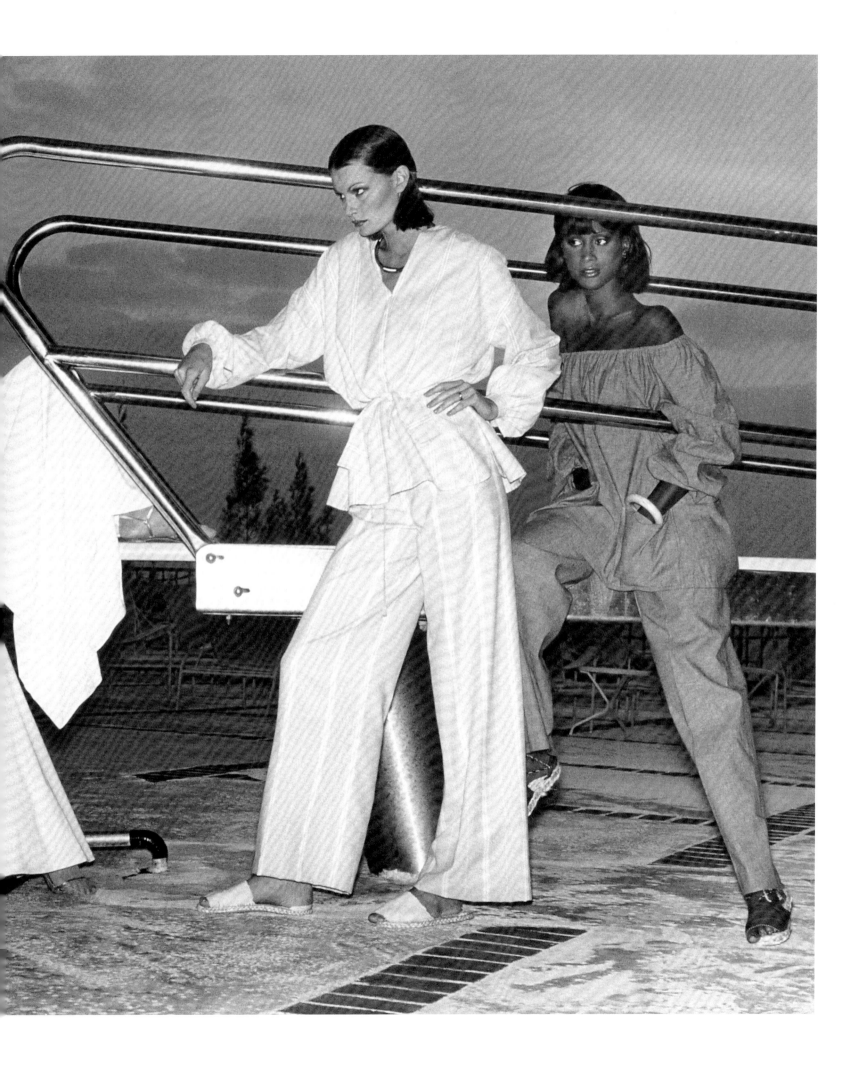

This Carolyn Schnurer shorts outfit appeared on a 1950 cover of Harper's Bazaar. *Based on a djellabah, the top was made of white oxford cloth with white cord passementerie. Hat by Mr. John, Vera scarf. Photographed by Louise Dahl-Wolfe in Tunisia.*

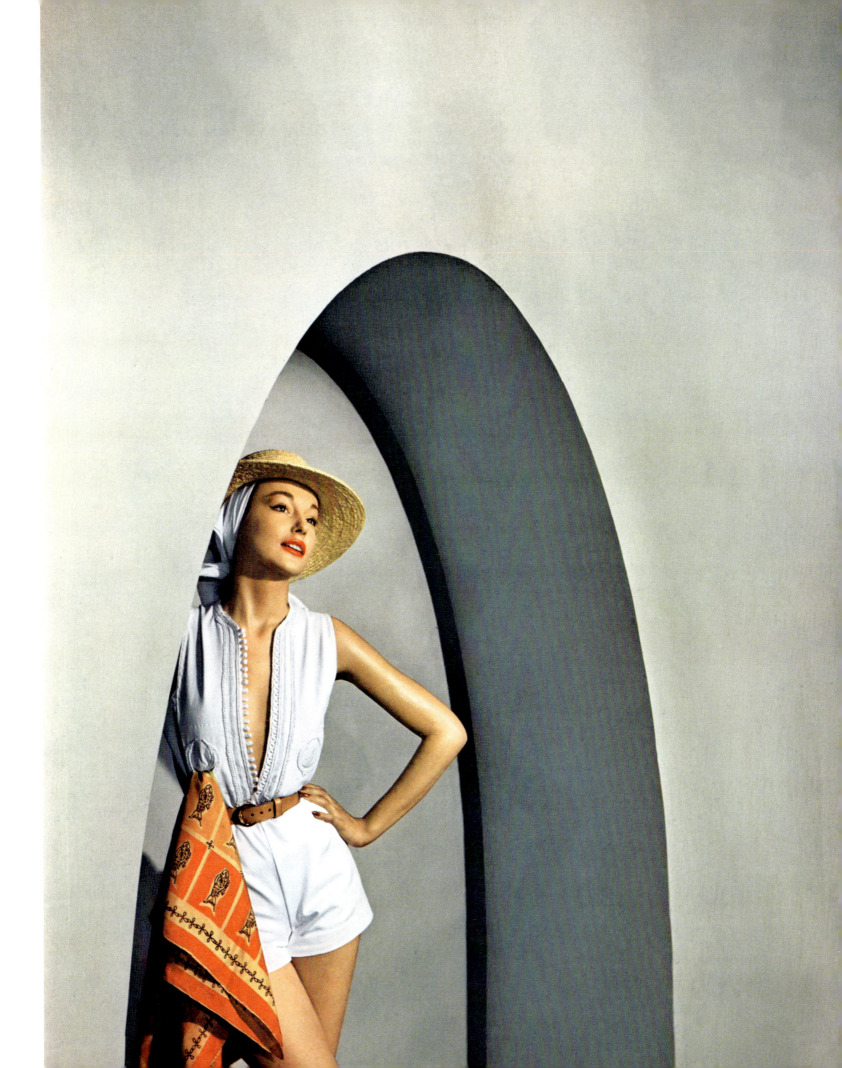

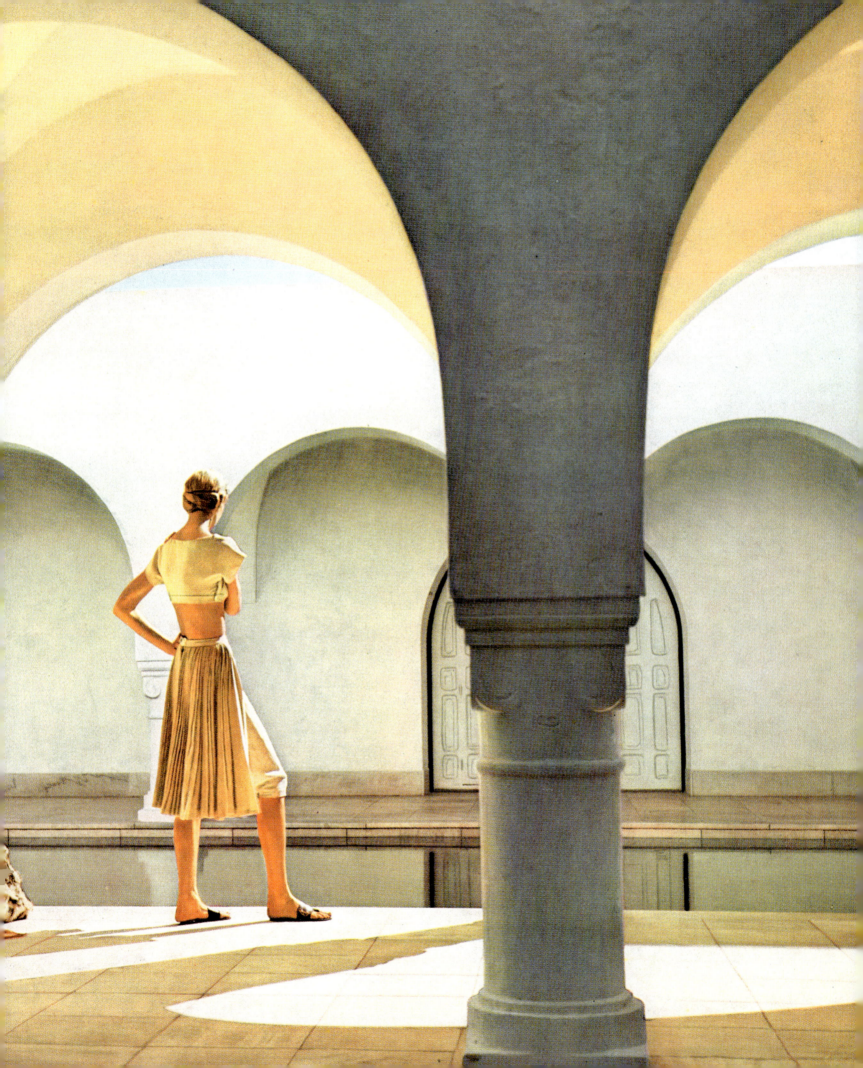

Although best known for her intricately draped jersey evening dresses, Mme. Grès designed all manner of clothes to be worn at home or on holiday, usually featuring inventive and well-designed bareness. This couture ensemble was made with an abbreviated top, just-below-the-knee trousers, and knife-pleated overskirt, all in "driftwood" beige. Photographed in Tunisia by Louise Dahl-Wolfe for Harper's Bazaar, *1950.*

Narrow pants like these, popularized by Jax and Pucci, quickly became a jet-set travel mainstay and are shown here stepping into a gondola in front of the Ca' d'Oro, Venice, 1956.

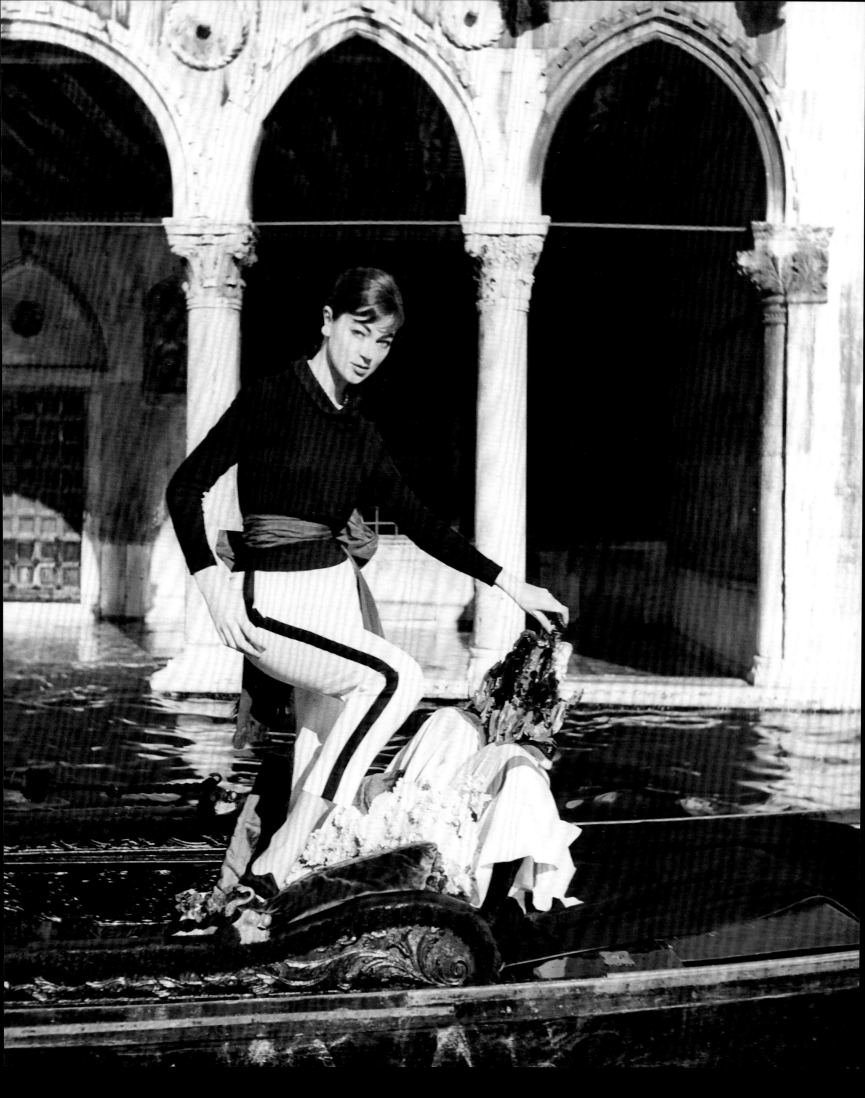

SIX

The Summer Dress

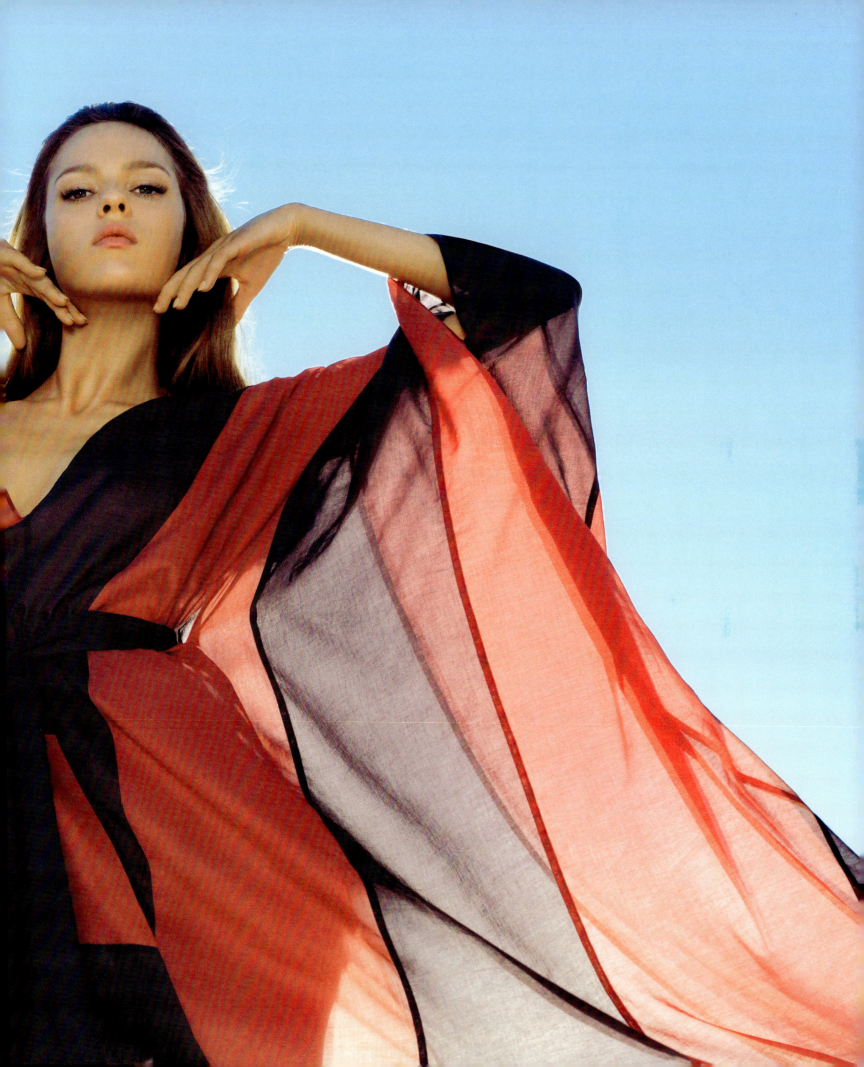

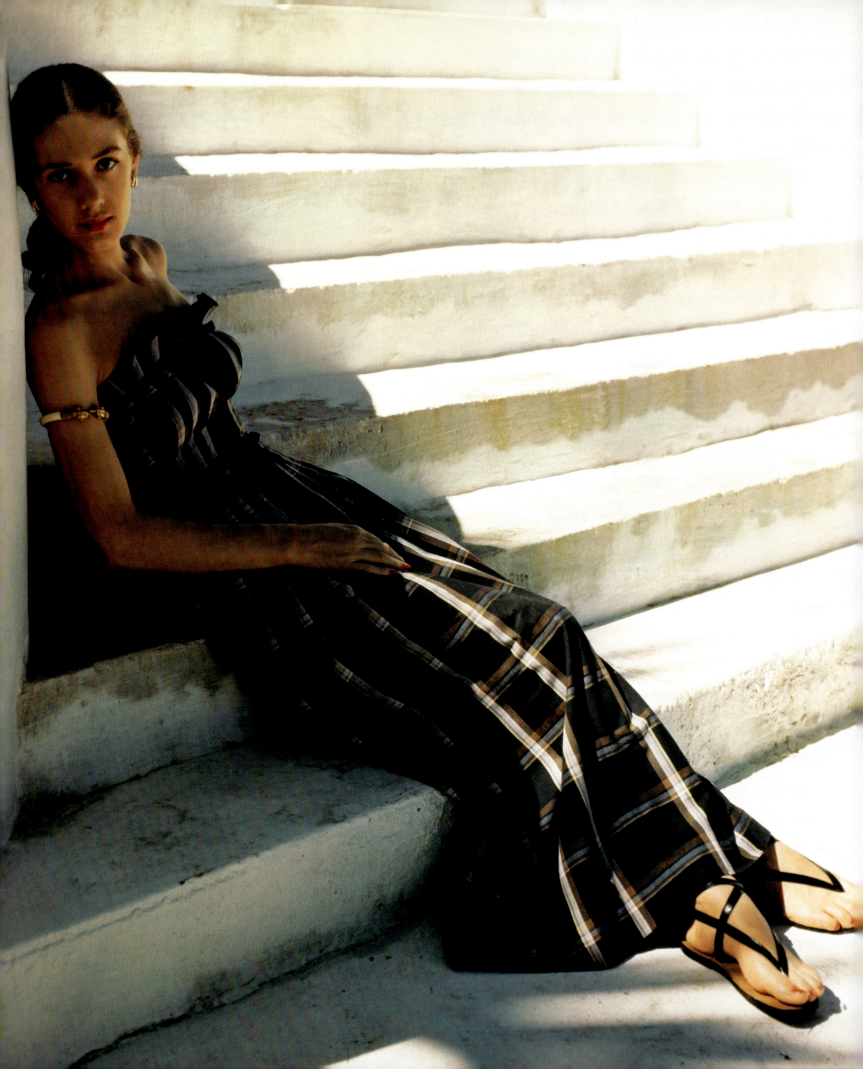

THE SUMMER DRESS

Lighter and less cumbersome, or at least less serious than, say, a little black dress, the summer dress owes its origins to the gaulles, frocks made by Rose Bertin for Marie Antoinette's court to wear at her private retreat, the Petit Trianon. Previously, summer dresses had differed from winter ones only in the fabric they were made from; they were otherwise just as formal, form-fitting, decorated, and restrictive. Described by Caroline Weber in *Queen of Fashion*, the gaulles were white muslin shifts worn over a soft fabric bodice instead of a rigidly constructed corset, with a drawstring neckline and simple ribbon sash. Marie Antoinette gave one to her friend the Duchess of Devonshire, and soon they were being worn not just in France but in England as well.

Fashion in the first two decades of the nineteenth century was dominated by slender, unpretentious, empire-waisted styles in light fabrics such as cotton or muslin. By the Victorian era, the fashion was for more complicated dresses, with elaborate crinoline and, later, bustle silhouettes. By necessity, a summer style, descended from the gaulles and called the lingerie dress, came into being. Made of linen or fine cotton and decorated with bands of lace or white embroidery in the moment's prevailing silhouette, this washable frock was worn well into the 1920s.

During the twentieth century, dresses in general became both less important, as other clothing options for women multiplied, and more relevant, as increasingly practical versions appeared. Milestones in wearability include Claire McCardell's waistless monastic dress, shown in every collection from the late 1930s until she died

PREVIOUS SPREAD: *Eres designed this flowing caftan cover-up for summer 2008.* LEFT: *Madras at its best, after having been washed so the colors could bleed. This plaid pattern has long been a mainstay of the American East Coast preppy look. In 1947, when Mildred Orrick designed this dress, its length meant that the wearer could politely forgo stockings, a boon in great heat. Sandals by Bernardo. Photographed by Louise Dahl-Wolfe for* Harper's Bazaar, *1947.*

in 1958; her 1940s wrap-style popover that sold for as little as $6.95; Pucci's slithery, five-ounce silk jersey shift of 1960, which demanded that the wearer dispense with lumpen underwear; Lilly Pulitzer's straight-up-and-down cotton shift of the early 1960s; and Diane von Furstenberg's wrap dress, the alternative to the business suit in the mid-1970s and again in the early twenty-first century. The sundress has been an enduring favorite since the 1930s when, inspired by the new craze for suntans, couturiers began to show short dresses with sunburn or suntan backs.

 Glamorous resorts are just the places to wear exotically scanty evening clothes that look fantastic on the runway but inappropriate at a charity ball. The jet set popularized numerous versions of the summer dress for evening, from the Moroccan-inspired caftan to bare-midriff, transparent, or slit-all-the-way-up looks that left little to the imagination. In 1980 Andy Warhol wrote in his diary about a daringly bare resort style he had seen on Lynn Wyatt at her house, the Villa Mauresque, on Cap Ferrat: "Lynn was wearing a dress that was split up the sides and you could see all her breasts and she just had a little bikini on and she looked beautiful."

 The widespread adoption of glacial air-conditioning has made the idea of wearing a bare dress to keep cool obsolete, yet dresses, like high heels, satisfy a longing for femininity that is practically atavistic. The dresses of summer have been repopularized by the daughters and granddaughters of the women who abandoned skirts for pants when first breaking glass ceilings decades ago.

Geoffrey Beene swimsuit-bare evening dress, from his Spring 1992 collection.

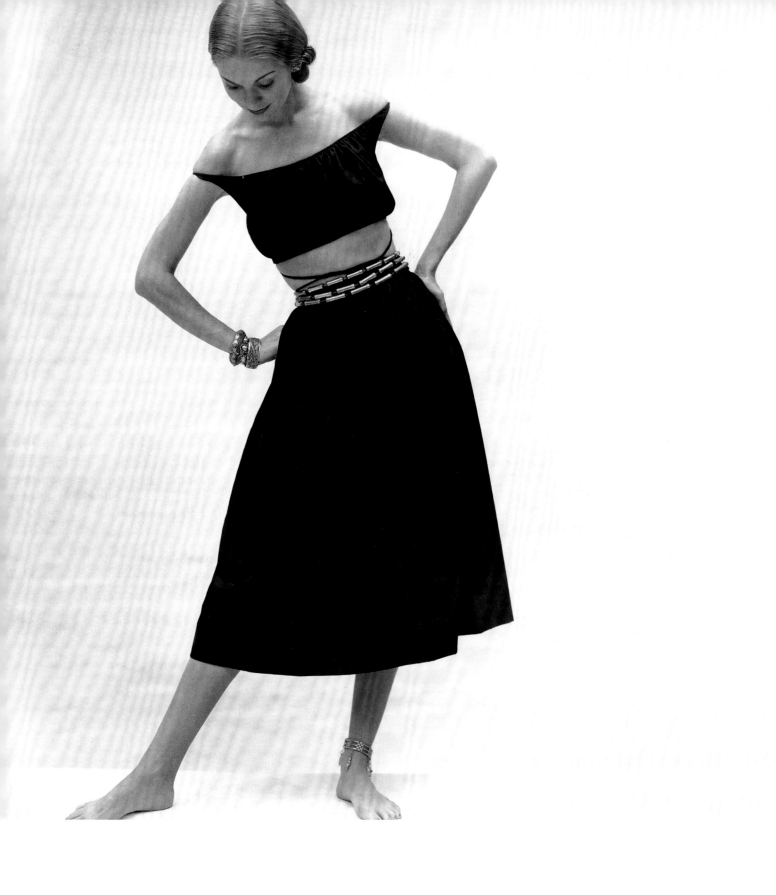

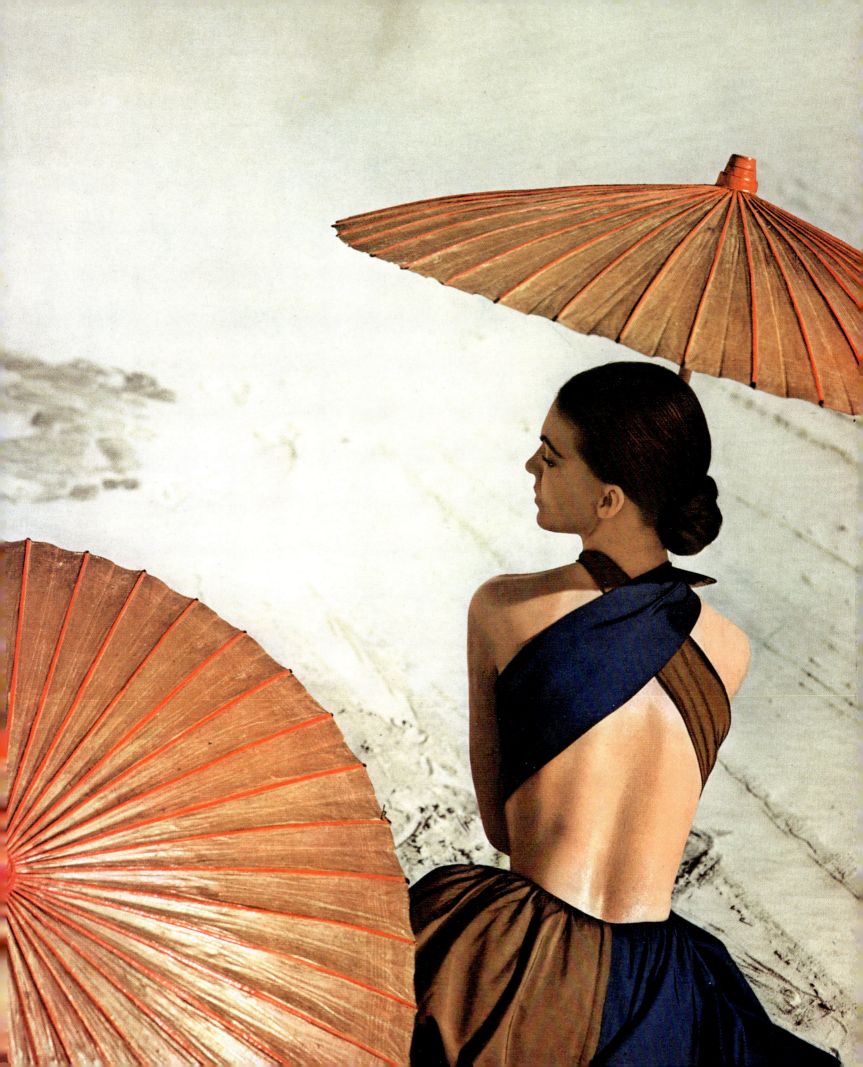

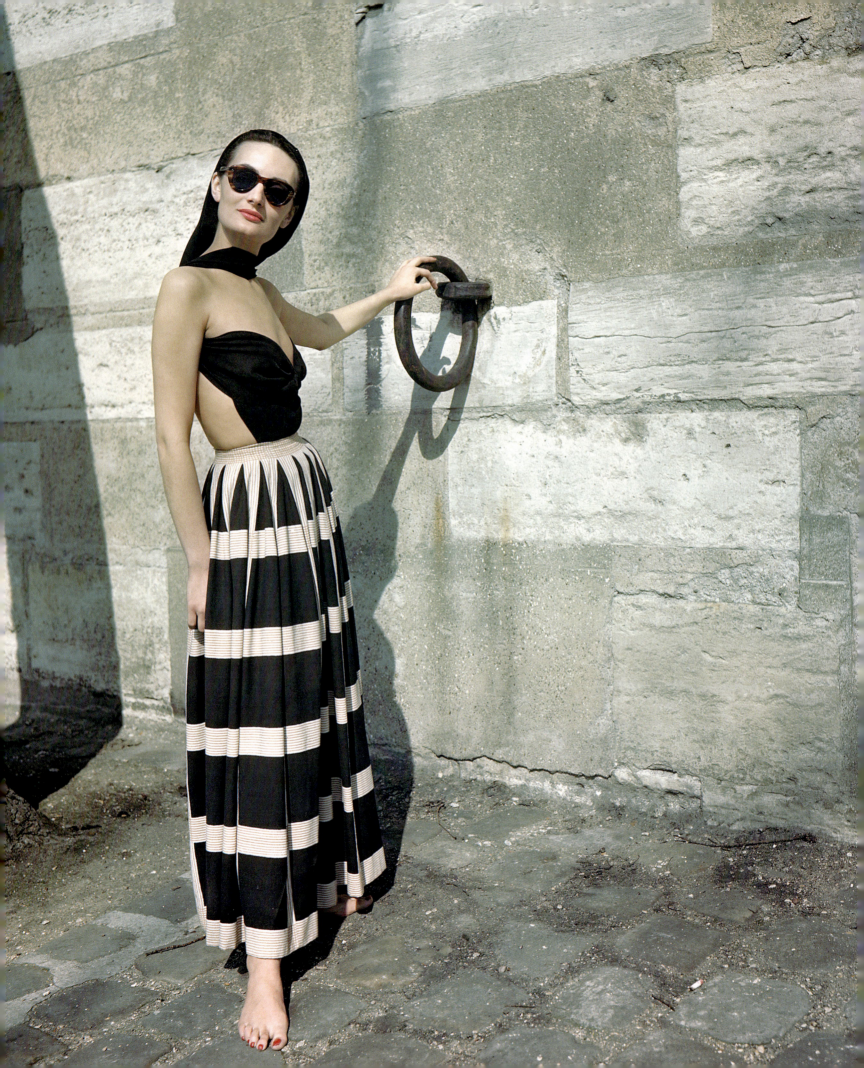

PREVIOUS SPREAD, LEFT: *Claire McCardell bare-midriff sundress in black cotton with her signature spaghetti-wrapped waist along with a jeweled belt and an ankle bracelet by Gerli. Photographed by John Rawlings for* Vogue, *1945.* PREVIOUS SPREAD, RIGHT: *Joset Walker dress worn by Virginia Stewart in the California desert near Yuma. Photographed for the cover of* Harper's Bazaar *by Louise Dahl-Wolfe, 1948.* LEFT: *Pierre Balmain was still the new couturier in town when he designed this postwar (1946) evening dress with pared-away sides, shown near the Seine. Photograph by Genevieve Naylor.* FOLLOWING SPREAD: *Giambattista Valli silk organza dress on her; on him, cotton pants by Prada. Photographed by Patrick Demarchelier for* Allure, *June 2007.*

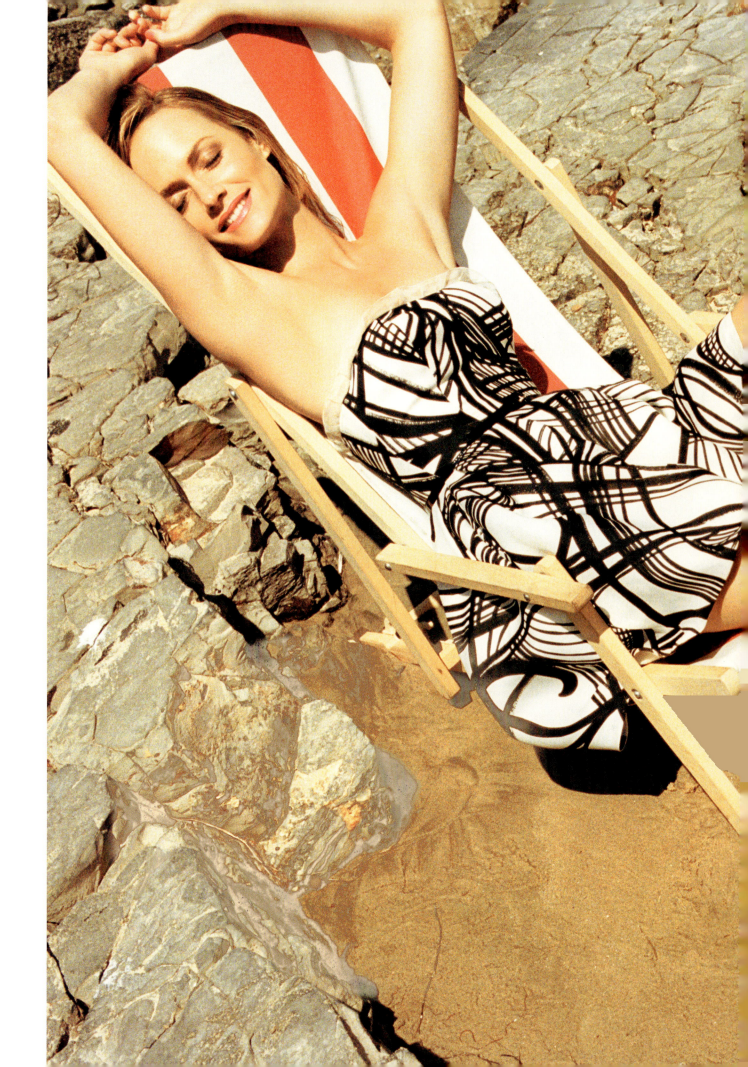

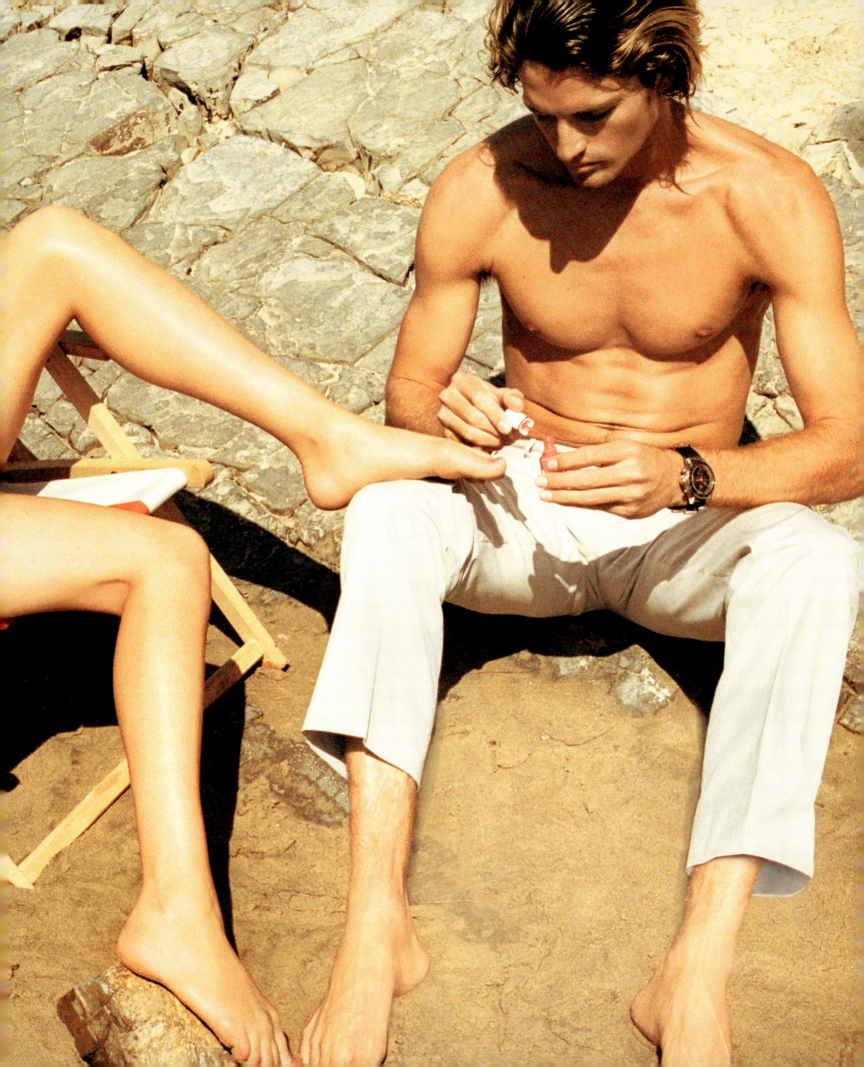

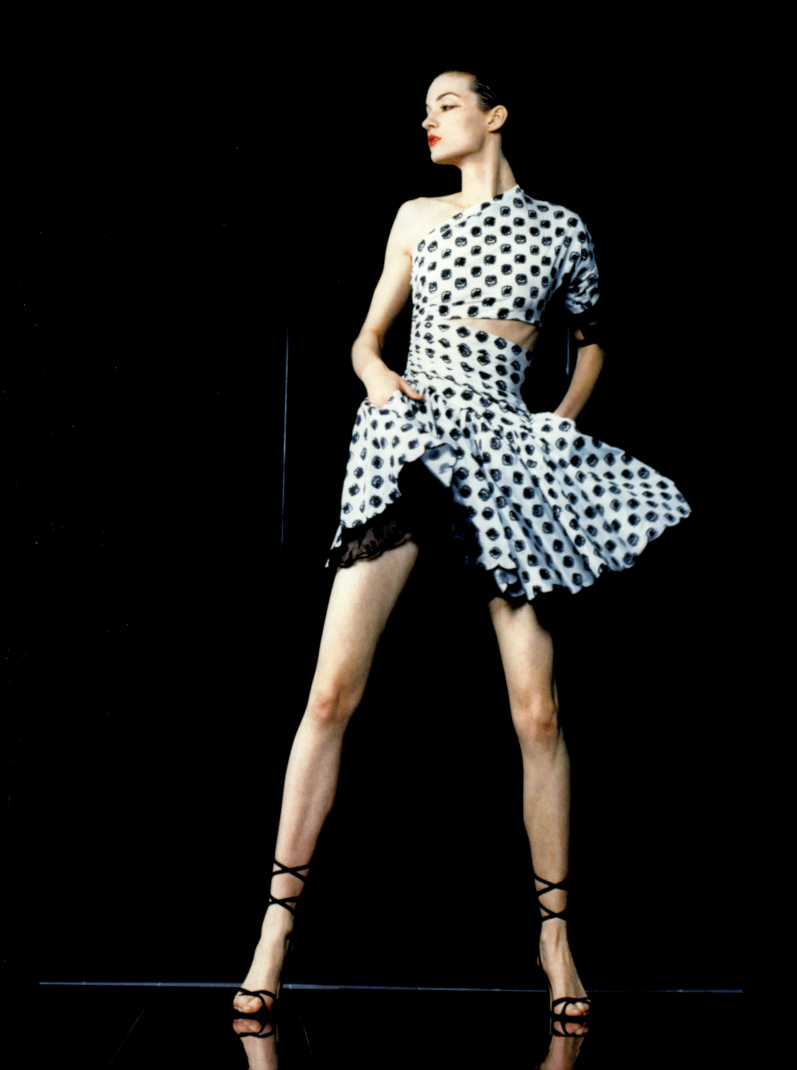

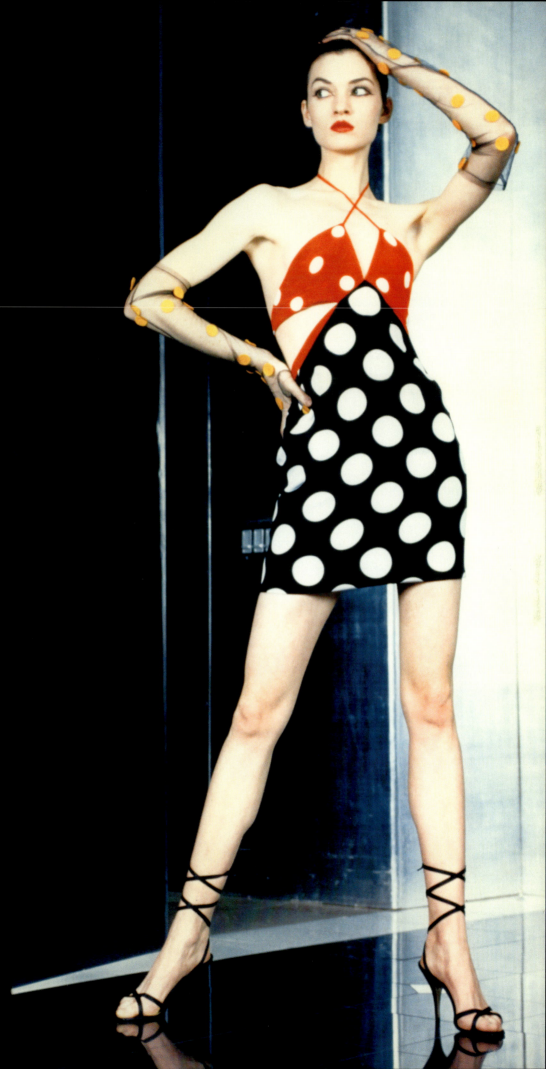

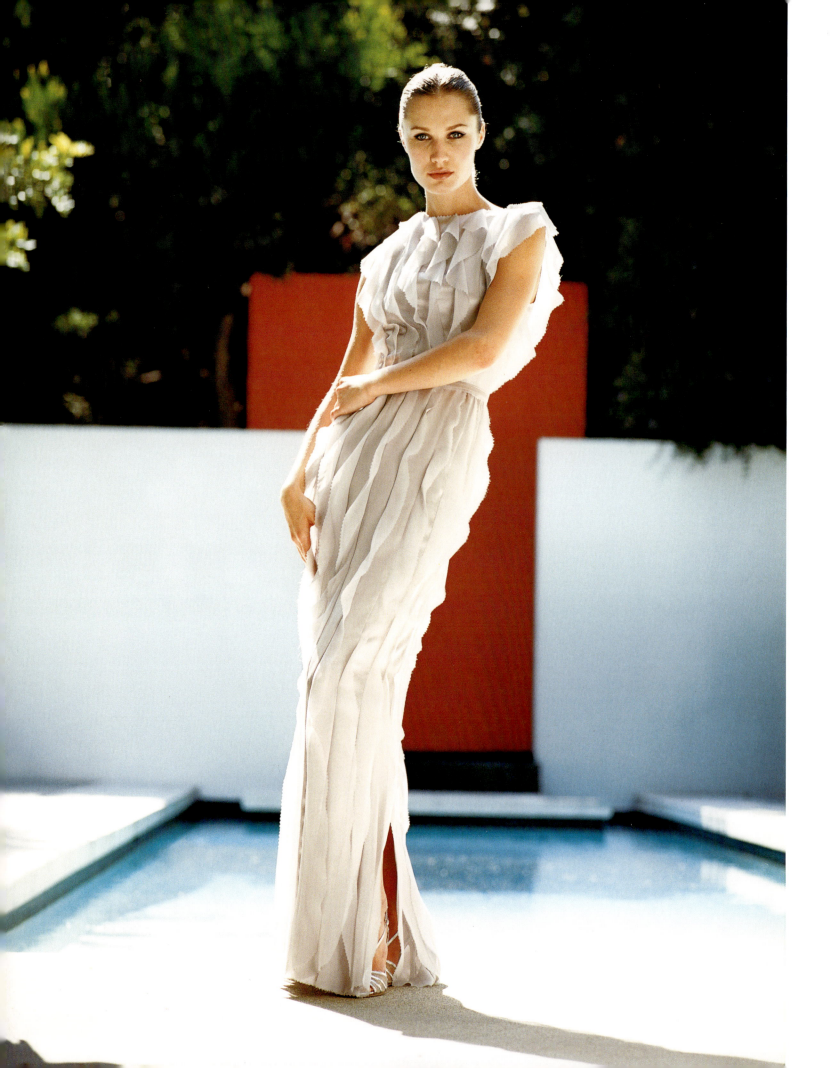

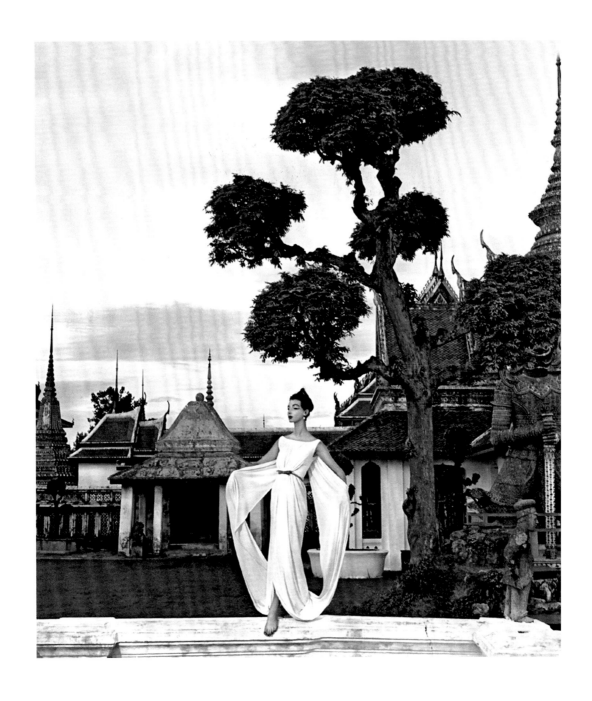

PREVIOUS SPREAD, LEFT: *A short evening dress by Geoffrey Beene from the Spring 1992 collection features his signature triangles in the angle of the one-shouldered neckline and the cut-out at the side of the waist.* PREVIOUS SPREAD, RIGHT: *Geoffrey Beene polka-dot cut-out short evening dress also from his Spring 1992 collection.* LEFT: *Kate and Laura Mulleavy of Rodarte arranged the silk in this dress in waves, emphasizing its Hockney pool-ripple appeal. Photographed by Jim Jordan for* Vogue, *2005.* ABOVE: *Bill Blass was still a designer at Anna Miller when he created this exotic evening dress. Composed of rayon matte jersey, it featured panels continuing from the slit hem that attached at the back décolletage. Photographed on Derujinsky's wife at sunrise at the Temple of Dawn in Bangkok by Gleb Derujinsky for* Harper's Bazaar, *1958.*

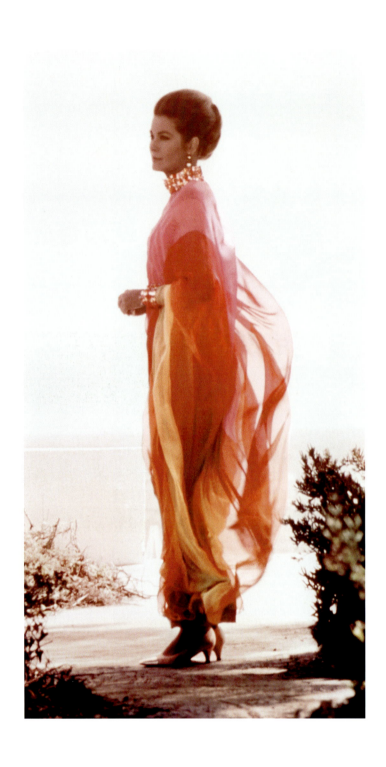

A breeze catches the caftan overdress of Princess Grace's evening gown, circa 1970. RIGHT: *B. H. Wragge playsuit in mint green linen with swirling green and pink overskirt, which goes from the beach to the balcony of San Simeon, the Hearst estate in California. Photographed on Tan Arnold by Louise Dahl-Wolfe for* Harper's Bazaar, *1958.*

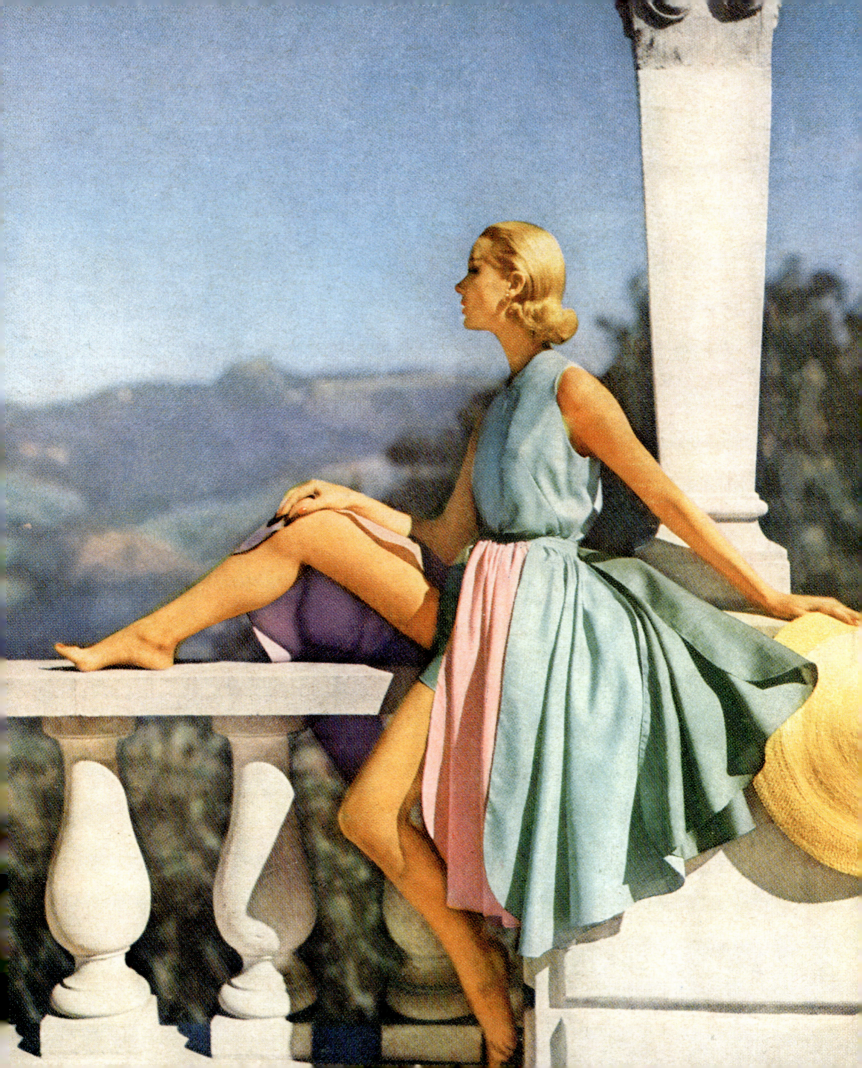

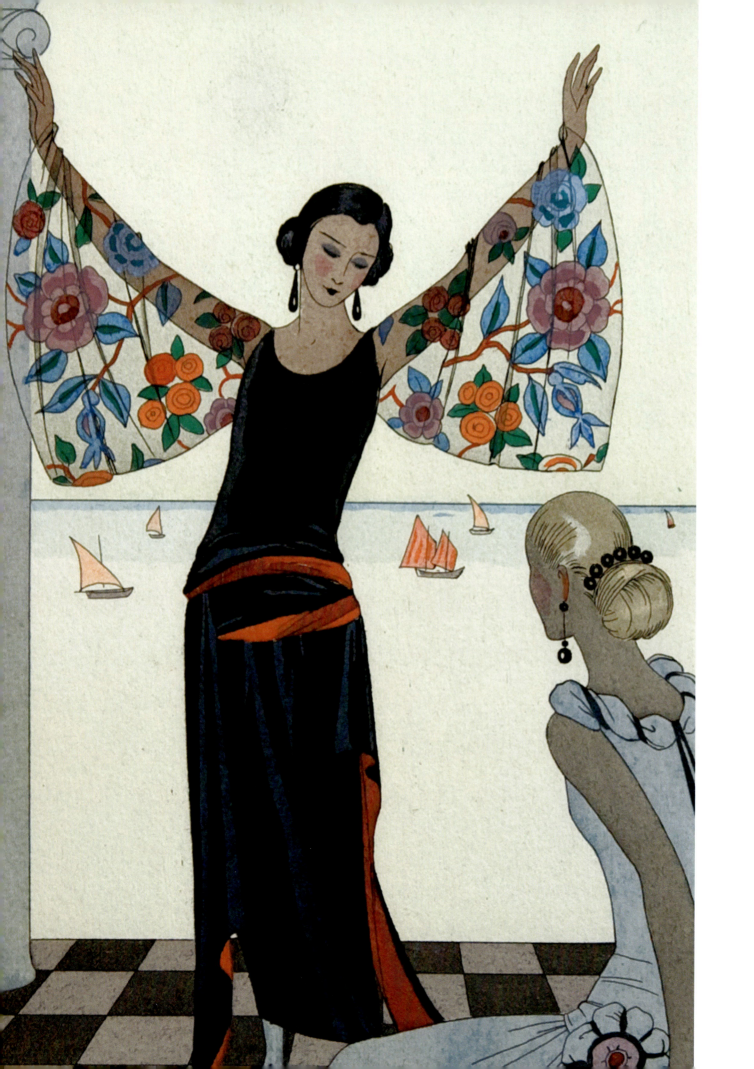

"Voici mes ailes!" Pochoir illustration by George Barbier, 1922.

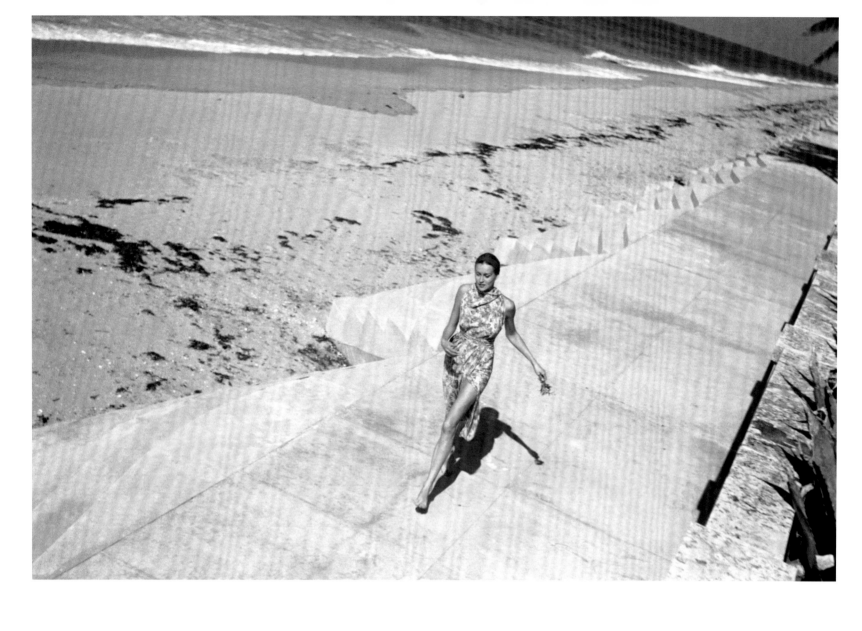

Model in a flowered dress striding along a boardwalk. Photographed by Toni Frissell for Harper's Bazaar, *1937.* RIGHT: *Mirroring its royally ornate surroundings, this John Galliano slip dress in gold lace is embroidered with flowers. Photographed on Maggie Rizer at the City Palace of Jaipur, India, by Arthur Elgort for* Vogue, *1999.*

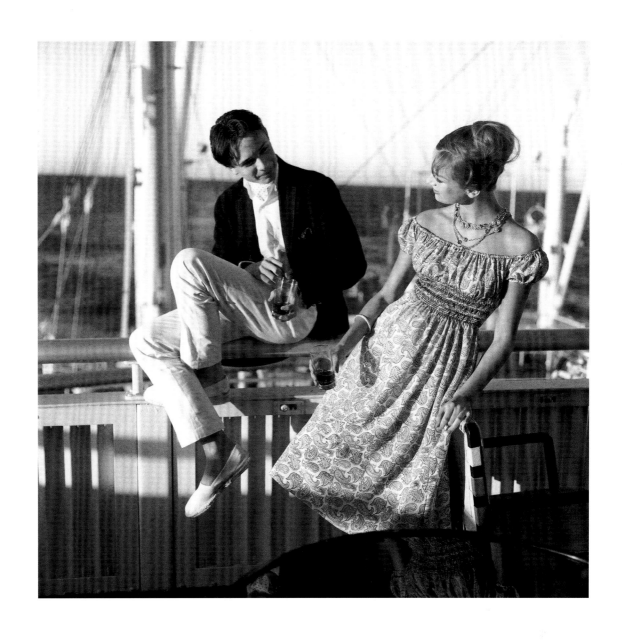

LEFT: *This dress was designed by Nelly de Grab in an unusually bright palette for madras: marigold and poppy. Pictured sitting under the circular canopy of the Westhampton Bath & Tennis Club in 1957, model Dolores Hawkins also wears a bib necklace and bracelet by Kramer. Photographed by Herman Landshoff for* Mademoiselle, *1957.* ABOVE: *Although made after Claire McCardell's death, this paisley cotton georgette frock by her original firm, Townley, bears several of her hallmarks, most notably the elasticized waist and the tiny puffed sleeves of a Napoleonic-era dress. Photographed by Herman Landshoff for* Mademoiselle, *1959.*

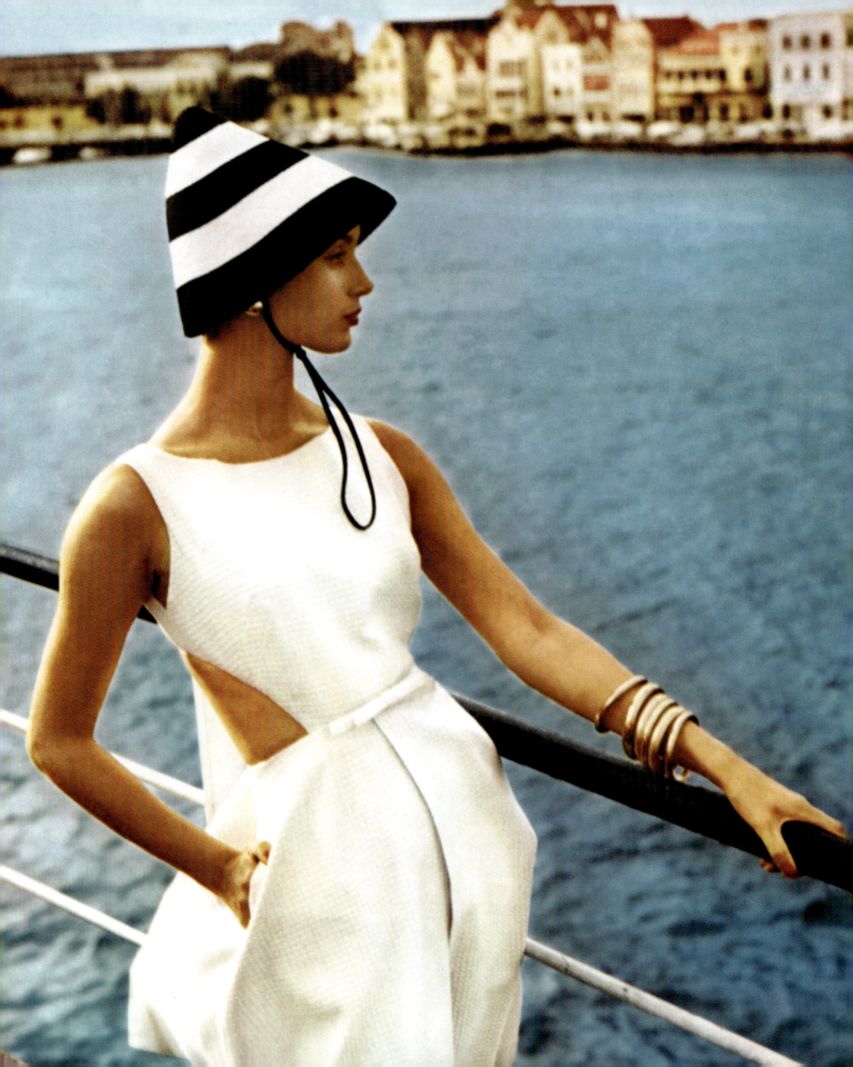

Originally described in Mademoiselle *as "the seafaring sundress," this cut-out midriff dress was made in waffleweave cotton by Jeanne Campbell for Sportwhirl. Hat by Madcaps, bracelets by Monet. Photographed by Herman Landshoff at Willemstad, Curaçaos,* Mademoiselle, *1959.*

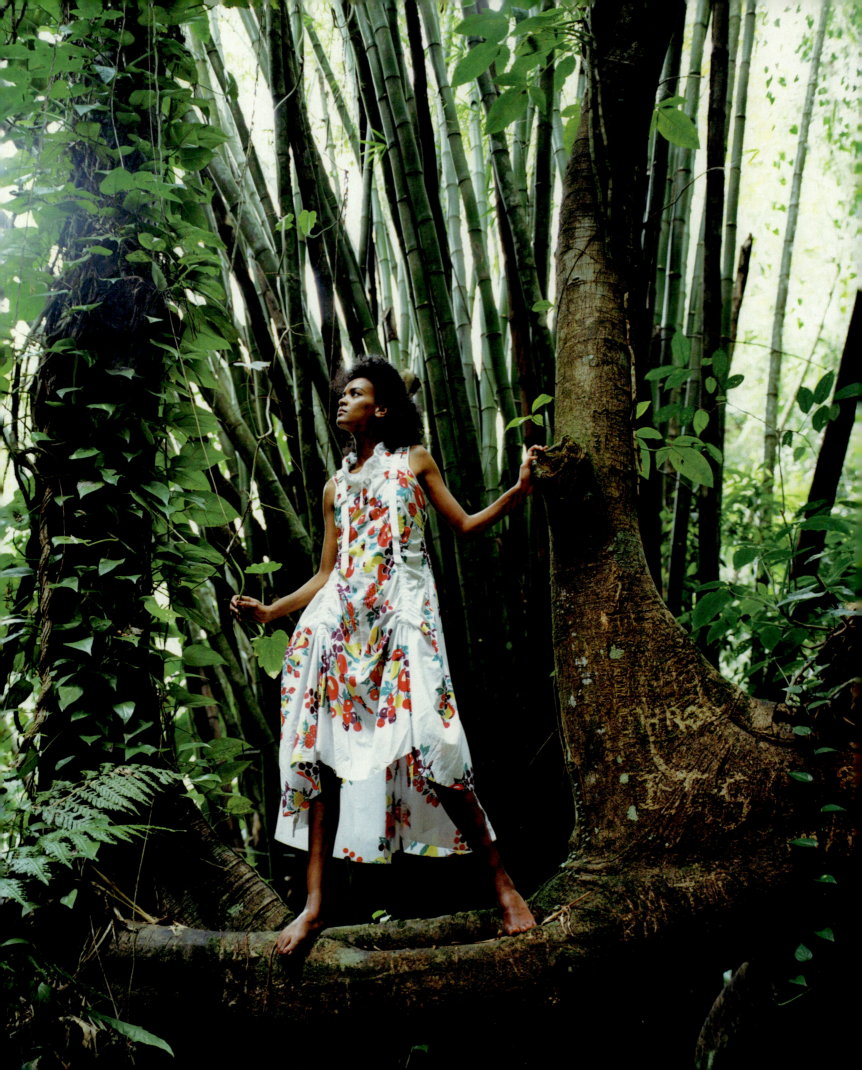

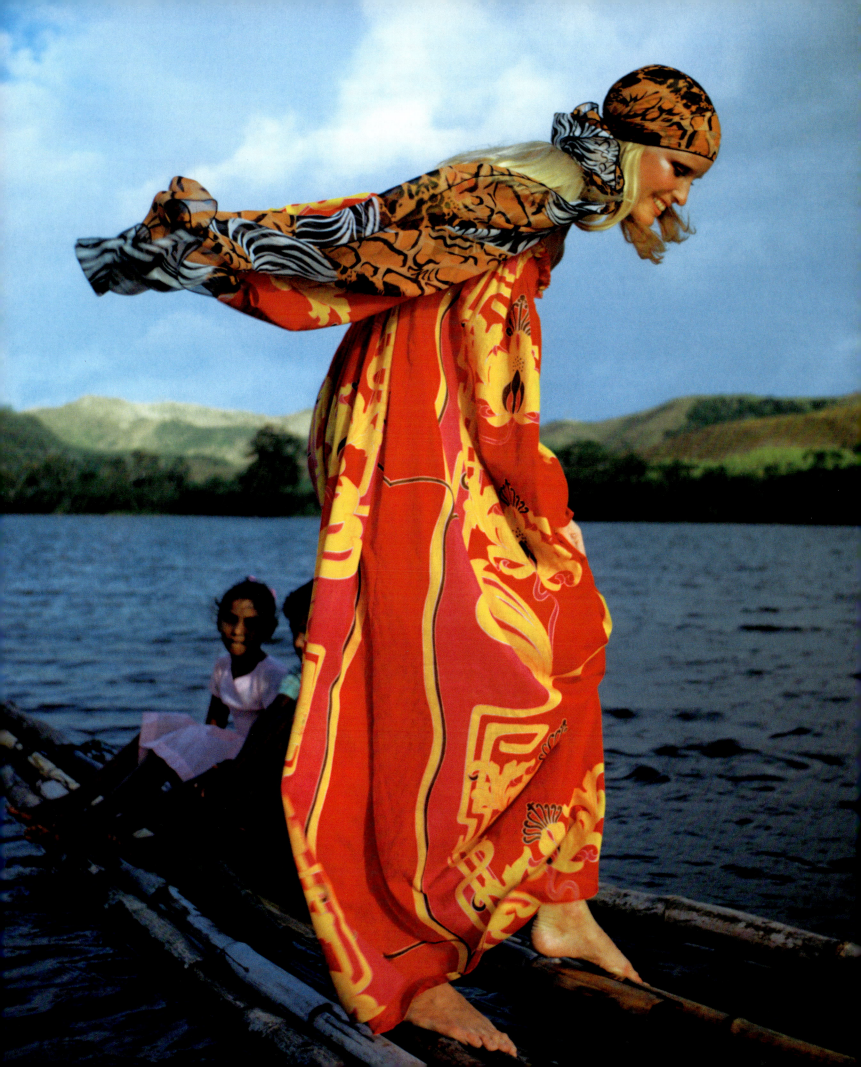

PREVIOUS SPREAD, LEFT: *Liya Kebede in the rainforest wearing a parachute-strapped dress by Junya Watanabe for Comme des Garçons. The fruit design is reminiscent of vintage tablecloths. Photographed by Arthur Elgort for* Vogue, *2003.* PREVIOUS SPREAD, RIGHT: *An Oscar de la Renta caftan in lacquer red cotton voile printed with flowers, fit to wear at home, out to parties, or as a swimsuit cover. Photographed on a raft in the Sigatoka River, Fiji, by J.P. Zachariasen for* Vogue, *1971.* RIGHT: *In the 1960s, Italian designers reincarnated beach pajamas as lavish palazzo pants. This Forquet evening ensemble of silk organza shawl and dhoti pants is very much in this jet-set spirit. Mimi di N earrings, Coppola & Toppo anklet. Photographed at Durbar Hall, Jag Mandir Palace, Udaipur by Henry Clarke for* Vogue, *1967.*

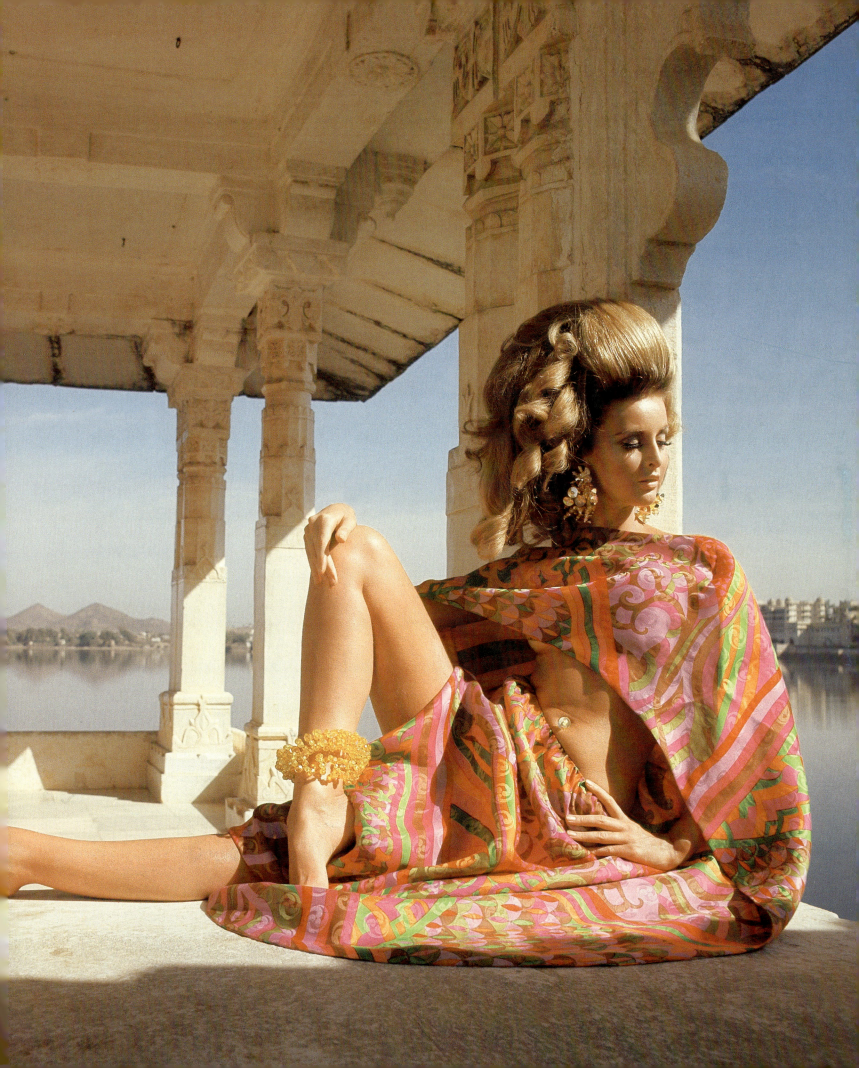

SEVEN

The Bathing Suit

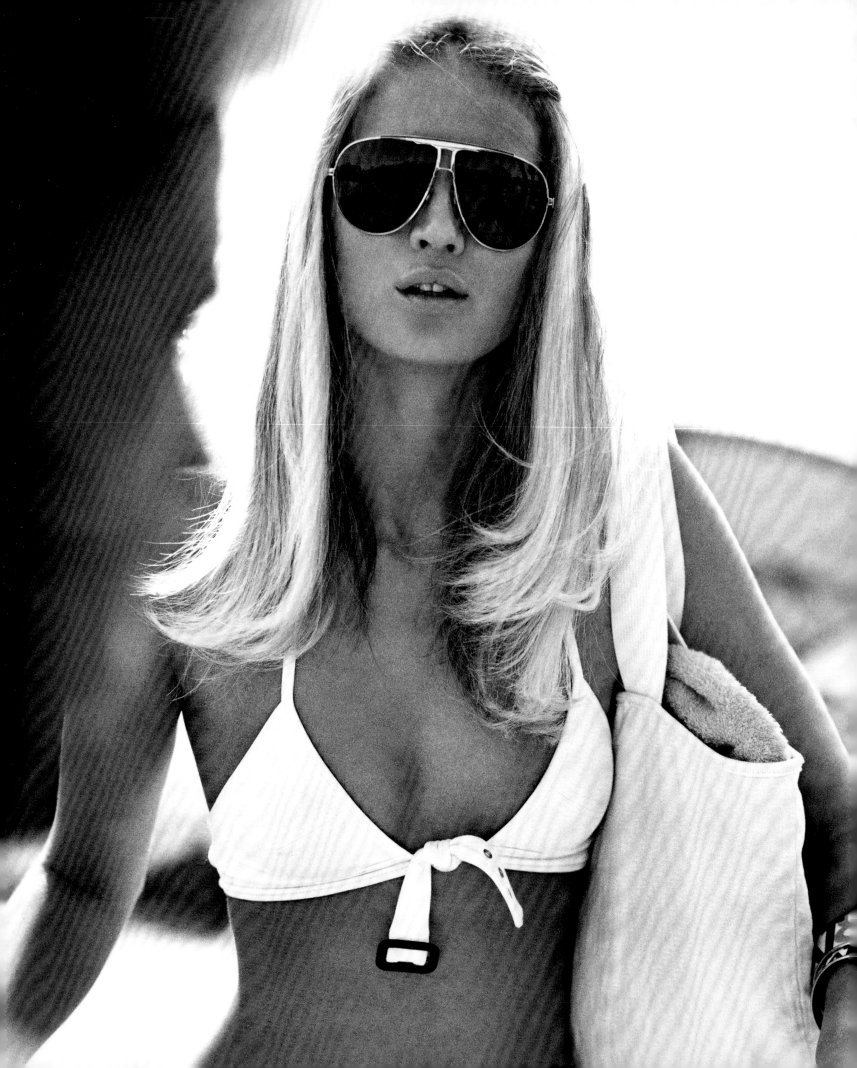

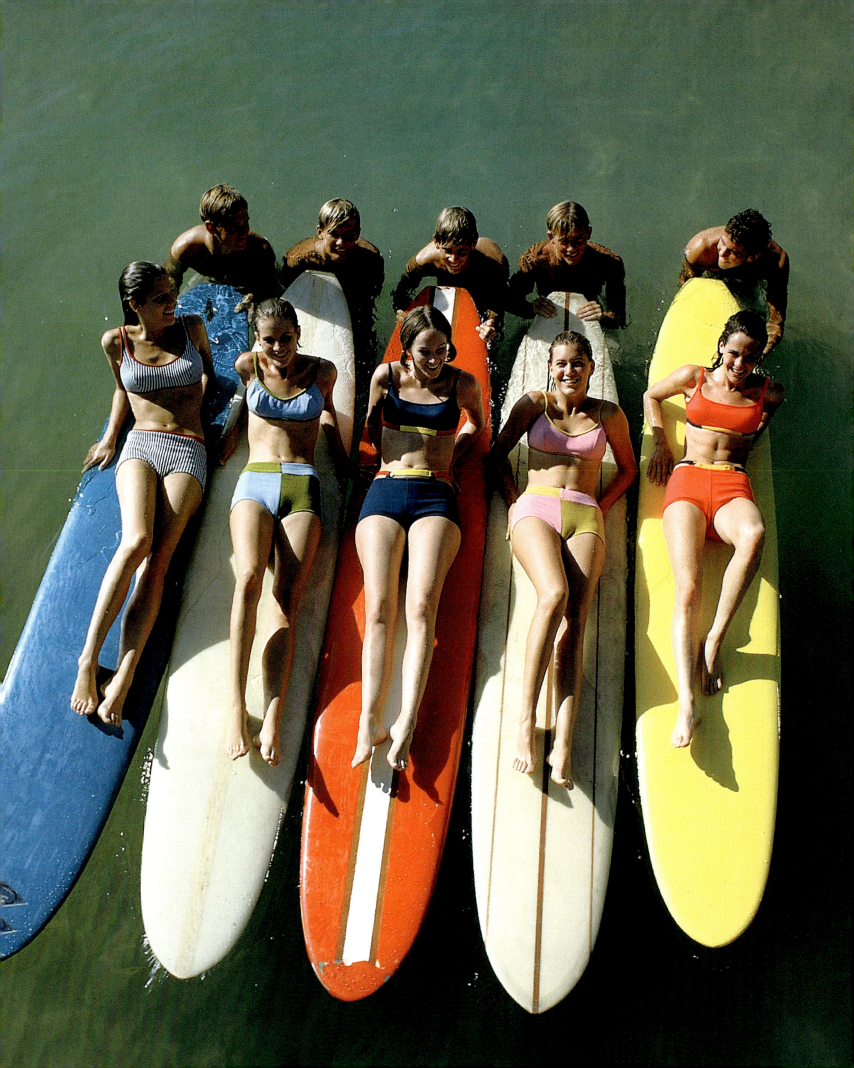

THE BATHING SUIT

Prior to the late nineteenth century, swimming was an activity that was performed for its bracing health benefits and, in typical Victorian style, had to be done with as much fuss and bother as possible. Perhaps the most preposterous, to contemporary minds, convention of the Victorian seaside experience was the bathing machine: a kiosk that was wheeled into the waves and from which the female swimmer could descend into the water unseen. Not that there was much to see: women wore short dresses with bloomers, stockings, bathing shoes, and hats; men wore knitted one-piece garments or two-piece suits comprised of a short-sleeved jacket and knee-length pants. The road to bareness on the beach would be filled with detail-oriented bureaucrats devising municipal rulings to uphold Victorian mores, and newspapers looking to sell papers by publishing photographs of swimsuit inspections or, even better, comely exhibitionists being hauled off in black marias.

Swimming was just catching on as a sport when Annette Kellerman, an Australian, came to international attention as a kind of Irene Castle of the sea. Her early-twentieth-century swimming exploits were followed avidly, beginning with several attempts to swim the English Channel, and followed by water ballet and high-diving performances in vaudeville shows. In 1907 she was arrested in Boston for wearing the same suit on the beach that she wore during her performances; she then set out to devise a new type of suit for women that would be decorous without being a drag in the water. Using the style of her performance costume—a one-piece suit

PREVIOUS SPREAD: *Seventies redux, 2006. Celine bikini in polyamide elastin, D&G aviator glasses, Hogan bag, and Hermès enamel cuff. Photographed by Regan Cameron for* Allure, *2006.* LEFT: *Surfer girls, wearing rather modest bikinis by Jantzen, photographed around the time the television series* Gidget *debuted, 1965.*

with tank top and almost knee-length legs, similar to what men were then wearing—she added stockings to make a swim unitard.

For more than a decade following this, men and women swam in similar costumes of knitted sleeveless tunic and short trunks. By 1913 the American firm Jantzen was selling wool knit suits for rowers to wear. The company's emphasis on engineering suits that increased athletic performance was expressed in their emblem, an appliqué of a woman performing a graceful dive. During the late 1920s the maillot evolved, its name adapted from the French *maillot de bain*. Swimsuit makers steadily came up with new ways to make maillots fit well, dry quickly, and continue to fit once wet. Synthetic materials and experiments in elasticity made these developments possible.

As bathing suits were becoming more seaworthy and better equipped to enable vigorous swimming, there was a concurrent movement toward highly designed suits to see and be seen in. The requirements of glamorous resort life, as well as the increasing popularity of suntans, led to a category of bathing suits that were actually sunbathing suits. For men, this meant doing away with tank tops, which, as with every other advance in bareness, would take longer to accomplish in puritanical America than in Europe. By 1931, Paris designers were offering "sunburn" suits: maillots with tops that went from bare, to barer, to barest. Soon, bathing attire was being designed as deliberately as any other item of clothing. The fashion press reported breathlessly on increasing femininity, new developments in materials, bathing suits as part of ensembles, and, most of all, daring new expanses of skin revealed in them. Two-piece or bare-midriff suits were first shown in 1932 by Paris couturier Jacques Heim and were inspired by Tahitian styles shown at the Exposition Coloniale held in Paris the previous year. By the middle of the decade, two-piece suits were fairly common, worn by everyone from Hollywood starlets posing for publicity shots to haute couture clients like the Duchess of Windsor, who was photographed cavorting in the water with friends wearing a bare-midriff suit in 1938, when she was approaching forty years of age.

Jantzen was referencing its own 1930s styles in this streamlined, athletic suit of nylon and Spandex from 1988. Photographed by Wayne Maser for Vogue, *1988.*

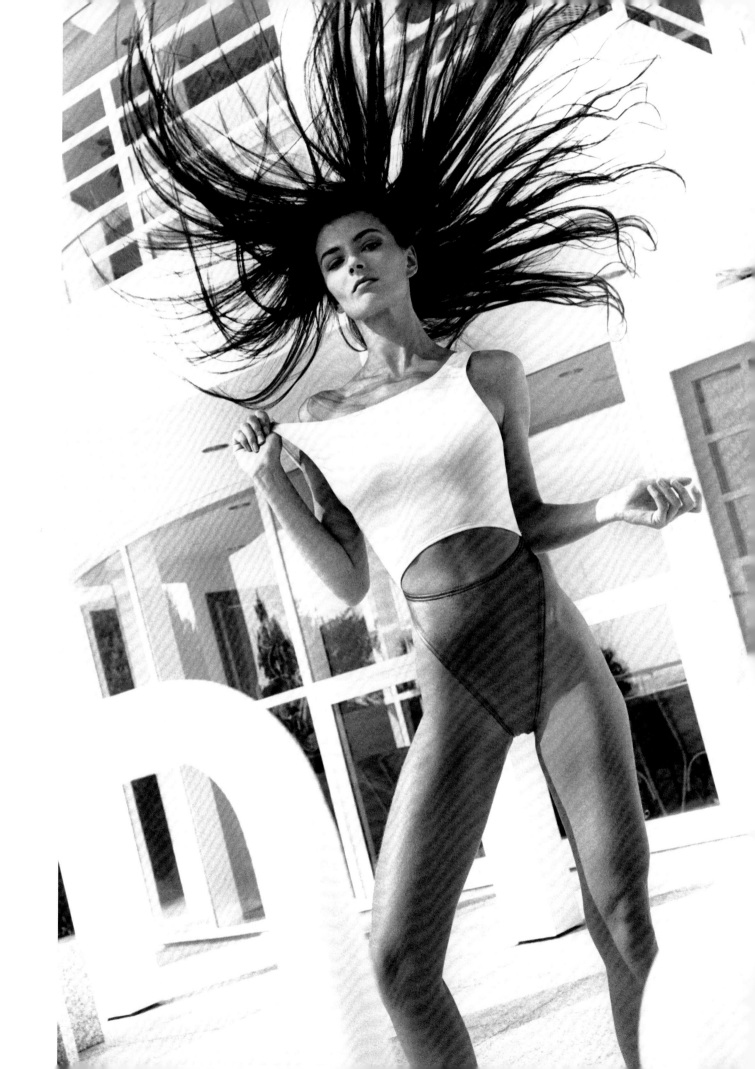

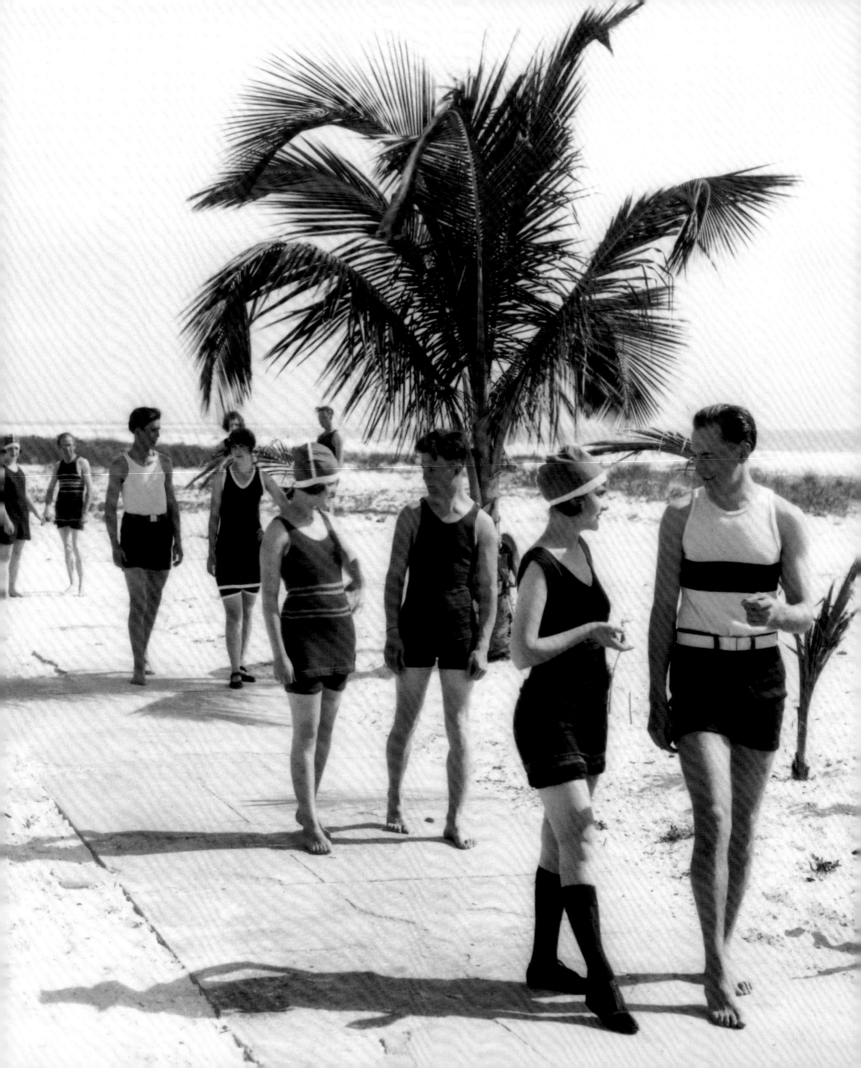

Designed suits could take a number of forms. While some designers were developing light-as-air second skins, California-based Rose Marie Reid, who began designing in 1932, was providing interior construction like boning, conical brassiere cups, and girdle panels. Synthetic versions of woven fabrics allowed designers to create shapes using shirring, sarong draperies, princess cuts, and twisted bandeaus. Some American designers, like Claire McCardell, saw the bathing suit as an integral part of a wardrobe, one of several interchangeable pieces that could take a woman through her entire day.

And then came the bikini. Its exact origins are controversial; on May 18, 1946, Virginia Pope wrote in the *New York Times* about Jacques Heim's collection, stating it "began with the formal evening gowns and ended with the most diminutive bathing suits seen anywhere, consisting of super-brief panties and bras." In honor of (and to publicize) its brevity, Heim named his suit the "Atome." A few weeks later, couture houses like Carven and Maggy Rouff also began trotting out abbreviated two-piece swimwear designs. Literally bringing up the rear was Louis Réard, who debuted a two-piece suit in June. An engineer turned boutique owner, rather than a couturier, Réard introduced a design that consisted of a bra top and a bottom resembling the loincloth-like trunks worn by male bodybuilders or wrestlers. To underscore its newsworthiness, it was made out of a fabric printed with a collage of newspaper clippings, reminiscent of Elsa Schiaparelli's amusing beach sunhats of 1935. On July 18, 1946, Réard registered his patent drawing for a bathing suit bottom fastening with narrow ties. A week later, the first nuclear tests at Bikini Atoll in the Marshall Islands occurred. Riffing on Heim's "Atome," Réard called his design the bikini, the idea being that it was so much smaller, it was a "split atom," like the ones produced in the bombs that were dropped on the atoll.

The earliest bikini that looks like a bikini to contemporary eyes is the Carolyn Schnurer design worn by Dovima in the 1947 photograph by Toni Frissell.

Tampa promenade, 1920s. From the late teens into the early thirties, men and women dressed similarly for swimming, in wool knit tank tops, sometimes worn as tunics, and shorts.

Available by special order only, it was probably commissioned by the fashion editors to make an editorial point and, thus, especially revealing.

Bikinis would continue to be considered daringly "European" for quite some time. *French Vogue* cautioned in 1953 that two-piece suits should be reserved for solitary beaches or private boats, and that maillots might be more appropriate for hotel pools. When offered by American designers, bikinis were usually described as being more modest than their St. Tropez, Amalfi, or Rio counterparts. That they were not yet an ordinary sight by the beginning of the next decade is clear in a scene from the 1962 James Bond film *Dr. No*. Sean Connery's Bond is so taken aback by the apparition of Ursula Andress rising Venus-like from the sea in a beige bikini that a momentarily goofy expression crosses his typically suave-looking face. The explosive popularity of the bikini during the years that followed was aided by two particular conditions of prosperous postwar America and the Baby Boom: the new popularity of private swimming pools and the "youthquake." Bareness became an integral part of 1960s fashion, with each new inch of raised hem or exposed midriff skin representing another victory in the war on uptight propriety.

Every bit as much a publicity stunt as the introduction of the "Atome" and the bikini—though, ultimately, far less influential—was the topless bathing suit designed by California sportswear designer Rudi Gernreich in 1964. Gernreich had been making bathing suits since 1952; seeking to banish the constructed, corseted suits he saw all around him, he made tank suits out of wool knit that were daringly unconstructed but also a throwback to the knitted wool suits of the 1910s and 1920s. The outrage to the topless suit was global, with everyone from the Pope to the Soviet government weighing in, the latter decrying it as another example of "capitalist decay." *Sports Illustrated* writer Frank Deford opined that the suit "managed somehow to make bare breasts unbecoming." (Gernreich later admitted he had intended it more as a theoretical statement about attitudes toward nudity than as a potential item of apparel.) The trend toward more nudity on the beaches didn't require much design

On the Maspalomas Beach in the Canary Islands, Sondra Peterson wears a textured Orlon and Lastex knit suit by Maurice Handler and a white cotton sunhat. Photographed by Herman Landshoff for Mademoiselle, *1958.*

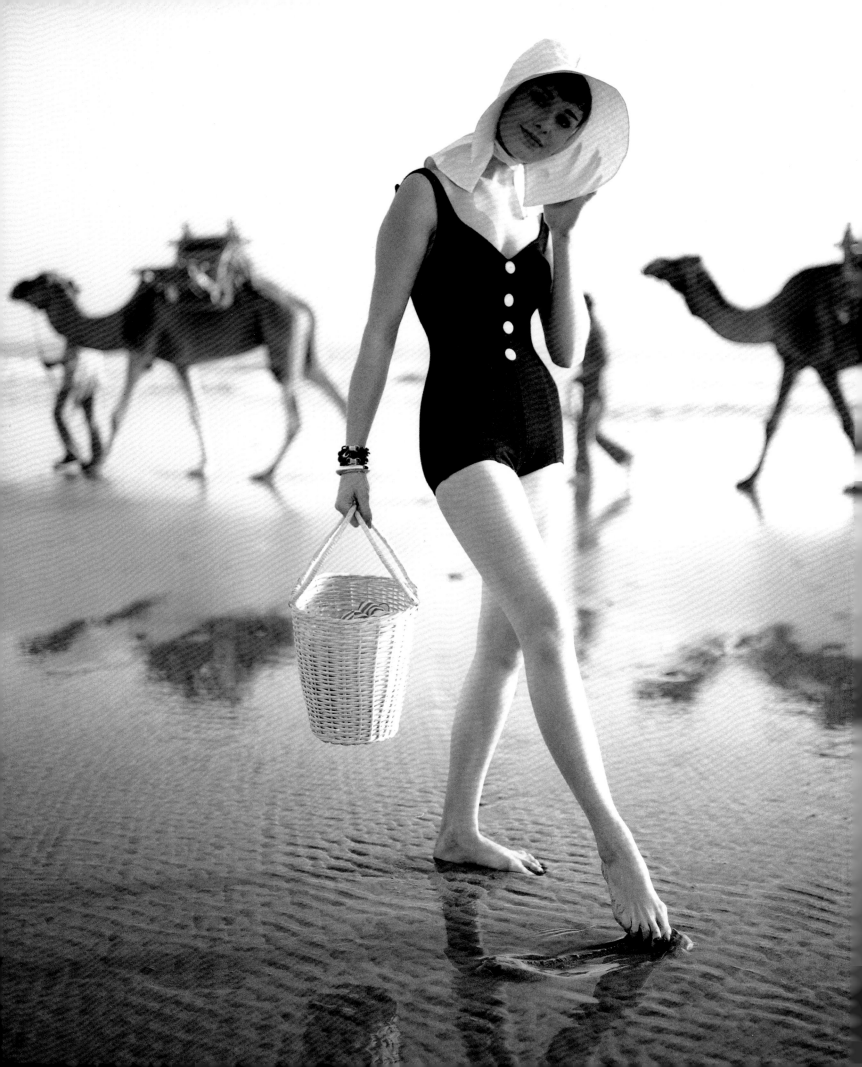

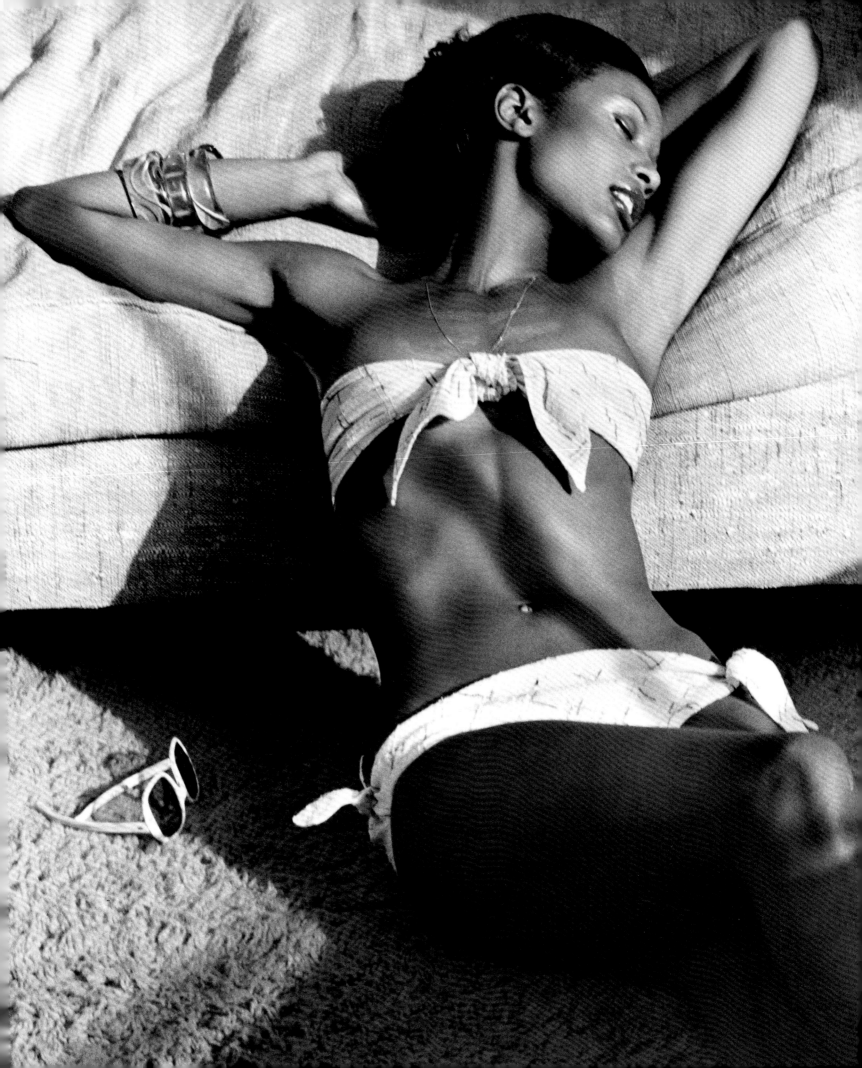

at all, anyway; by this time women, especially in Europe and on Caribbean islands like St. Barth's, simply took their bikini tops off.

Meanwhile, constructed suits continued to be designed, sold, and worn by the more modest customer base. The chunky wool knits Gernreich and others had used were supplanted by a new generation of test-tube fabrics being developed by companies like Dupont. The increasingly aerobicised figure of the 1980s (surgically perfected would be next) called out for emphasis rather than camouflage. Late-twentieth-century suits showcased the bottom and the upper leg, just as earlier designs had gotten barer and barer on the top. In the February 1980 swimsuit issue of *Sports Illustrated*, Christie Brinkley posed in an almost entirely backless Norma Kamali bathing suit aptly named "Half Moon."

The dangers of melanoma became more widely known during the early 1990s, and swimwear that covered more rather than less skin gained favor. Originating in Australia were suits made with elbow-length tops and knee-length shorts. Bathing suit style came full circle with the super-aerodynamic Speedo LZR, introduced before the 2008 Summer Olympics; a unitard, it is reminiscent in coverage of the suit devised by Annette Kellerman one hundred and one years earlier.

Beverly Johnson wearing a white bikini with wrap-around bandeau top, Vogue pattern #2881. Photographed by Kourken Pakchanian in artist Peter Lobello's New York loft, 1973.

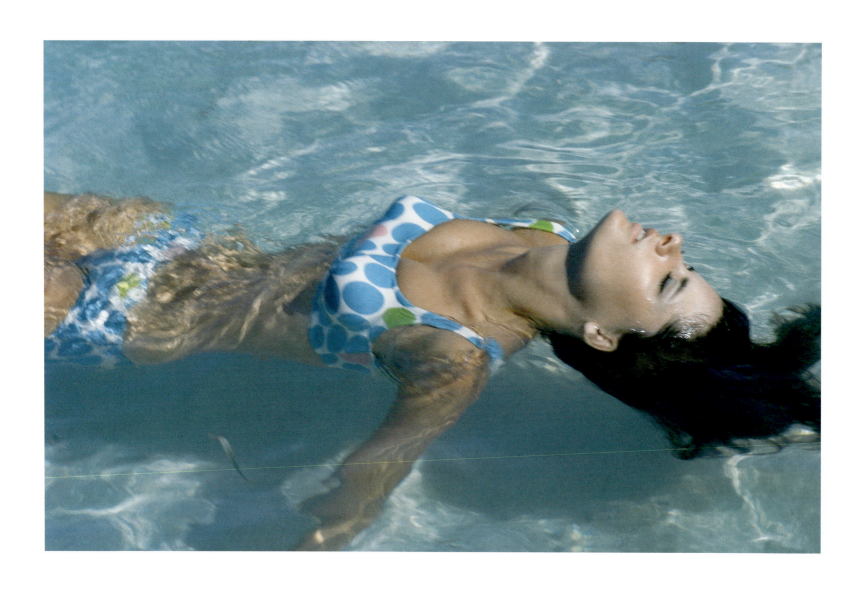

A hardly teeny polka-dot bikini designed by Rose Marie Reid. Photographed by Sante Forlano for Glamour, *1965.*
RIGHT: *With rugs, a silver tray, stemmed wineglasses, and a portable phonograph, the beach became a place to spend a full day. Here at Cap d'Antibes's plage de la Garoupe, this languorous sun worshipper, Chou Valton, has pulled her suit up at the bottom and down at the top to maximize her tan. Photographed by Jacques-Henri Lartigue, 1932.*

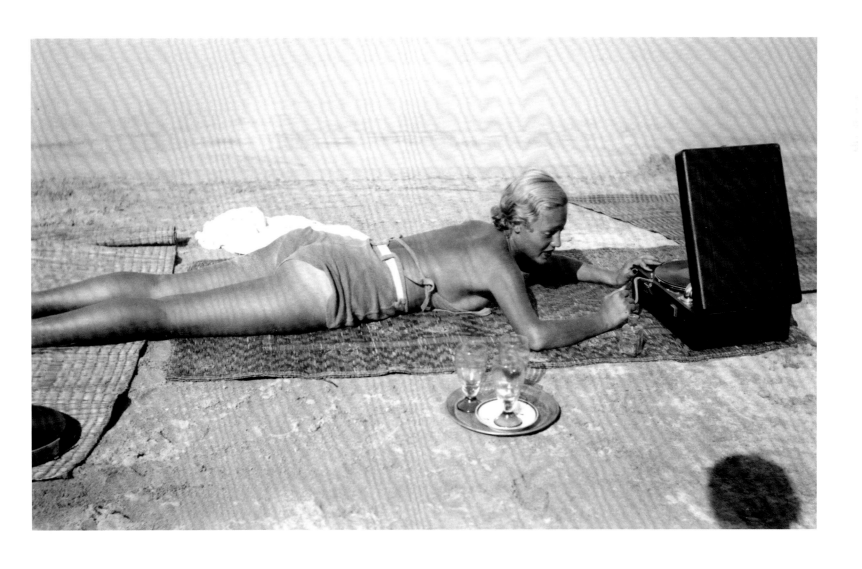

235

ABOVE: Mademoiselle *described this suit as a "skin-suit" made of a knit that "stays loyal to every last curve, in and out of water." Hat by Sally V. Photographed by Herman Landshoff for* Mademoiselle, *1958.* RIGHT: *The illustrator Antonio Lopez filming Jerry Hall wearing "the smallest bikini on any horizon" in navy and white stripes by Walter Albini. Manolo Blahnik gold sandals and Yves Saint Laurent bangles. Photographed at the Jamaica Inn, Ochos Rios, Jamaica, by Norman Parkinson for* British Vogue, *1975.* FOLLOWING SPREAD: *"Le Bain de Mer." Aquarelle by Charles Martin,* Sports et Divertissements.

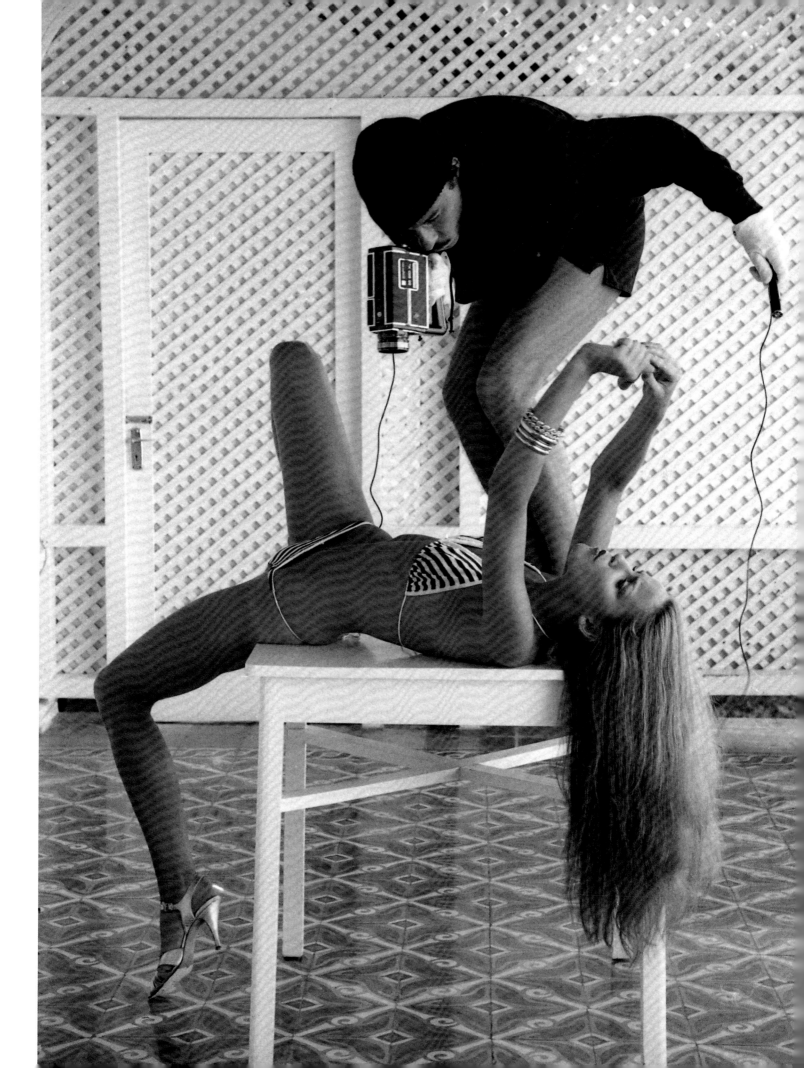

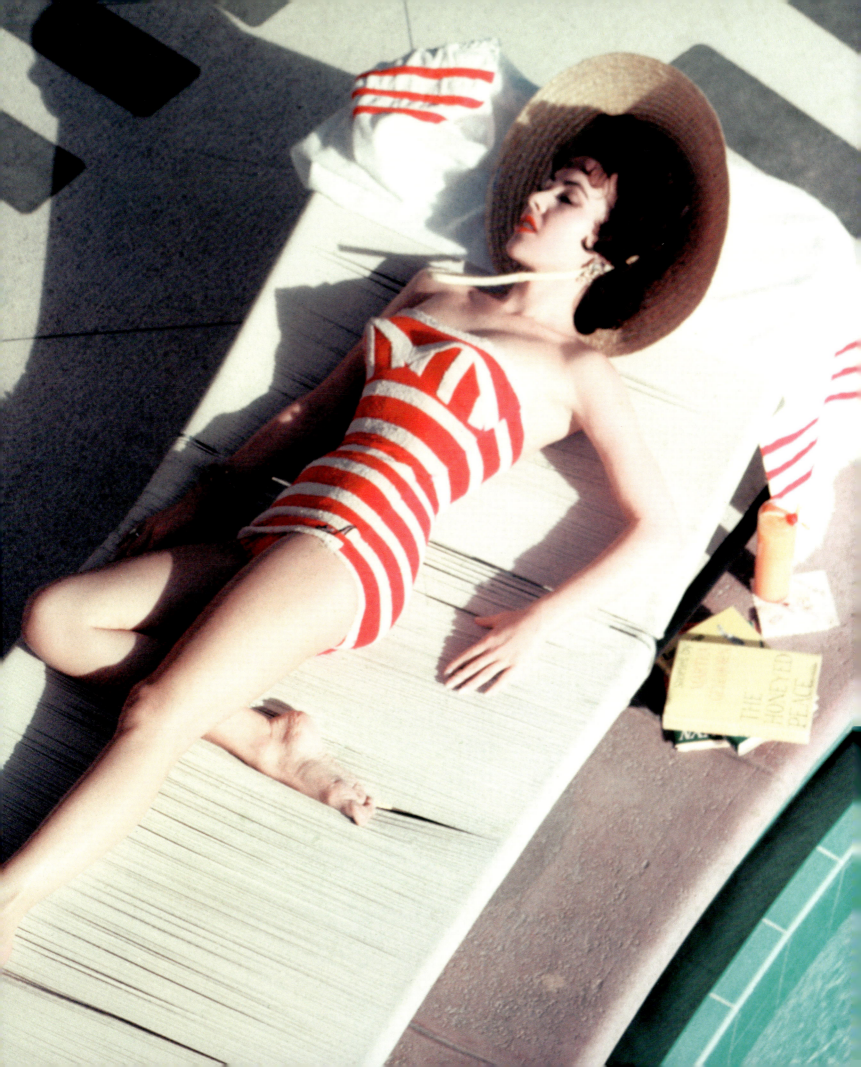

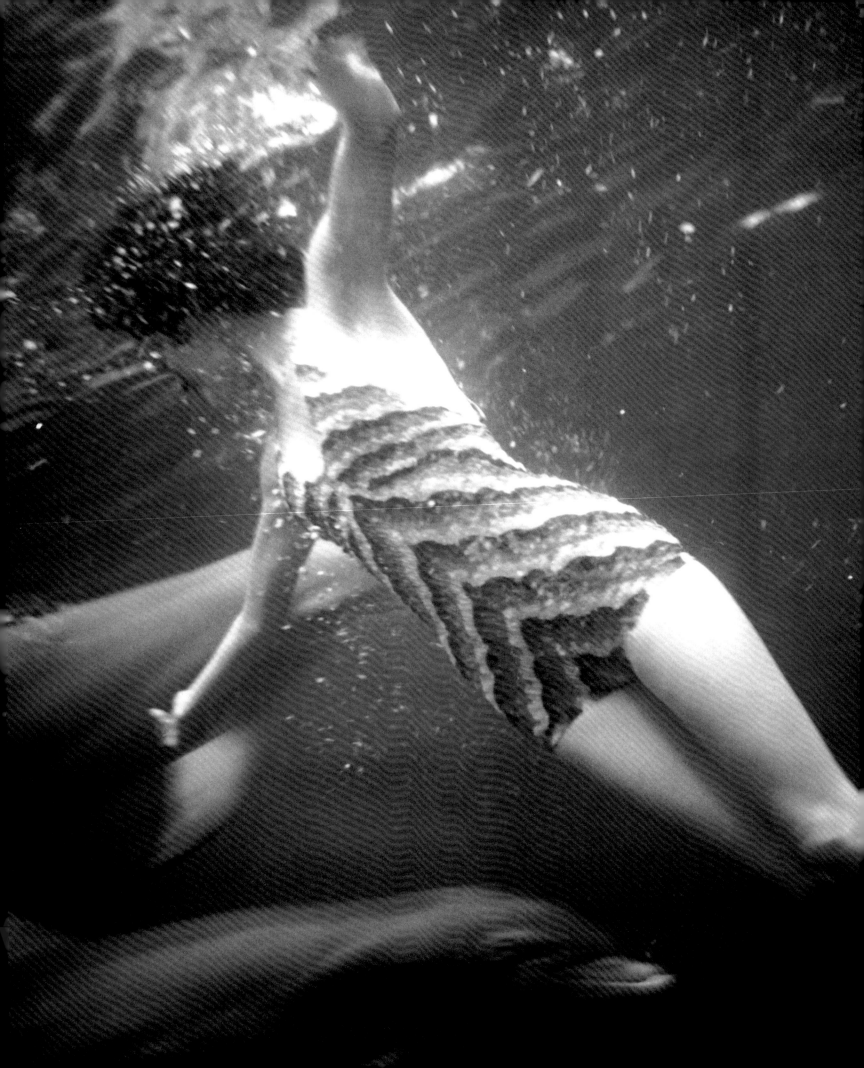

PREVIOUS SPREAD: *At the Sands Hotel, Las Vegas, Austrian actress Mara Lane wearing an elaborately constructed Jantzen swimsuit. Photographed by Slim Aarons, 1954.* LEFT: *Late 1930s developments in stretch fibers had a tremendous effect on dress, from hosiery and underwear to sportswear and even evening clothes. This 1939 suit from Macy's was made of a test-tube material called Matletex; it could be crushed to fit inside the hand but then stretch to cover an entire body. Photographed at Marineland, Florida, by Toni Frissell for* Vogue, *1939.*

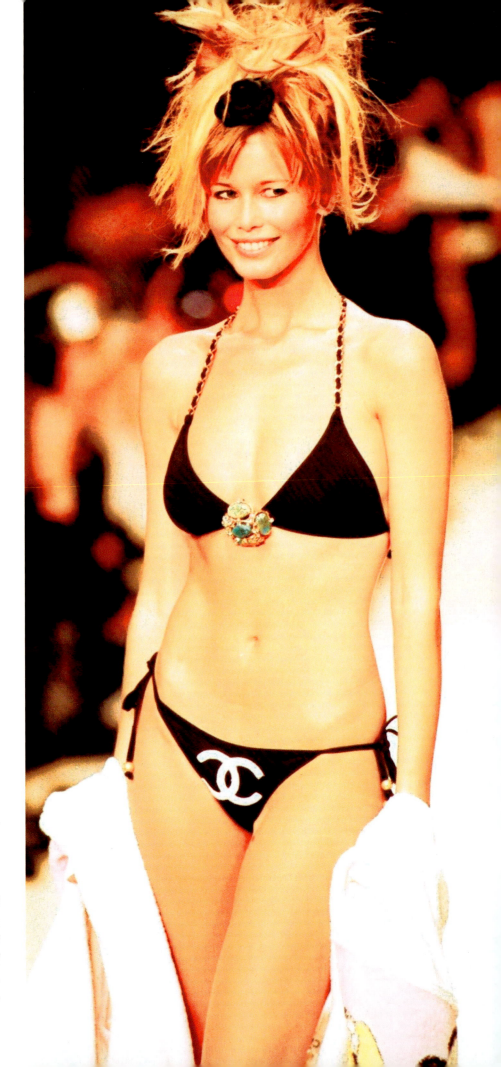

RIGHT: *Chanel logo bikini, worn on the runway by Claudia Schiffer, 1994. Even in this abbreviated format, Karl Lagerfeld is able to incorporate several Chanelisms: the chain handle straps, the jeweled brooch, and the prominently placed logo.* FAR RIGHT: *Shot on top of the mountain Nemrud Dagh in Turkey beside an enormous royal portrait, this model wears a Catalina maillot shaped by French seams and a coif of organdy by Halston of Bergdorf. Photographed by Gleb Derujinsky for Harper's Bazaar, 1962.*

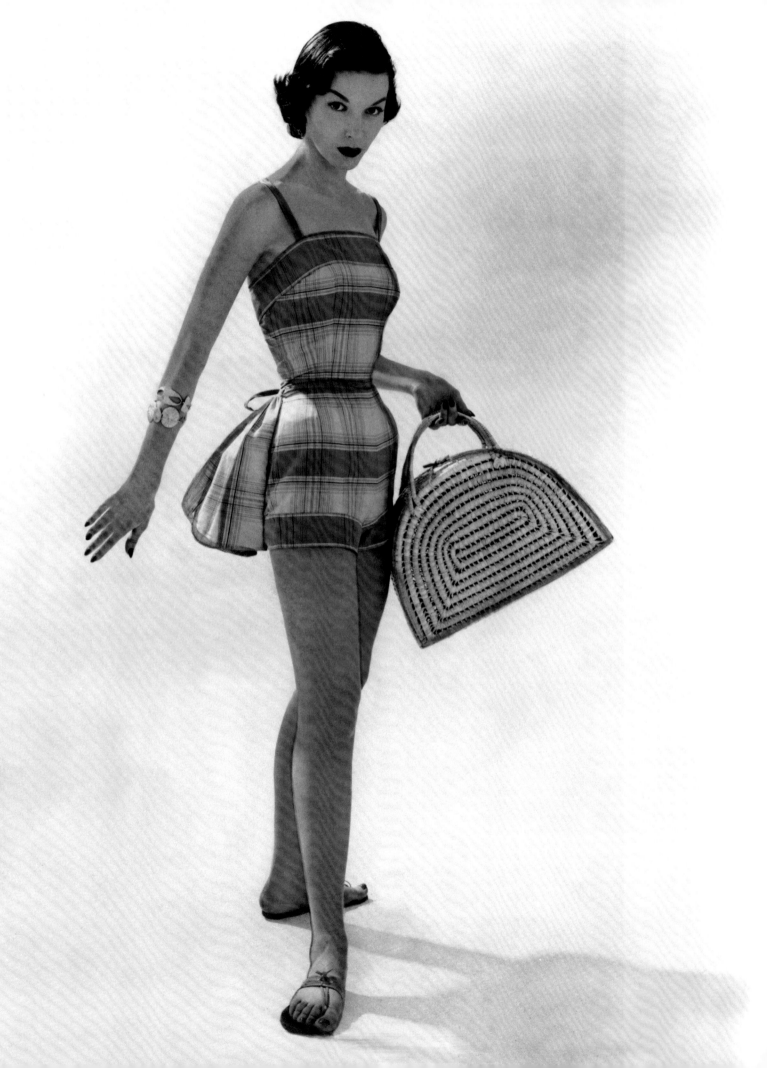

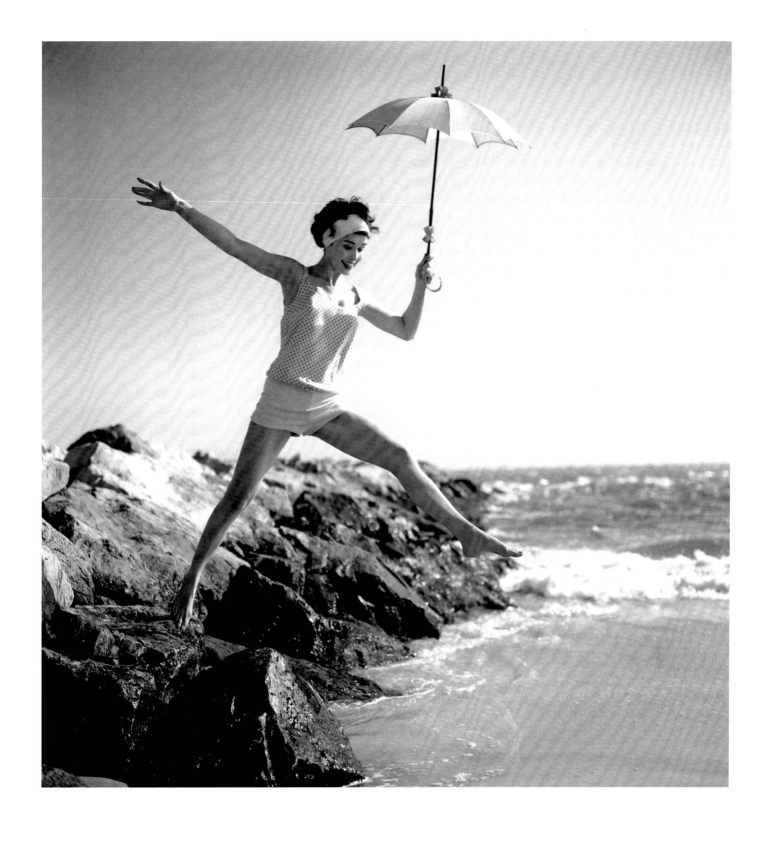

LEFT: *Tina Leser bustle-back dressmaker swimsuit in cotton, 1955.* ABOVE: *Gamboling into the surf 1958. Sondra Peterson wears a one-piece bathing suit designed by Elisabeth Stewart to look like knit shorts and a dotted knit top. Photographed by Herman Landshoff.*

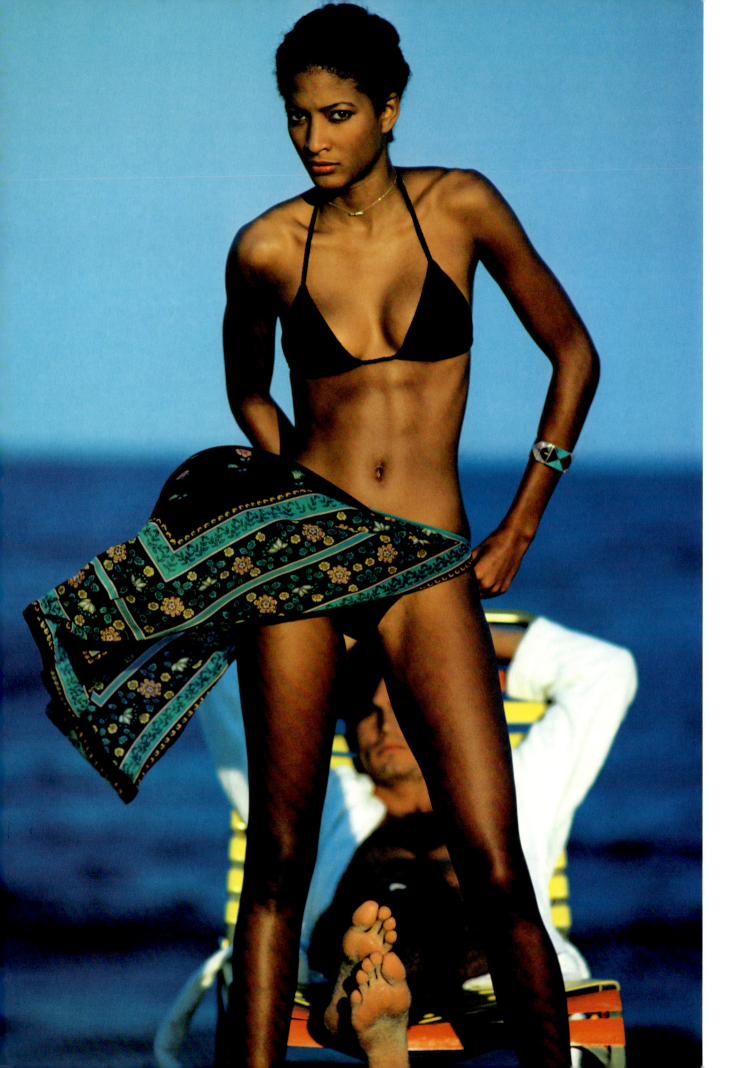

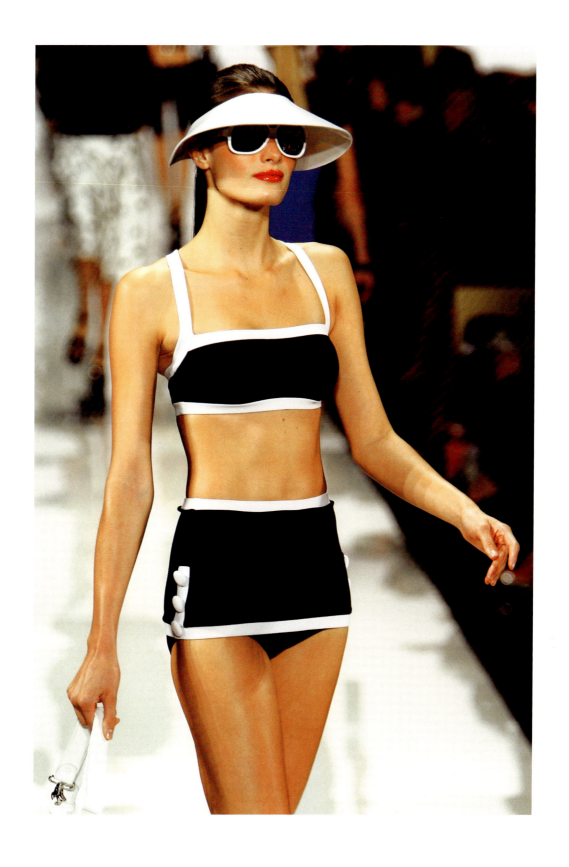

LEFT: *Black string bikini with "no bra" bra top, worn with a sarong in turquoise, pink, and black by Barbara Grosberg for Going Places. Photographed by Guy Le Baube for* Vogue, *1977.* ABOVE: *Michael Kors skirtsuit and visor/hat from his Spring 2009 resort-themed collection.*

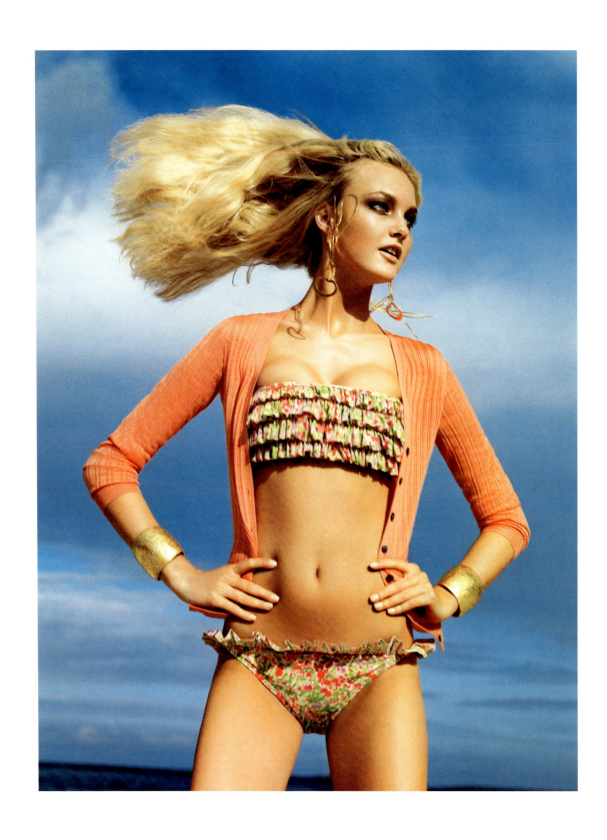

Michael Kors frilled Liberty-print bikini worn with a Louis Vuitton cardigan, Hervé van der Straeten earrings, and Lydia Courtelle cuffs. Photographed by Patrick Demarchelier for Vogue, *2008.* RIGHT: *Norma Kamali maillot in platinum, layered over a tank and worn with not one but two clear vinyl Chanel bags. Photographed at the Palais Royale, Paris, by Olaf Wipperfürth for* Jane, *2007.*

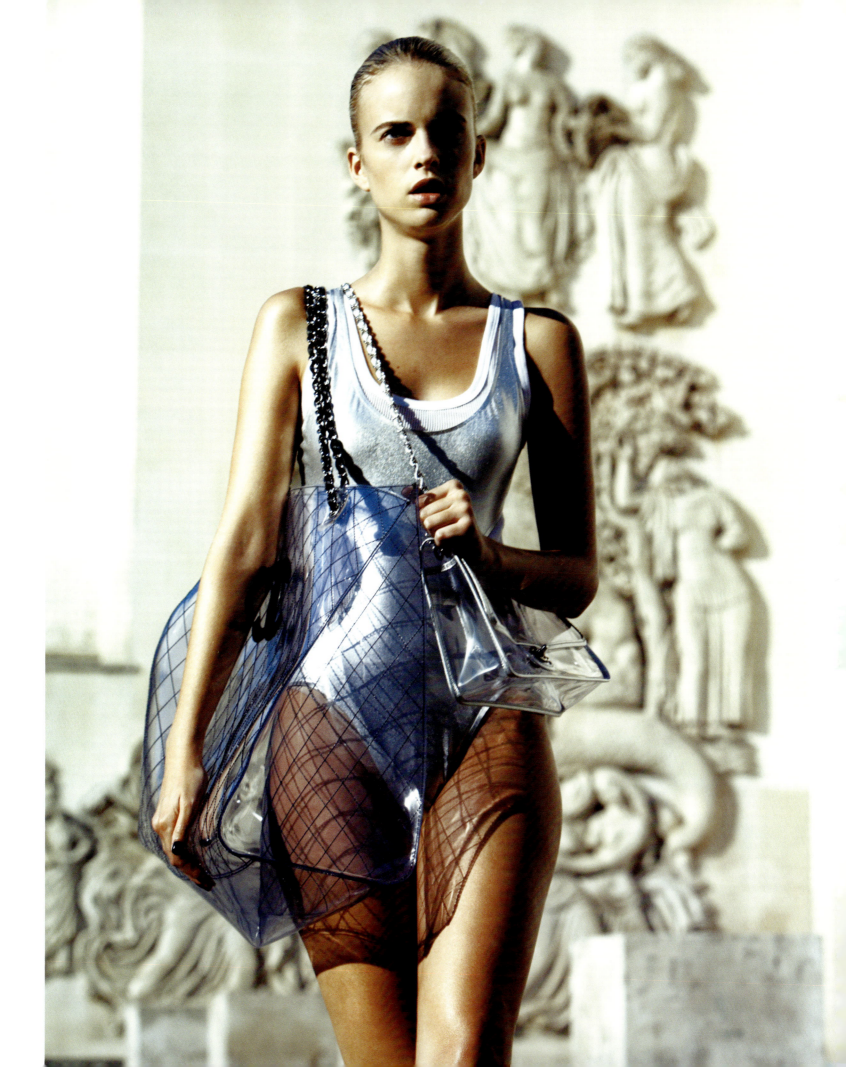

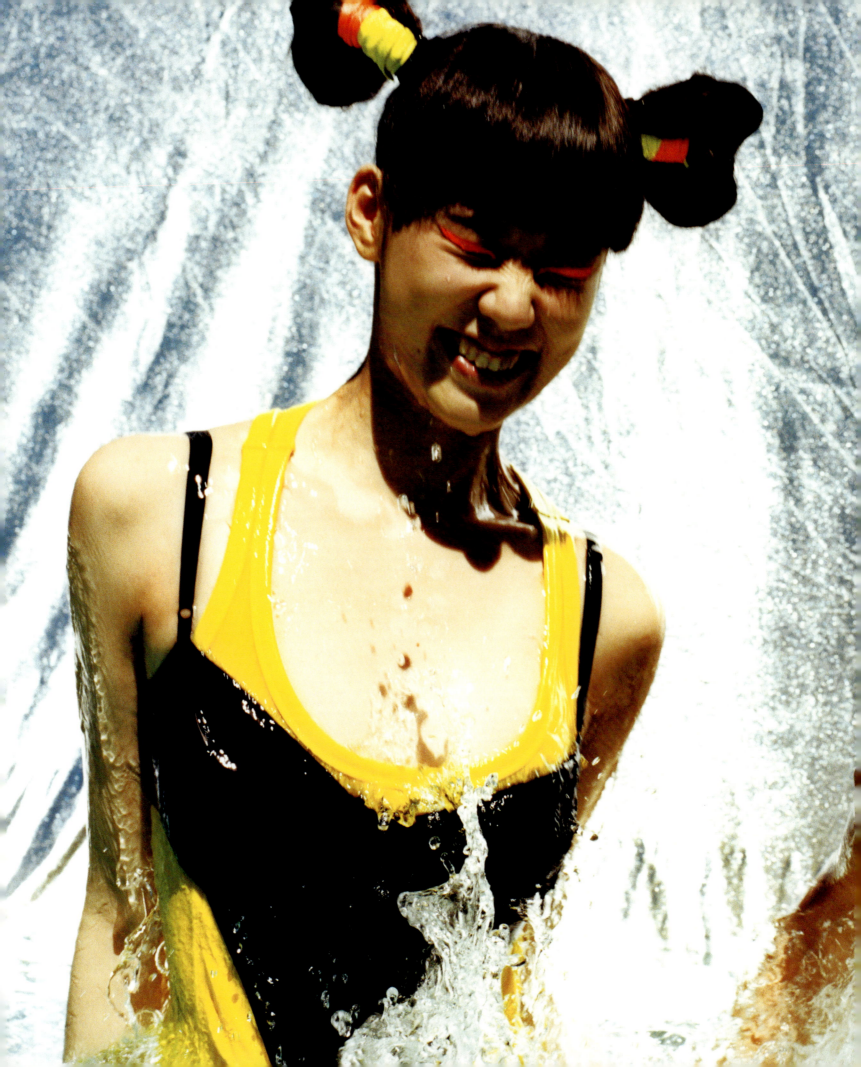

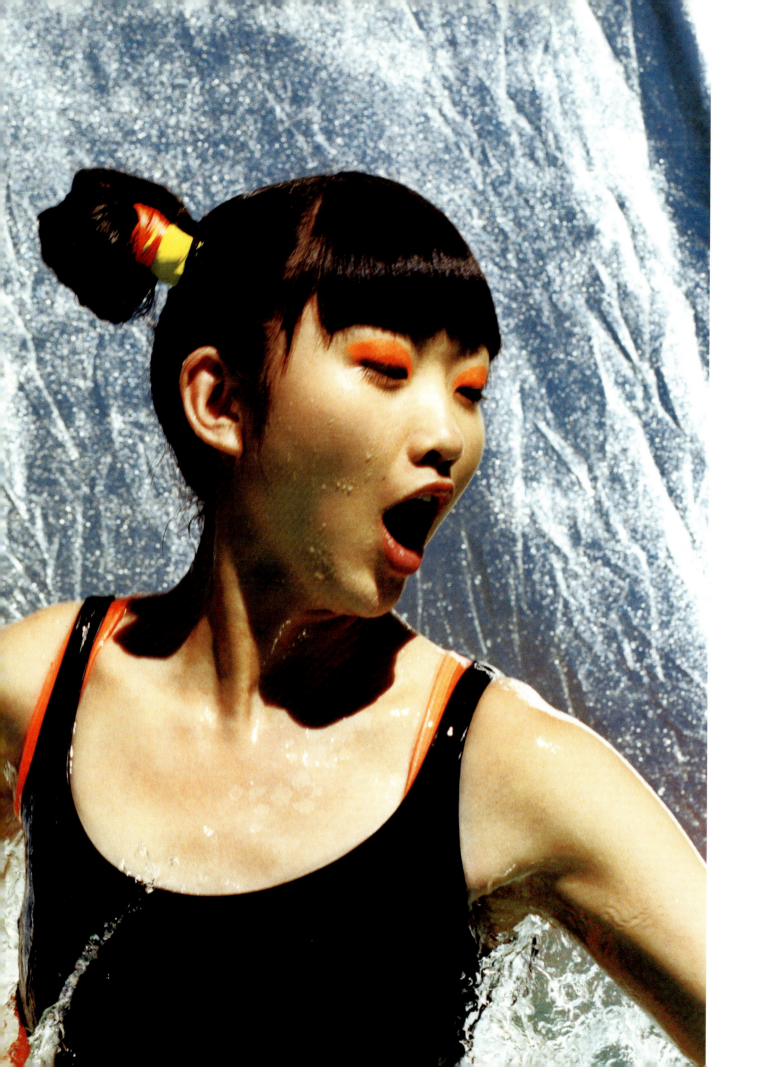

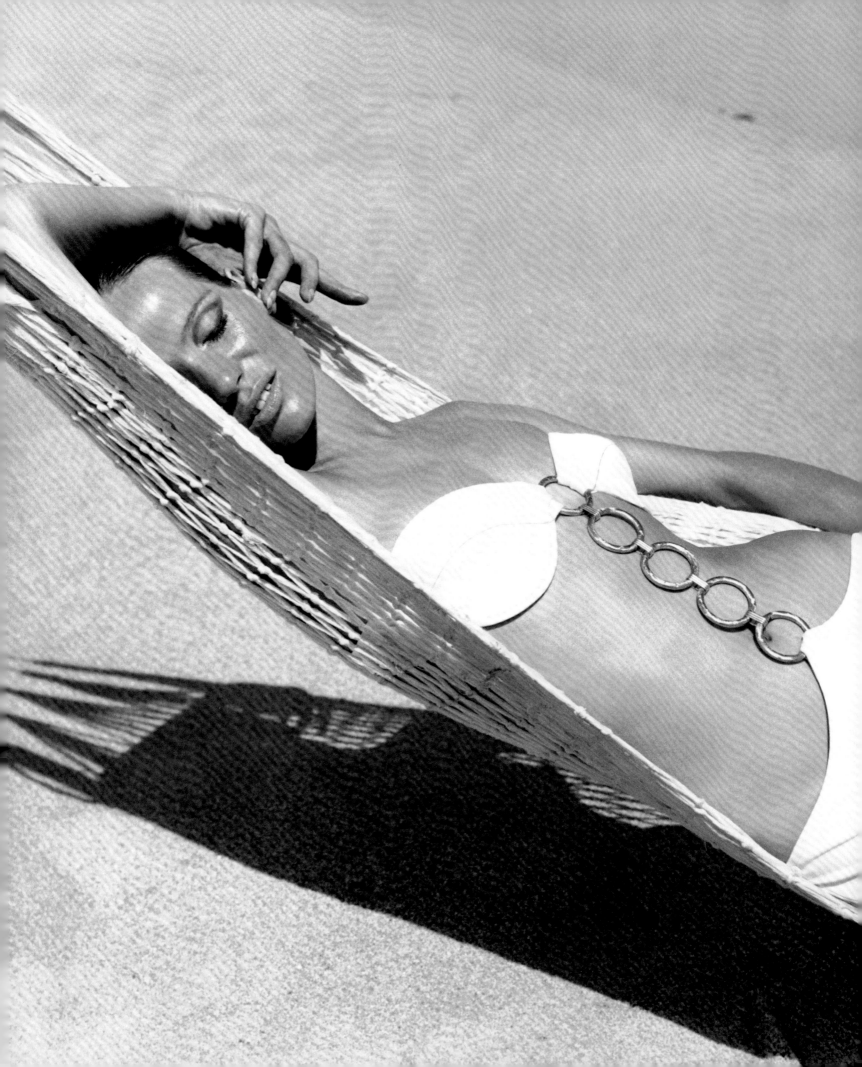

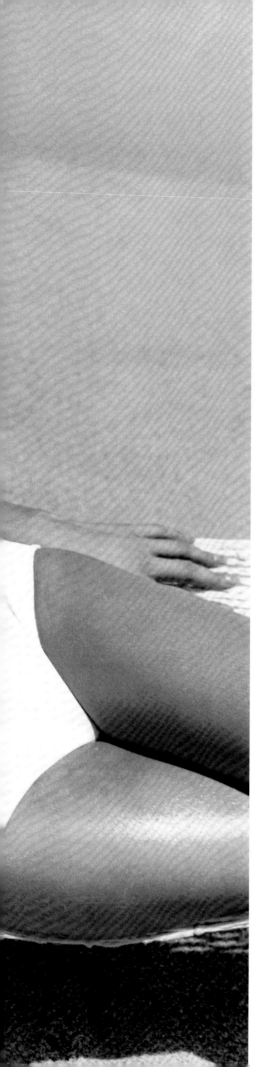

PREVIOUS SPREAD: *These cut-out suits by OMO Norma Kamali were shown in* Teen Vogue *layered over cotton tanks by DKNY and American Apparel. Photographed by Nick Haymes, 2007.* LEFT: *Supermodel Verushka, photographed in Brazil by her fashion photographer husband, Franco Rubartelli, wearing a Bill Blass design, 1968.*

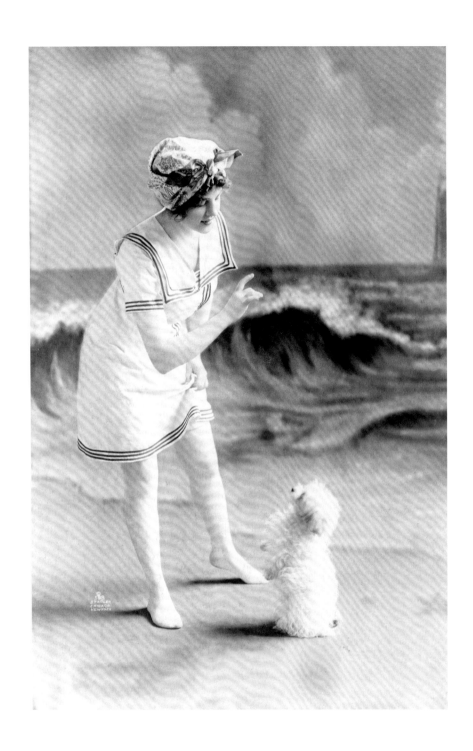

ABOVE: *Early bathing dresses often referenced sailor suits, a suitably nautical touch but also youthful to the point of being childish—sailor suits had been popular for children ever since the then Prince of Wales had been painted by Winterhalter wearing one in 1846. (Photograph circa 1913.)* RIGHT: *Jerry Hall reclining on a diving board wearing an Eres bikini of beige striped Lycra, its top open so as to perfect a deeply tanned décolletage. Photographed at the Royal Biscayne Hotel, Key Biscayne, Florida, by Helmut Newton for* Vogue, *1975.* FOLLOWING SPREAD: *Dinner jackets and dazzling décolletages were integral to James Bond films—almost as integral as the Bond Girl in her bikini. Many websites list favorites, but always making the top ten are Ursula Andress (left page), photographed in Jamaica while filming* Dr. No, *1962, and Halle Berry in* Die Another Day, *2002 (right page).*

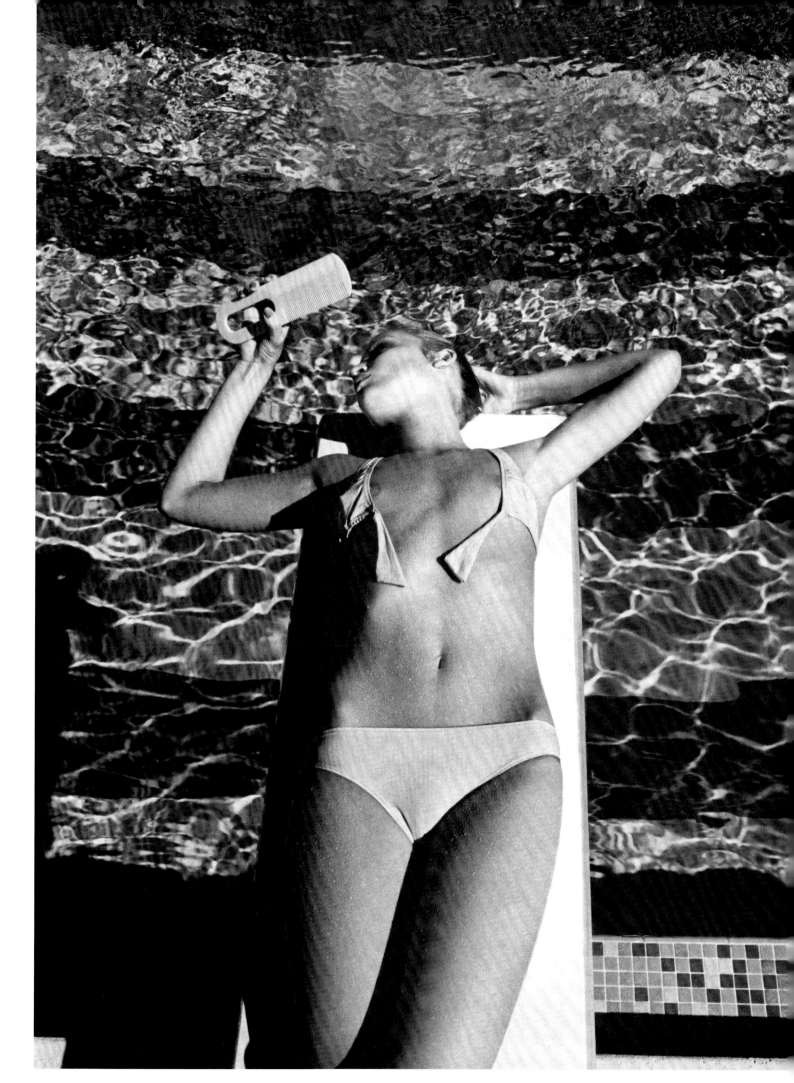

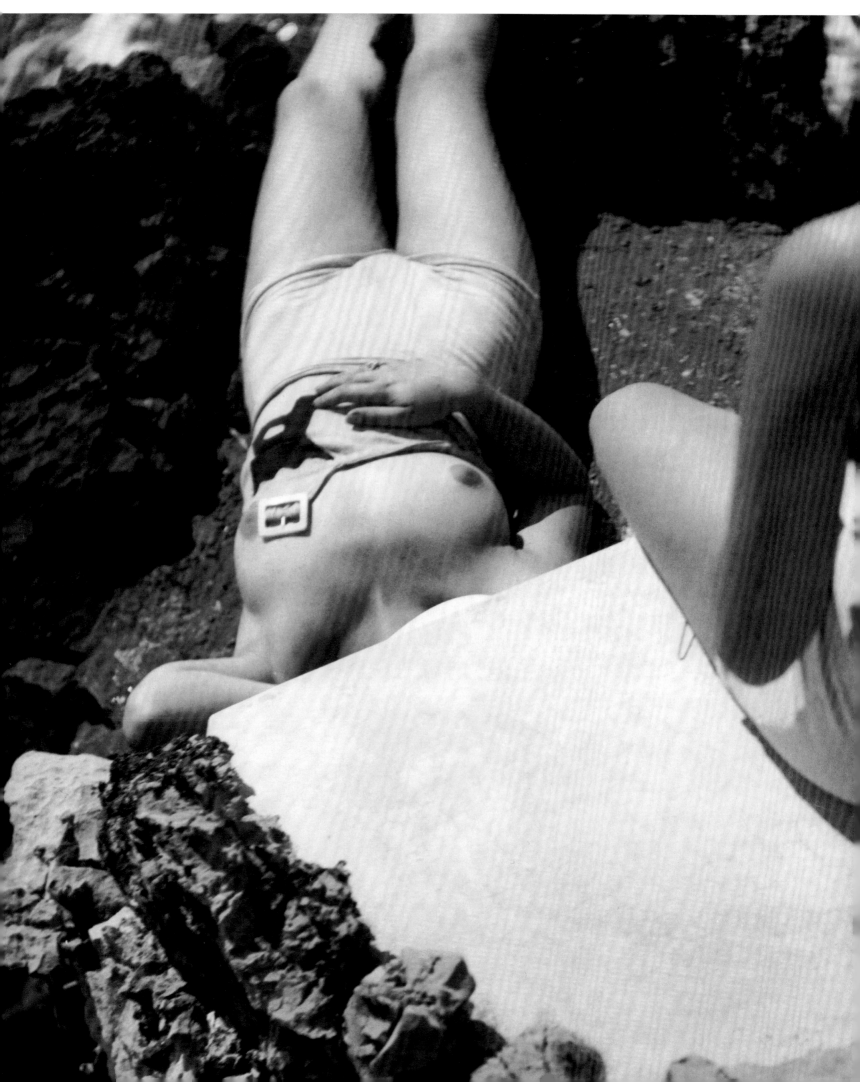

Mother-daughter dressmaker suits with watercolor hibiscus print, 1961.

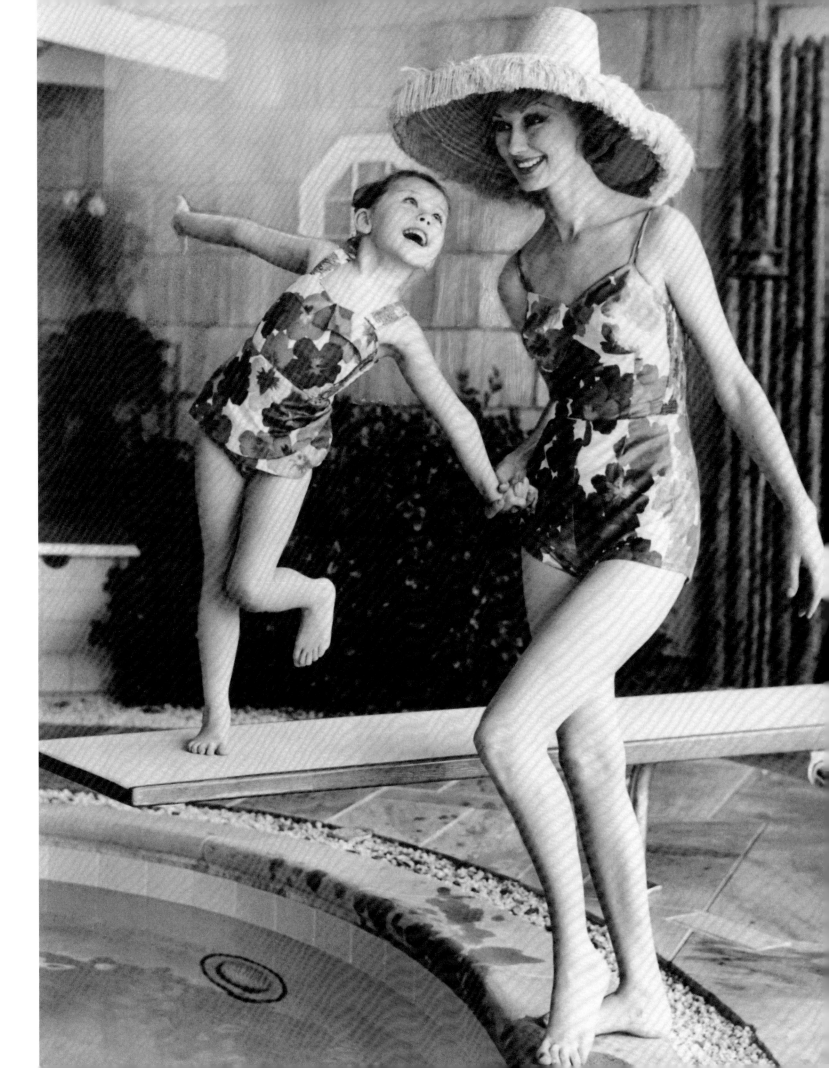

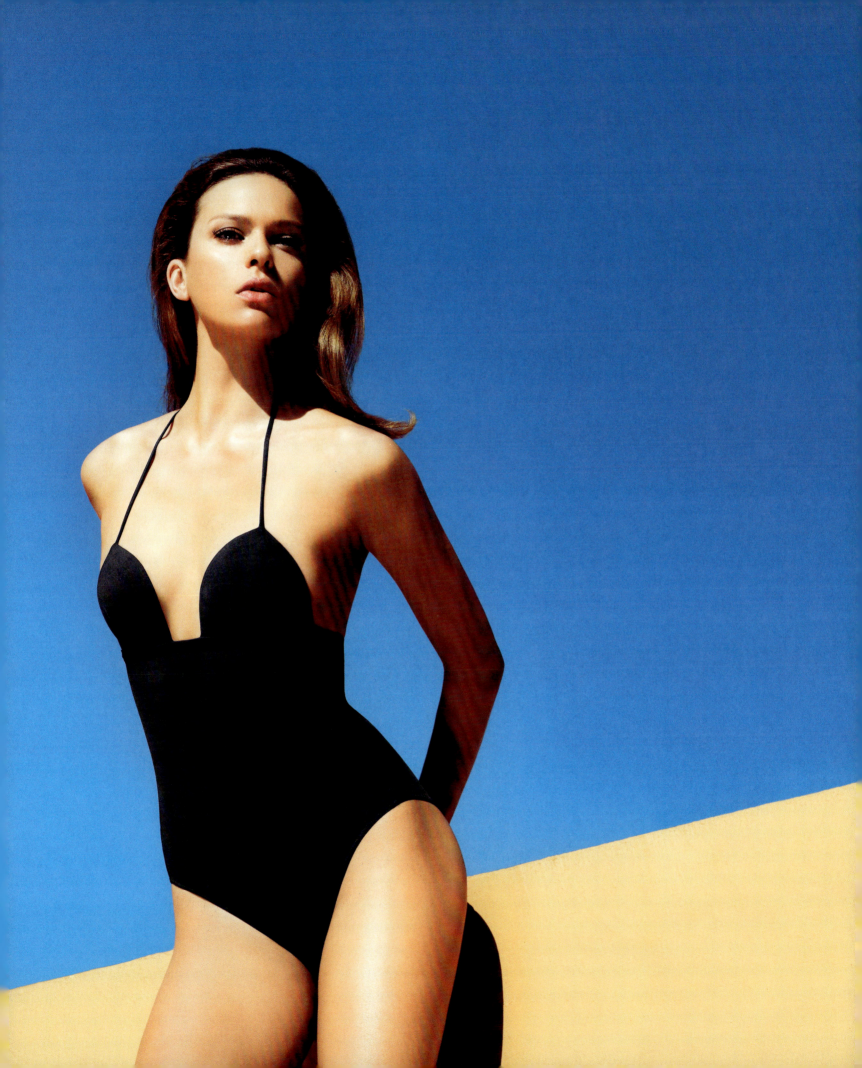

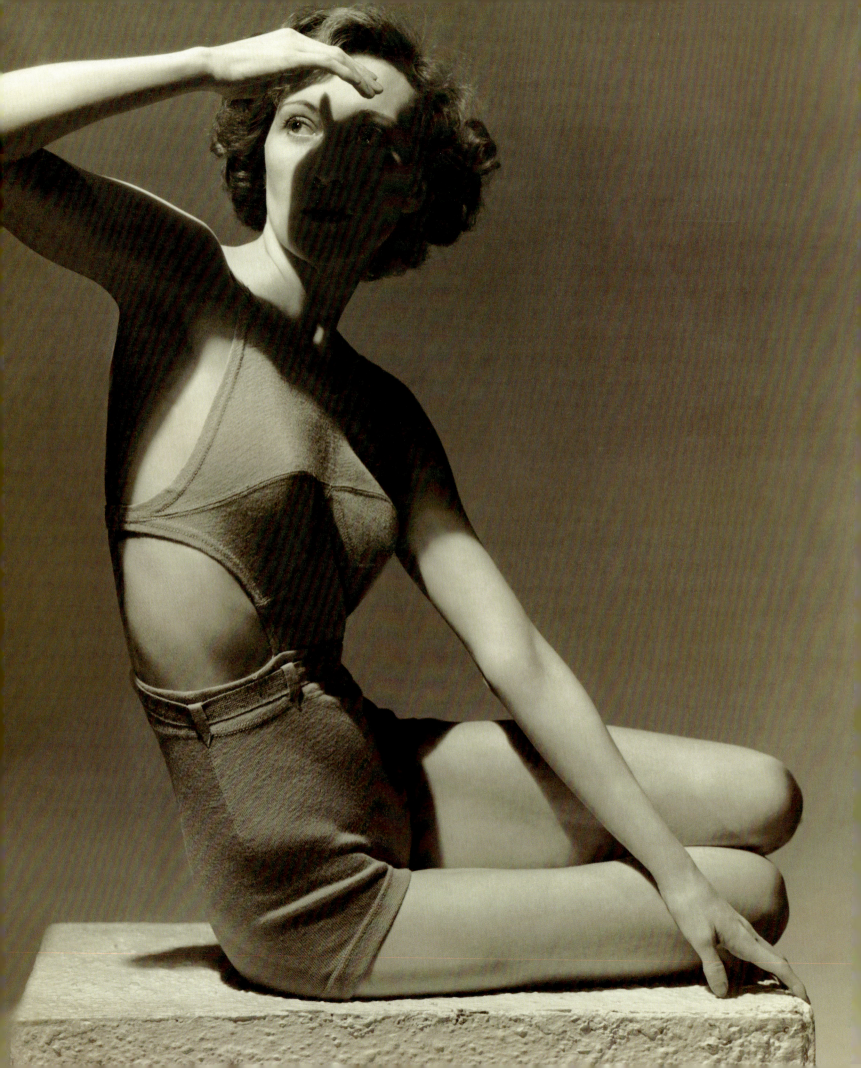

PREVIOUS SPREAD: *Eres suit in a fabric called "peau douce," 2008.* LEFT: *Jantzen suit with daringly cutaway sides. Photographed by Horst P. Horst for* Vogue, *1934.*

Dovima wearing a green and white rayon "token sunning suit" designed by Carolyn Schnurer. Photographed on Montego Bay, Jamaica, by Toni Frissell for Harper's Bazaar, *1947.*

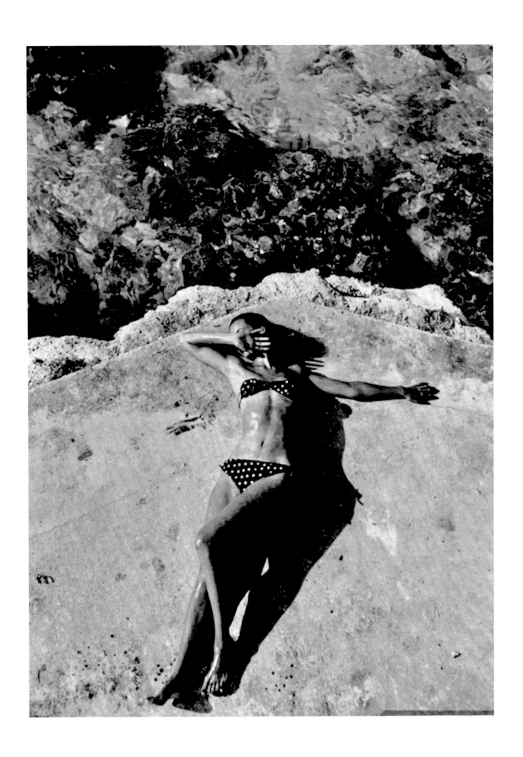

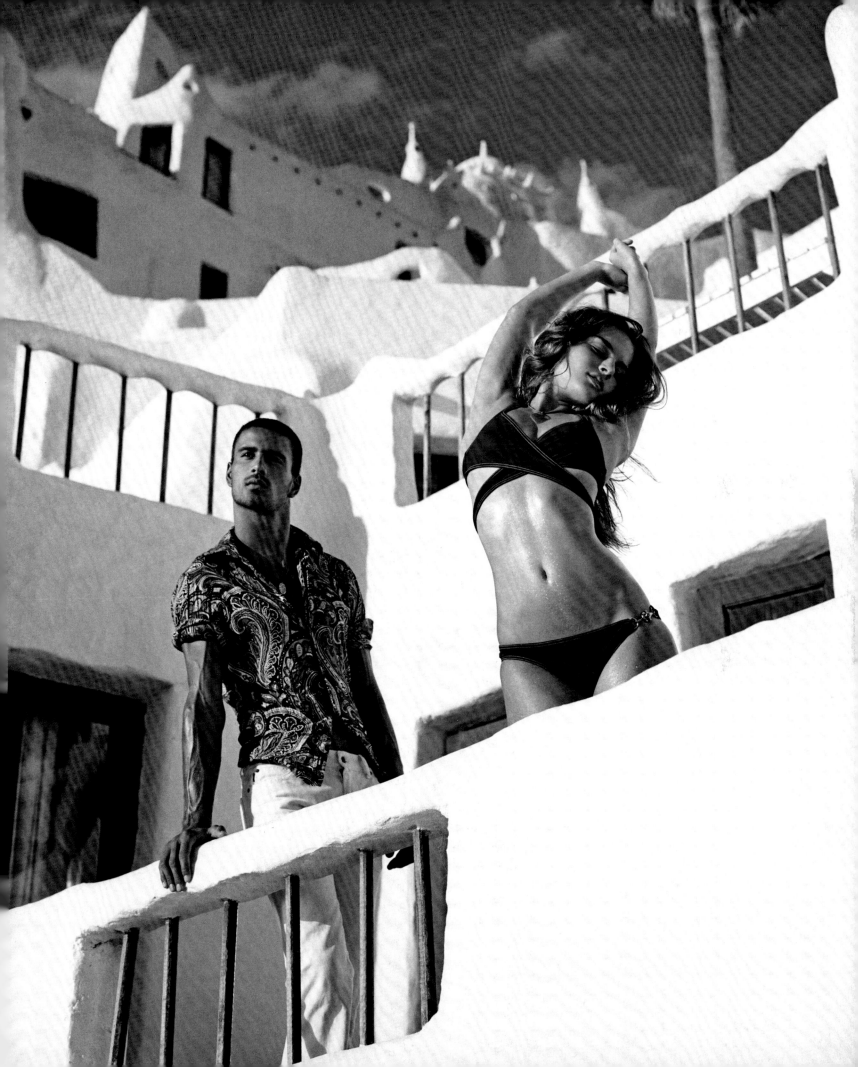

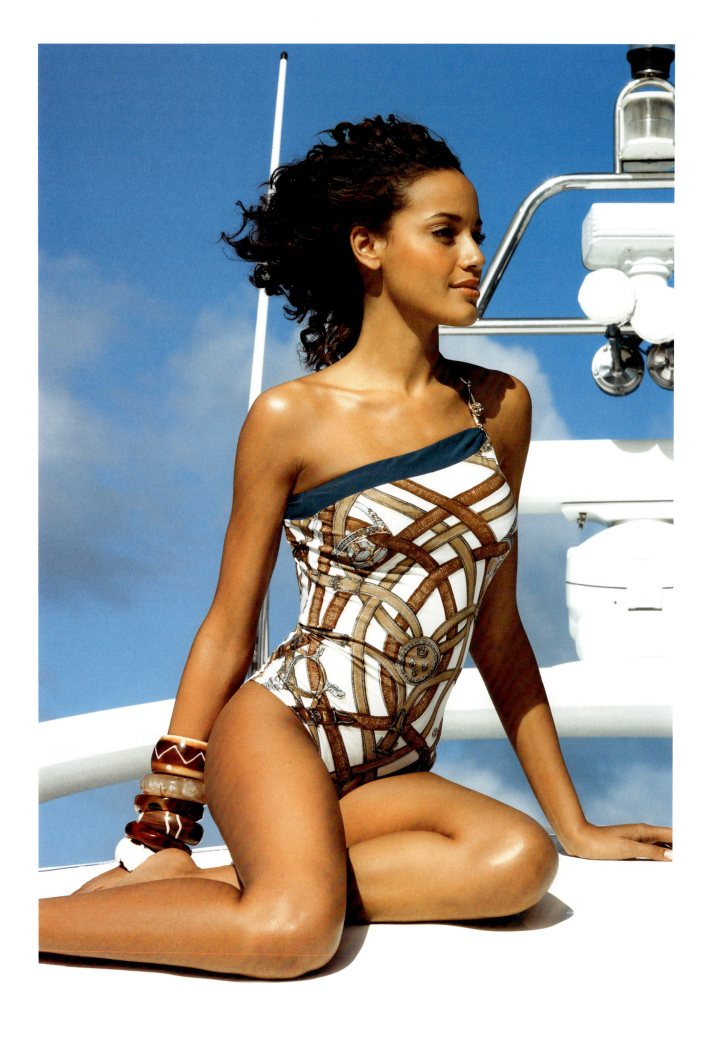

PREVIOUS SPREAD: *On her, an Hermès bikini with a me&ro necklace. On him, a Michael Kors shirt. Photographed at the Casapueblo—the intriguing, sculptural hotel created by artist Carlos Páez Villaró in Punta del Este, Uruguay—by Anders Overgaard for* GQ, *2007.* LEFT: *One-shoulder Hermès suit splashed with bridle and other riding regalia, worn with Hermès and other bangles. Photographed by Patrick Demarchelier for* Glamour, *2008.* ABOVE: Vogue *described this Cole of California one-piece suit of black taffeta woven with Lastex as having "the merest snippet of a skirt in front." Photographed in California by Karen Radkai for* Vogue, *1954.* FOLLOWING SPREAD: *Gilding the logo, Louis Vuitton maillot. Photograph by Rennio Maifredi, 2007.*

The 1950s saw some bathing suits become as elaborate as evening dresses. This example by Howard Greer for Caltex was made of black velvet edged with black lace. Photographed in Tunisia by Louise Dahl-Wolfe for Harper's Bazaar, *1950.*

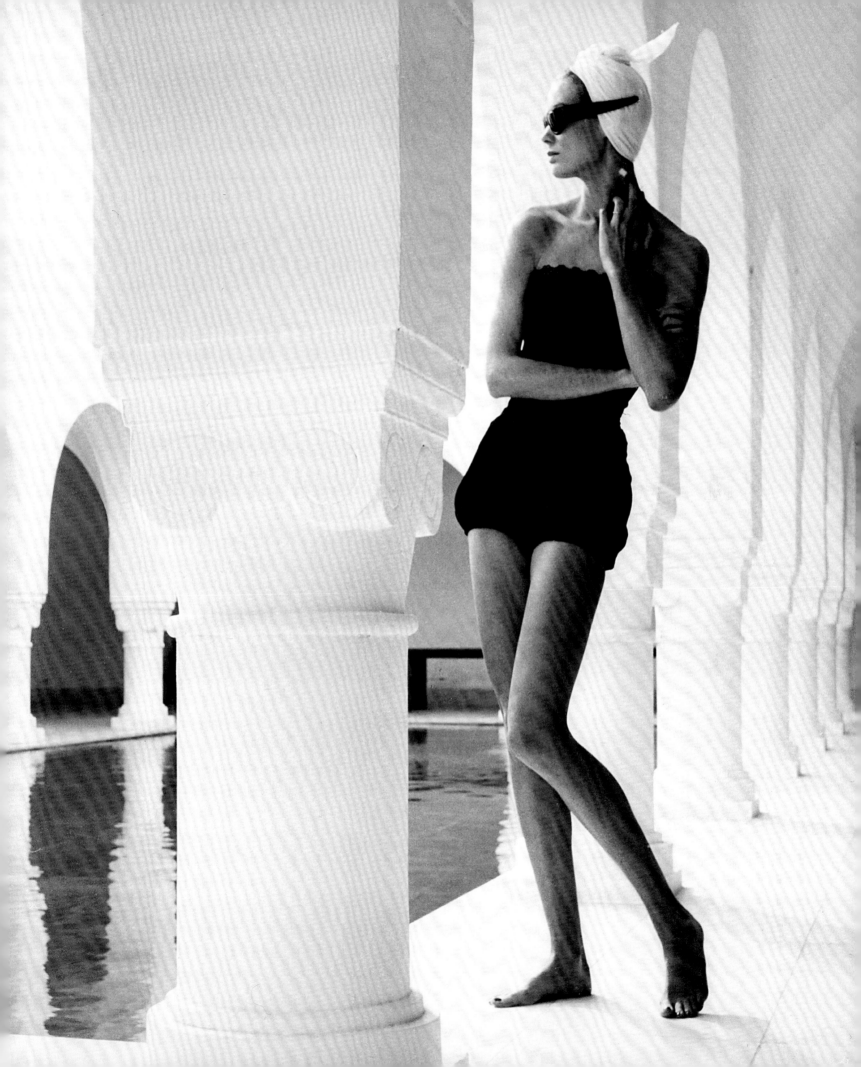

IMAGE CREDITS

Gleb Derujinsky © Gleb Derujinsky/Empire Editions: p.2; Helmut Newton © Vogue, Helmut Newton/ Condé Nast Publications: pp.4-5; Patrick Demarchelier © Vogue, Patrick Demarchelier/ Condé Nast Publications: pp.6-7; © Everett Collection: p.8; Toni Frissell, courtesy Library of Congress: p.9; courtesy Norman Parkinson Archive, London: p.10; photograph by John Rawlings, courtesy of the Museum at the Fashion Institute of Technology, New York: p.12; Pamela Hanson © Pamela Hanson/Art + Commerce: p.13; Slim Aarons/ Getty Images © 2004 Getty Images: p.14; photograph by Louise Dahl Wolfe, courtesy of the Museum at the Fashion Institute of Technology, New York: p.17; photograph by Jacques Henri Lartigue © Ministère de la Culture - France / AAJHL: pp.20-21; Slim Aarons/ Getty Images © 2007 Getty Images: p.22; courtesy Leonard Fox Gallery: p.25; Roger Viollet/ Getty Images © Lipnitzki/Roger Viollet: p.26; © Everett Collection: p.28; © Bettmann/CORBIS: p.31 (left); Time & Life Pictures/ Getty Images © Time Life Pictures: p.31 (top right); courtesy Library of Congress: p.31 (bottom right); Patrick Demarchelier © Glamour, Patrick Demarchelier/ Condé Nast Publications: p.33; George Hoyningen-Huene © Condé Nast Archive/CORBIS: p.34; Toni Frissell, courtesy Library of Congress: p.36; photograph by John Rawlings, courtesy of the Museum at the Fashion Institute of Technology, New York: pp.38-39; Time & Life Pictures/Getty Images © Time Life Pictures: p.41; Patrick Lichfield © Vogue, Patrick Lichfield / Condé Nast Publications: p.42; courtesy Library of Congress: p.43; Estate of Valentina Schlee: p.44; photograph by Louise Dahl Wolfe, Courtesy of the Museum at the Fashion Institute of Technology, New York: p.45; © Everett Collection: pp.46-47; courtesy Leonard Fox Gallery: pp.50-51; photography Regan Cameron: p.52; photography Gleb Derujinsky © Gleb Derujinsky/Empire Editions: p.55; Toni Frissell © Vogue, Toni Frissell / Condé Nast Publications: p.56; photography Gavin Bond: p.58; photograph by John Rawlings, courtesy of the Museum at the Fashion Institute of Technology, New York: p.59; Fox photos © Getty Images: p.60; Pamela Hanson © Pamela Hanson / Art + Commerce: p.61; © Everett Collection: p.62; photo by Frederike Helwig © Frederike Helwig: p.63; © 2007 Getty Images: pp.64-65; Gleb Derujinsky © Gleb Derujinsky/Empire Editions: p.66; Edward Steichen © Condé Nast Archive/CORBIS: pp.68-69; photography Raymond Meier © Raymond Meier: p.70; Edward Steichen © Vogue, Edward Steichen / Condé Nast Publications: p.71; courtesy Leonard Fox Gallery: p.73; © 2007 Getty Images: p.74 (top); photography Joe Standart: p.74 (bottom); Arthur Elgort © Vogue, Arthur Elgort / Condé Nast Publications: p.75; photograph by Herman Landshoff, courtesy of the Museum at the Fashion Institute of Technology, New York: pp.78-79; © Genevieve Naylor/CORBIS: p.80; courtesy Leonard Fox Gallery: p.83; © 2007 Getty Images: p.84; Serge Balkin © Condé Nast Archive/CORBIS: p.85; © Everett Collection: p.86; photograph by Herman Landshoff, courtesy of the Museum at the Fashion Institute of Technology, New York: pp. 89-91; © Condé Nast Archive/CORBIS: p.92; photograph by Herman Landshoff, Courtesy of the Museum at the Fashion Institute of Technology, New York: p.95; photograph courtesy Beinecke Library, Yale © Estate of Honoria Murphy Donnelly/Licensed by VAGA, New York, NY: p.96 (left); © Getty Images: p.96 (right); Patrick Lichfield © Vogue, Patrick Lichfield / Condé Nast Publications: p.97; Arthur Elgort © Vogue, Arthur Elgort / Condé Nast Publications: p.99; photo by Stuart Morton/WireImage for MAC International © Getty Images: pp.100-101; Popperfoto/Getty Images © Getty Images: p.102; © Condé Nast Archive/CORBIS: p.103; Walter Chin/ Marek & Assoc/ trunkarchive.com: pp.104-105; photography Craig McDean © Craig McDean / Art + Commerce: pp.108-109; Toni Frissell, courtesy Library of Congress: p.110; photography Catherine Wessel: p.113; Henry Clarke © Vogue, Henry Clarke / Condé Nast Publications: p.114; photography Regan Cameron: pp.116-117; Miles Aldridge © Miles Aldridge/ trunk Archive.com: p.118-119; courtesy Leonard Fox Gallery: p.120; Pamela Hanson © Pamela Hanson / Art + Commerce: p.121; courtesy Lilly Pulitzer: p.122; photography Jonathan Becker: p.125; Patrick Lichfield © Vogue, Patrick Lichfield / Condé Nast Publications: p.126; AFP/Getty Images © 2007 AFP: p.127; Horst P. Horst © Vogue, Horst P. Horst / Condé Nast Publications: p.128; photograph by Louise Dahl Wolfe, Courtesy of the Museum at the Fashion Institute of Technology, New York: p.130; Karen Radkai © Vogue, Karen Radkai / Condé Nast Publications: p.131; Chris Von Wangenheim © Vogue, Chris Von Wangenheim / Condé Nast Publications: pp.134-135; Slim Aarons © 2005 Getty Images: p.136; photography Toni Frissell: p.139; © Everett Collection: p.140; Arthur Elgort © Vogue, Arthur Elgort / Condé Nast Publications: p.141; Gleb Derujinsky © Gleb Derujinsky/Empire Editions: p.142; photograph by Herman Landshoff, Courtesy of the Museum at the Fashion Institute of Technology, New York: p.143; Fox photos © 2007 Getty Images: p.144; © Everett Collection: p.145; Toni Frissell, courtesy Library of Congress: p.147; Natalie in Grès coat, Kairouan, 1950, photo by Louise Dahl Wolfe, Collection Center for

Creative Photography, University of Arizona © 1989 Arizona Board of Regents: p.148; Toni Frissell, courtesy Library of Congress: p.149; courtesy Norman Parkinson Archive, London: p.151; Arthur Elgort © Vogue, Arthur Elgort / Condé Nast Publications: pp.152-153; © 2007 Getty Images: pp.154-155; photograph Francesco Scavullo: p.156; Toni Frissell, courtesy Library of Congress: p.157; Arthur Elgort © Vogue, Arthur Elgort / Condé Nast Publications: p.159; Toni Frissell, courtesy Library of Congress: p.160; © Everett Collection: p.161; © Condé Nast Archive/CORBIS: pp.164-165; Gleb Derujinsky © Gleb Derujinsky/Empire Editions: p.166; photograph by Louise Dahl Wolfe, Courtesy of the Museum at the Fashion Institute of Technology, New York: pp.169-170; photograph by Herman Landshoff, Courtesy of the Museum at the Fashion Institute of Technology, New York: p.172; photograph by Louise Dahl Wolfe, Courtesy of the Museum at the Fashion Institute of Technology, New York: pp.173-175; Estate of Valentina Schlee: p.176 (left); photograph by Louise Dahl Wolfe, Courtesy of the Museum at the Fashion Institute of Technology, New York: p.176 (right); © Bettmann/CORBIS: p.177; Toni Frissell, courtesy Library of Congress: pp. 178-179; Kourken Pakchanian © Condé Nast Archive/CORBIS: pp.180-181; photograph by Louise Dahl Wolfe, Courtesy of the Museum at the Fashion Institute of Technology, New York: pp.183-184; Henry Clarke © 2008 Getty Images: p.187; courtesy Eres (Paris): pp.190-191; photograph Louis Dahl Wolfe © Harper's Bazaar, 1947: p.192; © Don Freeman, courtesy of Jayne N. Baum, New York: p.195; photograph by John Rawlings, Courtesy of the Museum at the Fashion Institute of Technology, New York: p.196; photograph by Louise Dahl Wolfe, Courtesy of the Museum at the Fashion Institute of Technology, New York p.197; Genevieve Naylor © Genevieve Naylor/CORBIS: p.198; Patrick Demarchelier © Allure, Patrick Demarchelier/ Condé Nast Publications: pp.200-201; photos: Jack Deutsch: pp.202-203; photography Jim Jordan: p.204; Gleb Derujinsky © Gleb Derujinsky/Empire Editions: p.205; © Everett Collection: p.206; photograph by Louise Dahl Wolfe, Courtesy of the Museum at the Fashion Institute of Technology, New York: p.207; courtesy Leonard Fox Gallery: p.208; courtesy Library of Congress: p.210; Arthur Elgort © Vogue, Arthur Elgort/Condé Nast Publications: p.211; photograph by Herman Landshoff, Courtesy of the Museum at the Fashion Institute of Technology, New York: pp.212-213; photograph by Herman Landshoff, Courtesy of the Museum at the Fashion Institute of Technology, New York: p.214; Arthur Elgort © Vogue, Arthur Elgort / Condé Nast Publications: p.216; JP Zachariasen © Vogue, JP Zachariasen / Condé Nast Publications: p.217; Henry Clarke © Condé Nast Archive/CORBIS: p. 219; photography Regan Cameron: pp.222-223; © Condé Nast Archive/ CORBIS: p.224; Wayne Maser © Vogue, Wayne Maser / Condé Nast Publications: p.227; courtesy Library of Congress: p.228; photograph by Herman Landshoff, Courtesy of the Museum at the Fashion Institute of Technology, New York; p.231; Kourken Pakchanian © Condé Nast Archive/CORBIS: p.232; © Condé Nast Archive/CORBIS: p.234; photograph by Jacques Henri Lartigue © Ministère de la Culture - France / AAJHL: p.235; photograph by Herman Landshoff, Courtesy of the Museum at the Fashion Institute of Technology, New York: p.236; courtesy Norman Parkinson Archive, London: p.237; courtesy Leonard Fox Gallery: pp.238-239; Slim Aarons © 2007 Getty Images: p.241; Toni Frissell, courtesy Library of Congress: p.242; © Everett Collection: p.244; Gleb Derujinsky © Gleb Derujinsky/Empire Editions: p.245; courtesy Library of Congress: p.246; photograph by Herman Landshoff, Courtesy of the Museum at the Fashion Institute of Technology, New York: p.247; Guy Le Baube © Vogue, Guy Le Baube / Condé Nast Publications: p.248; Getty Images for IMG © 2008 Getty Images: p.249; Patrick Demarchelier © Vogue, Patrick Demarchelier/ Condé Nast Publications: p.250; photo Olaf Wipperfurth: p.251; photography Nick Haymes: pp.252-253; © Condé Nast Archive/CORBIS: p.254; courtesy Library of Congress: p.256; Helmut Newton © Vogue, Helmut Newton / Condé Nast Publications: p.257; © Everett Collection: p.258; MGM/UA/Photofest © MGM/UA: 259; photograph by Jacques Henri Lartigue © Ministère de la Culture - France / AAJHL: pp.260-261; Toni Frissell, courtesy Library of Congress: p.262; © Bettmann/CORBIS: p.263; courtesy Library of Congress: p.265; courtesy Eres (Paris): pp.266-267; © Condé Nast Archive/CORBIS: p.268; Toni Frissell, courtesy Library of Congress: p.271; photography Anders Overgaard: pp.272-273; Patrick Demarchelier © Glamour, Patrick Demarchelier/ Condé Nast Publications: p.274; Karen Radkai © Vogue, Karen Radkai / Condé Nast Publications: p.275; Rennio Maifredi / Chris Boals Artists / trunkarchive.com: pp.276-277; Natalie Paine in Hammamet, Tunisia, 1952, Collection Center for Creative Photography, University of Arizona © 1989 Arizona Board of Regents: pp.278-279; courtesy Leonard Fox Gallery: p.285.

NOTES

p. 23 & p. 24, "wooden bathhouses . . ." and "After donning a shapeless Mother Hubbard . . ." and "watching the restless surge": Vanderbilt, Queen of the Golden Age, 101–102.

p. 24, "lift their hats on entering a railway carriage": Rives, Complete Book of Etiquette, 332.

p. 24, "formal introductions are really not necessary at sea": Holt, Encyclopaedia of Etiquette, 441.

p. 27, "The days when a trip to Europe invariably meant . . .": Rives, Complete Book of Etiquette, 328–329.

p. 32 & p. 35, "Everywhere in the country and for almost every sport . . .": Vogue, 15 June 1936, 39.

p. 35, "nary an eyebrow was raised": Charlotte Curtis, "Resort Attire Is Varied and Colorful," New York Times, 13 July 1963, 20.

p. 35, "In the 1950s there was a shift . . .": De Holguin, Tales of Palm Beach, 92.

p. 35 & p. 37, "The most influential fashion leader . . ." and "a centimeter short of suffocation": Phyllis Lee Levin, "Women's World Abroad," New York Times, 10 August 1959, 22.

p. 57, "For the first time in years Norman Norell hasn't made any sailor dresses": Bernadine Morris, "Designers Take to the Sea," New York Times, 13 March 1969, 42.

p. 112, "I tried bougainvillea pinks . . ." and "In Italy, or any warm climate . . .": Nan Robertson, "Sportswear Revamped by an Impatient Italian," New York Times, 12 January 1956, 20.

p. 137 & p. 138, "one of a whole coterie of women . . ." and "Spanish beauty . . .": Beaton, The Glass of Fashion, 166.

p. 138, "now seems class-ridden, patronizing . . .": Suzy Menkes, "Runways: Remembrance of Thongs Past," New York Times, 18 July 1993, Style section, 6.

p. 138, "It's a bold color—nothing's cleaner than white": Cheryl Lu-Lien Tan, "Jason Wu's 'Dream-Like' Vision for Michelle Obama," Wall Street Journal fashion blog "Heard on the Runway," 21 January 2009, http://blogs.wsj.com/runway/2009/01/21/.

p. 168, "increasing trend toward practical but pretty attire . . .": "Fashions: New Shorter Length Slacks Popular This Season," New York Times, 29 August 1952, 30.

p. 194, "Lynn was wearing a dress that was split up the sides . . .": Warhol, The Andy Warhol Diaries, 300–301.

p. 229, "began with the formal evening gowns . . .": Virginia Pope, "Americans' Types in New Heim Garb," New York Times, 18 May 1946, 16.

p. 230, "managed somehow to make bare breasts unbecoming": Frank Deford, "A Daring Reporter Tries on a Thong and Tells the Truth About It," Sports Illustrated, 24 March 1975, 6.

SELECTED BIBLIOGRAPHY

Amory, Cleveland. The Last Resorts. New York: Harper, 1952.

Baumgarten, Linda. What Clothes Reveal: The Language of Clothing in Colonial and Federal America; The Colonial Williamsburg Collection. Williamsburg, Va.: Colonial Williamsburg Foundation; New Haven: Yale University Press, 2002.

Beaton, Cecil. The Glass of Fashion. Garden City, N.Y.: Doubleday, 1954.

Bender, Marylin. The Beautiful People. New York: Coward-McCann, 1967.

Blum, Dilys E. Shocking! The Art and Fashion of Elsa Schiaparelli. Philadelphia: Philadelphia Museum of Art; New Haven: Yale University Press, 2003.

Charles-Roux, Edmonde. Chanel and Her World. London: Weidenfield & Nicolson, 1981.

De Holguin, Beatrice. Tales of Palm Beach. New York: Vantage, 1968.

Hall, Carolyn. The Thirties in "Vogue." New York: Harmony, 1985.

Holt, Emily. Encyclopaedia of Etiquette: What to Write, What to Wear, What to Do, What to Say; A Book of Manners for Everyday Use. Garden City, N.Y.: Doubleday, Page, 1915.

Kennedy, Shirley. Pucci: A Renaissance in Fashion. New York: Abbeville, 1991.

Lee-Potter, Charlie. Sportswear in "Vogue" Since 1910. New York: Abbeville, 1984.

Lenček, Lena, and Gideon Bosker. Making Waves: Swimsuits and the Undressing of America. San Francisco: Chronicle Books, 1989.c

Martin, Richard, and Harold Koda. Splash! A History of Swimwear. New York: Rizzoli, 1990.

McCardell, Claire. What Shall I Wear? The What, Where, When, and How Much of Fashion. New York: Simon and Schuster, 1956.

Milbank, Caroline Rennolds. New York Fashion: The Evolution of American Style. New York: Harry N. Abrams, 1989.

Probert, Christina. Swimwear in "Vogue" Since 1910. New York: Abbeville, 1981.

Rives, Hallie Erminie. The Complete Book of Etiquette. Philadelphia: John C. Winston, 1926.

Rothschild, Deborah, ed. Making It New: The Art and Style of Sara and Gerald Murphy. Introduction by Calvin Tomkins. Williamstown, Mass.: Williams College Museum of Art; Berkeley: University of California Press, 2007.

Silmon, Pedro. The Bikini. London: Diadem, 1986.

Vanderbilt, Cornelius, Jr. Queen of the Golden Age: The Fabulous Grace Wilson Vanderbilt. New York: McGraw-Hill, 1956.

Vickers, Hugo. The Private World of the Duke and Duchess of Windsor. London: Harrods Publishing, 1995.

Wallach, Janet. Chanel: Her Style and Her Life. New York: Doubleday, Nan A. Talese, 1998.

Warhol, Andy. The Andy Warhol Diaries. Edited by Pat Hackett. New York: Warner, 1989.

Weber, Caroline. Queen of Fashion: What Marie Antoinette Wore to the Revolution. New York: Henry Holt, 2006.

SELECTED PERIODICALS

Harper's Bazaar, Mademoiselle, New York Times, Sports Illustrated, Town & Country, Vogue

ACKNOWLEDGMENTS

It has been an utter delight, a breeze, to bring *Resort Fashion* to fruition, thanks to everyone at Rizzoli, especially publisher Charles Miers, managing editor Anthony Petrillose, designer Reed Seifer, and copy editor Ann Marlowe. Most of all I thank my editor, Caitlin Leffel, and photo editor and editorial assistant Allison Power.

No research project can be launched smoothly without the élan of Stéphane Houy-Towner at the Costume Institute at the Metropolitan Museum of Art. I am deeply grateful to Irving Solero and Valerie Steele at the Museum at the Fashion Institute of Technology, Marilyn Ibach at the Library of Congress, and Florence Palomo at Condé Nast.

For graciously making available photographs or other illustrations, many thanks to: Leonard Fox, Cecily Dyer, Kohle Yohannan, Russell Nardozza, Michele Oka Doner, Joe Standart. For copy photography, thanks to Leyla Tatiana Rosario and Chris Dadap.

For inspiration, feedback, interesting leads, technical savvy, or enthusiasm I am indebted to Margaret Chace, Margo Donahue, Celeste Ford, Martha Glass, Anne Goldrach, Margot Horsey, Harold Koda, Laura Layfer, Dorota Liczibnska, Lisa Fingeret Milbank, Amélie Rennolds, Lynn Sellin, Clinton Standart, Abby Stowe, Kathy Tyree, and Harriet Whiting. And thanks as well to Amy Fine Collins for gracing this book with her prose.

Resort Fashion could not have happened without just a little on-site investigation. Therefore it is dedicated to my able research assistants, not to mention favorite traveling companions: Jerry and Rives.

Summer frock by Paul Poiret. Pochoir illustration by Georges Lepape for Gazette du Bon Ton, *1920.*

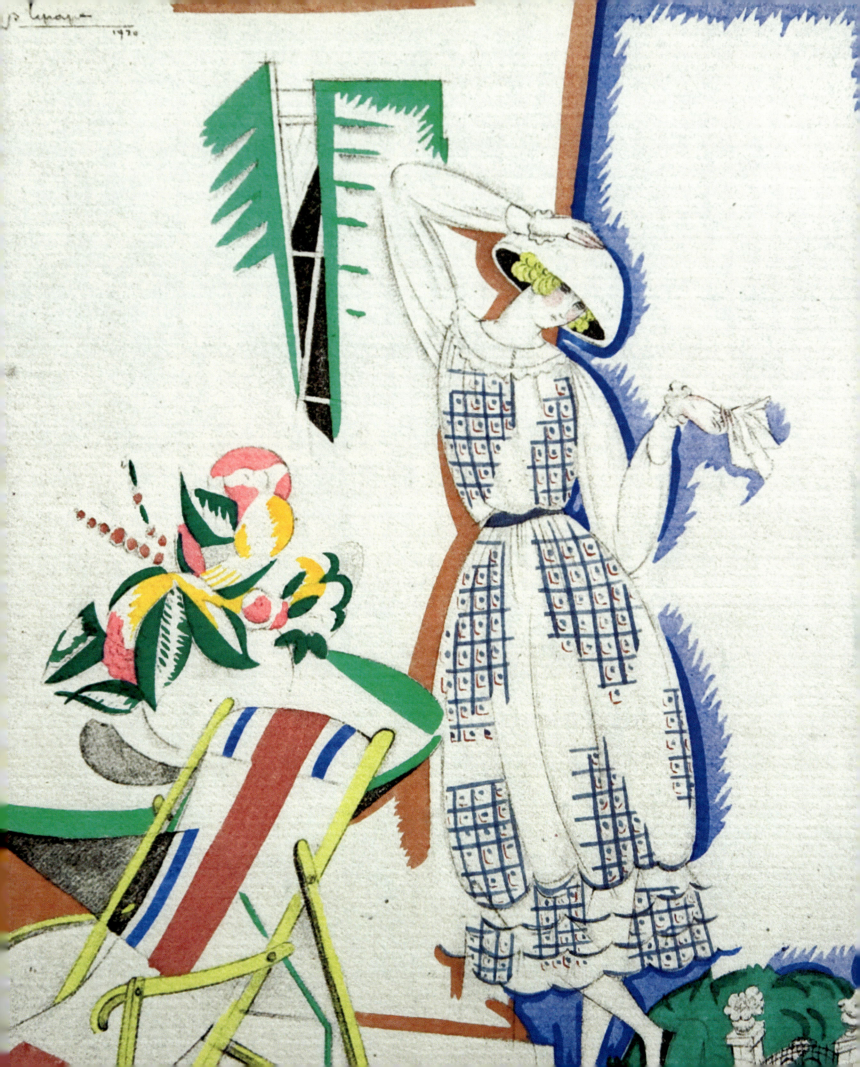

ADDITIONAL CAPTIONS

FRONTISPIECE: *Carmen Dell'Orefice wearing what* **Harper's Bazaar** *called a "Roman bathrobe—a long, narrow run of red, blue, and gold stripes on white," designed by Toni Owen. Photographed by Gleb Derujinsky in East Hampton, 1957.*

PAGES 4-5: *Charlotte Rampling practicing yoga in a Givenchy Boutique maillot on the pool deck at her Roger Herrera-designed St. Tropez villa. Photographed by Helmut Newton for* **Vogue**, *1976.*

PAGES 6-7: *Chanel cut-out suit with pearl and jewel belt, worn with Capezio shoes. Photographed by Patrick Demarchelier for* **Glamour**, *2006.*

FIRST PUBLISHED IN THE UNITED STATES OF AMERICA IN 2009 BY

RIZZOLI INTERNATIONAL PUBLICATIONS, INC.

300 PARK AVENUE SOUTH, NEW YORK, NY 10010

WWW.RIZZOLIUSA.COM

All rights reserved. No part of this publication may be reproduced, stored in a retrieval system, or transmitted in any form or by any means, electronic, mechanical, photocopying, recording, or otherwise, without prior consent of the publisher.

Typeset in Linotype Didot and Antenna

ISBN: 978-0-8478-3348-1

LIBRARY OF CONGRESS NUMBER: 2009925975

COPYRIGHT © 2009 CAROLINE RENNOLDS MILBANK

DESIGN BY REED SEIFER
EDITED BY CAITLIN LEFFEL

2009 2010 2011 2012/

10 9 8 7 6 5 4 3 2 1

PRINTED IN SINGAPORE